THE PHOTOGRAPH AND THE AMERICAN INDIAN

M

The Photograph
and the American Indian

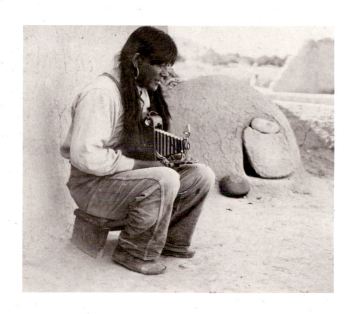

Alfred L. Bush
and Lee Clark Mitchell

PRINCETON UNIVERSITY PRESS

PRINCETON · NEW JERSEY

Published by Princeton University Press, 41 William
Street, Princeton, New Jersey 08540
In the United Kingdom: Princeton University Press,
Chichester, West Sussex

Publication of this book has been aided by a grant
from the New Jersey Department of Higher
Education

Library of Congress Cataloging-in-Publication Data

Bush, Alfred L.
 The photograph and the American Indian / Alfred
L. Bush and Lee Clark Mitchell.
 p. cm.
 Includes bibliographical references.
 ISBN 0-691-03489-3 (CL)
 1. Indians of North America—Pictorial
works. 2. Photography in ethnology. I. Mitchell,
Lee Clark, 1947- . II. Title.
E77.5.B87 1994
970.004′97—dc20 94-12178

This book has been composed in Bembo
by The Composing Room of Michigan

Printed by The Stinehour Press, Lunenburg, Vermont

10 9 8 7 6 5 4 3 2 1
10 9 8 7 6 5 4 3 2 1
(Pbk.)

Designed by Laury A. Egan

Contents

FOR OUR SONS

Carl Mitchell and Paul Tioux

Preface

On September 18th, 1985, a three-day conference on "The Photograph and the American Indian" convened at Princeton University. Sponsored by the Program in American Studies, the Princeton Collections of Western Americana of the University Library, and the New Jersey Department of Higher Education, the conference brought together students of both the American Indian and photography. A wealth of new perspectives on American iconography and cultural change were suggested by the formal papers, and the discussions that followed gave spirited evidence of the sensitive place photography still occupies in the lives of Native Americans.

Three days before the conference began, as members arrived in Princeton, an exhibition with the same title as the conference opened in the gallery of the University Library. This gathering of photographic images of American Indians was selected not only from collections at Princeton but also from a score of museums, libraries, and private collections throughout the country. The purpose of the exhibition was simply to suggest the dimensions of the available photographic record by presenting as diverse a sample of images of Native Americans as possible, from the earliest calotypes of 1844–45 to the latest photomontage. We threw our nets wide, seeking photographs not only by notable artists but also by amateurs, representing a range from the most elaborately conceived composition to casual snapshots, searching for the self-conscious artist as well as the accidental one. We looked for popular stereotypical images as well as more deeply informed visions, trying to balance the concept of the "other" with documents from the inside, aspiring to gather as diverse and disparate a vision of the many worlds of indigenous Americans as the record would allow. We intended that these documents should stimulate the conference dialogue as well as the thoughts of later visitors to the exhibition regarding the richness of the photographic archive. The American Indian has fascinated photographers from the earliest years of the medium, and the record of that fascination seemed ripe for scholarly attention.

Princeton University is fortunate in its collections of photographs of Native Americans, which rests on an initial gift of portfolios and albums of nineteenth-century albumen prints gathered by Sheldon Jackson (1,040 images in all). This collection was given to Princeton in the 1880s at a time when Jackson was also providing ethnographic materials to the college for its museum, then housed in Nassau Hall. Not until nearly a century later did the Princeton Collections of Western Americana begin adding to that initial gift, and the extensive present holdings are what prompted the idea for both conference and exhibition.

Energetic discussion and considerable attention were generated by the conference, with many individuals expressing the hope that the exhibition could be extended to a larger audience through a catalogue. Unfortunately, by the time the decision to publish was made, the exhibition had been dismantled, the borrowed pieces returned to their owners. For various reasons, some of these photographs could not be recalled to Princeton. One of the special regrets is that photographs by representative painters of the artist colonies that flourished early in the century in Santa Fe and Taos could not be included in the catalogue, although they enriched the exhibition. Still, by and large this is an accurate record of the 1985 exhibition, with images no longer available for reproduction replaced by others not in the show.

This catalogue, like the exhibition, has a simple objective: to present the broadest range of photographs with American Indians as subject. Generally we have offered these documents in chronological progression, even if sometimes only an approximation of a date can be suggested. As both the confer-

ence and exhibition emphasized, the exact identification of photographers and subjects is unusually fraught with difficulty, especially since the custom of many nineteenth-century photographers was to appropriate other practitioners' images without giving credit to the original artist. It was also not unusual to label lesser-known Indian subjects with the names of more famous native personalities in the hope that sales would increase; or, for the same reason, to attach tales or explanations to subjects with no legitimate justification. Dates were rarely associated accurately with an image. Struggle as we have with these three difficulties, correctors are certainly in the wings (given the frequency with which captions are emended in the current literature), and we will be grateful for their help.

Our foremost concern has been to reproduce these images as faithfully as modern printing allows: they deserve no less, whether as documents of the historical record or as works of art. Princeton University Press has fortunately put this delicate task into the hands of the Stinehour Press, whose reputation for reproductive integrity has served the photographs well. Whenever possible the photographs are reproduced at exact size; on those occasions when the original is larger than the catalogue page allows, we have indicated the dimensions in the caption.

As the exhibition was being planned, a special concern was that it not be a show of non-Indian visions of the Native American, and we made a special effort to discover American Indian photographers. This began with invitations to contemporary native artists to contribute work to the show, and continued with research that extended our representation of such photographers back into the nineteenth century. Like many other aspects of our conceptions of the American Indian, the assumption that photography by them was a recent phenomena proved baseless. Benjamin and Henry Haldane and Thomas Eaton, all Tsimshian, pursued their work in the nineteenth century with exacting professionalism, one even stamping his work that of a "Native Photographer." Their present-day successors are a surprisingly large number of skilled professionals, many of whom were eager to add their vision to the exhibition. Viewers

were pleased to find so many tribal designations after photographers' names in the contemporary section of the show.

Lastly, a caveat: we have allowed "American Indian" in our title to be more comprehensive than a number of native groups, particularly those in the far north, would wish. We apologize for not correctly distinguishing between Native Alaskans, Inuit, and American Indians. It is the impulse to avoid ponderously listing these groups separately that has lent greater currency to the term Native American. Furthermore, we regret having to ignore the largest population of American Indians—that in Central and South America—in the effort to offer a fuller view of those in North America, from Mexico's border with Guatemala north to the Arctic.

In the decade since we began planning the exhibition and conference, fascination with this subject has accelerated. The formation of the Native Indian/Inuit Photographers Association in Canada by participants in the Princeton conference, the mounting bibliography of relevant publications, the proliferation of exhibitions of photographs by and of Native Americans, and the emerging recognition in native communities that photographic images are part of their cultural patrimony: all confirm a spreading enthusiasm in the subject and reinforce our belief in the special connections between the photograph and the American Indian. We hope this record of an exhibition will mark a better understanding of the conjunction between that American population with the oldest roots in this hemisphere and the most ubiquitous of modern inventions.

We are grateful for the cooperation of many people in making this catalogue possible. Lenders were generous not only with photographs but with their knowledge. In the instance of one private collection, we called so extensively and found a response so generous (both in images and information) that its owners need to be specially named: Victor Germack and Lori Shepard Germack. Marni Sandweiss (then associated with the Amon Carter Museum) was an early and reassuring advisor; Paula Fleming extended the facilities of the National Anthropological Archives at the Smithsonian Institution to the complex-

ities of identification; Michael Coe smoothed our way into the riches of the photographic collections of the Peabody Museum at Yale University; Richard Rudisill made the images in the Museum of New Mexico collections accessible and was unfailingly generous with his phenomenal knowledge of photography; Lynn Ponce de Leon and Kim Wilson toiled effectively and imaginatively on the research and writing of the biographies of photographers found at the end of this catalogue.

Curators, collectors, and scholars throughout the country were uniform in their willingness to share their knowledge of the locations of photographs and to identify problematic images. Victor Masayesva, Alfonso Ortiz, Regis Pecos, and Jaune Quick-To-See Smith were crucially helpful in our search for contemporary Indian photographers. A grant from the New Jersey Department of Higher Education not only made the conference and exhibition possible but also provided a subvention to aid in the publication of this catalogue. We are also indebted to the Princeton University Committee on Research in the Humanities and Social Sciences for providing financial assistance in the late stages of this project. Finally, it is a special pleasure to thank Stephen Stinehour for the very personal attention he has given the production of this catalogue at the Stinehour Press; and to acknowledge the indispensible part played by Elizabeth Powers of the Princeton University Press in bringing this work to its final form.

Alfred L. Bush
Lee C. Mitchell

The Photograph and the American Indian

Lee Clark Mitchell

Occasionally, someone will regret that the camera came too late for Native American life: too many tribes had declined by the 1860s when photographers first began packing gear west, precluding little other than a record of physical deterioration and cultural malaise. Yet upon more considered reflection, regret seems an inappropriate, even illogical response, since it is clear that the sophisticated technology which led to the camera resulted from the very forces imperilling tribal life. It was no mere accident of historical circumstance that linked photography with imperialism; quite the contrary, the expertise crucial for first a photograph, then a photographic industry, accrued directly as a result of the centuries-long process of colonial acquisition.[1] Photography was therefore "too late" as well in Africa, Australia, and South America, where colonists likewise enthused at snapshots depicting cultures they sought to displace. Compounding this irony of camera as product of a culture expansively imperialistic is the photograph's own intrinsically imperializing role—as a tool, in Susan Sontag's words, that enables "people to take possession of space in which they are insecure." Long before colonials had actually settled their various continents, then, a "colonization through photography" had successfully confirmed the very process of decline and extinction that the photographic record was supposedly meant to forestall.[2]

In the face of so self-confirming a logic, it may come as a surprise to learn that the supposedly "vanishing race" has not merely survived but now produces celebrated photographers of its own. With astonishing success, these professionals have learned to bridge two disparate cultures, transforming a tool that initially bore witness to their demise and in the process taking themselves from a condition of pictorial subjugation to artistic mastery. The following selection of images outlines the history of that journey—a history at once contradictory, circuitous, anguished, and now largely forgotten. Indeed, precisely because so much has been irrevocably lost, these photographs possess (at the very least) a conspicuously remedial status, awakening us to the rich legacy of misapprehensions held both by and about Native Americans.

The fact is that Indians have repeatedly posed for the camera in ways they assumed were expected, even as photographers have just as persistently set scenes they envisioned as natively apt. Little as that pattern has altered over a century and a half, however, particular expectations have clearly changed along with more general standards of composition. Any meeting of cultures, after all, both challenges and confirms expectations in ways exposed with peculiar force through the camera lens. For that is photography's singular prerogative among the pictorial arts: to register all that falls within the camera's range, exposing the photographer as ineluctably as his subject, revealing furtive assumptions as tellingly as open biases. That mixed array of assumptions and biases constitutes a remarkable and ongoing cultural dialogue, documented with particular force in the photographs that constitute this volume. Before turning to that dialogue, however, we need to clarify the simple historical coordinates within which it can be understood.

The Photograph? *The* Indian?

The best place to begin is with Plate 1, an image of an Indian village in eastern Nebraska composed by the famous photographer of the American West, William Henry Jackson. Dozens of blanketed Pawnee, enthralled by what looks like a secret tribal ceremonial, huddle with their backs to the rain and the camera. Confined to the outskirts of the village, the camera is ignored by all (including four dogs) even as it visually penetrates the closed circle from which it is excluded. That tension between camera and scene elicits the impression of cultural modes opposed to each other, an impression tacitly reinforced by the photograph's iconography: the finely detailed texture of the image attests to a sophisticated technology that contrasts, in vividly material fashion, with the earthen lodges and hand-crafted garments represented *in* the image. Medium and subject stand defiantly at odds in a conflict represented as intrinsically cultural—one that continues to resonate through the following selection of photographs. Yet even this marvelous image by Jackson allows no simple resolution by parts. Look more carefully at its center, which is also the center of the tribe's attention, and all of a sudden the depiction of a mysterious Indian ceremonial is transformed into a prosaic record of three white men. The object of their apparently animate exchange remains forever an enigma, but their emergence from indistinct shadows provides what should be a continuing lesson as we proceed: any hasty reading of cultures or of photographs is made at our hazard.

Perhaps the most productive approach to the following series of photographed moments can be found in the title, "The Photograph and the American Indian"—if only because our general assumptions are structured in the tension between its two terms. Not that either term is precisely accurate, or needs to be for our purposes. "*The* American Indian" has long been acknowledged a notorious misnomer, less fitting as sign of indigenous peoples than as symbol of all that European cultures deplore and a capitalist ethos rejects. By contrast, "*the* photograph" forms a perfect emblem of urban-industrial consciousness in its tacit claim to represent the physical world exactly as is. That powerful attention to actual surfaces as well as the capacity for endless reproduction suggests how fully the camera embodies a break with anything subjective, ineluctably private, or otherwise immeasurable.

Making everything equally apparent, equally accessible to the eye, the camera reinforces a misplaced premise of objectivity. No matter how odd or idiosyncratic particular images may seem, photographs all tend to resonate at the same semantic frequency, with the effect of reducing experience to a visual form of the least common denominator. By contrast, Indian cultures tend to honor the private and participatory, to venerate invisible ties and otherworldly affinities, to preserve sacred knowledge from all but the initiated. Which may explain why the photographer has been denounced from the beginning as a "shadow stealer" who challenged the cultural context of what he so often recklessly exposed to view. The very glare of full disclosure valued by a technological society threatened the disappearance of "shadow" truths essential to tribal cultures. And with their disappearance, it was thought the cultures themselves would fade away.

It is all too easy to forget that the twin abstractions of the title exist within a specific set of historical contexts that alter the abstractions themselves. "The photograph" may imply a process that has remained uniform for over a century and a half, but that notion is thoroughly repudiated by the selection gathered here. In fact, the term "photography" embraces an eclectic assortment of image-objects, from stereographs to Kodak snapshots, from calotypes, tintypes, and ambrotypes to prints both albumen- and gelatin-based, from the earliest silver daguerreotypes to the most recent digital reproductions. Nor are the scenes represented less varied than the techniques by which they were chemically fixed, whether posed or candid, studio shots or domestic views, anthropological studies or *carte de visites*. In much the same fashion, the singular "Indian" stands for hundreds of tribes that differed as dramatically as those here represented by Apache and Tlingit, Sioux and Kwakiutl, Pueblo, Cree, and even the "last

Monhecan." So comprehensive is the concept that sometimes the non-Indian Eskimo are assumed part of the race. Even when properly used, the category "Indian" seems inadequate to the variety invoked, as a glance at the following images reveals. There is a rich multifariousness to the costumes, hairstyles, and adornments that Indians wear as well as to the utensils, artifacts, and architecture they created—in short, to the cultures entailed in the monolithic abstraction, "American Indian."

Despite the variety disguised beneath this semblance of sameness, the "photograph" and the "American Indian" possess a sheer power *as* abstractions that leads us to think of them straightforwardly. Start with the commonly accepted view of photographs as simple, self-evident documents in little need of interpretation. "They are indeed able to usurp reality," Susan Sontag observes, "because first of all a photograph is not only an image (as a painting is an image), an interpretation of the real; it is also a trace, something directly stenciled off the real, like a footprint or a death mask. While a painting . . . is never more than the stating of an interpretation, a photograph is never less than the registering of an emanation (light waves reflected from objects)—a material vestige of its subject in a way that no painting can be."[3] And because they "usurp reality" in this way, we mistakenly assume that photographs reproduce scenes as they are, and dismiss too readily the way the camera shapes experiences it records. It does so, moreover, through "frames" more tightly constraining than lighting levels and camera angles, compositional strategems or darkroom tricks. The larger, historically determined assumptions that lie behind these techniques predispose us to the views we accept, since before we even begin to look those assumptions shape our judgment of what a picture ought to be—our interest in some figures rather than others, our preference for a characteristic stance or typical costume or familiar demeanor. Any photographer has a more or less hidden agenda, involving at a minimum certain simple economic considerations. To be aware of those considerations is to address a set of similarly simple questions whenever faced with a photograph

worth serious attention. For whom is the photographer working or to whom is he planning to sell his image? What is the audience meant to see, and at the same time, not to see? The small-time entrepreneur grinding out postcards for a tourist trade is driven by one kind of motive; the scholar preparing a systematic catalogue for the Bureau of American Ethnology, by another. Studies planned for an arts exhibition require different considerations than institutional records commissioned for a school graduation or a prison identification. In recognizing such differences, we begin to see how powerfully institutional considerations (and larger cultural assumptions) shape photographic images in ways we otherwise tend to ignore. For photographs only seem to image reality transparently, disguising as they do so the terms of their own production. In fact, we need to keep reminding ourselves that they are cultural artifacts no more "natural" than any other.

The concept of the Indian likewise evokes assumptions that at one time seemed both natural and ahistorical (indeed, seemed natural because ahistorical). Far from that, however, those assumptions directly contradict one another and defy any consistent perspective from which Native Americans might be represented. Were they noble savages or bloodthirsty demons, confirmed pagans or redeemable souls, displaced nomads or an abiding symbol of the American landscape itself? The nineteenth century certainly could not decide, and given the collective cultural confusion, it is understandable why so many photographers failed to transcend stereotypes, even when the stereotypes were clearly belied by the subjects standing right before them. Some of the more revealing pieces of evidence for these framing preconceptions are the captions that photographers often attached to their work. "Primitive methods" by a "Hopi squaw" happens to describe Nampeyo, now considered among the most distinguished of modern potters (Plate 218).[4] Another caption facetiously refers to a bare-breasted woman as "Apache Belle: in evening dress" (Plate 153). Yet another describes a group of Seminole prisoners in Florida with the title "Indian Cut Throats and Scalpers" (Plate 132). Looking at captions first, the viewer is provided

with a ready-made mental category that forestalls the need to look closely or searchingly at the image itself. The fact that such titles have come to seem flagrantly misleading is due, at least in part, to the capacity of the photographs themselves to teach us to see past the captions with which they were labelled. No longer is it possible so easily to insulate oneself behind slogans of racial intolerance or to dismiss the implications of images that ask us to reconsider aspects of our own way of life. The sheer diversity of this selection of photographs encourages, at a minimum, respect for human variety even as it generates a healthy skepticism about any captioned claim to cultural authority.

Yet reductive and contradictory as the terms are, the photograph and the Indian still have a seductive conceptual power, due to nothing more than that so many have for so long accepted them. True as it is that Indian tribes differed radically one from another, they nonetheless shared more in common with each other than with the Europeans who displaced them from the land. Even though many did not closely resemble each other in social practice or technological achievement, the cogency of the European concept of "the Indian" led to their being treated alike. The misconception then confirmed itself in a continuing history of misunderstandings that prevented white Americans from recognizing distinctions that might have altered the basic paradigm.

In the case of photography, we likewise tend to assume a uniform standard, expressed most readily in the judgment that photographs present things more or less as they are. Despite all the ways we have learned they can lie, we nonetheless initially believe that they offer scenes as we would have seen them. The reason for this, as Beaumont Newhall asserts, is that:

The camera records, within certain limits, whatever is focused on the ground glass, no matter how chaotic the subject or how complex its texture. Unconsciously we are convinced that if we had been there, we could have seen it exactly so. We feel that we could have touched it, counted the pebbles, noted the wrinkles, and found it identical. We have been shown again and again

that this is frequently pure illusion . . . but the knowledge cannot shake our implicit faith in the truth of a photographic record.[5]

Or, in Roland Barthes's more succinct claim, "the referent adheres."[6] Because the photographic image represents a particular moment, it seems to place the viewer back at that same time and place: "I inevitably include in my scrutiny the thought of that instant, however brief, in which a real thing happened to be motionless in front of the eye."[7] That feeling was heightened at first through the use of the stereopticon, which enjoyed a broad popularity in the nineteenth century precisely for this reason. One stood not merely in front of a picture but actually caught within its perspective, or so at least the illusion led one to believe.

There is, in short, a magical power that seems to emanate from the photographic image, and to understand how fully that image can be feared and cherished simultaneously, we need to recover a sense of our own subliminal amazement at its powers of illusion. So closely is the photograph able to replicate visual phenomena, in fact, as to instill an unsettled feeling at the sight of one's own photographed face—making it seem somehow no longer one's own. That possibility was precisely what many natives had dreaded long before the 1830s, when George Catlin and Karl Bodmer first traveled west to paint Indian tribes unaffected by eastern life. The painters' assurances that portraits could in no way rob the self did little to allay suspicions, and in fact a certain historical irony accompanies the realization that those suspicions have since proved partially justified. For over a long history in which Indians have served as models without remuneration, photographers have profited from images sold as exotica in a white economy. One need not share tribal fears to understand native antipathy. Consider the battles with long-lensed paparazzi fought by such celebrities as Jacqueline Kennedy Onassis, whose confrontations have been sparked by the same desire for common courtesy that led the Hopi to ban photography entirely in 1915. In both cases, the camera that ostensibly served to entertain also posed a threat—a threat less sustained and less serious for Mrs. Onassis than

for those with fewer means of defense against visual acts of aggression. As well, Native Americans have rarely been as certain as she what the stakes involved could be. Is the photographer a passive recorder or someone who alters what he finds, sympathetic participant or rude intruder, preserver or thief?

Perhaps the issues at work in the meeting of photographers and Indians can best be adumbrated through an anecdote. Some years back, a Japanese tourist was sitting on a pueblo roof at Hopi, watching the famous snake ceremony with the aid of his binoculars. A Hopi soon touched him on the shoulder and, pointing to the binoculars, asked that he put them away. Aware of the prohibition against photography and jumping to the conclusion that the Hopi was simply unfamiliar with his equipment, the Japanese tourist offered a somewhat elaborate explanation of its function. The Hopi listened patiently before finally responding: "I know they are binoculars and I know what binoculars are for. But I also know that cameras can be hidden inside binoculars." With a brief pause, he then added, "Especially by the Japanese." One might note that it is a mark of change in the modern world that technological expertise and an enthusiasm for picture-taking are now so readily identified with the Japanese rather than Anglo-Americans.

The exchange also reveals a new technological sophistication among Indians themselves that exists side by side with a traditional reverence for cultural integrity. Such reverence has commonly been expressed by forthright resistance to the "shadow stealers" who for generations intruded upon native ceremonials. Yet Indians have for just as long been fascinated by photography, and as a few of them have become accomplished practitioners, a painful awareness has emerged of the tension between traditional values and the desire to photograph. One native artist, Victor Masayesva, nicely expresses this ambivalence: "As Hopi photographers we are in a delicate place and a dangerous time." Like generations before him, he is wary of the camera's power as "a weapon that will violate the silences and secrets so essential to our group survival." Nonetheless, he cannot help marvelling at what it uniquely has the power to create and appreciates its value "as cere-

mony, as ritual, something that sustains, enriches, and adds to our spiritual well-being."[8] It is worth recalling at this point the disagreeable example of Frederick Monsen, who in the 1890s surreptitiously photographed scenes that had been explicitly proscribed. His legacy is a source at once of embarrassment and of admiration to Hopi today, since despite his cavalier behavior and the genuine threat he posed to cultural integrity, he produced an extensive record of ceremonial as well as domestic life. The conflict expressed by Masayesva defines the coordinates of Monsen's career as well as most meetings of Indians and photographers over the past century and a half.

Those coordinates do not offer a very convenient mapping of the following selection of photographs, however, which is organized according to no specific tribe or any special category. In an eclectic assortment narrowed down from a large number of photographic collections, each choice has been made because it dramatically attests to a tension between cultural systems. Yet lacking any other organizational premise, the approach to these images is via an arbitrary division into three periods distinguished by major photographic developments. To that end, the following discussion first reviews breakthroughs in camera technology that have been responsible for characteristic differences in technique. Passing attention is also paid to certain large social influences that altered either photographic styles or general attitudes toward Native Americans. Of course, the wider one casts an interpretive net, the less accurate are firm chronological distinctions, and for that reason it is worth bearing in mind that the three "periods" are no more than a convenient arrangement, to be treated with due caution. Look a little closer at individual photographs and, as with Jackson's Pawnee village, neat distinctions begin to disappear.

From 1845 to the 1880s

The first known photograph of an American Indian was taken far from America's shores and for reasons not at all directly connected with the fact that the subject was an Indian. Yet the 1843 portrait of Kah-kewaquonaby (known as the Reverend Peter Jones)

xv

represents photographic technology at almost its earliest moment. This photograph was serendipitous, having been made in Great Britain by English photographers who specialized in portraits of clergymen. They used the calotype process discovered the decade before by Henry Fox Talbot, who developed the negative-positive system of photography that has become ubiquitous today. Like the single-step daguerreotype, which was at the time far more popular in the United States, calotypes required exposures so long that subjects were compelled to adopt a fixed pose. That pose soon became standard, aided by a series of body clamps and head vices, which lent a certain apparent homogeneity to otherwise quite different subjects. Although Indians might have darker complexions and be outfitted in seemingly outlandish garb, their gestures and demeanor were necessarily no different than those of most white sitters.

The discovery of collodion in 1846 did little to change the need for long poses, although it established the future direction of photography by ensuring a satisfactory negative-positive process. For the first time, detailed negatives could be developed inexpensively, in turn allowing accurate albumen-based prints to be produced by the hundreds. This so-called "wet-plate" process was successful enough to replace all others for the next thirty years and transformed the ways in which a newly emergent consumer society thought of images. The enormous popularity of personal photographs now available to the middle class had little effect, however, in simplifying a process inherently cumbersome and imperfect. To produce an image, fragile glass plates had to be delicately covered with iodized collodion, bathed in a silver-nitrate solution, carefully exposed, and then developed—all within about ten minutes. The exposures themselves rarely lasted less than several of those minutes, during which the subject concentrated on not scratching his nose, blinking his eyes, or moving his head from the vice that pinched from behind. It was not yet possible, moreover, to print enlargements from photographic negatives, so that images of reasonable size required cameras that were large and unwieldy. The glass plates required for even these moderately sized prints weighed nearly a pound apiece. To complicate matters further, all chemical processing had to take place in lightless conditions, which required darkrooms in the studio or cumbersome darkened tents in the field. Understandably, therefore, most photographs in the first quarter-century consisted of formal studio productions, whether of delegations invited to the nation's capitol or of individuals who visited local photographers in nearby western towns.

The conclusion of the Civil War turned the nation's energies more certainly westward, and both railroad surveys and Army explorations competed for young photographers, not only to document the landscape but to depict native peoples more accurately than ever before. Like earlier western explorers who had commissioned such painters as Karl Bodmer and Alfred Jacob Miller, the expeditions of the 1870s and 1880s offered unique opportunities to three premier photographers of the nineteenth-century American West: William Henry Jackson, John K. Hillers, and Timothy O'Sullivan. Few others were as fortunate as these three extraordinary practitioners, although occasionally even unattached cameramen responded to the lure of the West. As one proclaimed in 1866, he wanted "to illustrate the life and character of the wild men of the prairie."[9] However benighted, this reference reflects a genuine pictorial interest in tribes still independent and unchanged by white society. Not until the Battle of Wounded Knee nearly a quarter of a century later was active Indian resistance to the reservation system finally overcome.

Three major elements can be said to have contributed to the kind of image common to this period: equipment was delicate yet bulky, easily broken yet hard to move; photographers were frequently on government payrolls, subject to the dictates of changing policy and bureaucratic inflexibility; and many Indian cultures were still relatively unaffected by Anglo-American society. Because of the conjunction of these influences, a certain characteristic style evolved, identified most obviously by the way the camera itself intrudes into the image it records. Look at the photographs of delegations to Washington,

which differ little from studio prints in the West: subjects in both stare past or at a camera whose presence is fiercely affirmed by their gaze. Whether they wear presidential medals, or clench tomahawks or proffer a peace-pipe, their tight-lipped demeanors seem grimly defiant of the photographer himself. This contributes to the special power of many of these images. Nor is that power simply explained by the need for long exposures, since white contemporaries were forced to assume a similar pose.

Dark skin, long hair, odd costumes, and a variety of weapons confirm the Indian's allegorization as the "other"—counter to all that had come to mark civilized life. Like Australian aborigines and African tribes, Indians were identified with a continent desired by whites with increasing national passion. The need to legitimate such cravings led to a dismissal of indigenous peoples as unfit for residency, unsuited for efficient husbanding of the land and its resources. Their very clothing and shelter proclaimed their unfitness, and with appearances against them, what defense was conceivable? The Bannock, Ute, and Omaha teepees photographed by William Henry Jackson after the Civil War (Plates 46, 87, 29), the dirt pueblos in New Mexico (Plates 86, 96), the "waffle gardens" at Zuni (Plate 247), the Paiute brush shelters in Utah (Plate 190): like the mounds in Jackson's Pawnee village, all confirmed the strangeness as well as the technological incapacity of Native Americans.

It mattered little that photographers took an active hand in their subjects' appearance, sometimes literally dressing them up or down.[10] The point is that from a Victorian perspective portraits of bare-breasted Apache or Mohave or Navajo women clearly bespoke a primitive state (Plates 178, 172, 182). The "cheesecake" image referred to above of an "Apache Belle in evening dress" (as some versions of the photograph were captioned) is a telling example of this iconography of cultural backwardness—beaded necklace wound around the neck so as visually to divide bare torso from painted face, a division nicely embellished by the one loop dangling between the breasts. It is as if her figure embodied the logical contradictions in any conventional view of Indians:

lacking cultural constraints yet mired nonetheless in primitive beliefs. The confusion in this view did little to diminish its continuing power; whether one pursues the ideological implications of the woman's nakedness or of her figured face, she is in either case confirmed as alien to allegedly civilized values. And if this motif was hardly invented by Baker and Johnson, it was certainly popular enough to be replicated all but exactly in later photographs (Plates 77, 156, 178).

Perhaps it is predictable that images of violence should tell the clearest story. The three sullen Yuma Apache scouts photographed (once again) by Baker and Johnson represent a transition between two cultures (Plate 154). The broad horizontal stripes of their brand new cotton shirts wrap the men in the forms of a prefabricated civilization; yet the breechcloths concealed by bullet-laden belts, the bare feet and tightly muscled legs, the long black hair and white bandannas confirm how unreconstructed these men actually are. The casual grip of rifles and pistol together with three hard stares indicate the threat the scouts present—perhaps to enemy Indians, perhaps to Army commands. A grimmer set of images was captured by Joel Emmons Whitney in his photographs of the Dakotah prisoner Medicine Bottle before and after being executed by hanging at Fort Snelling (Plates 26, 27). A year separates the thoughtful young man from the swinging body, leaving the viewer to ponder a number of issues: the relationship of photographer and subject during that time; the actual cause of the "massacre" for which Medicine Bottle was tried and hung; his thoughts about the radically different culture displacing his own, or about the way his case was sensationalized to confirm native depravity.

The reason an allegorical impulse appears so often in early photographs may be that practitioners had not yet abandoned patterns established by contemporary painters. Delegation photographs, for instance, were supposedly meant as simple record shots, of interest primarily in identifying individuals, not as pictorial compositions. Yet photographers seized the opportunity to read implications into the occasion. Alexander Gardner, for instance, who became one of

the premier photographers of the Civil War, produced a series of notable images of delegations visiting the nation's capitol. The Sioux who gathered in Washington in the summer of 1858 are at once "civilized" by their shiny silk hats and just as clearly native, with "Little Paul Shoots as He Walks" standing fixed in the middle of the photograph wearing feather headdress, long braids, and a blanket (Plate 16). In a visit from a delegation of Sacs, Fox, and Kaws Indians, Gardner posed a government negotiator pointing dramatically to the viewer's left, thereby directing his native listeners westward and reinforcing the inexorable implications of the document he holds in his other hand (made more firmly explicit by the caption, which notes "the Commissioner advising them to go to a new home, better adapted to their condition"; Plate 30). The official's pose and demeanor, however, offer a marked contrast to the cheerless, tomahawk-wielding adversary who is just as stiffly facing the other way.

Another photograph from the same era borrows this iconographic vocabulary in a scene only somewhat less allegorical, of soon-to-be extinct Mandans and plains Arickarees asked to sit, having apparently just signed a treaty with the negotiators standing expectantly above them (Plate 24; also 88, 98). Perhaps the most interesting delegation photograph was William Henry Jackson's gathering of four Creek chiefs, staring in different directions, with hands pointed and clasped in markedly diverse fashions, as if each were having a conversation with himself (Plate 68). All four are dressed in middle-class dinner clothes, but the caption describes varied histories that explain ineffable differences in appearance, including the fact that one is an African-American convert and another a first lieutenant in the Union Army. The photograph itself serves to transform "Native" Americans into a group of American citizens.

The photographed images of American Indians posed for a moral or symbolic purpose are hardly limited to the mid-nineteenth century. Indeed, the single most famous example of this sort was executed in 1904 by Edward Sheriff Curtis: a print of seven riders in Canyon de Chelly entitled "The Vanishing Race" (Plate 223). The most telling aspect of

this soft-focus image is the scale of composition, as diminutive figures trail in single file under a shadowed mesa. The small, hunched natives on their ambling horses appear to have been forced from ancient homes not by white depredations or federal policy but by the immensity of the landscape itself. Likewise fitting the dominant nineteenth-century trope of the "vanishing American" is the photograph by M.R.R. Harrington entitled "Last family of potters and pipemakers" (Plate 232). That in 1908, these Virginia natives were hardly the last to practice their craft does not diminish the feeling of pained displacement evoked by the wide-eyed daughter and mother. And the fragile artifacts proffered to the camera by the other children form a hesitant gesture against the ineluctable processes that seem to be displacing them.

Then as now such allegorical impulses were not easily separable from noted individuals, and a number of Indian faces reappear in photographs precisely because they were historically significant—or conceived to be so. The Crow known as Curly had been General George Armstrong Custer's scout and was widely presumed to be the sole survivor of the Battle of the Little Big Horn in 1876. The fact that he was not actually at the scene of American history's most notorious massacre had little effect on the perception of a nation more than willing to believe he was there, and two of the countless prints made of this photogenic figure, by David Herrin and Frank Haynes, capture the wide-eyed look of the witness (Plates 164, 165). Actually present, in fact, was Pizi, known as Gall, who as War Chief of the Hunkpapa Sioux was the principal warrior at the battle. David Barry's brooding photograph of him in an open-necked shirt suggests a mood and personality dramatically different from his public persona, also captured by Barry in the more commercially valuable image of Gall in full regalia (Plates 158, 159).

The most photographed Indian of all was Red Cloud, who alone could claim to have led his people to victory over the United States Army. Perhaps the fact that he was a Dakota Sioux contributed to the familiarity of his image, captured by Charles Bell in 1880 (Plate 161). The western style of his unusual

bone war-vest, his buckskin-fringed and beaded shirt, his flowing hair with eagle feather fit the conventional notion of the Plains Indian. And like other Indians portrayed in the period, he manifests a spirit of fierce indomitability. Even three years later, in F. A. Bowman's image of him during a visit to Yale University, the look has not essentially changed (Plate 162). Despite the substitution of dinner clothes, white shirt, and stylized coiffure, for Sioux garb and braided hair, he seems even more stalwart and determined. That conventional fixed stare altered little in these early photographs, due in large part to inherent limitations in the photographic process, confirming tacit assumptions about native loss. As it happens, technological improvements late in the century accompanied changed attitudes by photographers and Indians about each other, leading to a more varied and comprehensive photographic legacy.

The 1890s to World War II

With the development in the 1870s of a gelatin process for exposing negatives, dry plates soon replaced collodion as the technique of choice. The photographer's field tent now disappeared from the landscape of the American West along with the unwieldy cameras, bottles of chemicals, and pack mules loaded with glass plates. The days of the juggling photographer mixing and balancing under a black-cloth hood were consigned to history. A simple box camera was enough, and negatives now awaited the return to a studio before being developed. Factory-manufactured plates, moreover, produced consistently better results than a collodion process that depended on the vagaries of climate, terrain, and physical agility. In the 1880s, the invention of so-called "detective cameras" prompted George Eastman to develop and market his first Kodak with a fixed lens and simple shutter. The photographer could now expose a cartridge of one hundred snapshot negatives before returning it to Rochester, New York, for developing and printing. As Eastman advertised with great popular success: "You press the button and we do the rest."

By 1900, Eastman was selling in excess of 100,000

Box Brownies a year for a dollar apiece with film at fifteen cents a cartridge. Millions of amateur photographers merely pointed their cameras and snapped a picture. The new technology altered forever the stiff poses required by long exposures, while the inexpensiveness of snapshots (and the frequency with which they could be taken) tended to encourage more relaxed responses from subjects. Familiarity bred, if not contempt, a certain understandable casualness. The only drawback to the new technique was the uncertainty of dry-plate processing, in most cases completed long after replacement pictures could easily be made. With the new process it was no longer possible immediately to confirm the quality of one's work, which meant that the efforts of an entire expedition could be lost.

During this same period, the federal government successfully completed its "pacification" of Indian tribes. New railroad lines continued to spur an enormous amount of real estate speculation and, in conjunction with land developers also eager to encourage tourism, the railroads hired staff photographers to portray Native Americans with exotic appeal. Impelled by less self-aggrandizing motives, ethnologists and anthropologists turned to the camera because they realized its efficacy for the study of material culture, and anxiously began compiling comprehensive records of costumes, artifacts, and ceremonies. Other factors as well led to styles that contrasted with earlier photographs. Action shots began to replace standard formal poses, whether in the studio or on tribal grounds, and because newer cameras could easily be wielded and pointed at subjects surreptitiously, a whole array of secret enactments and sacred places now became accessible. Yet notwithstanding these two developments, the enforced conversion of tribes into respectable bourgeois ironically encouraged at the same time portraits of natives garbed as Victorians. Three general categories—termed roughly exotica, candid, and Victorian—characterize most of the images in this period. And although the three are not altogether mutually exclusive, it is clear that Victorian poses are inherently at odds with exotica. The one major link between these different kinds of image, however, is

that they continue to reveal as much about the photographer behind the lens as of the natives sitting before it.

Portraits of proper Victorian Indians form a curious evolution from those of defeated aliens that had been so popular only two decades before—a peculiar development already intimated in the sartorial transformation of Red Cloud from striking frontier garb to sedate drawing-room wardrobe. Most of these later photographs present natives in conventional middle-class roles, wearing broadcloth suits and gingham dresses that emblematize their acceptance of the dominant culture's mores (Plate 188). In some, they gather together in Sunday best outside their clapboard homes, with children primly buttoned to the neck, their hair slicked down under hats and bonnets (Plates 236, 239). In others, Blackfeet women put up vegetables (Plate 245), or conventionally dressed mothers hold bound papooses in native baby carriers (Plate 265), or "Sioux police" stand before the reservation "police station" proudly displaying tin badges on swelling chests (Plate 212), or Mission boys in overalls duel with wooden pistols while their homespun-clad parents hoe the fields (see "Civilizing the Red Man," Plates 266, 267, 268). These scenes are replicated countlessly in images of workaday chores and reservation schools, of baptisms and weddings as elaborately Christian as that captured by the Tsimshian photographer Thomas Eaton in 1910 Alaska (Plate 240). In each of these images, the ideological message of untroubled assimilation is clearly conveyed.

With a more dramatic flourish, the influence of Anglo-American behavior can be seen in the picture of boxing Eskimoes taken by Robert Peary, the intrepid Arctic explorer (Plate 213). Yet the photograph does more than merely attest to the attraction of western sport, for the fur pants and skin boots worn by both contestants reveal features of native life only reluctantly put aside. Reubon Albertstone captured this cultural conflict in his 1890 portrait of two Alaskan women seated calmly in what looks like a conventional front parlor, with the mirror between them hanging on a wall that is covered by a busy Victorian design (Plate 194). Yet the additional arti-facts hanging above them suggest they have been assimilated only in part, a conclusion strengthened by the Chilkat blankets and the bone nose-rings they proudly wear. The confluence of cultures is addressed more self-consciously and wittily in a print by George L. Bean from the Princeton exhibition not included in this volume. A smiling Taos artist daubs oils onto a conventional European canvas, having donned a Plains feather headdress that is at odds with his own southwestern culture as well as his occupation as a painter. The scene is a remarkably clownish one, although the painter has in fact done no more than draw attention to the process of role-playing and stereotyping. Nothing more (but nothing less) than a self-conscious whimsy distinguishes him from countless other Native Americans compelled to sacrifice their most cherished beliefs.

The erosion of cultural integrity—or acculturation, as it was commonly called—appears most starkly in the explicit "transformation photographs" of those who had passed from the "savage" to the "civilized" (see Plates 104–112). Attesting straightforwardly to the camera's use as a tool of ideology, these extremely popular images define a troubling process. To train the "Indian" out of Native Americans appears misguided to most of us today, and yet that was the goal of considerable governmental and religious effort in the late nineteenth century. It also formed the basis on which the famous Carlisle School in western Pennsylvania was founded, and the fruits of this educational program are evident in the anonymity of mass group pictures of divinity students and tuberculosis patients. The process is also exposed in before-and-after sequences of Tom Torleno's metamorphosis from elegantly attired Navajo into high-collared student (Plates 102, 103), or Donald McKay's more modest but no less extreme transfiguration as Chief of the Warm Spring Indians (Plates 100, 101). These images comprise a visual testimony to how much was lost in the shearing of hair, the donning of machine-made suits, and the schooling in book-lined classrooms. John Choate's photograph of Red Dog visiting his daughters at the Carlisle School (Plate 113) is a striking instance of the skewed prejudices and aspirations at

work: the father sits, puffing on a traditional long Sioux pipe, with a fringed medicine bag tucked under his left arm, while his stern adolescent daughters dressed in crinoline with cotton bows at their necks (and a cross on the girl on the left) place calming hands firmly on each of his shoulders. Past and future meet here in a strangely wrought composition that suggests, if only in the look in the eyes of the three, that the daughters may have lost more than they gained.

The poses in many of these images are clearly, sometimes self-consciously Victorian, as women stand next to seated husbands and loving children, with hands affectionately placed on their shoulders. Or individuals sit alone, altered by clothes and context into apparently more cultivated, sometimes even more youthful poses. The camera served what we now can see was a distinctly cultural mission: in the process of producing images that appeared more candid, the photographers seem to be making the Indian more like his white contemporary. This disposition to acculturate (and thereby to humanize) the Native American was strengthened during the last decades of the century by improvements in both equipment and film. New kinds of images of Indians in native surroundings had become more readily available. The photographer, no longer constrained to pose figures in uncomfortably fixed positions, was now able to wander around tribal grounds and snap candid shots. Scenes of daily and ceremonial life hitherto represented only in paintings could be photographed with a marvelous life-likeness—whether white-haired Navajo women cheerfully grooming each other (Plate 258), or Zuni Shalako dancers planting plumed sticks (Plate 196). Indeed, among the most delightful of images is one by Frederick Monsen, not included here, of Hopi women playfully thrusting corn stalks at the camera. Having wrest them from the arms of Hopi men in a spontaneous celebration of fertility rarely seen by whites, they giggle at the camera and in the process defy the popular conception of the dour, reserved Indian. The new fast cameras, in other words, helped to subvert stereotypes as well as to reinforce them. And it is not surprising that the Hopi should have cherished

such snapshots and sought them for themselves. Much as conventional white families did, they liked to place domestic portraits on view inside their homes.[11]

The extraordinary simplicity of Eastman's handheld Kodak quickly revolutionized photography, making possible pictures altogether unlike the Victorian poses described above. In particular, the camera allowed access to a radically increased range of images. So unusual and sacred were scenes now sought by photographers that tribes felt compelled to place certain areas strictly off-limits. Yet a combination of science and commerce encouraged individuals to transgress these proscriptions in the noble hope of compiling a record for posterity or, more crassly, to entice a tourist trade. By the 1880s, "Indian country" had been at last declared safe, and railroad companies lured white settlers with advertisements of picturesque native domestic scenes as well as fascinating rituals. The image was hardly new, even if the motives had changed. Earlier photographs had offered a similar perspective on the Indian as "other," with images of bare-breasted women and armed men attesting to the superiority of civilized values. Now, with tribes safely on reservations, the image of the Native American was used as a lure, not a warning. Amateur enthusiasts of all sorts flocked to the southwest in particular, since ceremonial life there had remained largely traditional and the variety of cultures was greater than anywhere else.

For somewhat different reasons, professional anthropologists contributed to this craze of picture-taking. Darwinism had led many scientists to accept a belief in genetic strains, and photographs made it possible to delineate physiologies thought characteristic of tribal groups. With his *Types d'Indiens,* for instance, Prince Roland Napoleon Bonaparte attempted just such a project in Paris in the 1880s (Plate 170). More thoroughly, twenty years later, Frederick Starr compiled a catalog of "mug-shot" front and side views of a wide variety of Indian subjects. Like other such studies, however, his photographs of a Chinantec Indian from Oaxaca (Plates 234, 235) offer evidence of little more than a passing historical preoccupation. Scientists interested less in

physiological than in social determinants turned to evidence of material culture, and their photographs continue to have an anthropological importance, as is clear in the pictures of basket-makers. Frank LaRoche's stunning image of a Siwash expert surrounded by her art (Plate 208), like Amy Cohn's 1899 view of Datsolalee, "Queen of basket makers" (Plate 206), provides precise pictorial data that attest to the cultural skills thought to be lacking in native tribes. Similarly, Adam Clark Vroman's view of the interior of a Hopi pueblo is still a valuable research document, offering eloquent testimony to the conditions of everyday native life (Plate 222; also 252). If less intricate or comprehensive than certain painterly depictions of more than half a century before—say, George Catlin's or Karl Bodmer's identically titled "The Interior of a Mandan Hut"—it and similar private views promote an understanding of past native life unavailable through any other medium.

Clearly, however, it was the exotic nature of native ceremonials that primarily drew cameramen, and nowhere as much as in the southwest were those ceremonials so alien and unaltered by contact with whites. Edward Sheriff Curtis's simple 1904 portrait of a Navajo deity, a masked Yeibitchai, embodies all the mysterious alterity that native cultures have always represented for Anglos (Plate 225). The Flute ceremony at Hopi and the fiesta of San Esteban at Acoma attracted Adam Clark Vroman, Sumner Matteson, and Frederick Maude for similar reasons, as well as the need to photograph what all assumed would soon pass away (Plates 217, 251, 253). John K. Hillers captured a series of rituals at Zuni in stunning shots, one of which nicely represents the pencil-thin figure of Frank Hamilton Cushing, dressed in his Bow society costume, standing on the edge of a ring of figures (Plate 89). Cushing, the mysterious white man accepted so fully into the tribe that he was made first a Bow priest and then head war chief, left Zuni in 1885 after nearly five years, and never returned nor revealed the mysteries to which he had been made privy. The burgeoning number of photographers visiting the southwest, many of whom showed neither Cushing's respect for

tribal values nor his accompanying patience, soon began to alter native life dramatically.

The single most compelling event to attract photographers to the southwest was the Hopi Snake and Antelope ceremony, largely because during the ten-day ritual priests carried rattlesnakes in their mouths. This became the most popular photographic subject in North America, a ceremony that attracted nearly every important practitioner of the late nineteenth century, as the series of photographs here suggests (Plates 197–205). Indeed, white enthusiasts became so numerous by the turn of the century that, as Ben Wittick's views confirm, they sometimes crowded out the priests themselves (Plates 198, 199). The urge to document ceremonials led cameramen to increasingly rude behavior, which appeared as serious a threat to tribal life as overtly hostile acts once had been. In part, this pattern was fostered by a cultural disposition toward the confrontational—a disposition itself reinforced by the camera's ability to reveal and expose. Tactless as photographic manners had become even by the standards of a brash Anglo society, such manners were incomprehensible from a tribal perspective where silence, autonomy, and secrecy were cultural givens. Pueblo Indians rightly feared the threat that reproductions posed to their cultures—not only the final images themselves, but the very process of making them—and soon requests were made to curtail photographs to only certain selected ceremonies and less sacred sites. These initial objections, however, met with little success among persistent cameramen like Frederick Monsen, prompting the Hopi in 1915 to declare a ban against all photography. The other pueblo tribes soon followed suit and a general interdiction remains in effect for reasons that continue to be quite sound. Still, we cannot fail to appreciate the stunning array of early images—much as pueblo Indians also seem to do. History, after all, forgives the infringements that constitute its record.

Despite what turned out to be a passing fashion for soft-focus exposures, despite an exoticism that mars many images, despite hasty compositions and the cameraman's more than occasionally rude intru-

siveness: the photographic chronicle of this middle period is notable for its breadth and incisiveness. Among the finest practitioners was a group from Pasadena often associated with each other, referred to familiarly as the "Eight," which included George Wharton James, Charles Lummis, Frederick Monsen, and Adam Clark Vroman. They were joined by a handful of others who became leading photographers of Native American life in the late nineteenth century: Frank Rinehart, George Ben Wittick, and in particular, Edward Sheriff Curtis. Curtis's current reputation is mixed for a number of reasons: he sometimes posed his pictures elaborately and inaccurately, he required natives to don inappropriate or inconsistent tribal garb simply for a colorful image, he heavily manipulated a soft focus that was the fashion at the time and deceptively tampered with negatives to achieve an aesthetic effect. Yet Curtis was driven by an extraordinary ambition to record all North American tribes before they had altered or passed away, and his photographs constitute an enviable effort. Twenty major portfolios with accompanying volumes of anthropological description stand as the most exhaustive sustained effort of any photographer of Indian life. However much one wishes for a less sentimental touch, Curtis's bold, comprehensive effort was the consummation of the period's visual fascination with the Native American.

The 1940s to the Present

In the third chronological period of Indian photographs, no spectacular technological achievements occurred to match those of the earlier two. Of course, equipment and technique continued to improve with the advent of color film, the development of sophisticated optics, and the invention of the single-lens reflex camera. But the fundamentals were already firmly in place. Likewise, visual changes in indigenous life occurred less dramatically than before. Instead of declining numerically, tribes have increased to a remarkable extent, in ironic contradiction to widespread nineteenth-century apprehen-

sions. And the photographic image has entered more fully into everyone's everyday life, which means it has therefore become a part of the subliminal consciousness of individuals, red and white. The consequences of such developments have been at once predictable and surprising. The Indian continues to be the subject of photographic interest but now has also become his and her own photographer. Likewise, the camera draws attention to itself as it did in the beginning when hard stares and stiff poses were required, but now its functional possibilities frequently appear self-consciously in the exposed print itself. These characteristic emphases, moreover, have seriously altered our understanding of the possibilities in photography as well as in American Indian life.

Depending on one's perspective, the camera has become either more or less obtrusive than it was half a century ago. Long-distance lenses now offer access to scenes that have always been off limits and do so without leaving a trace of the cameraman's presence in the subject's expression. Since it is the cameraman's place behind the lens that we figuratively adopt in viewing his shots, we no longer feel as if we also are rude intruders into the photographic space. Photographers now introduce us not only to guarded ceremonies but to guarded emotions, and are able to avoid the stiff demeanors that most subjects inadvertently bring to the camera. The effect of this on native scenes has been altogether revelatory. In William Hess's powerful image of two Alaskan matrons whispering, it seems that one can almost hear what they are saying across the room (Plate 289). Jeffrey Thomas captures a Comanche-Omaha in the process of painting himself for the Pow Wow dance as if right at the dancer's shoulder (Plate 286), while Alex Harris portrays Lizzie Lee in finely etched detail, making the camera seem somehow inches from her face although it is not even in the room (Plate 282).

Yet as with the other two Eskimo photographs here, Harris's portrait also draws attention to the means by which this uninhibited moment has been caught. The long lens announces its presence in the shallow depth of field that compresses facial

features—a compression that artfully contributes to the curve of cheek, eyelid, and tight-lipped smile. It is as if the process of highlighting the aesthetic pleasure of the subject's face itself draws attention to its own mechanically foreshortened perspective. Cynthia Wooley likewise combines the intimate with the artful in her photograph of Tehuana women lounging in hammocks, conversing in a mood of lively animation and casual trust as scimitars of hands and arms slice the air (Plate 299). Paradoxically, the presence of the camera is betrayed in the photograph's artfully balanced rendering of an otherwise intimate exchange.

There are other ways beside the flattening effect of long lens by which the camera announces itself through its images, as in Everett Scott's study of a Native American in New York City (Plate 297). Only the torso appears within a frame that has obviously been severely cropped, suggesting the photographer's strategy as decisively as blurs on an albumen print. Similarly, the tension in "Mohawk Steelworker" is created by David Noble's focusing the viewer's attention on a figure whose own attention is focused so intensely elsewhere (Plate 278). Once again, the camera has made the "photographic window" more opaque, as it selectively organizes, arranges, and intrudes. Even creative printing can signal the photograph's status as an artifact. Hulleah Tsinhnahjinnie, a Navajo artist, has achieved this effect in her portrait of a woman in full Sioux regalia staring directly at the camera (Plate 295). As much in its tonal balance and exacting detail as in the traditional pose itself, the photograph draws attention to its own production. With a greater sense of irony, the composition entitled "Silhouette with Feathers, 1983" seems at once a finely detailed product of the most sophisticated technology and a throwback to the earliest kind of "shadow-catching" in both form and content, memorializing the outline of a traditionally costumed Plains Indian (Plate 294). Contributing further to the irony is that the young artist is Christopher Sheriff, a distant cousin of Edward Sheriff Curtis.

Such self-conscious use of the camera is hardly recent, however characteristic it may have become.

Indeed, the commitment to photography as an art form emerged at the turn of the century and might well have been discussed in the preceding section had it not so come to dominate the present period. The Photo-Secessionists wanted to prove the camera was more than a documentary tool and some of them turned to Indian subjects to confirm its aesthetic possibilities. Gertrude Kasebier and Joseph Kieley, for instance, both likewise borrowed the fashionable soft-lens technique to add a romantic painterly allure to their Indian subjects. Painters, on the other hand, sometimes ironically reversed this aesthetic practice, adopting the camera to assist in the preparation of preliminary sketches. E. Irving Couse posed and marked off his photograph of Joe Sunhawk for transfer to what would become a well-known painting. And that process was replicated by other members of the Taos and Santa Fe schools, including Oscar E. Berninghaus and Joseph Henry Sharp.

Whether painters used photographs to make an accurate record or photographers now recognized painterly possibilities, they both came to view American Indians in newly visual terms. No longer was a viewer's attention caught by the subject matter primarily but rather by cardinal aesthetic considerations of form, light, and composition. Laura Gilpin, for instance, who became the premier photographer of the Navajo, created visually charged portraits of native friends. Even Ansel Adams, whose career was devoted almost entirely to landscape, celebrated the formal possibilities of native life in the brief excursion of *Taos Pueblo* (1930). Far from simply reproducing the strange and exotic, the camera has increasingly made its demands visually apparent, actively transforming a world now all too familiar into something once again new.

In the past half-century during which photography has become more thoroughly self-conscious, Native Americans have continued to develop an interest in what the camera can do. That interest is nicely represented in Sumner Matteson's pre-World War I photograph of three Gros Ventres quizzically investigating a large box camera (Plate 2). Later, in the 1920s, an Apache attempted to operate a motion-picture camera while the San Ildefonsan, Agapito

Pino, portrayed his Pueblo mother washing clothes (Plate 3). Countless natives since have purchased Brownies and Instamatics out of an enthusiasm no different from that of shutterbugs the world over. A. Boyd Whitesinger nicely captures that collective delight in his view of the inauguration of a Navajo tribal chairman (Plate 9).

It may come as a surprise that Indians have been taking photographs for more than a century, ever since Sitting Bull happened to press the shutter of a loaded camera. Paula Fleming convincingly argues this felicitous historical irony, claiming that an 1882 photograph entitled "Stealing the Trade" was set up by a white photographer and actually snapped (if in-advertently) by the famous chief of the Hunkpapa Sioux. Yet even without this accidental first, profes-sional photographs were being taken by Indians themselves at about the same time. The Tsimshian, Thomas Eaton, for instance, was already a profes-sional soon after the turn of the century and boldly marked his cabinet photographs with his name and the title "Native Photographer." Like his contempor-aries and fellow Tsimshians, the Haldane brothers (Peter and Benjamin), he achieved a solid reputation for the bread and butter work familiar to any small-town practitioner: family portraits and domestic scenes.

As Indians have become their own photographers, they have sometimes reluctantly if respectfully turned to scenes that recall the rude efforts of their white predecessors. Not until the 1940s did a Hopi turn a camera on his tribe's ceremonies, and even then Jean Fredericks did not consider offering his photographs for sale (Color Plate 2). Like other Hopi, he maintained respect for the camera and its potential hazards. "Even if you are a Hopi photo-graphing a Hopi," Victor Masayesva has observed, "you will not confront the silences." Yet just as art can endanger ceremony it can also play a ceremonial role, allowing a fuller understanding of one's culture in the process of recording it. Recognizing this para-doxical fact has led Native Americans to turn the camera on each other with increasing sophistication. Merwin Kooyahoema's 1980 photograph of a line of Deer Dancers (Plate 292), Victor Masayesva's 1983

sequence on the Rain Runner (Plate 293), and Herbert Zazzie's 1985 "Dancer" (Plate 300) all memorialize moments usually proscribed to white photographers yet now countenanced for these Hopi and Navajo artists. And the conflict that sometimes emerges in their images registers the artists' own ambivalence about being part of two cultural systems whose deepest premises are opposed. That mixed consciousness, which the Native American in the modern world must sustain, is perhaps best represented here in Jesse Cooday's painted mask superimposed on a self-portrait (Color Plate 5).

Over and over, the technology now so fully a part of native life is not artificially excluded from the fin-ished print, but made a central feature of it—as in the scene of an airplane surrounded by Eskimos at Tununak, Alaska (Plate 273), and more obviously, in Whitesinger's view of a Navajo ceremony at night, with figures silhouetted in front of a bonfire and two large diesel trucks (Plate 277). Best exemplifying this marriage of opposites is Dugan Aguilar's study, which forms only the most recent in a long line of Native American portraits (Plate 284). An earringed Paiute wearing a traditional turquoise necklace stares to the left of the camera, reminding us of the count-less studio shots of similar figures a century before. This time, however, the man sports a jacket that ad-vertises a well-known insurance company, worn over pin-striped baseball trousers and a shirt emblazoned with the clichéd logo of a Plains Indian chief. His neck-length hair is kept in place by a cap, sunglasses shade his eyes, and he clutches an inexpensive trophy with a mixture of pride and faint embarrassment. Clearly, American Indians are still no more easily categorized than ever. Not only do they continue to live and act in diverse cultural worlds but the fear of their indigenous cultures collapsing has proved slightly premature.

Conclusion

What conclusion can possibly be drawn from so di-verse a selection of photographs? More specifically, what exchange of influences has occurred between

photographers and Indians over a century and a half? If nothing else, we can recognize how full a record of Native American life photographers have made, itself a remarkable feat in the face of so many cultural obstacles and technological impediments. While the camera's advent was not as late as some have occasionally regretted, it is nonetheless true that the legacy of photographs we actually have of tribal life has been largely forgotten. This selection confirms that, despite the intentions of many early photographers, their work resists those stereotypes they wanted it to project. The 1876 photograph by Charles M. Bell of "Cassadora and his wife, Penal Apaches," can be taken as representative (Plate 67). The silver medallions, the textile shawl, the cotton clothing and traditional style of hair, and most importantly, the straightforward stares past and through the camera lens are richly informative yet nonetheless understated. We stare back into the picture and read not only the stalwart independence of the subjects, but as well a knowledge of ceremony, of religion, of technology and culture that is alien to our own. Little more than a century later, Douglas Kent Hall's "Taos elder" holds himself similarly in a photograph nonetheless significantly different (Plate 279). The similarity emerges from a subject that proclaims how at odds with technocracy native life still is. The difference results from the influence of natives on the dominant culture—or at least, the views and assumptions of its photographic practitioners.

That leads to a second observation, which forms a converse of the first: that Indians are now more obviously adapting parts of Anglo-American culture to their own ends, and in particular, incorporating photography into everyday activities. Whether or not native practitioners will alter photographic conventions or have a radical effect on the kinds of images we generally revere, only time can tell. Whether the camera will enhance the more sacred aspects of native life remains likewise uncertain, if more problematic. The one inescapable conclusion is that photographs yet to come will form no less varied a history of exchange than those we already have.

Notes

1. Most dramatically, the first satisfactory process for printing photographic images on paper was the result of the invention of guncotton in 1846. Its derivative, collodion, was used initially for military dressings before being adapted for the wet-plate photographic process that was popular through the 1880s.

2. *On Photography* (New York: Farrar, Strauss and Giroux), pp. 6, 64.

3. *On Photography,* p. 154.

4. *Photography: A Short Critical History* (2d ed.; New York: Museum of Modern Art, 1938), pp. 50–51.

5. *Camera Lucida: Reflections on Photography,* trans. Richard Howard (New York: Hill & Wang, 1981), p. 6.

6. Roland Barthes, *Camera Lucida,* p. 78.

7. "Kwikwilyaqa: Hopi Photography," in Victor Masayesva, Jr., and Erin Younger, *Hopi Photographers/Hopi Images* (Tucson: Sun Tracks and Univ. of Arizona Press, 1983), pp. 10–11.

8. Ridgeway Glover's claim is cited in Russell E. Belous and Robert A. Weinstein, *Will Soule: Indian Photographer at Fort Sill, Oklahoma, 1869–74* (Los Angeles: Ward Ritchie Press, 1969), p. 14. For other figures, see Lee Clark Mitchell, *Witnesses to a Vanishing America: The Nineteenth-Century Response* (Princeton: Princeton Univ. Press, 1981), pp. 135–136.

9. For a fuller description of this practice, see Joanna Cohan Scherer, "You Can't Believe Your Eyes: Inaccuracies in Photographs of North American Indians," *Studies in the Anthropology of Visual Communication* 2 (1975): 67–79.

10. See Erin Younger, "Changing Images: A Century of Photography on the Hopi Reservation (1880–1980)," in *Hopi Photographers/Hopi Images,* p. 20: "From the start, they readily accepted duplicate prints and often hung these images on the walls of their homes."

11. "Kwikwilyaqa: Hopi Photography," p. 10.

Plates

The photographer is not always obvious in his finished work. Sometimes he seems a hidden presence, as Jackson does in his 1871 image of Pawnees amid their earthen lodges. At other times, the camera itself is caught in another camera's view. Those rare photographs with both cameras *and* Indians together document a relationship ranging from indifference to curiosity to collaboration, and finally to Native Americans assuming the active role of photographer. But before Indians took their place behind the camera, Hill and Adamson's portrait of Kahkewaquonby launched six decades of Anglo-American fascination with Indian subjects.

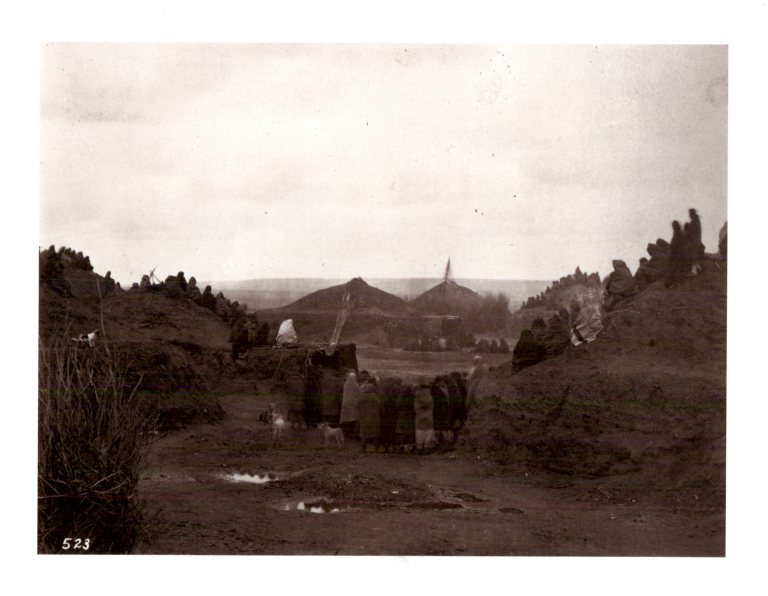

1. William Henry Jackson (1843–1942), *Pawnees gather outside their earth lodges near Loup Fork, Nebraska, for what is most probably a ceremonial occasion, 1871.* Albumen print. The Princeton Collections of Western Americana, Gift of Sheldon Jackson

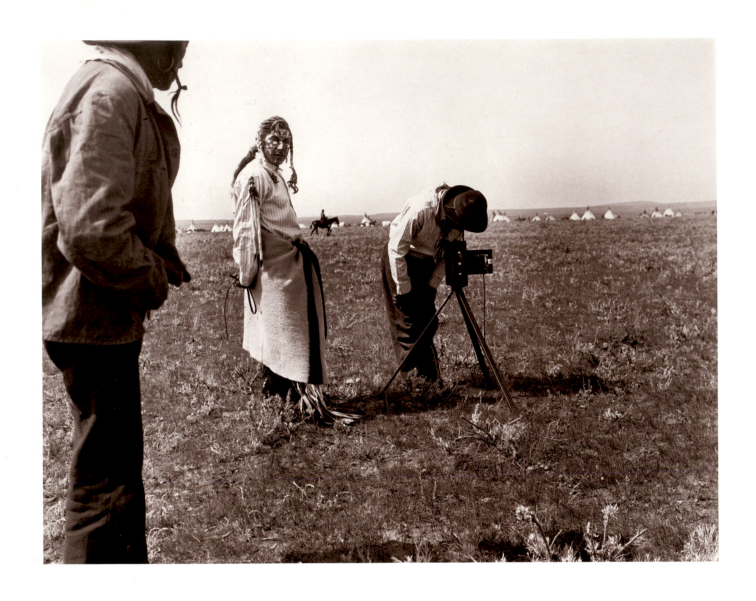

2. Sumner W. Matteson (1867–1920), *Three Gros Ventre investigate one of Matteson's cameras*. Modern print by Phil Bourns from the original negative in the collection of The Science Museum of Minnesota, St. Paul. The Princeton Collections of Western Americana

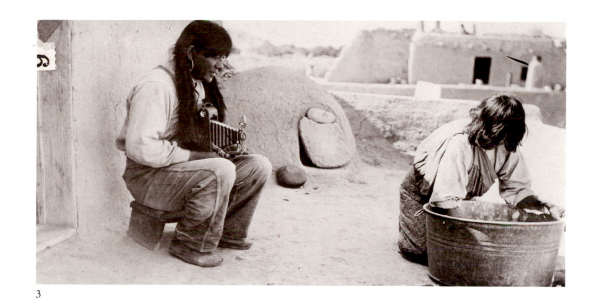

3

4

3. *Agapito Pino, A Koshare from San Ildefonso Pueblo, New Mexico, photographing his mother at work.* Silver print. The Museum of New Mexico, Santa Fe (number 3740)

4. *Photographing Siletz dancers at Government Hill, Oregon.* Silver print. The Oregon History Society

5

6

5. *A camera at work among the Seminoles of Florida*. Silver print. The Indian Rights Association, Philadelphia

6. *A camera at work in the Pueblos, about 1920*. Silver print. The Indian Rights Association, Philadelphia

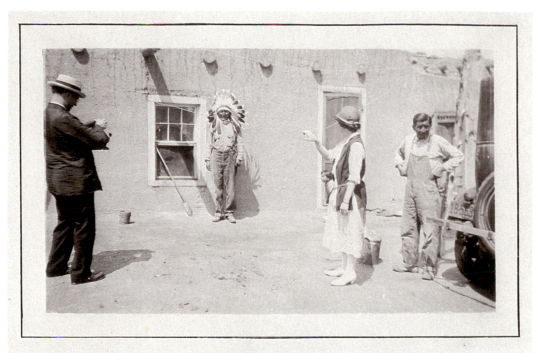

7

Groupe of Ute Indian's

8

7. *Tourists at work with their camera on an accommodating Pueblo man (with stereotypical Plains headdress), about 1930.* Silver print. The Indian Rights Association, Philadelphia

8. Benjamin H. Gurnsey (1844–1881?), *A party of Utes in front of the photographer's establishment in Colorado Springs.* Albumen print in an album once belonging to Frances Metcalfe Wolcott. The Princeton Collections of Western Americana

9. *Filming in one of the Pueblos in the 1930s.* Modern print from a negative in the collections of The Museum of the American Indian, Heye Foundation, New York City, 25.3 × 20.4 cm. The Princeton Collections of Western Americana

10. A. Boyd Whitesinger (Navajo, born 1946), *Navajo cameras at the inauguration of a new tribal chairman*. Silver print. The Princeton Collections of Western Americana

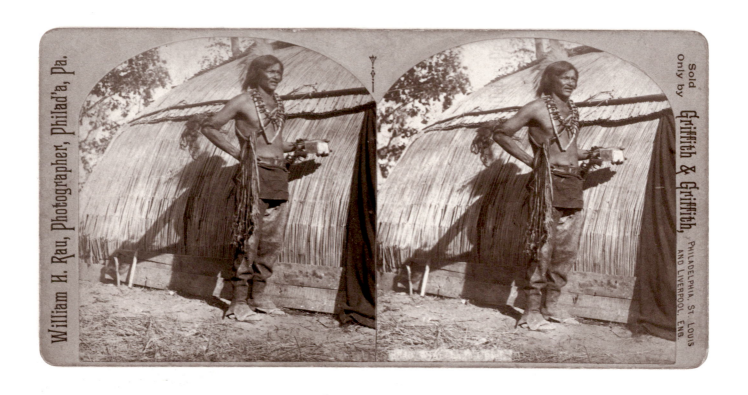

11. William H. Rau (1855–1920), *Indian man with a daguerreotype in his hand.* Albumen print stereograph. Collection of Lori and Victor Germack

12. *PFC Ira Hayes, Pima, of Bapchule, Arizona, points out his place in the celebrated photograph by Joe Rosenthal of the flag raising on Mt. Suribachi, Iwo Jima.* Official U.S. Marine Corps Photo. Silver print, 20.8 × 25.4 cm. Archive of the Association on American Indian Affairs, The Princeton Collections of Western Americana

13. Dan Budnik, *Taos leaders tolerate the camera during their crusade for the return of Blue Lake: right to left, Seferino Martinez, Governor John Reyna, Paul Bernal and William Byler (cameraman is unidentified), 1966.* Silver print, 20.5 × 25.4 cm. Archive of the Association on American Indian Affairs, The Princeton Collections of Western Americana

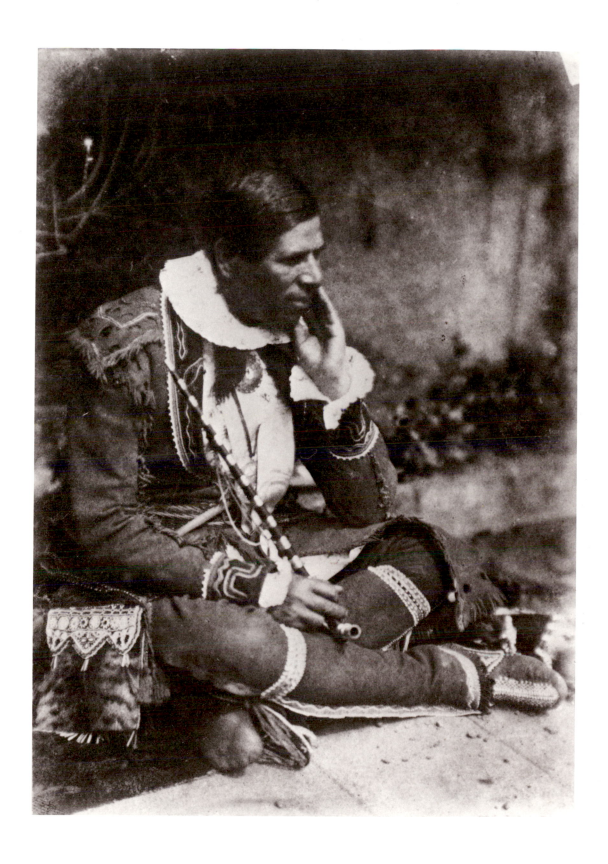

14. David Octavius Hill (1802–1870) and Robert Adamson (1821–1848), *Kahkewaquonaby, also known as the Rev. Peter Jones.* Son of a Welsh father and a Mississauga Indian mother, Jones is the first Indian known to have been photographed. During a visit to Great Britain in 1844–1845 several images, including this one, were created by Hill and Adamson. Calotype, 21.5 × 16.4 cm. The National Portrait Gallery, Edinburgh, Scotland

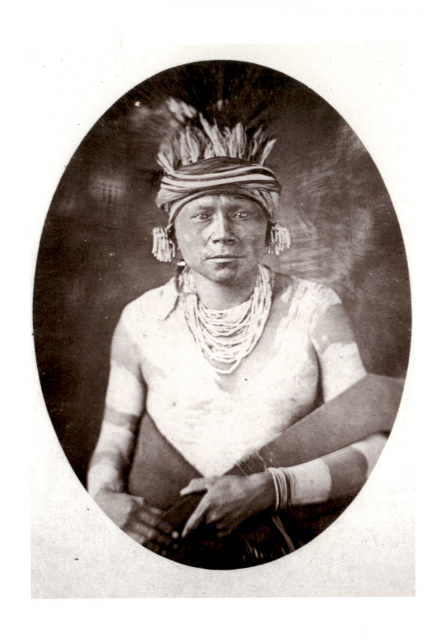

15. *"Magashapa, or Goose, a Blackfeet Dakota."* From a daguerreotype of 1852. Albumen print. The Princeton Collections of Western Americana

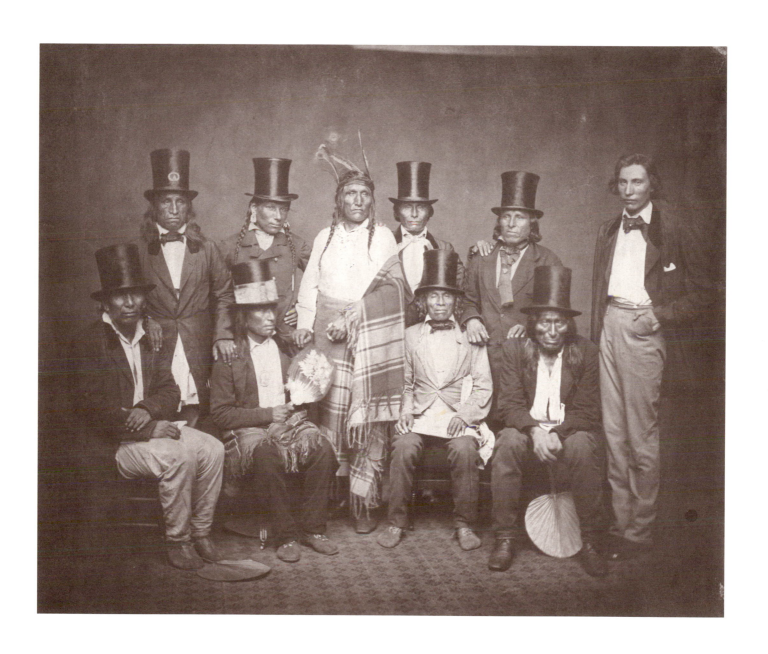

16. Alexander Gardner (1821–1882), *Delegation of Upper Sioux in Washington*. The sitting, on June 21, 1858, includes, seated from left, Little Iron Walker, John Other Day, Stumpy Horn, and Sweet Corn; standing, from left, Akepa "The Meeter," Scarlet Plume, Little Paul Shoots as He Walks, Red Eagle Feather, Red Iron, and Charles D. Crawford. Salt print, 40 × 59 cm. Collection of Lori and Victor Germack

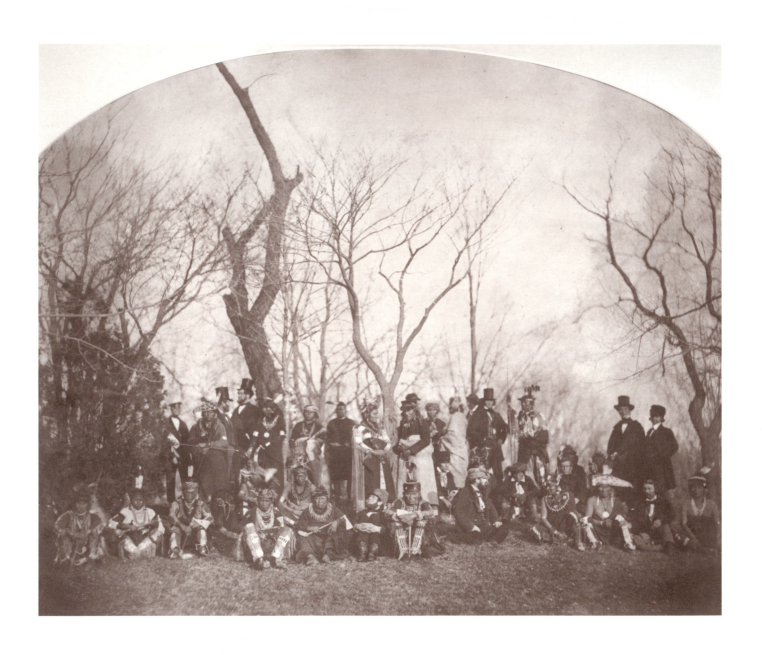

17. Alexander Gardner (1821–1882), *Delegation on the White House lawn*. This is the earliest known photograph of Indians in Washington. Photographed on December 31, 1857, the delegation represents four tribes: Pawnee, Ponca, Potawatomi, and Sac and Fox. The image was commissioned by Charles MacKay for *The Illustrated London News*. Salt print. Collection of Lori and Victor Germack

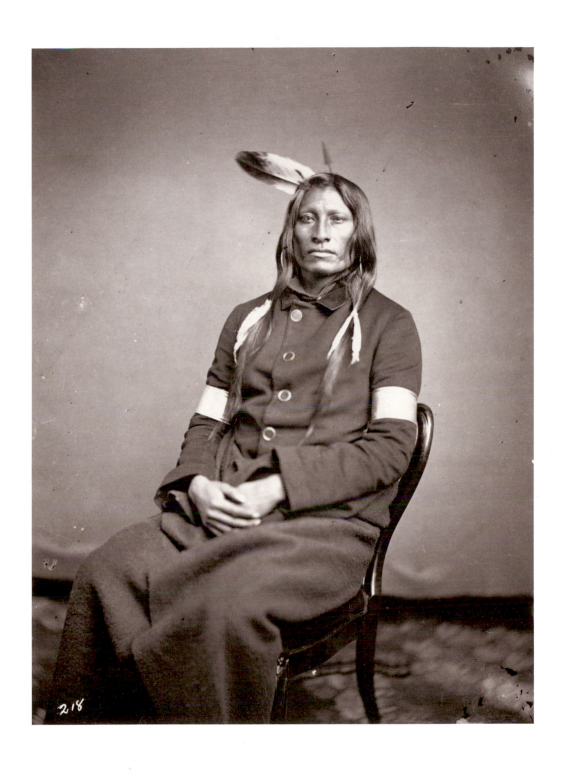

18. Julian Vannerson and Samuel Coher, *Jumping Thunder, a Yankton Dakota, 1857–1858*. Albumen print. The Princeton Collections of Western Americana, Gift of Sheldon Jackson

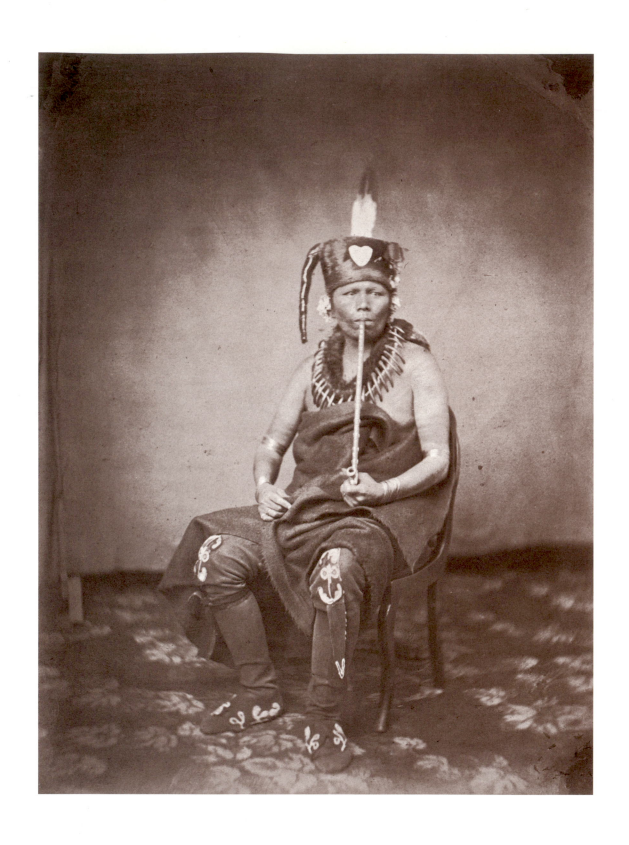

19. A. Zeno Shindler (1823–1899), *"Takako," known as Grey Fox, Chief of the Sac and Fox, 1858.* Salt print. Collection of Lori and Victor Germack

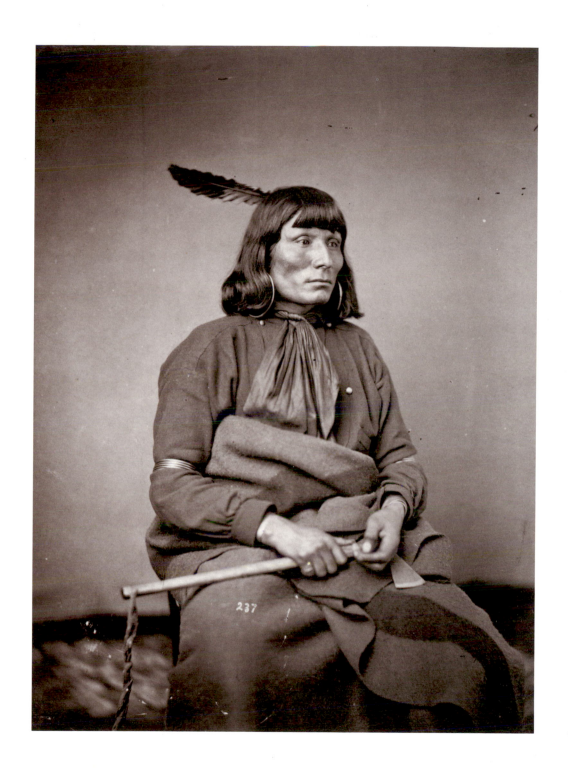

20. McClees Studio, *Hehakaanazin, or Standing Elk, A Yankton Dakota, 1858.* Albumen print. The Princeton Collections of Western Americana, Gift of Sheldon Jackson

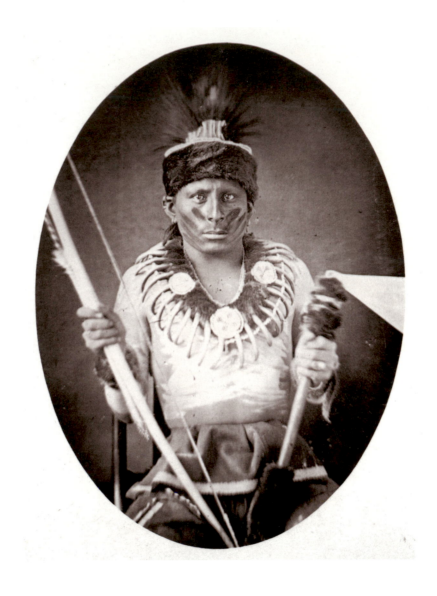

21. *Man with bow and tomahawk*. Albumen print. The Princeton Collections of Western Americana, Gift of Sheldon Jackson

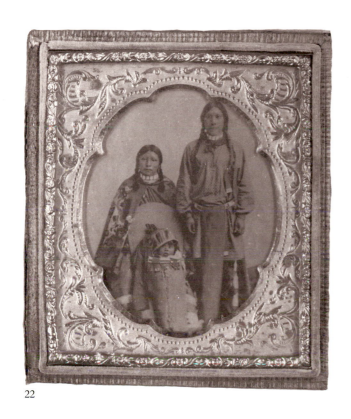

22

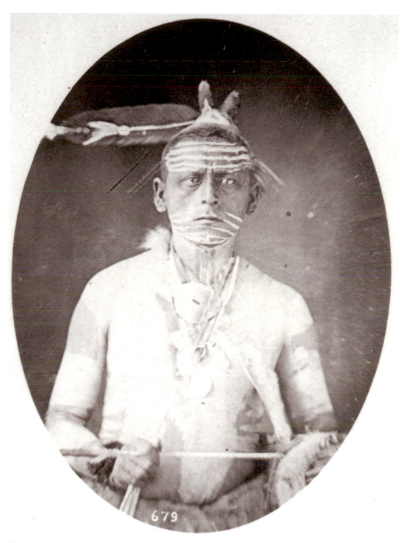

679

23

22. *Native family*. Sixth plate ambrotype. Collection of Lori and Victor Germack

23. A. Zeno Shindler (1823–1899), *Charles Keokuk, the grandson of Keokuk, A Sac and Fox, 1868*. Albumen print. The Princeton Collections of Western Americana, Gift of Sheldon Jackson

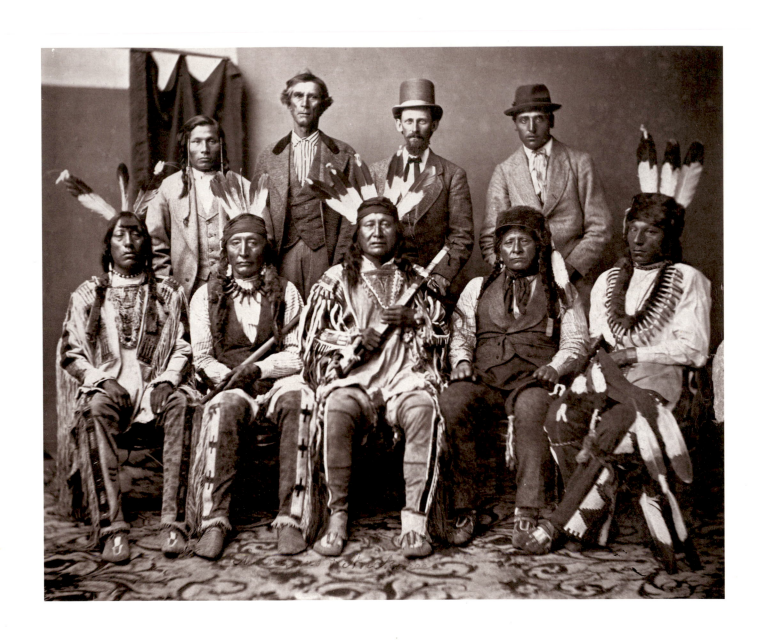

24. Mandans and Arickarees. Albumen print. The Princeton Collections of Western Americana, Gift of Sheldon Jackson

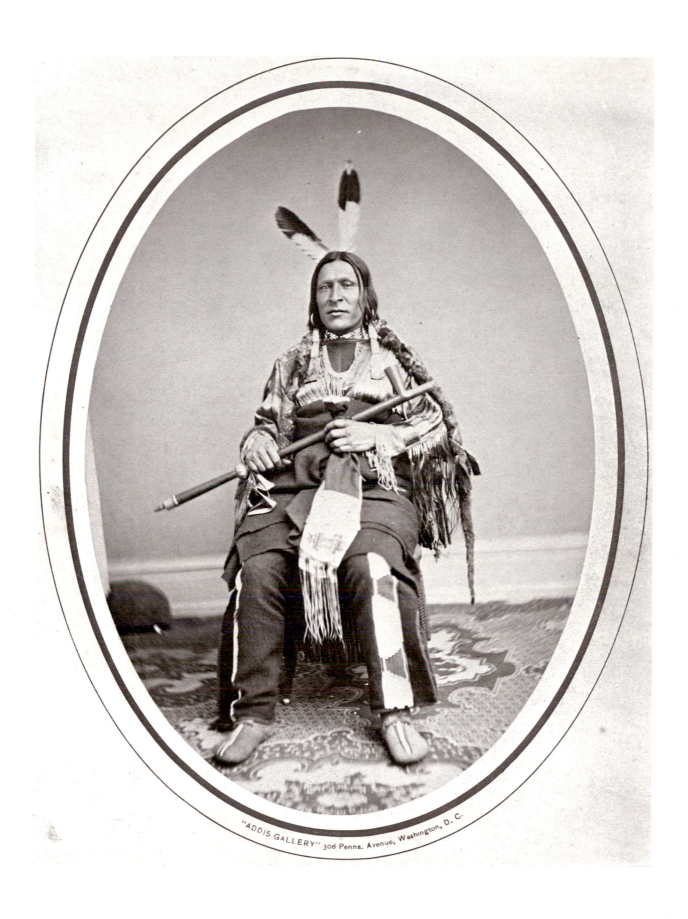

"ADDIS GALLERY" 308 Penna. Avenue, Washington, D. C.

25. Addis Gallery, Washington, D.C., *Cah-Lah-Ta' A-Ke-Ah, The Flying Bird, a Two Kettle Sioux Chief.* Albumen print, 1860s.
The Peabody Museum of Natural History, Yale University

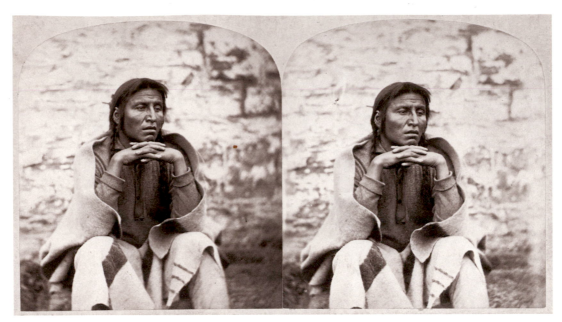

26

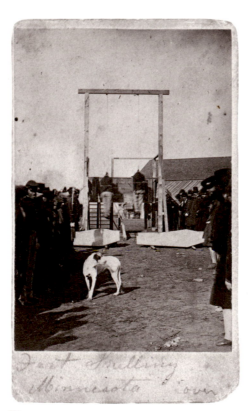

27

26. Joel Emmons Whitney (1822–1886), *Medicine Bottle, a Mdewakanton Dakota participant in the "massacre" of 1862, as a prisoner at Fort Snelling, June 17, 1864, awaiting the gallows.* Albumen stereograph. Collection of Lori and Victor Germack

27. Joel Emmons Whitney (1822–1886), *Little Six and Medicine Bottle on the gallows, 1865.* Albumen print. The Princeton Collections of Western Americana

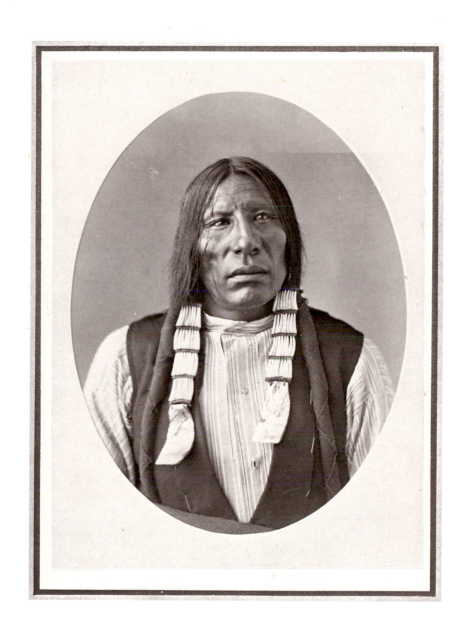

28. Alexander Gardner (1821–1882), *Tshan Gma-Ne-Toh (Cayote)*. Albumen print. The Peabody Museum of Natural History, Yale University

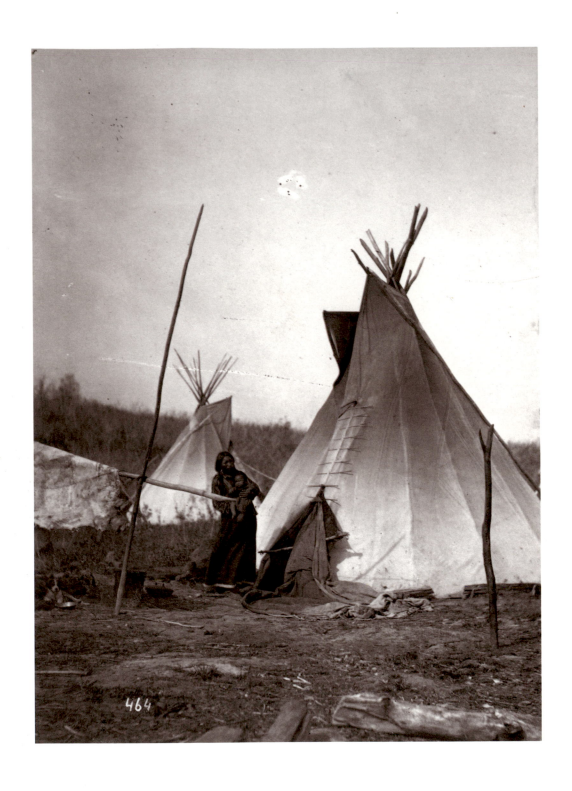

29. William Henry Jackson (1843–1942), *"Ga-hi-ge's Tipi."* This image was taken in 1868 or 1869 when Jackson photographed among the Omaha people. Albumen print. The Princeton Collections of Western Americana, Gift of Sheldon Jackson

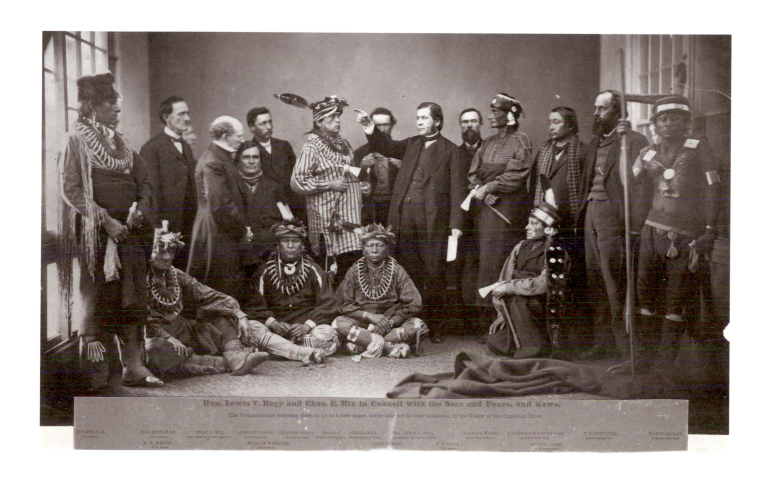

Hon. Lewis V. Bogy and Chas. E. Mix in Council with the Sacs and Foxes, and Kaws.

The Commissioner advising them to go to a new home, better adapted to their condition, in the Valley of the Canadian River.

30. Alexander Gardner (1821–1882), *"Hon. Lewis V. Bogy and Chas. E. Mix in Council with the Sacs and Foxes, and Kaws. The Commissioner advising them to go to a new home, better adapted to their condition, in the Valley of the Canadian River."* Left to right: Mut-Tut-Tah, Councilman; Man-Ah-To-Wah, Councilman; H. W. Martin, U.S. Agent; Chas. E. Mix, Chief Clerk of the Indian Bureau; Antoine Gokey, U.S. Interpreter; William Whistler, Half Breed; Ne-Quaw-Ho-Ho, 2d Chief of Sacs; Keokuk, Princ'l Chief of Sacs; Che-Ko-Skuk, Princ'l Chief of Foxes; Capt. Curtis; Hon. Lewis V. Bogy, Commissioner of Indian Affairs; F. R. Page, U.S. Agent; Al-Le-Ga-Wa-Ho, Head Chief of Kaws; Kaw-He-Ga-Wa-Ti-An-Gah, A Brave and Chief; Joseph James, U.S. Interpreter; T. S. Huffaker, Special Interpreter; Wah-Ti-An-Goah, A Brave and Chief. Albumen print, 25 × 47.5 cm. The Princeton Collections of Western Americana, Gift of Sheldon Jackson

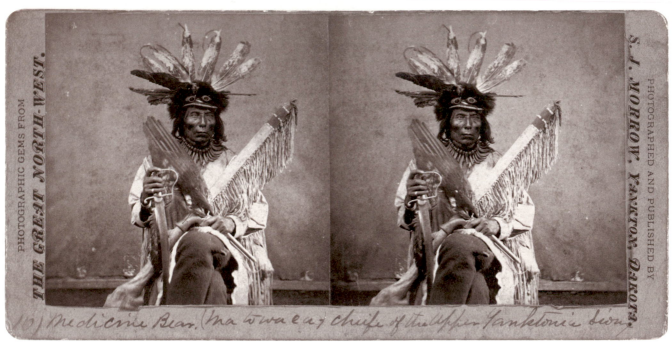

31

32

31. Stanley J. Morrow (1843–1921), *"Medicine Bear (Matowaea) leader of the Upper Yanktoni Sioux."* Albumen stereograph. Collection of Lori and Victor Germack

32. Benjamin Franklin Upton (1818–1901), *"Winneskiek and Warriors in Council."* "Upton's Indian Photos" is printed on the reverse of this *carte de visite* albumen print. Collection of Lori and Victor Germack

33. A. Zeno Shindler (1823–1899), *"Wahcoma, a Sac and Fox,"* 1868. Albumen print. The Princeton Collections of Western Americana, Gift of Sheldon Jackson

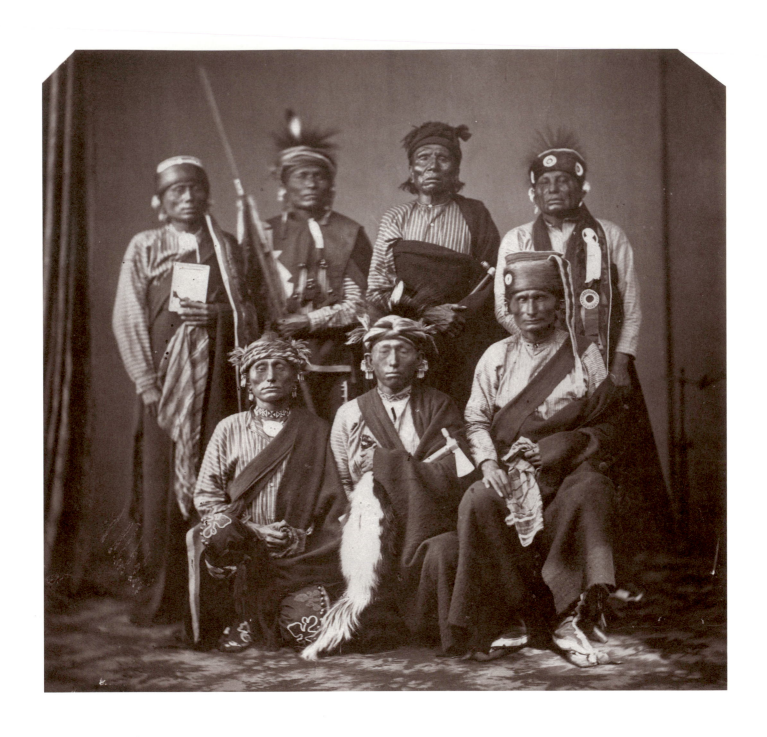

34. *A group of Fox Chiefs.* Albumen print, 29 × 30.7 cm. The Princeton Collections of Western Americana, Gift of Sheldon Jackson

35

36

35. *Brave*. Sixth plate tintype. Collection of Lori and Victor Germack

36. *"Standing Bear."* Sixth plate tintype, late 1860s. Collection of Lori and Victor Germack

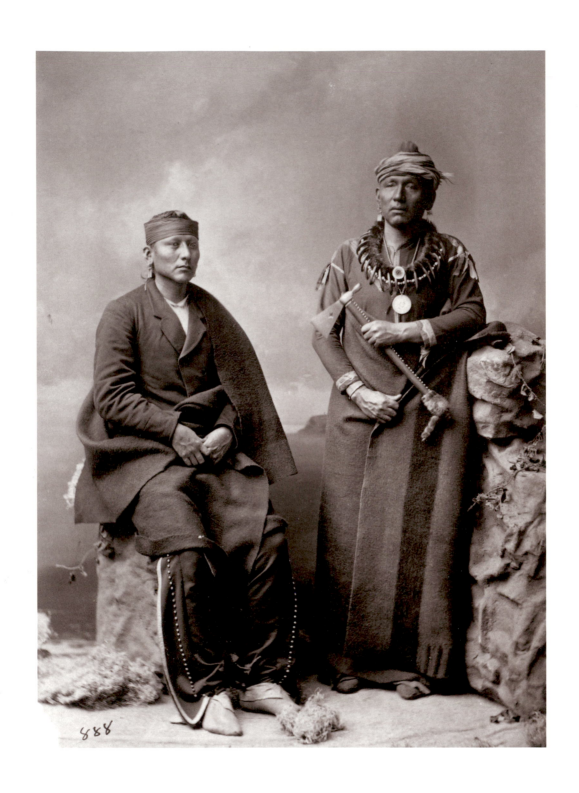

37. *Joseph and Black Dog, Osage.* Albumen print. The Princeton Collections of Western Americana, Gift of Sheldon Jackson

38. Stanley J. Morrow (1843–1921), *Pretty Sea Shells, one of White Bull's seven daughters.* White Bull was Chief of the Sans Arc band of the Teton Dakota or Sioux. Albumen print, 1860s. Collection of Lori and Victor Germack

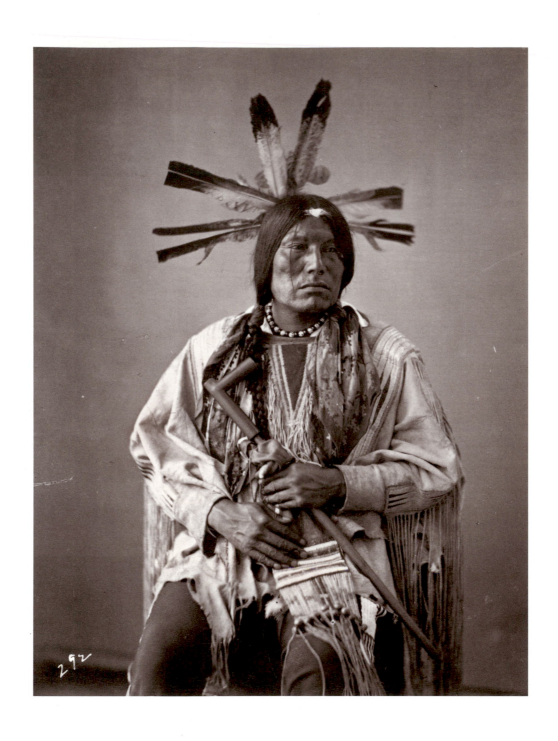

39. Alexander Gardner (1821–1882), *Wi-Cha-Wanmble' or Man Who Packs the Eagle, a Cut Head Dakota*. Albumen print. The Princeton Collections of Western Americana, Gift of Sheldon Jackson

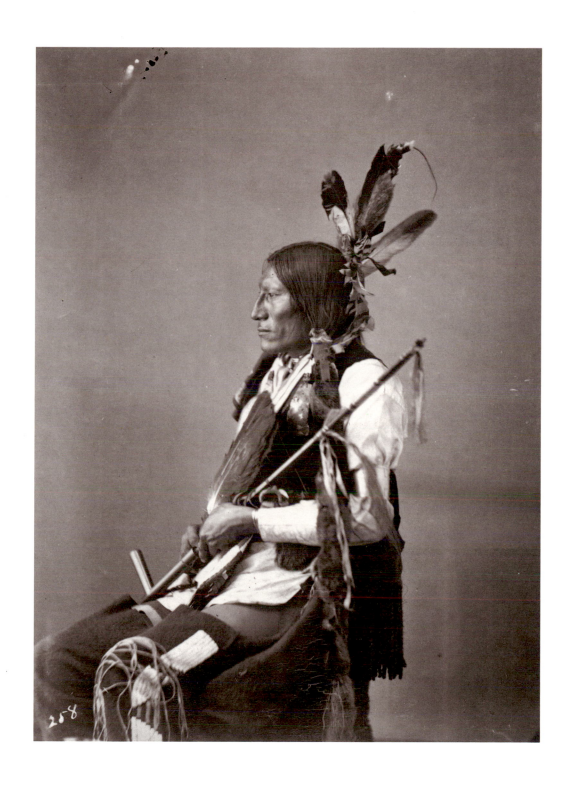

40. Alexander Gardner (1821–1882), *A profile view of Wi-Cha-Wanmble'*. Albumen print. The Princeton Collections of Western Americana, Gift of Sheldon Jackson

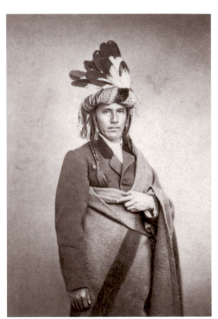

41

42

41. Joel Emmons Whitney (1822–1886). *"Po-Go-Nay-Ke-Shick" or Hole In The Day*. Albumen print, *carte de visite*, 1860s. This print was reissued under other photographer's names, including that of Charles Zimmerman (see the following image). Collection of Lori and Victor Germack

42. Joel Emmons Whitney (1822–1886), *"Po-Go-Nay-Ke-Shick, or Hole In The Day*. After Whitney retired in 1871, Charles A. Zimmerman (1844–1909) appropriated many of his images, including this one. This common practice suggests the complexity of identifying the original photographer of nineteenth-century photographic images. Albumen print, *carte de visite*, 1860s. The Princeton Collections of Western Americana

43. *Shun-To'-Ke-Cha-Ish-Na-Na, or Lone Wolf, Ogalala.* Albumen print. The Princeton Collections of Western Americana,
Gift of Sheldon Jackson

44. Mathew Brady (1823–1896), *Keokuk, Jr., and Charles Keokuk, Sac and Fox*. Albumen print, 1868. The Princeton Collections of Western Americans, Gift of Sheldon Jackson

45. William Henry Jackson (1843–1942), *"A Group of Pawnee Chiefs and Headmen": Kit-Ka-Hoct, La-Shara-Tu-Ra-Ha, La-Sharoo-Too-Row-Oo-Towy, Te-Rar-A-Weet and La-Shara-Chi-Eks, 1871.* Albumen print. The Princeton Collections of Western Americana, Gift of Sheldon Jackson

39

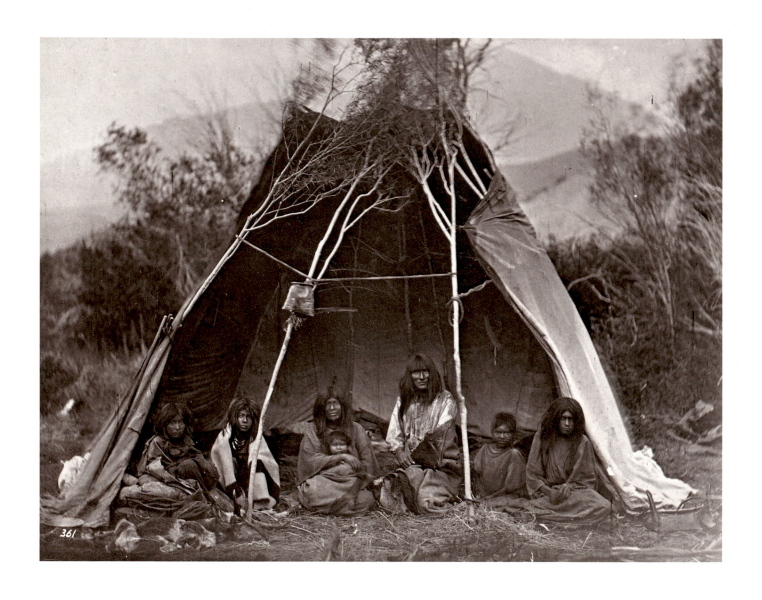

46. William Henry Jackson (1843–1942), *Bannock encampment at the head of Medicine Lodge Creek, Idaho.* Photographed in June 1871 while Jackson was a member of the Hayden Survey. Albumen print. The Peabody Museum of Natural History, Yale University

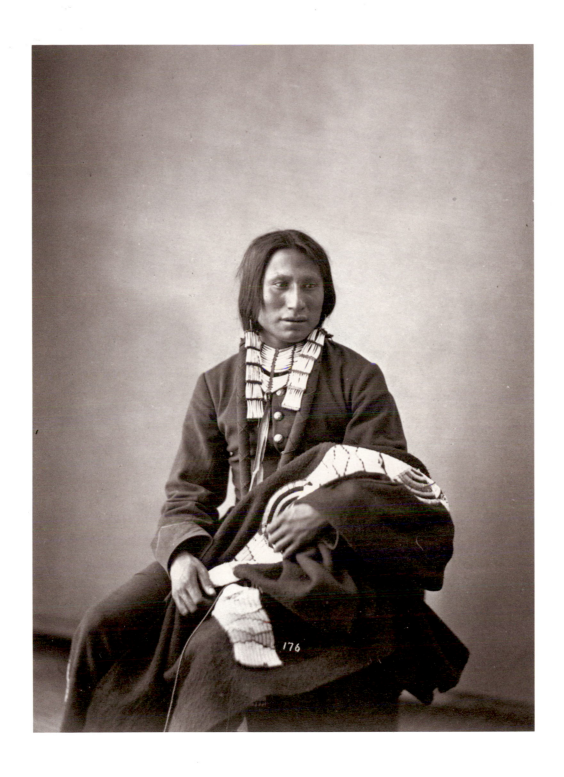

47. Alexander Gardner (1821–1882), *Yellow War Eagle, A Dakota*. This photograph was taken in 1872 when the Omaha delegation visited Washington, D.C. Albumen print. The Princeton Collections of Western Americana, Gift of Sheldon Jackson

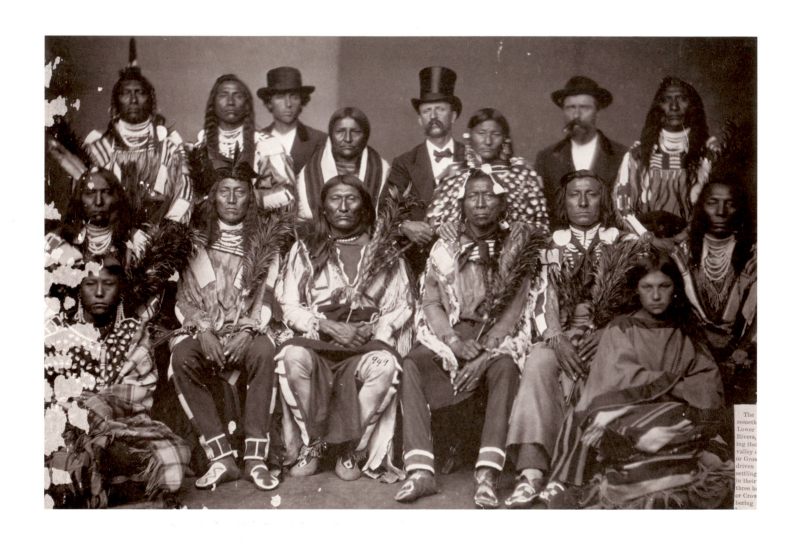

48. Julius (1833–1910) and Henry Ulke (1821–1910), *A Crow Delegation, Washington, D.C., 1872*. Albumen print, 26.7 × 40 cm. The Princeton Collections of Western Americana, Gift of Sheldon Jackson

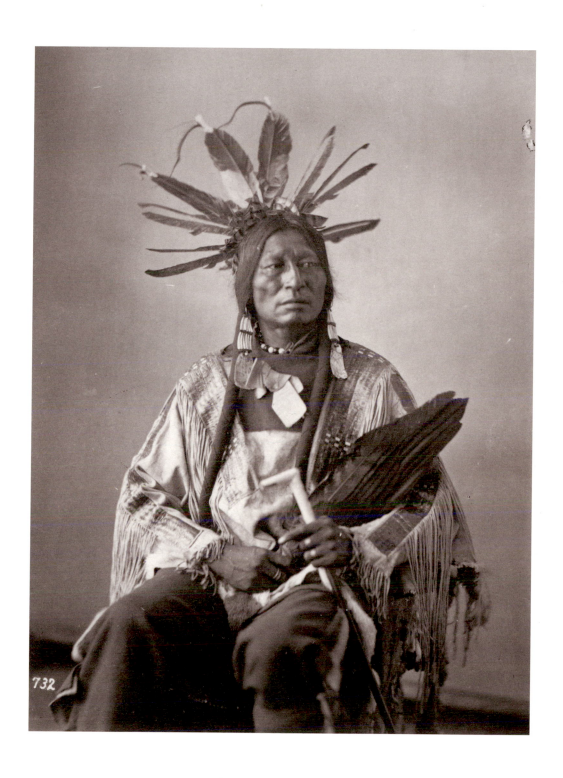

49. Alexander Gardner (1821–1882), *He Ota, also known as Many Horns, a Dakota*. This photograph was made when He Ota visited Washington as part of a Dakota delegation. Albumen print, 25 × 32.6 cm. The Princeton Collections of Western Americana, Gift of Sheldon Jackson

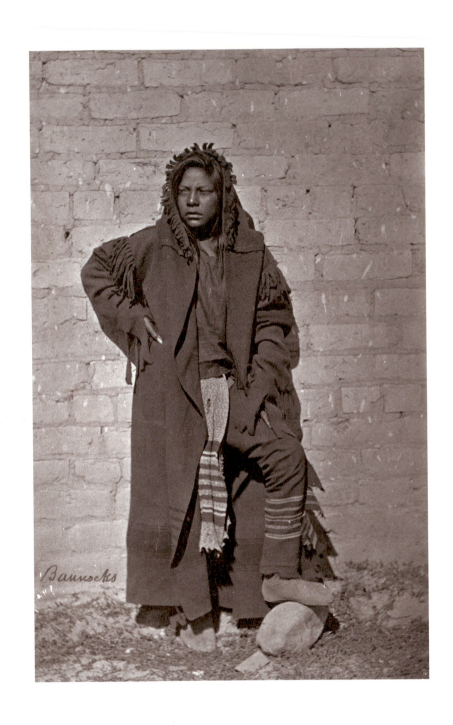

50. William Henry Jackson (1843–1942). *John, a Bannock prisoner, 1872, Camp Brown, Wyoming Territory*. Albumen print.
The Princeton Collections of Western Americana, Gift of Sheldon Jackson

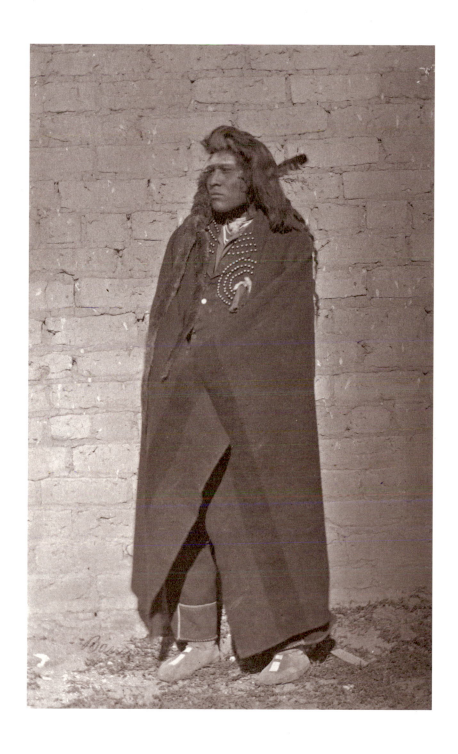

51. William Henry Jackson (1843–1942). *Na-Pe'-Oho, a Bannock prisoner, 1872, Camp Brown, Wyoming Territory*. Albumen print. The Princeton Collections of Western Americana, Gift of Sheldon Jackson

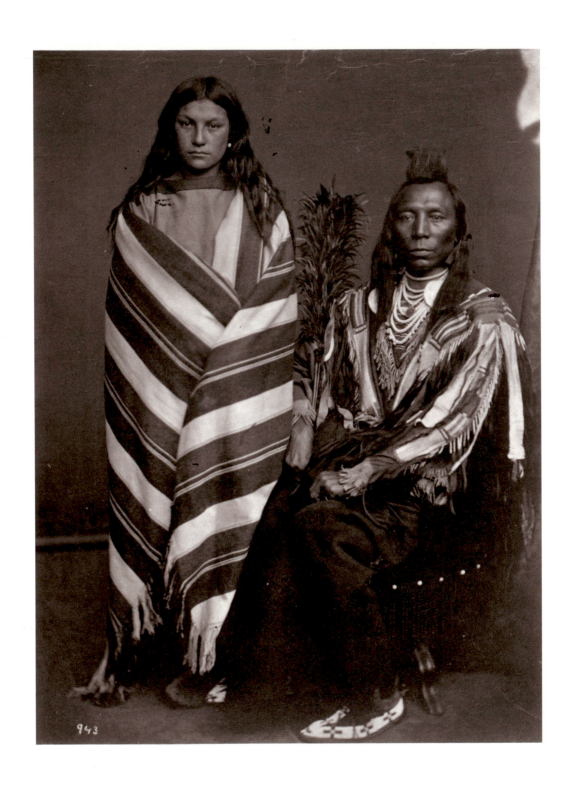

52. *"Peits-har-sts or Old Crow and wife, Ish-ip-chi-wah-pa-i-chis or Pretty Medicine Pipe," 1873.* Albumen print. The Princeton Collections of Western Americana, Gift of Sheldon Jackson

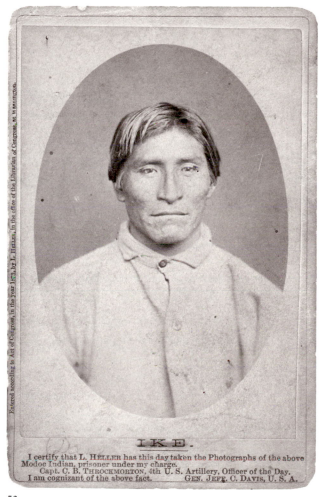

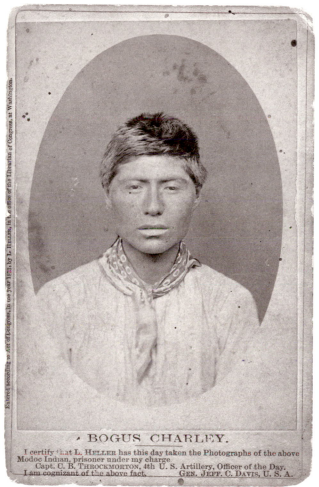

53

54

53. Louis H. Heller (1839–1928), *Ike, Modoc prisoner in California, 1873.* Albumen print. The New York Public Library

54. Louis H. Heller (1839–1928), *Bogus Charlie, Modoc prisoner in California, 1873.* Albumen print. The New York Public Library

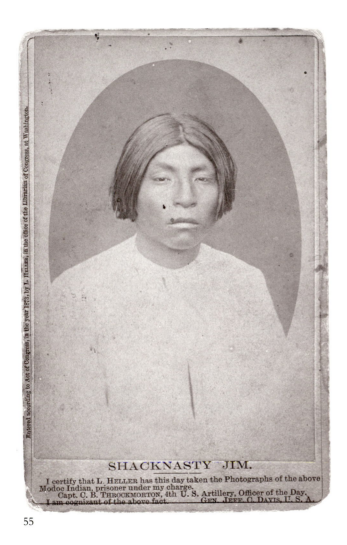

SHACKNASTY JIM.

I certify that L. HELLER has this day taken the Photographs of the above Modoc Indian, prisoner under my charge.
Capt. C. B. THROCKMORTON, 4th U. S. Artillery, Officer of the Day.
I am cognizant of the above fact. GEN. JEFF. C. DAVIS, U. S. A.

55

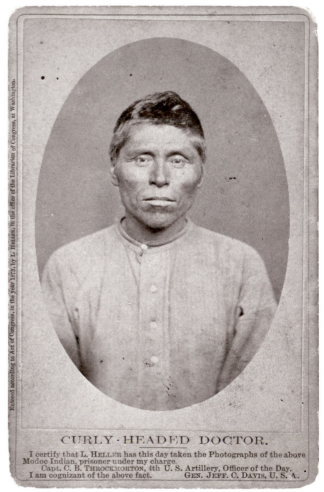

CURLY-HEADED DOCTOR.

I certify that L. HELLER has this day taken the Photographs of the above Modoc Indian, prisoner under my charge.
Capt. C. B. THROCKMORTON, 4th U. S. Artillery, Officer of the Day.
I am cognizant of the above fact. GEN. JEFF. C. DAVIS, U. S. A.

56

55. Louis H. Heller (1839–1928), *Shacknasty Jim, Modoc prisoner in California, 1873.* Albumen print. The New York Public Library

56. Louis H. Heller (1839–1928), *Curly-Headed Doctor, Modoc prisoner in California, 1873.* Albumen print. The New York Public Library

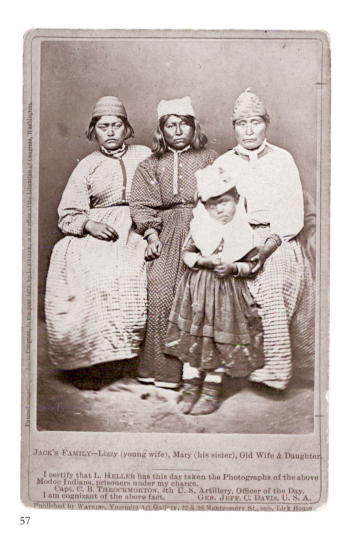

JACK'S FAMILY—Lizzy (young wife), Mary (his sister), Old Wife & Daughter.

I certify that L. HELLER has this day taken the Photographs of the above Modoc Indians, prisoners under my charge.
Capt. C. B. THROCKMORTON, 4th U. S. Artillery, Officer of the Day.
I am cognizant of the above fact. GEN. JEFF. C. DAVIS, U. S. A.
Published by WATKINS, Yosemite Art Gallery, 22 & 26 Montgomery St., opp. Lick House.

57

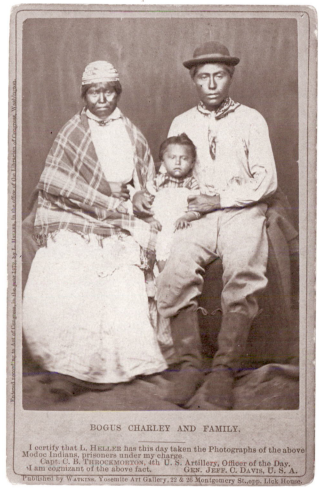

BOGUS CHARLEY AND FAMILY.

I certify that L. HELLER has this day taken the Photographs of the above Modoc Indians, prisoners under my charge.
Capt. C. B. THROCKMORTON, 4th U. S. Artillery, Officer of the Day.
I am cognizant of the above fact. GEN. JEFF. C. DAVIS, U. S. A.
Published by WATKINS, Yosemite Art Gallery, 22 & 26 Montgomery St., opp. Lick House.

58

57. Louis H. Heller (1839–1928), *Jack's Family, Modoc prisoners in California, 1873.* Albumen print. The Oregon Historical Society

58. Louis H. Heller (1839–1928), *Bogus Charley and Family, Modoc prisoners in California, 1873.* These Modoc prisoner images were published by Carleton E. Watkins. Albumen print. The Oregon Historical Society

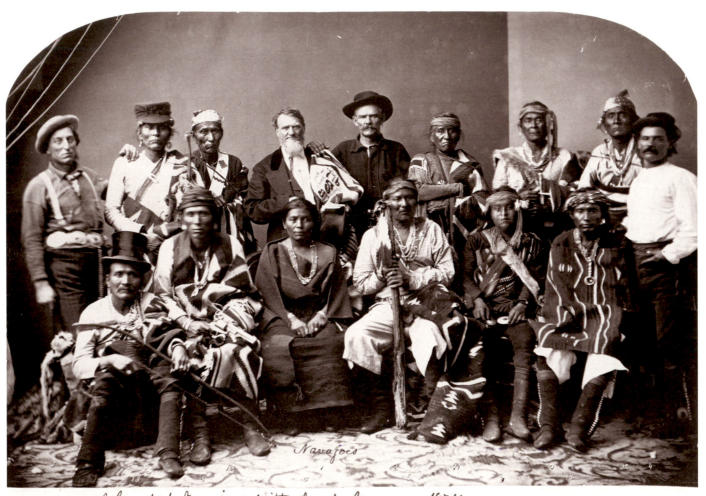

A Group of Navajoes with Agent Arney. 1874

59. Charles M. Bell (1848–c.1893), *A group of Navajos with Agent Arny, 1874.* Front row, from left: Carero Mucho; Mariani; Juanita, wife of Manuelito; Manuelito, head chief; Manuelito Segundo, son of Manuelito and Juanita; Tiene-su-se. Back row, from left: "Wild" Hank Sharp; Canada Micho; Barbas Bueros; Governor Arny; Indian agent for the Navajo reservation; Kentucky Mountain Bill; Cabra Segra; Caystanita; Narbona Primera; and Jesus Alviso, a Navajo captive. Albumen print, 21.3 × 32 cm. The Princeton Collections of Western Americana, Gift of Sheldon Jackson

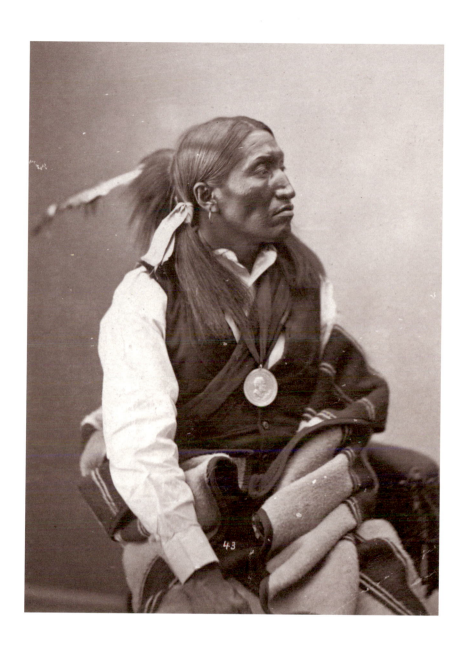

60. *Man wearing a Peace Medal*. Albumen print. The Princeton Collections of Western Americana, Gift of Sheldon Jackson

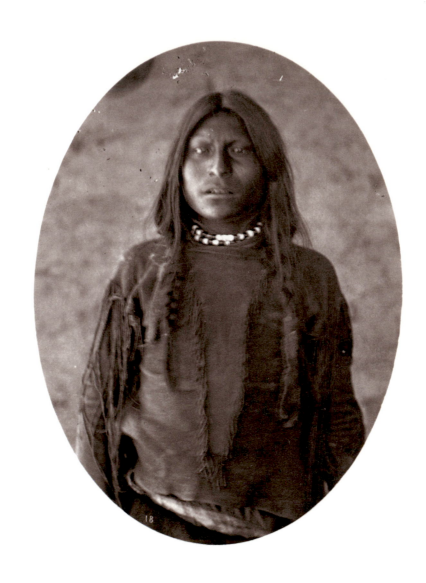

61. Orloff Westmann (1833–after 1886), *Son of Vicente, an Apache.* Albumen print. The Princeton Collections of Western Americana, Gift of Sheldon Jackson

62. *Eskayelah, an hereditary head chief of the Coyotero Apaches.* Albumen print. The Princeton Collections of Western Americana, Gift of Sheldon Jackson

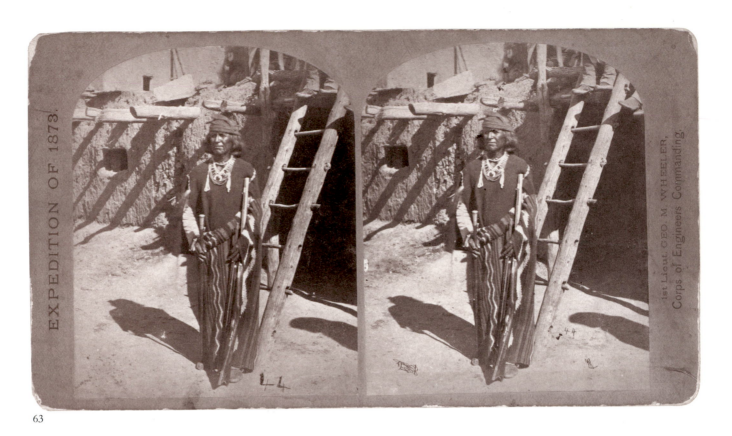

63

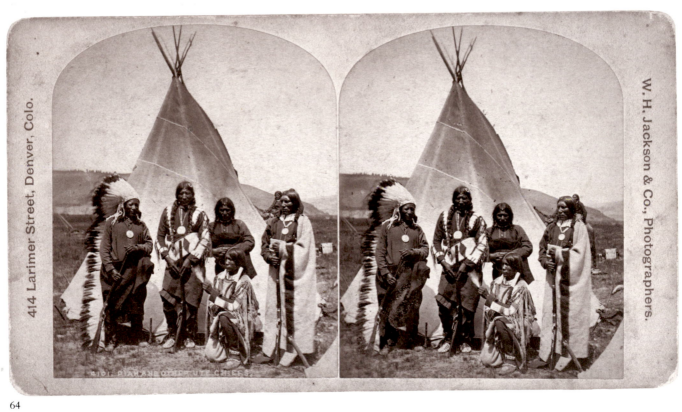

64

63. Timothy O'Sullivan (1840–1882), *Zuni War Chief Match-Olth-Tone with his rifle and cane of office.* Albumen stereograph. Collection of Lori and Victor Germack

64. William Henry Jackson (1843–1942), *Piah and other Ute Chiefs.* Albumen stereograph. Collection of Lori and Victor Germack

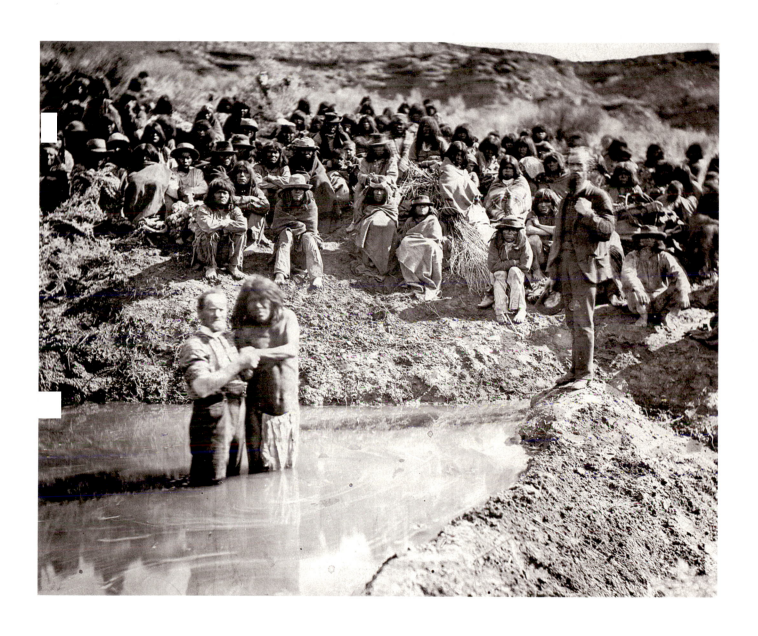

65. Charles R. Savage (1832–1909), *Shivwits Indians (a band of the Southern Paiute) being baptized by Mormons in Southern Utah, 1875.* The man performing the baptism is Daniel P. McArthur, President of the St. George, Utah, Stake of the Mormon Church. At right, with his hand on his lapel, is Sheriff Augustus P. Hardy. Albumen print, 21.5 × 24.9 cm. The Historical Department of The Church of Jesus Christ of Latter-Day Saints, Salt Lake City, Utah

55

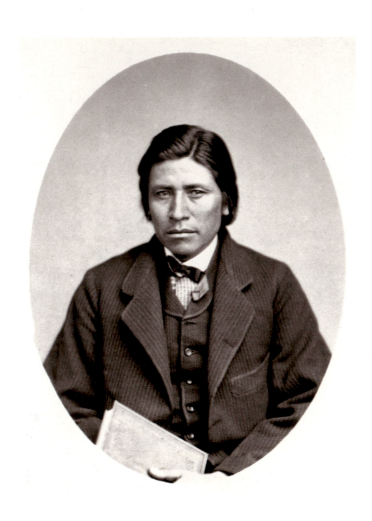

66. *Flute Player, a Santee Dakota.* Albumen print. The Princeton Collections of Western Americana, Gift of Sheldon Jackson

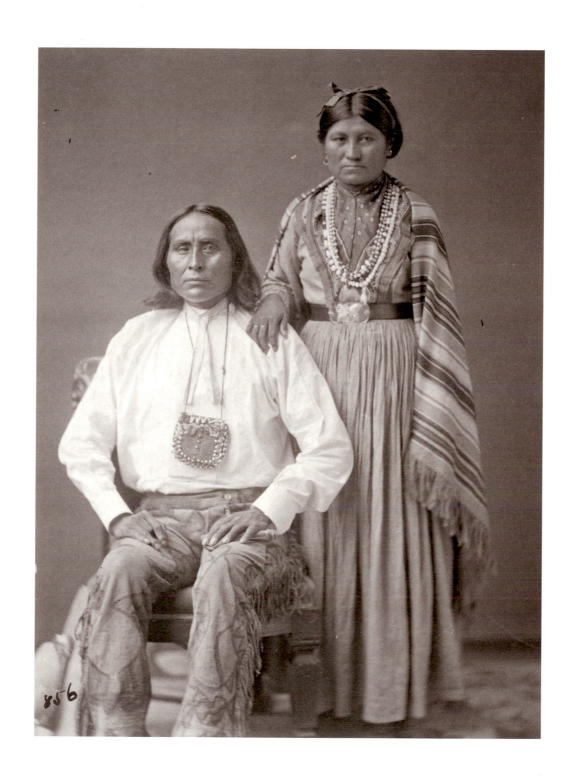

67. Charles M. Bell (1848–c.1893), *Cassadora and his wife, Penal Apaches, 1876.* Probably taken in Washington, D.C. Albumen print. The Princeton Collections of Western Americana, Gift of Sheldon Jackson

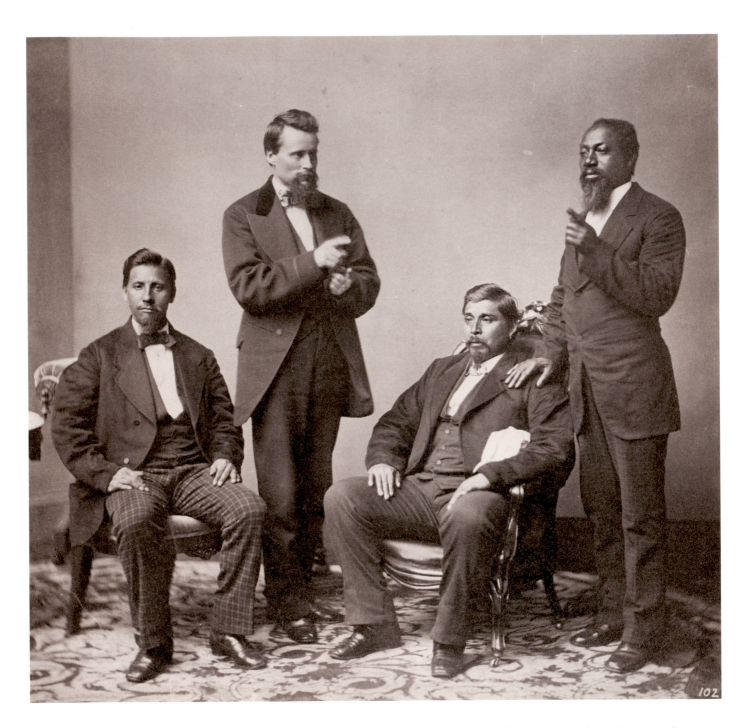

68. William Henry Jackson (1843–1942), *"Indian Chiefs, Creek."* These leaders are identified in Jackson's catalogue as, from left, La-cha-ha-jo, the Drunken Terrapin who "Served as first lieutenant in the Union Army during the rebellion, and . . . the leading spirit of the loyal Creeks. Is the treaty making chief. Age, about 35"; Tal-wa-mi-ko, Town King, "Commonly known as John McGilvry. Is a brother-in-law of Oporthleyoholo, a famous chief of the last generation, and stood by him during their struggles with and flight from the rebel Creeks. Is at the present time the second leading spirit of the loyal Creeks. Age, about 30"; Tam-si-pel-man, Thompson Perryman, "First Organizer of the loyal Creeks that came North during the rebellion. Was a councilor of Oporthleyoholo, and a steadfast adherent to the treaties made with the government. Age, about 40"; and Ho-tul-ko-mi-ko, Chief of the Whirlwind, "English name, Silas Jefferson; is of mixed African and Creek parentage; born in Alabama and raised among the Creeks in that state, removing with them to their present home in the Indian Territory. Is to all intents and purposes one of the tribe, taking a wife from among them, and sharing all their troubles. Was interpreter for the loyal Creeks during the war, and is now the official interpreter of the nation. Age, 45." Albumen print. Collection of Lori and Victor Germack

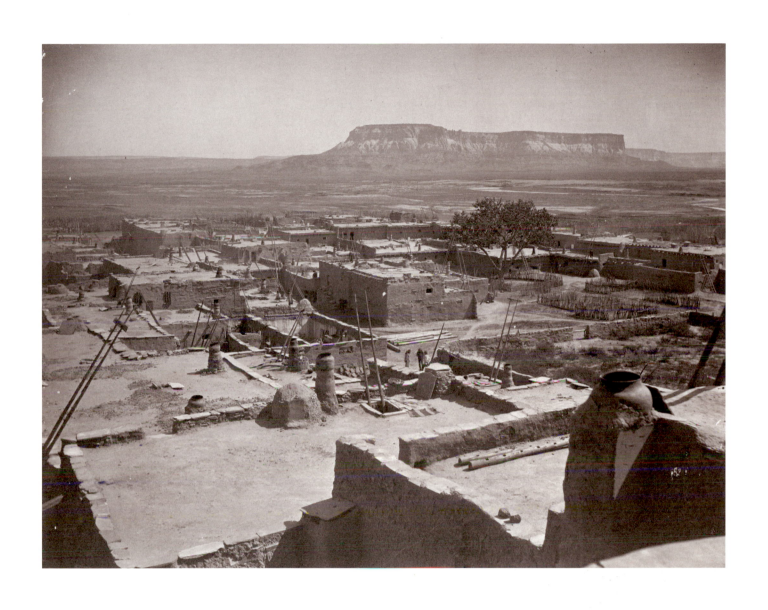

69. John K. Hillers (1843–1925), *Zunis on roofs and in the plazas of their Pueblo, September, 1879.* Albumen print. The Princeton Collections of Western Americana, Gift of Sheldon Jackson

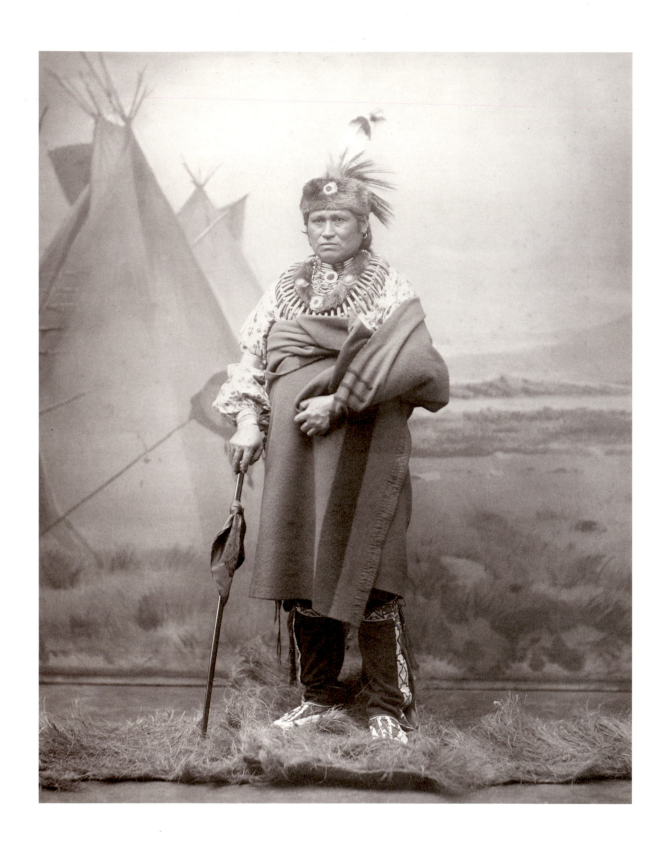

70. *Plains Indian man, 1870s.* Albumen print, 35 × 22 cm. Collection of Lori and Victor Germack

71. *Man with hat and wrapped braids.* Tintype, 1870s. Collection of Lori and Victor Germack

62

72. *"Wash-a-Kee, Head or War Chief, of the Shoshoni or Snake Indians of Utah and Washington Territory,"* with *"Fred Cook, Assist-*
ant Treasurer, Overland Mail Company, now engaged at Salt Lake City." Albumen print. Collection of Lori and Victor Germack

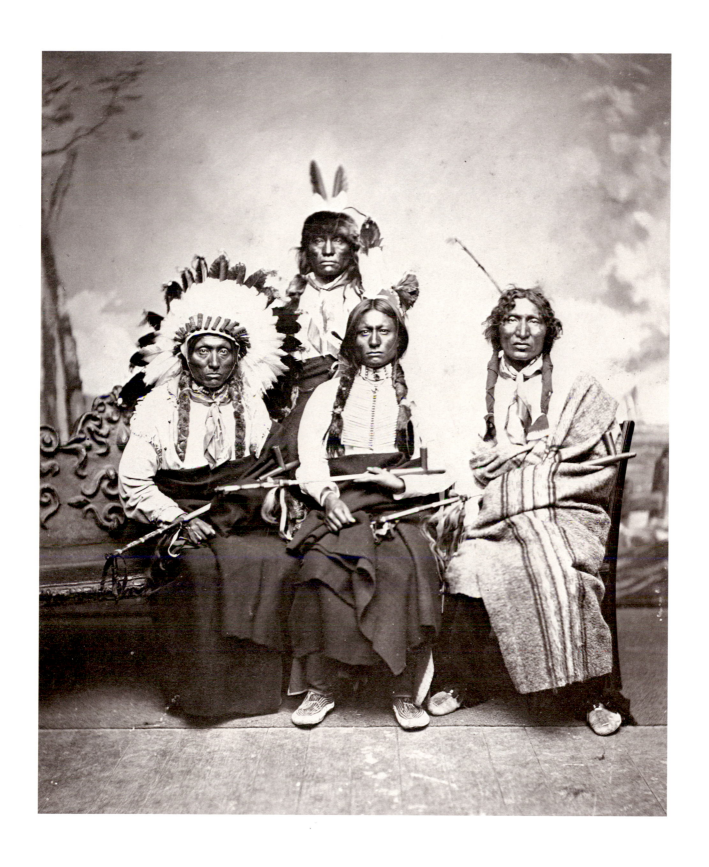

73. David F. Barry (1854–1934), *Four Plains men in a studio*. Albumen print. The Princeton Collections of Western Americana

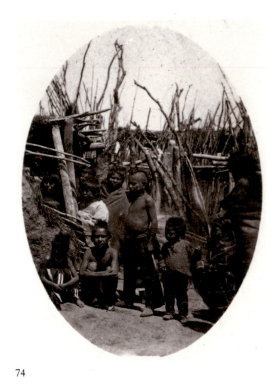

74

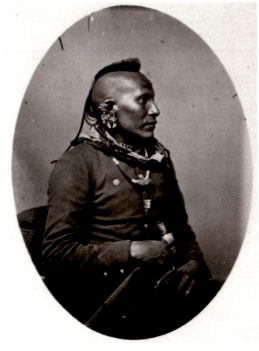

75

76

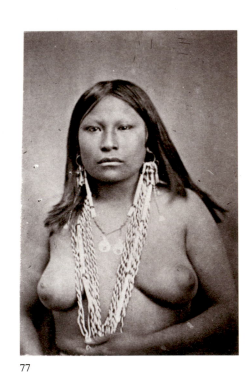

77

74. *Pawnee children.* Albumen print. The Princeton Collections of Western Americana, Gift of Sheldon Jackson

75. William Henry Jackson (1843–1942), *"White Horse, a Pawnee."* Albumen print. The Princeton Collections of Western Americana, Gift of Sheldon Jackson

76. *As-Sow-Weet and Sawka, Pawnees.* Albumen print. The Princeton Collections of Western Americana, Gift of Sheldon Jackson

77. *"Wichitah."* Albumen print in an album once belonging to Frances Metcalfe Wolcott. The Princeton Collections of Western Americana

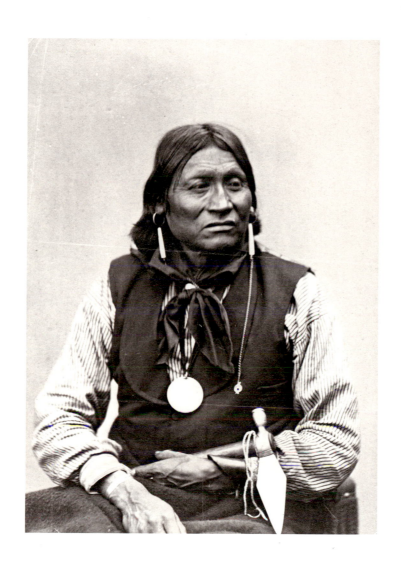

78. *Seated Man*. Albumen print. The Princeton Collections of Western Americana, Gift of Sheldon Jackson

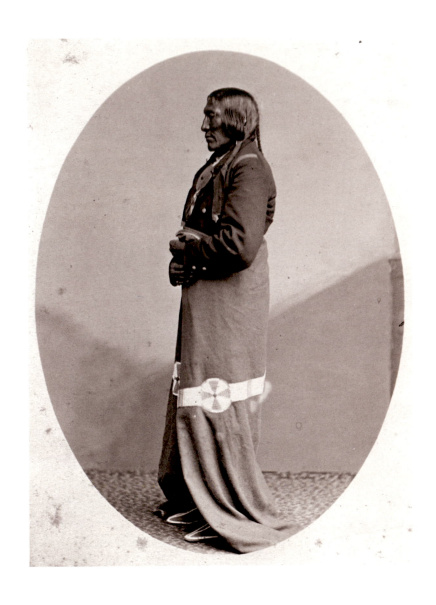

79. *Hah-Ket-Home-Mah, Little Robe, a Southern Cheyenne.* Albumen print. The Princeton Collections of Western Americana, Gift of Sheldon Jackson

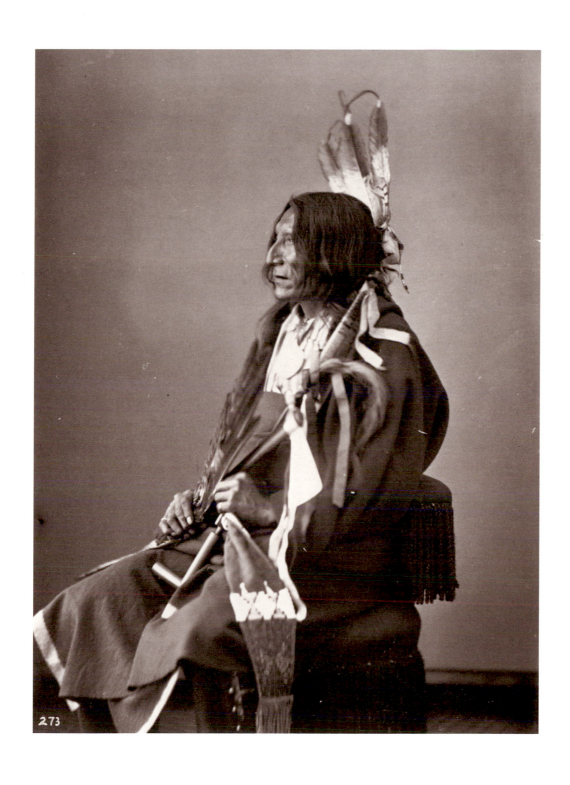

80. *I'-Sta-Sta'-Pa, Black Eye, an Upper Yanktonais.* Albumen print. The Princeton Collections of Western Americana, Gift of Sheldon Jackson

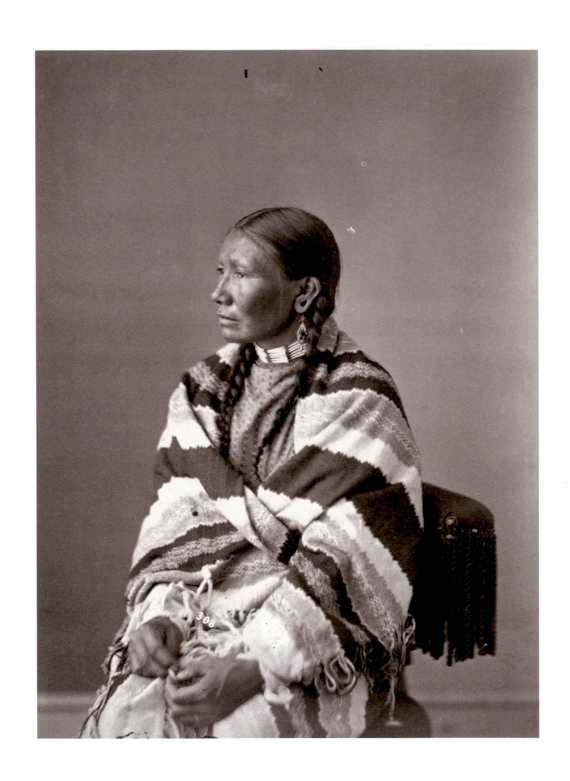

81. *White Hawk, Ogalalla Dakota.* Albumen print. The Princeton Collections of Western Americana, Gift of Sheldon Jackson

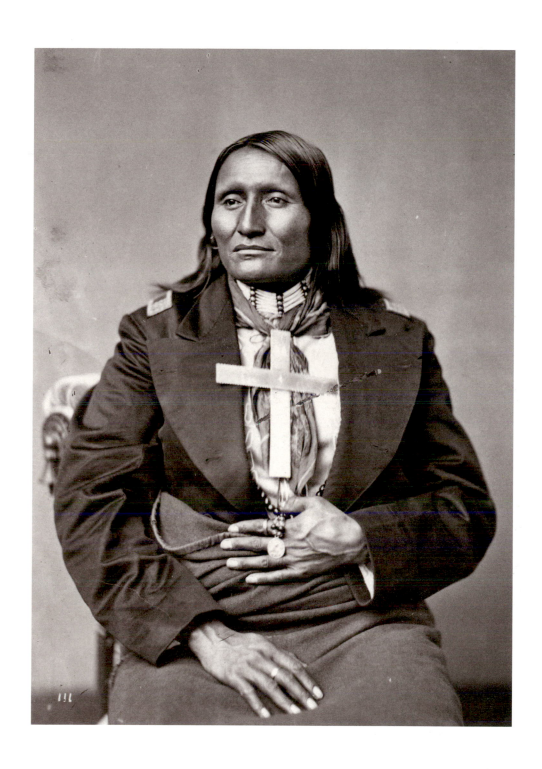

82. *White Shield, A Cheyenne.* Albumen print. The Princeton Collections of Western Americana, Gift of Sheldon Jackson

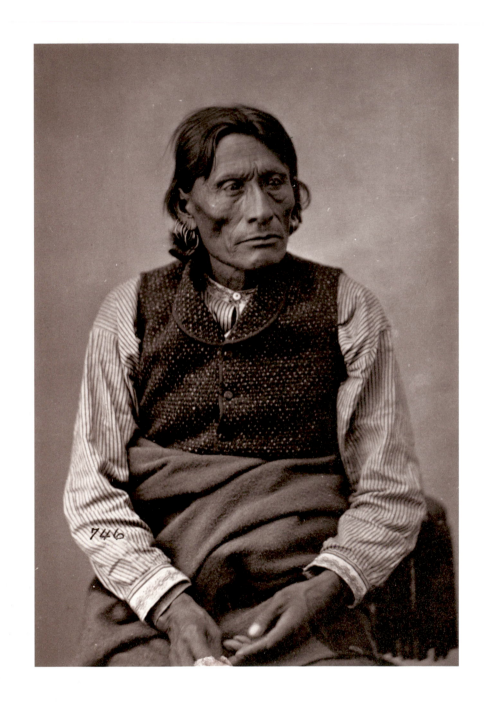

83. Alexander Gardner (1821–1882), *Esquitzchew, a Wichita.* This photograph was taken in Washington, D.C., in 1872, during a visitation of a Wichita delegation. Albumen print. The Princeton Collections of Western Americana, Gift of Sheldon Jackson

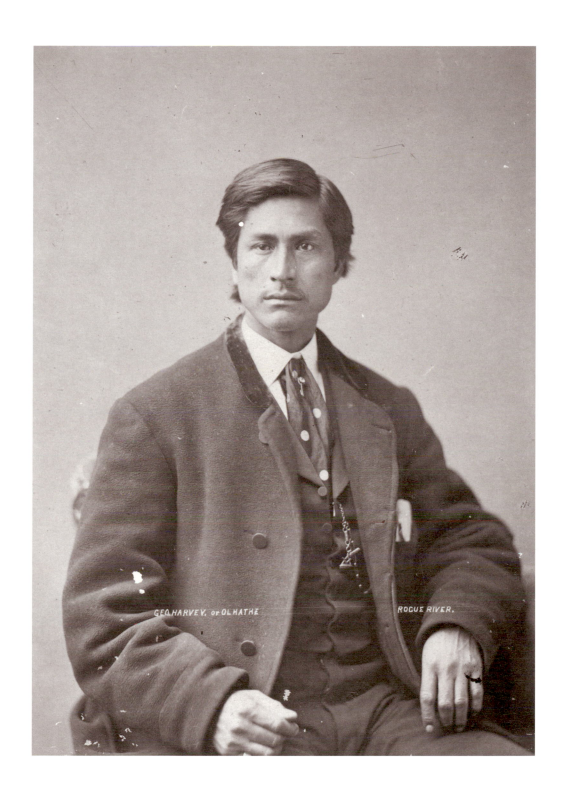

84. Charles M. Bell (1848–c.1893), *Olhathe, or George Harvey, a Rouge River Tututni.* Albumen print. The Princeton Collections of Western Americana, Gift of Sheldon Jackson

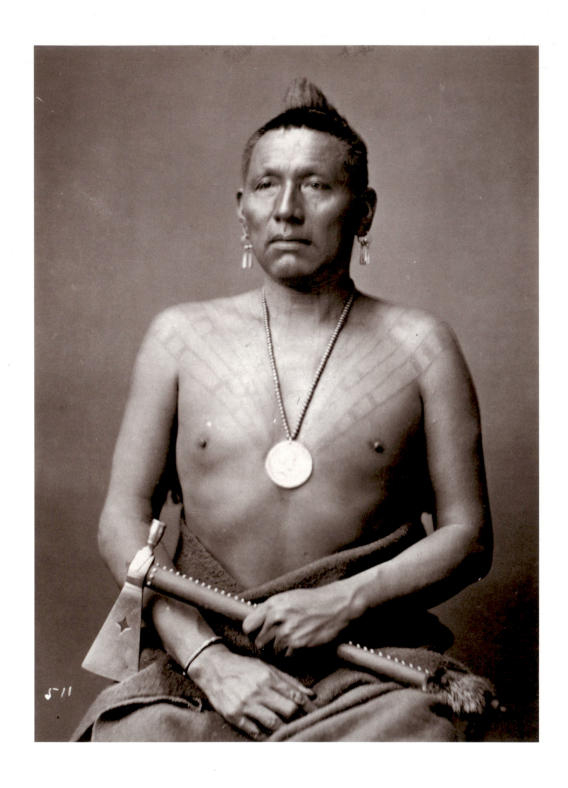

85. *Governor Joe (Pa-thin-non-pa-zhi, or Not Afraid of the Pawnee)*. The first Governor of the Osage. He died in 1883 and is buried in Pawhuska, Oklahoma. The image could have been made in Washington, D.C. in 1876. Albumen print. The Princeton Collections of Western Americana, Gift of Sheldon Jackson

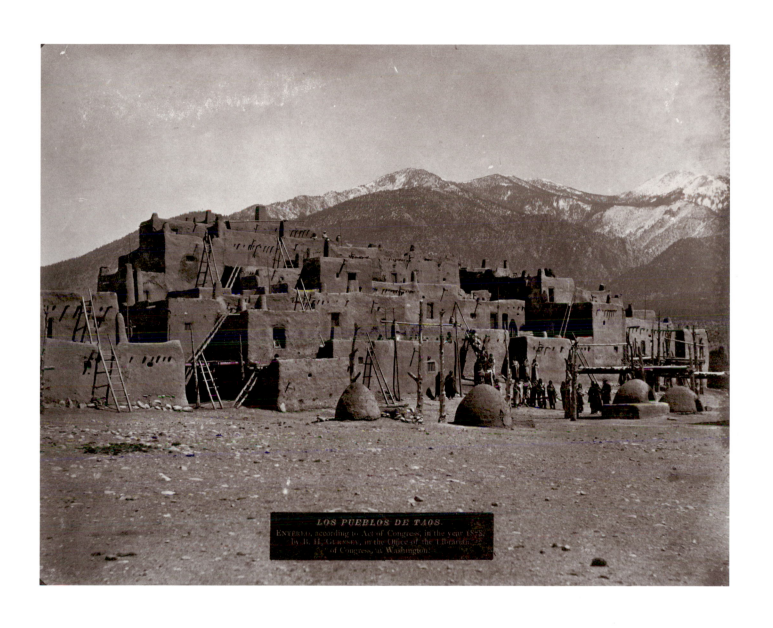

LOS PUEBLOS DE TAOS.
ENTERED, according to Act of Congress, in the year 1878,
by B. H. GURNSEY, in the Office of the Librarian
of Congress, at Washington.

86. Benjamin H. Gurnsey (1844–1881?), *"Los Pueblos de Taos," 1878.* Albumen print in an album once belonging to Frances Metcalfe Wolcott. The Princeton Collections of Western Americana

73

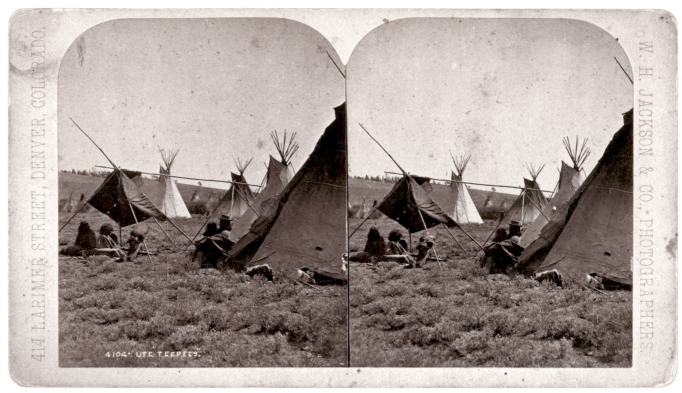

87

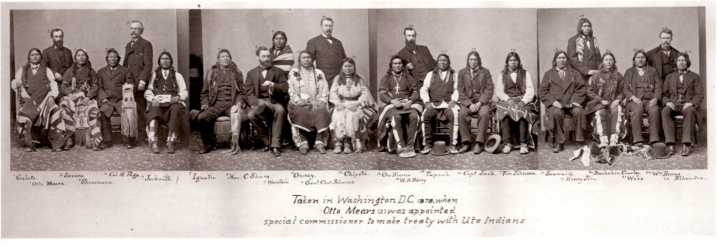

88

87. William Henry Jackson (1843–1942), *Ute teepees.* Albumen stereograph, 1870s. Collection of Lori and Victor Germack

88. Alexander Gardner (1821–1882), *Otto Mears with Ute Treaty Delegation: "Taken in Washington D.C. 1878 when Otto Mears was appointed special commissioner to make treaty with Ute Indians."* Commission members and delegation, from left: Galota, Otto Mears, Savero, Shavanaux, Colonel H. Page, Jocknick, Ignation, Honorable C. Shurz, Woretsiz, Ouray, General Charles Adams, Chipeta, Oho Blanca, Witt Berry, Tapuch, Captain Jack, Tim Johnson, Sowerwick, Henry Jim, Buckskin Charley, Wass, William Burns and Alhandra. Albumen print, 15 × 66 cm. Collection of Lori and Victor Germack

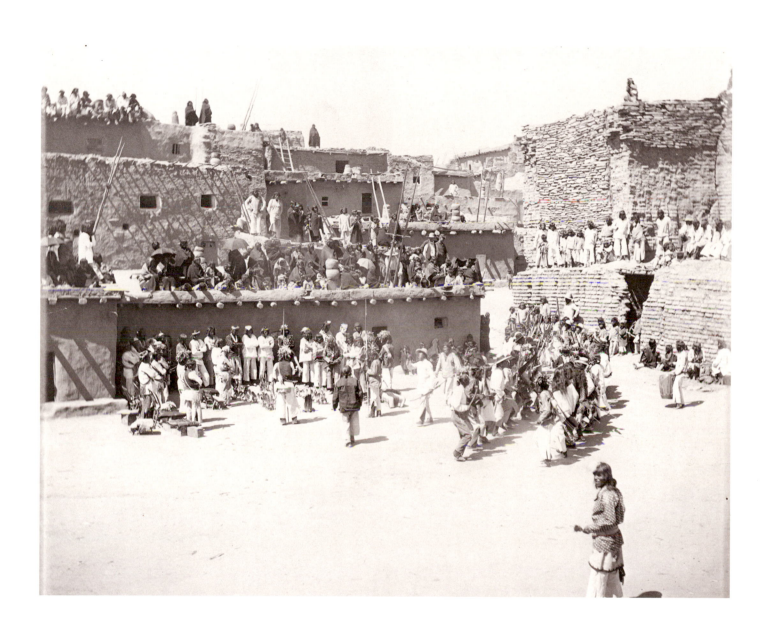

89. John K. Hillers (1843–1925), *A dance at Zuni Pueblo, 1879.* Albumen print. The Princeton Collections of Western Americana

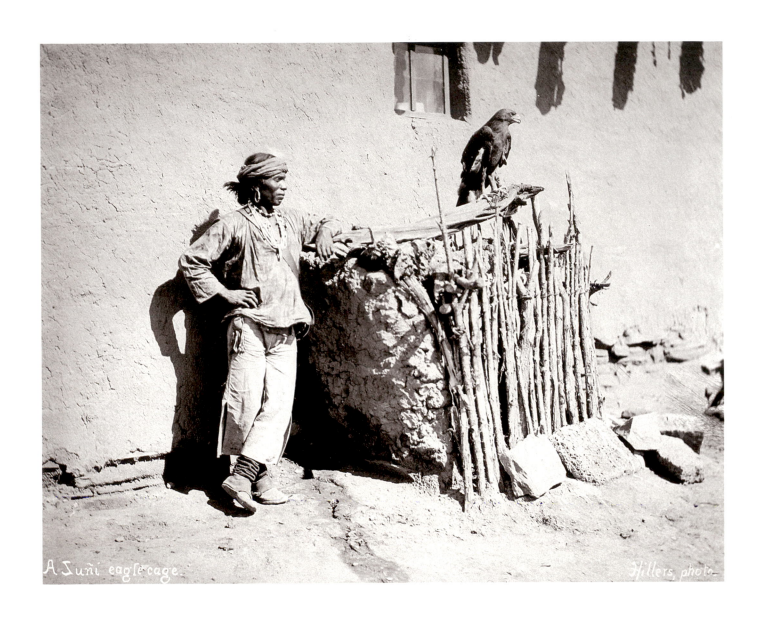

90. John K. Hillers (1843–1925), *A Zuni at an eagle cage, 1879*. Albumen print. The Historical Society of Pennsylvania

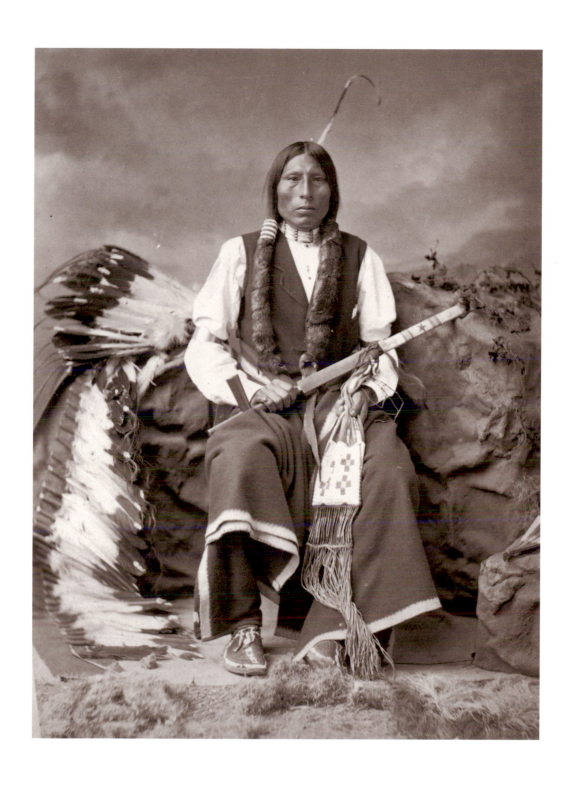

91. Charles M. Bell (1848–c. 1893), *Sword, an Oglalla Dakota*. The Princeton Collections of Western Americana, Gift of Sheldon Jackson

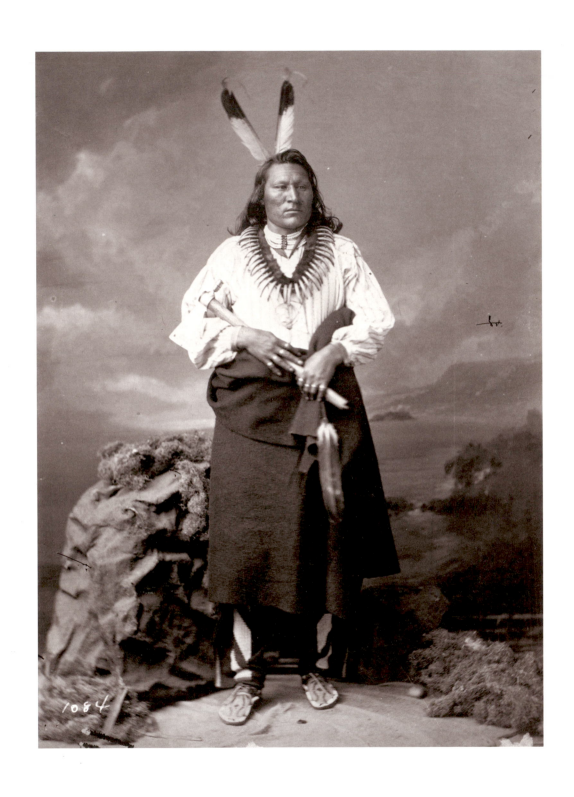

92. William Henry Jackson (1843–1942), *"Ump-Pa-Tonga, or Big Elk, son of Lone Chief, also called Robert Primeau," a Ponca, November 14, 1879.* Albumen print. The Princeton Collections of Western Americana, Gift of Sheldon Jackson

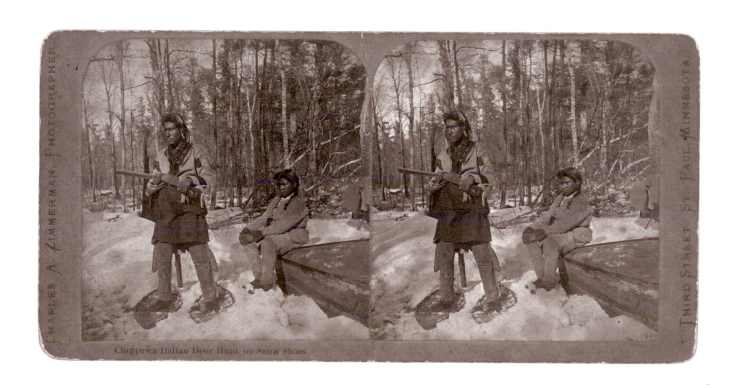

93. Charles A. Zimmerman (1844–1909), *"Chippewa Indian Deer Hunt, on Snow Shoes."* Albumen stereograph. Collection of Lori and Victor Germack

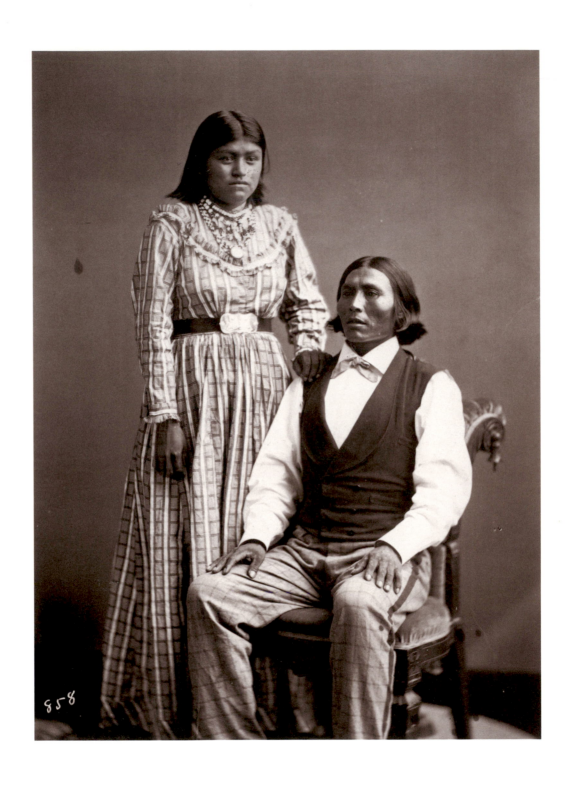

94. *Eskinilay and wife, Apaches.* Albumen print. The Princeton Collections of Western Americana, Gift of Sheldon Jackson

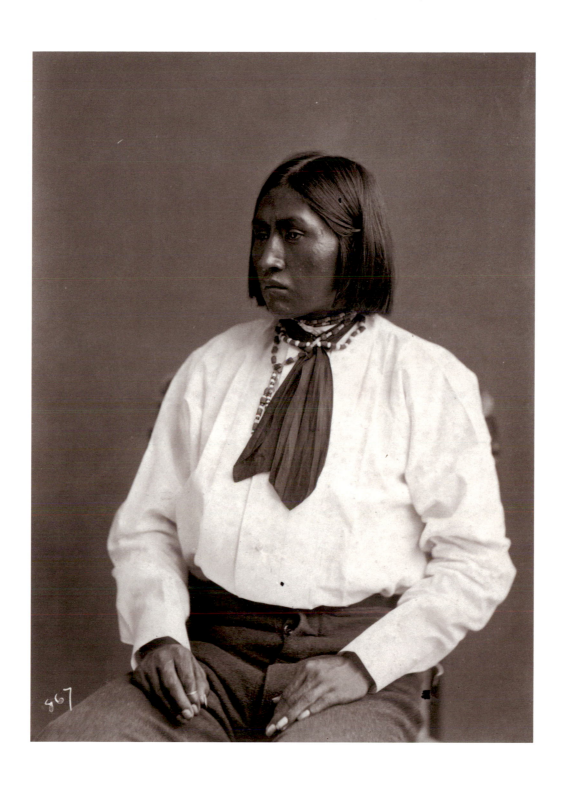

95. *Napashgingush, Apache*. Albumen print. The Princeton Collections of Western Americana, Gift of Sheldon Jackson

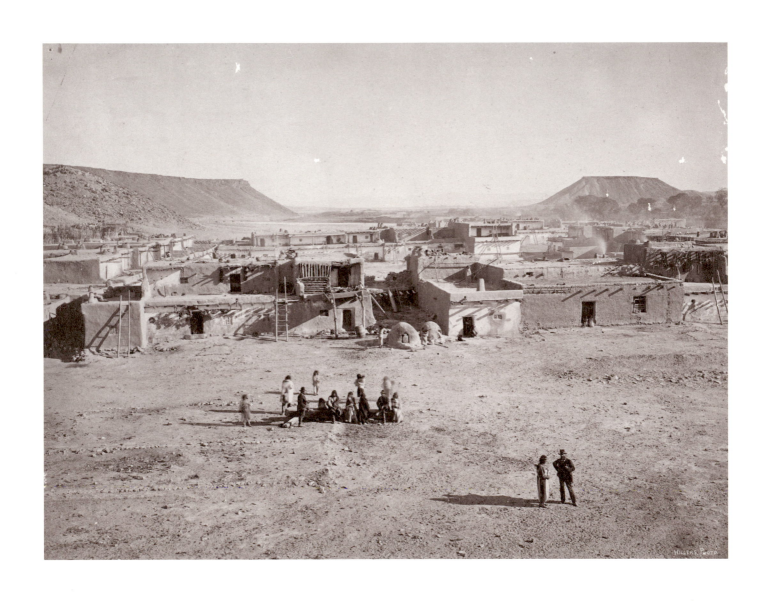

96. John K. Hillers (1843–1925), *A view of San Felipe Pueblo, New Mexico, 1880.* Albumen print. The Princeton Collections of Western Americana, Gift of Thomas Baird

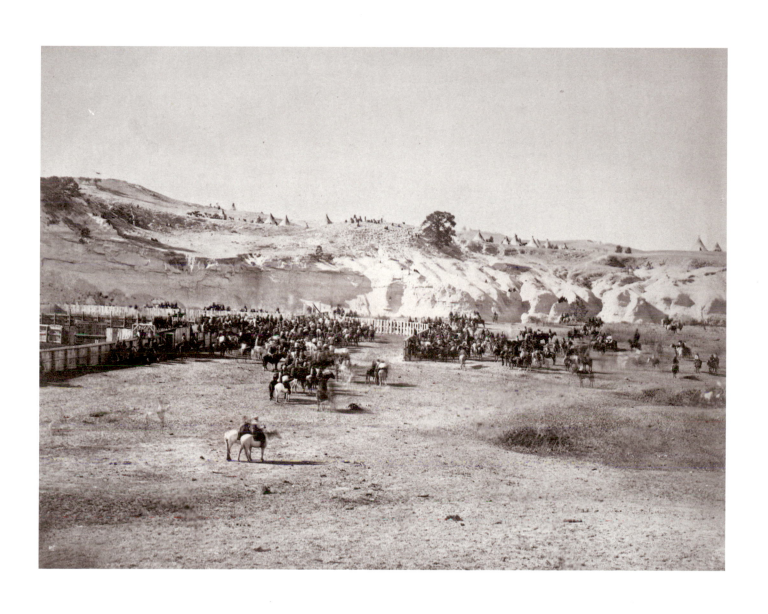

97. "Howard Photo," *"Beef issue at Spotted Tail's Agency, Neb."* Albumen print, 21.2 × 28 cm. The Princeton Collections of Western Americana, Gift of Thomas Baird

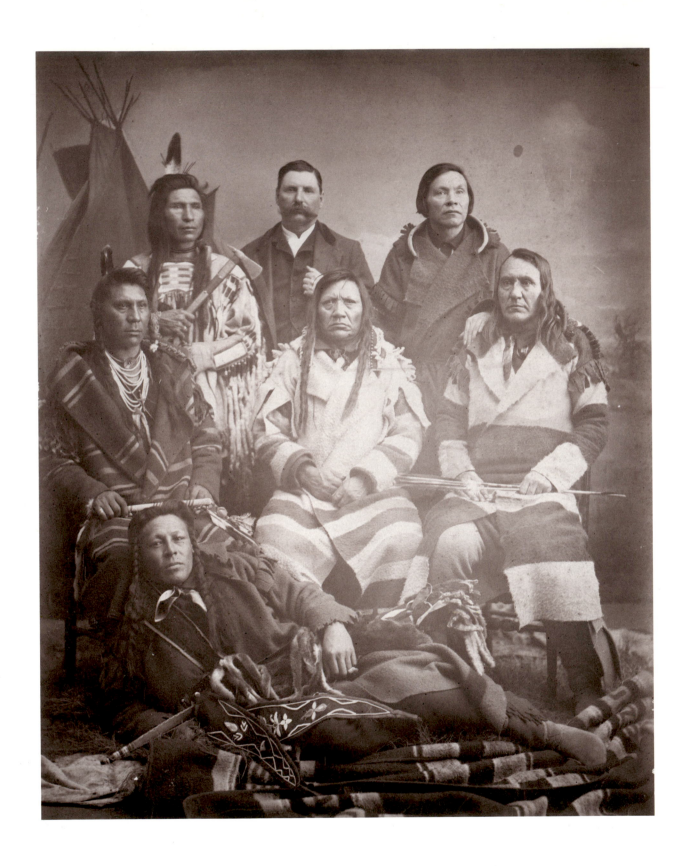

98. John K. Hillers (1843–1925), *A Flathead delegation to Washington, 1884.* Standing from left: Tah-hetchet or Hand Shot Off, Peter Ronan, U.S. Indian Agent, Tcinkusui Chin-coos-we or The Man Who Walks Alone. Seated from left: Gallup-squall-shee or Crane with Ring Around His Neck, Slem-hih-kay or Chief Little Claw of Grizzly Bear, and Kut-some or Grizzly Bear Far Away. Reclining in the foreground: Swam-ach-ham or Red Arm, a warrior. Albumen print, 40.6 × 33 cm. The Princeton Collections of Western Americana, Gift of Thomas Baird

Transformation

A telling American Indian subject that has fascinated photographers since the late nineteenth century is that of transformation—the change in Indian life brought about by European contact. Images that aspired to capture this process were most often produced by assimilationists, who meant to convince viewers by simple before-and-after images of the benefits of adapting to the dominant European culture. From our perspective on these sequences of photographs, it is difficult to share an original confidence that the Navajo Tom Torlino was improved by his transformation at the Carlisle Indian School—that "after" was really better than "before."

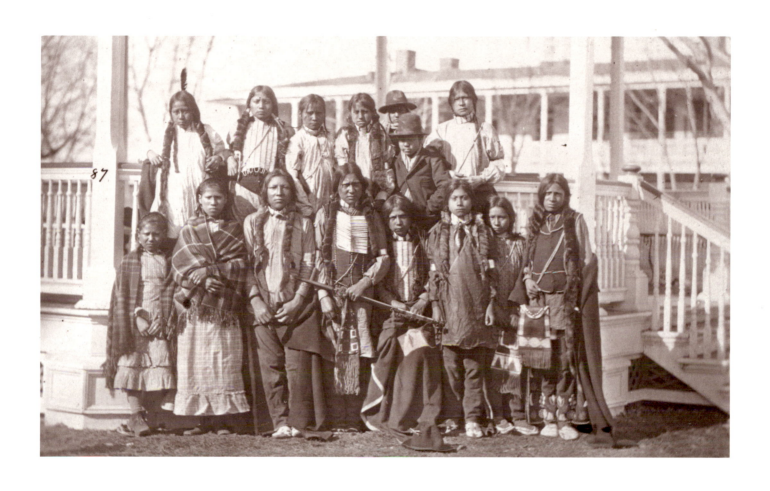

99. John N. Choate (1848–1902), *Two Shoshone and thirteen Arapahoe children on arrival at the Indian Training School, Carlisle,*
Pennsylvania, about 1880. Albumen print. The Princeton Collections of Western Americana, Gift of Sheldon Jackson

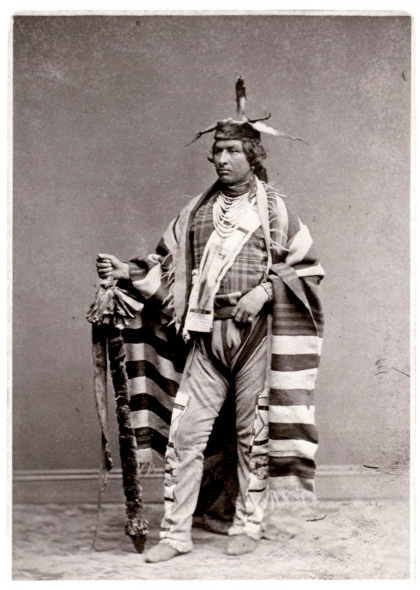

DONALD McKAY,
CHIEF OF THE WARM SPRING INDIANS.
HOUSEWORTH, PHOTO, 12 MONTGOMERY ST., SAN FRANCISCO.

100. Thomas Houseworth (1828–1915), *Donald McKay, Chief of the Warm Springs Indians in traditional dress.* Albumen print. The New York Public Library

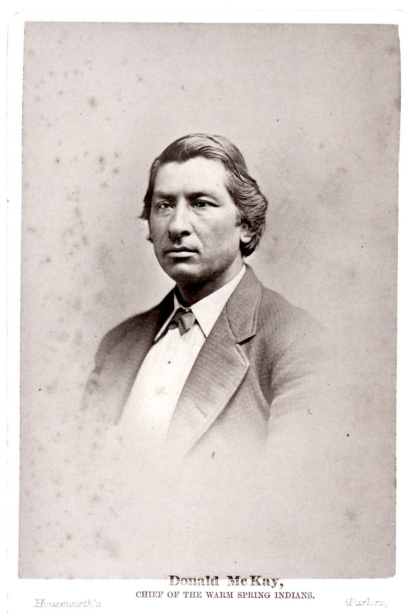

Donald McKay,
CHIEF OF THE WARM SPRING INDIANS.

Houseworth's　　　*Parlors,*

No. 12 Montgomery Street, opposite the Lick House, San Francisco.

101. Thomas Houseworth (1828–1915), *Donald McKay, Chief of the Warm Springs Indians.* Albumen print. The New York Public Library

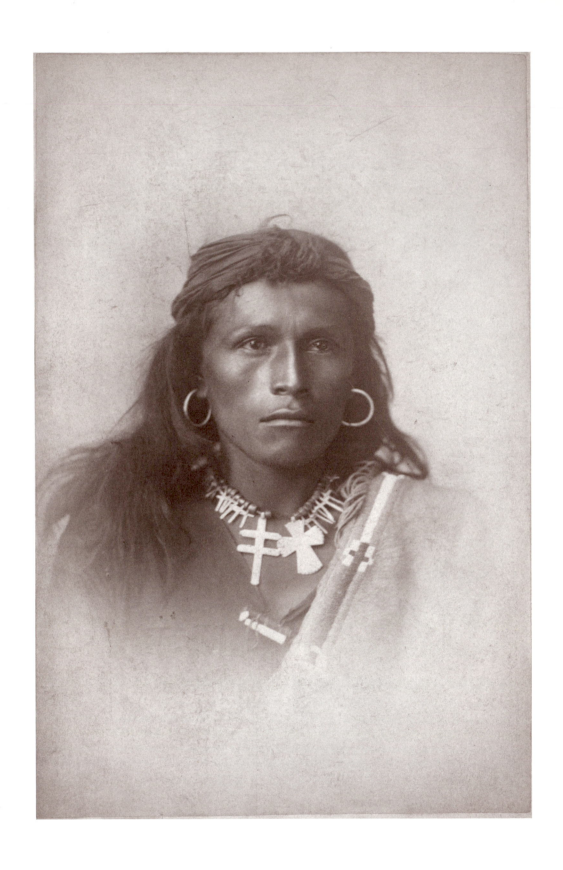

102. John N. Choate (1848–1902), *Tom Torlino, Navajo from Arizona, on arrival at the Indian Training School, Carlisle, Pennsylvania, 1885.* Albumen print, 21.6 × 13.3 cm. The Princeton Collections of Western Americana

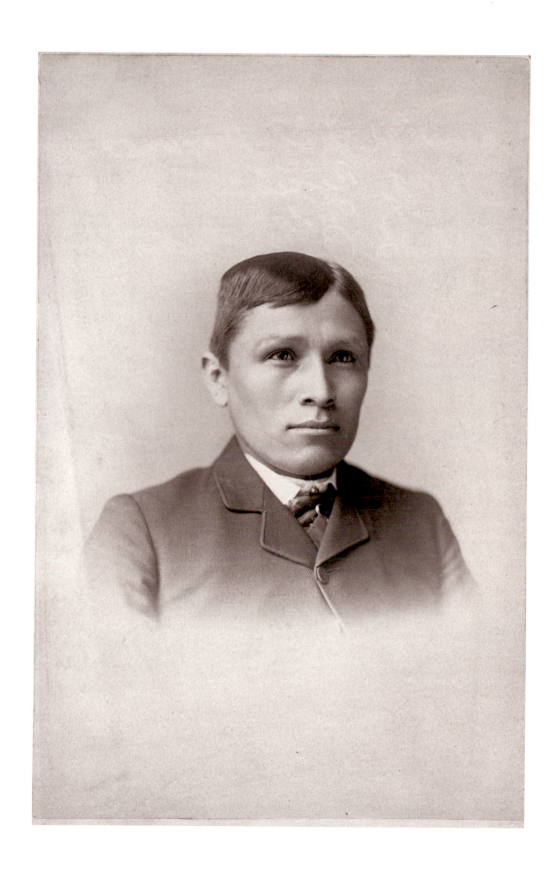

103. John N. Choate (1848–1902), *Tom Torlino, Navajo, after transformation at Carlisle, October 1885.* Albumen print. The Princeton Collections of Western Americana

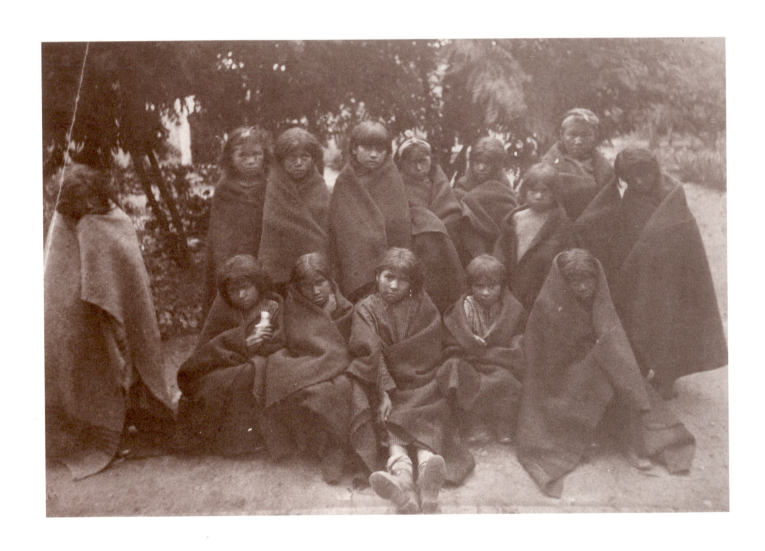

104. A. P. Neilsen (active 1886), *Transformation: Recruits for school on arrival at government school, Santa Fe, New Mexico.*
Albumen print. Collection of Lori and Victor Germack

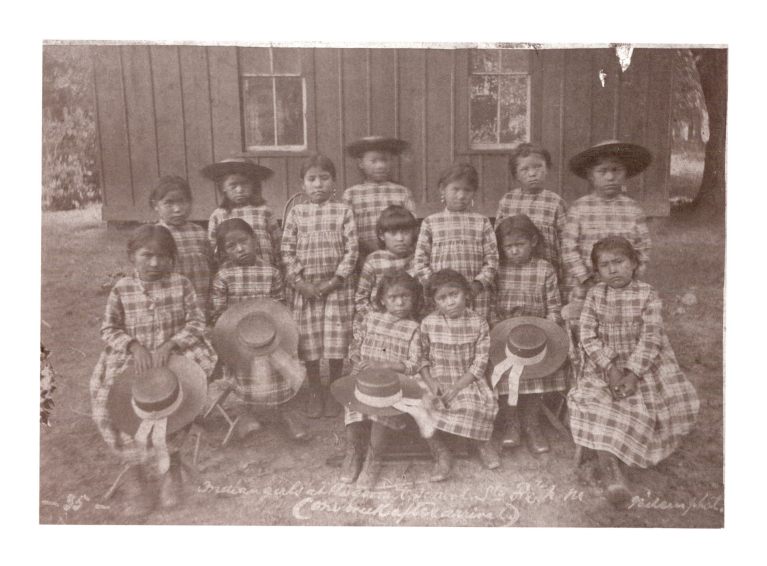

105. A. P. Neilsen (active 1886), *"Indian girls at the govemt School Sta. Fe (One week after arrival)."* Albumen print. Collection of Lori and Victor Germack

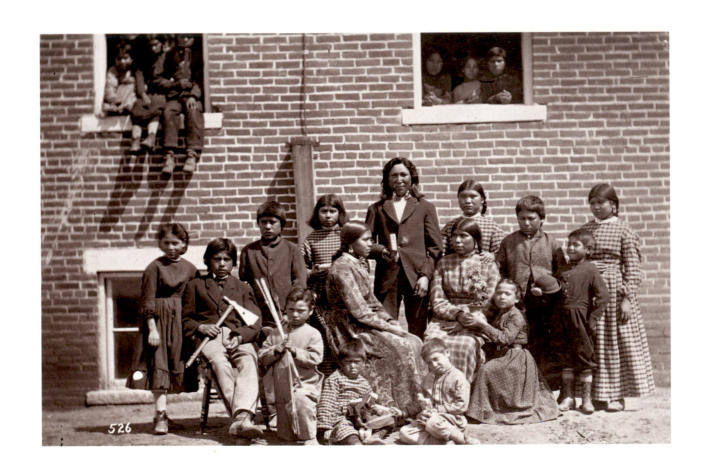

106. *Pawnee school children*. Albumen print. The Princeton Collections of Western Americana, Gift of Sheldon Jackson

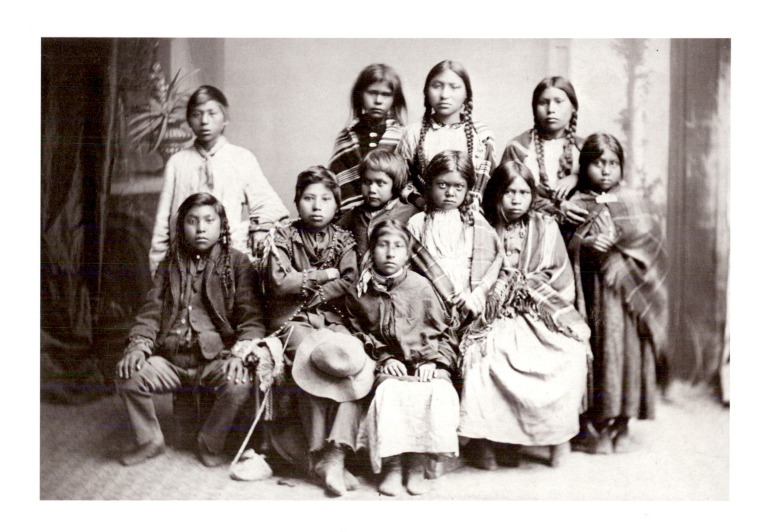

107. Isaac G. Davidson (born 1845), *"New Recruits—(Spokane's)."* Albumen print. The New York Public Library

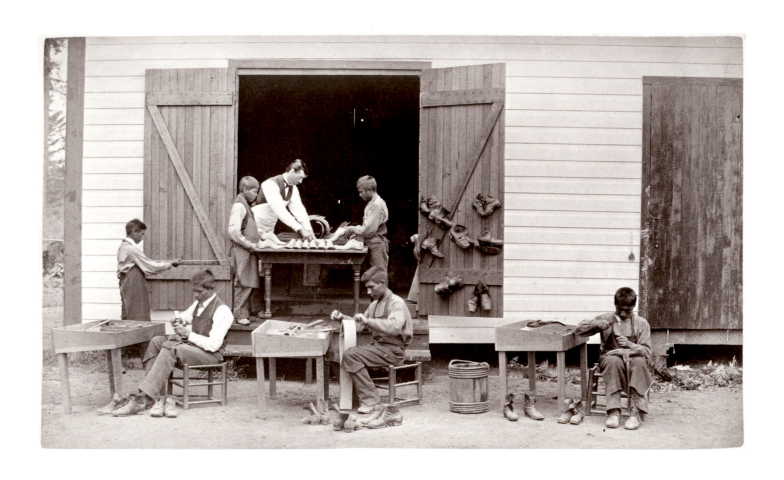

108. Isaac G. Davidson (born 1845), *Training to be cobblers in Oregon.* Albumen print. The New York Public Library

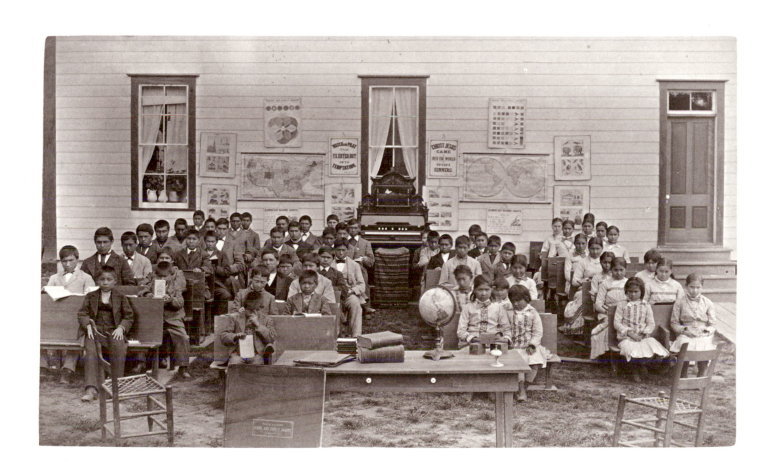

109. Isaac G. Davidson (born 1845), *Indians transformed into Christian students*. Albumen print. The New York Public Library

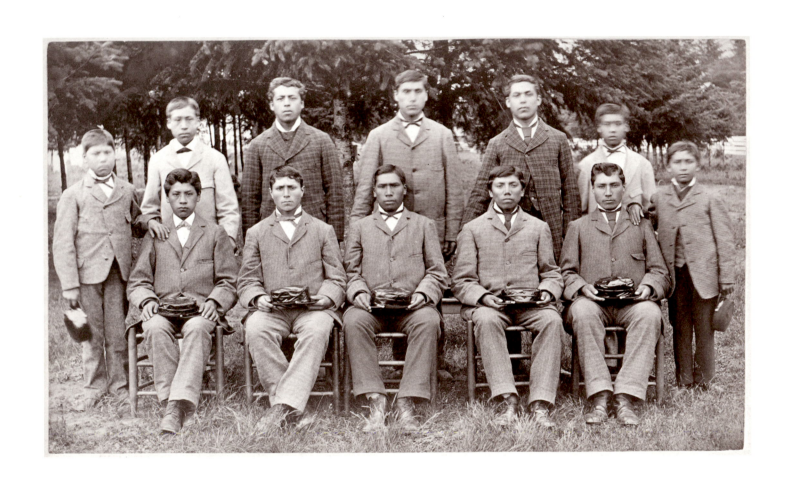

110. Isaac G. Davidson (born 1845), *Transformed Indian students in Oregon*. Albumen print. The New York Public Library

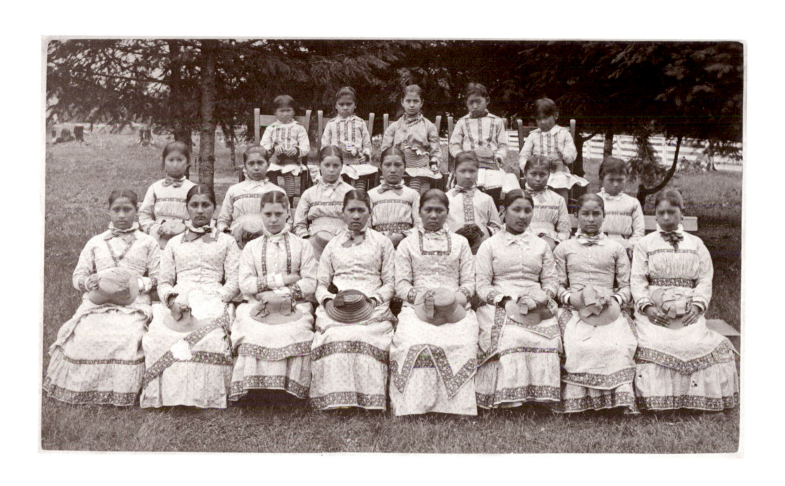

111. Isaac G. Davidson (born 1845), *Transformed Indian students*. Albumen print. The New York Public Library

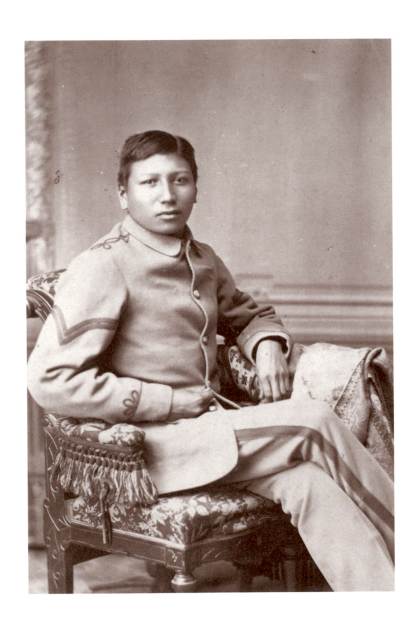

112. John N. Choate (1848–1902). *Ernest, son of White Thunder, at the Indian Training School, Carlisle, Pennsylvania.* Albumen print. The Princeton Collections of Western Americana, Gift of Sheldon Jackson

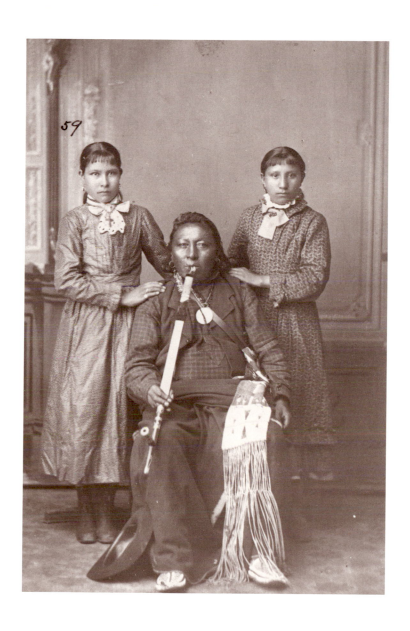

113. John N. Choate (1848–1902), *Red Dog and daughters, Sioux, at the Indian Training School, Carlisle, Pennsylvania.* Albumen print. The Princeton Collections of Western Americana, Gift of Sheldon Jackson

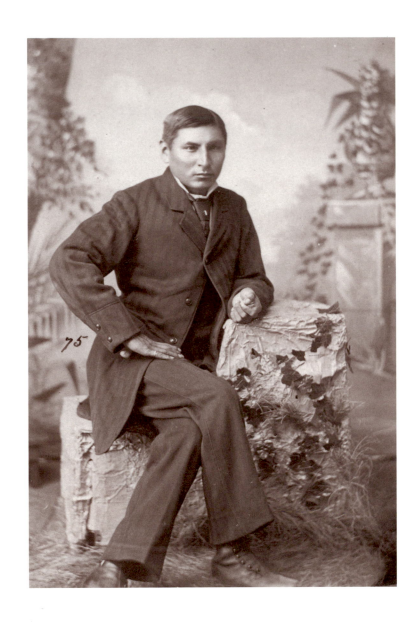

114. *Walter Matches, Cheyenne.* Albumen print. The Princeton Collections of Western Americana, Gift of Sheldon Jackson

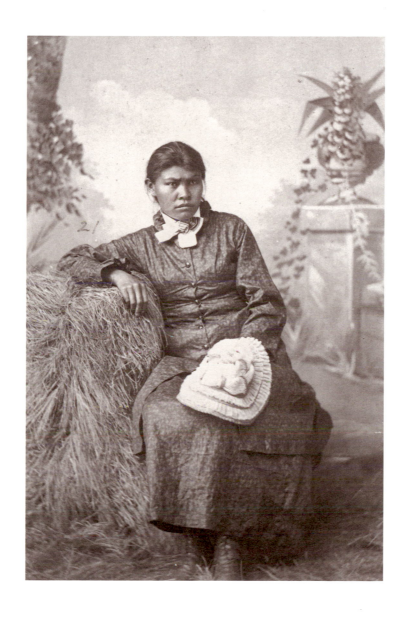

115. *Nellie Cary, an Apache.* Albumen print. The Princeton Collections of Western Americana, Gift of Sheldon Jackson

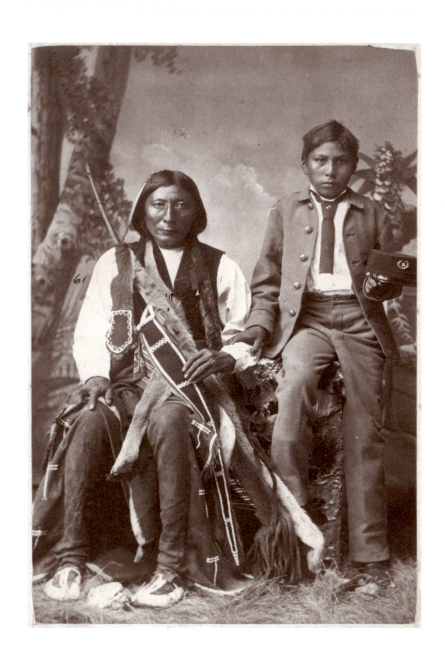

116. *Big Horse and his son Hubbel, Cheyenne.* Albumen print. The Princeton Collections of Western Americana, Gift of Sheldon Jackson

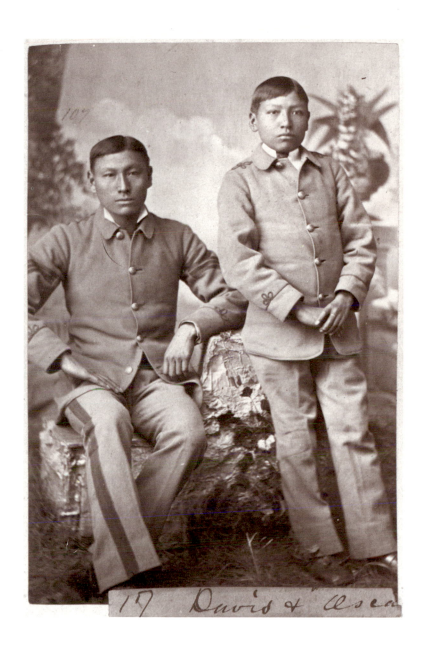

117. John N. Choate (1848–1902), *Davis and Oscar Stedman, Creeks, at Carlisle.* Albumen print. The Princeton Collections of Western Americana, Gift of Sheldon Jackson

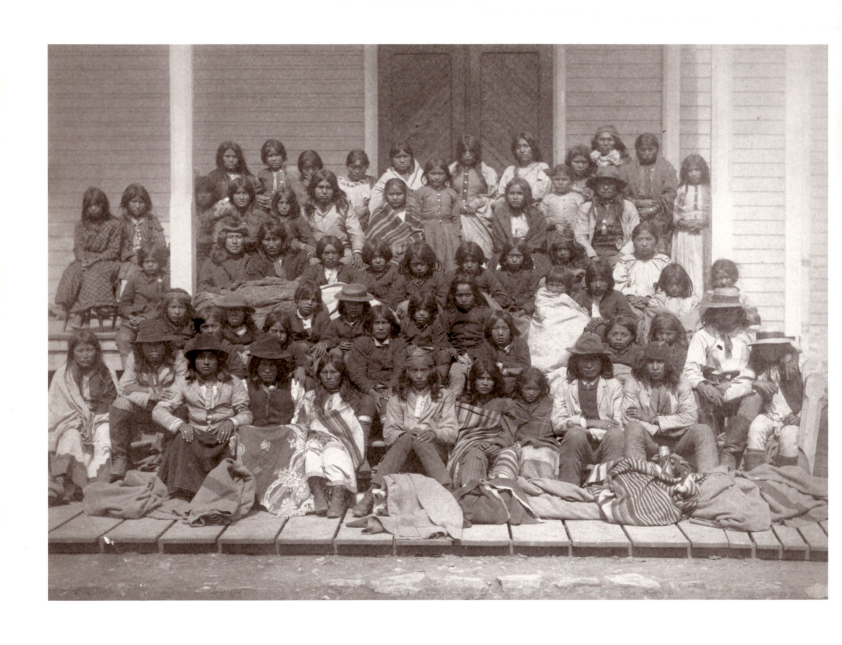

118. John N. Choate (1848–1902), *"Fort Marion Fla. Apaches as they arrived at Carlisle, May lst, 1885."* Albumen print, 20.5 × 25.4 cm. The Princeton Collections of Western Americana, Gift of Sheldon Jackson

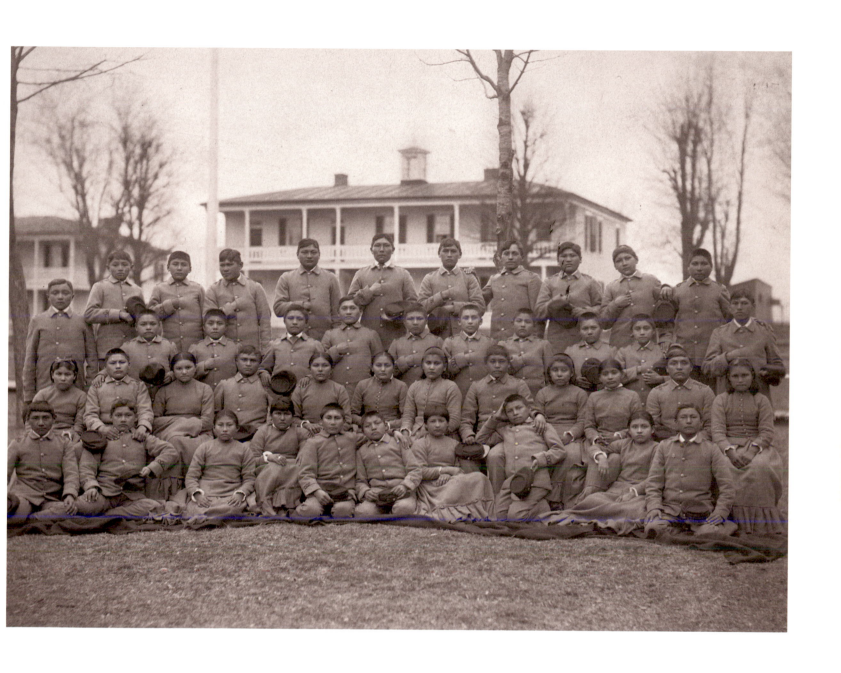

119. John N. Choate (1848–1902), *"Chiricahua Apaches Four Months After Arriving at Carlisle."* Albumen print, 20.4 × 25.5 cm. The Princeton Collections of Western Americana, Gift of Sheldon Jackson

120. John N. Choate (1848–1902), *"Last Delegation of Pueblos" to the Indian Training School, Carlisle, Pennsylvania.* Albumen print. The Princeton Collections of Western Americana, Gift of Sheldon Jackson

121. John N. Choate (1848–1902), *Miss Mather and a group of Menominees at the Indian Training School, Carlisle, Pennsylvania, 1880s.* Albumen print. Collection of Lori and Victor Germack

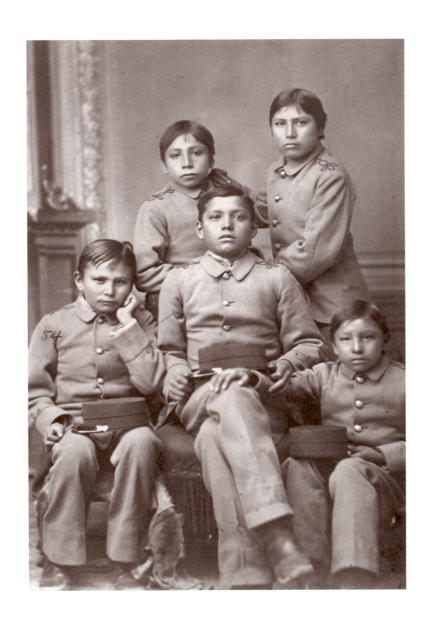

122. John N. Choate (1848–1902), *Students at the Indian Training School, Carlisle, Pennsylvania, 1881: Reuben Quick Bear (Rosebud Sioux), Bernard Ring Thunder (Rosebud Sioux), John Renville (Sisseton Sioux), Horace Coarse Voice (Rosebud Sioux) and Rufus Black Crow (Rosebud Sioux).*, Albumen print. The Princeton Collections of Western Americana, Gift of Sheldon Jackson

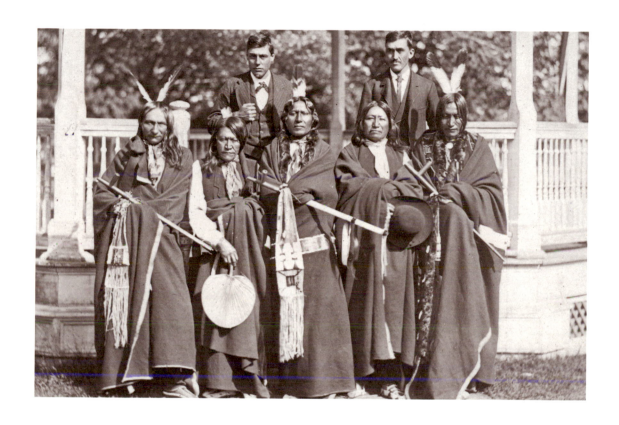

123. John N. Choate (1848–1902), *Black Crow, Two Strike, White Thunder, Spotted Tail, Iron Wing, Sioux chiefs from Rosebud Agency and their interpreters at Carlisle, Pennsylvania.* Albumen print. The Princeton Collections of Western Americana, Gift of Sheldon Jackson

124. John N. Choate (1848–1902), *Cook, a Sioux brave, and his daughter, Grace.* Albumen print. The Princeton Collections of Western Americana, Gift of Sheldon Jackson

The New Technology

By the 1880s, the technology for making photographs had advanced in ways that made both subject and cameraman more versatile. Gone were long exposures that necessitated fixed studio poses; the camera itself was not only more portable but also less expensive, which brought further freedoms. While it was the exotic aspect of American Indians that appealed to purchasers of photographs (motivating the photographer to dress subjects in a previous generation's regalia), the progressive thought of the time depended on evidence of the success of assimilation (creating a demand for the opposing subject matter: the Indian dressed as respectable Victorian neighbor).

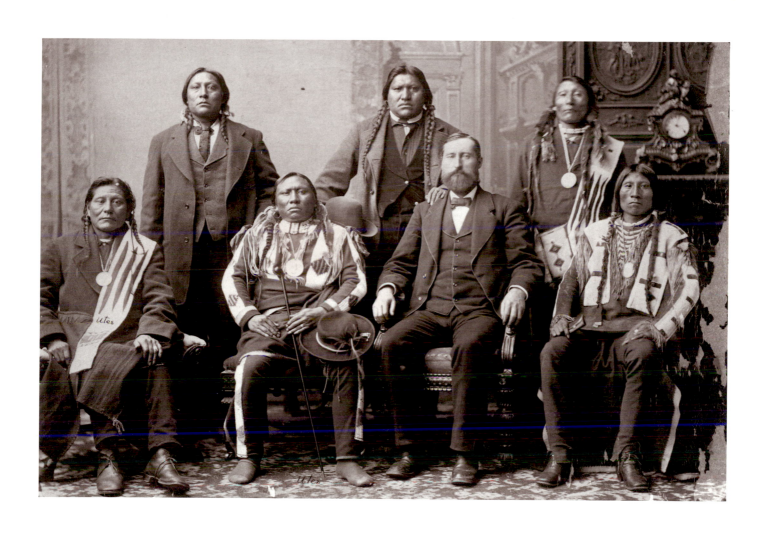

125. *Ute Delegation.* Albumen print, 26.8 × 40 cm. The Princeton Collections of Western Americana, Gift of Sheldon Jackson

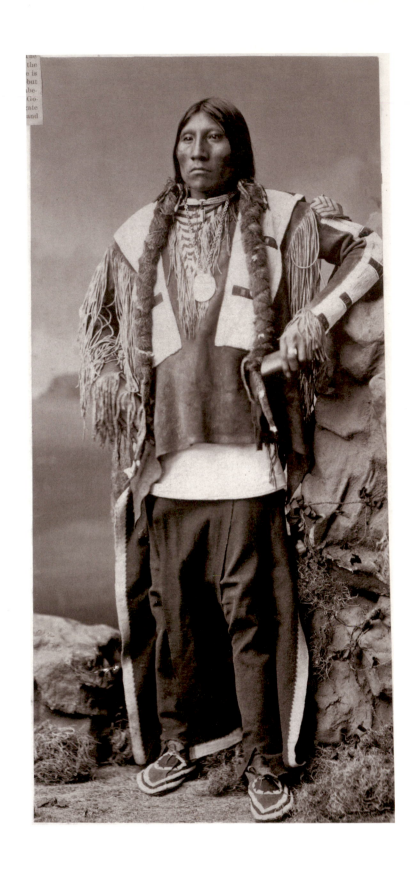

126. *A Ute man*. Albumen print, 17.2 × 35.7 cm. The Princeton Collections of Western Americana, Gift of Sheldon Jackson

116

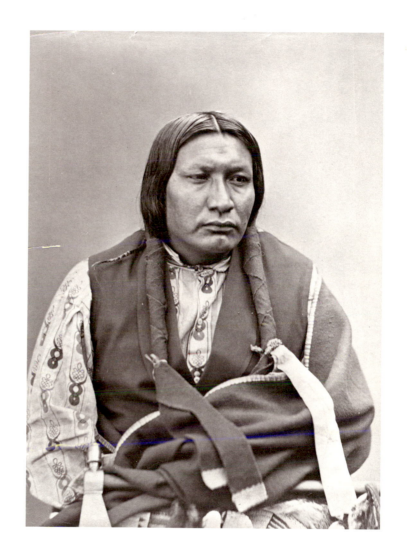

127. *Two Indians on a Pueblo roof.* Silver print. The Princeton Collections of Western Americana

128. *Indian man in wrapped braids.* Albumen print. The Princeton Collections of Western Americana

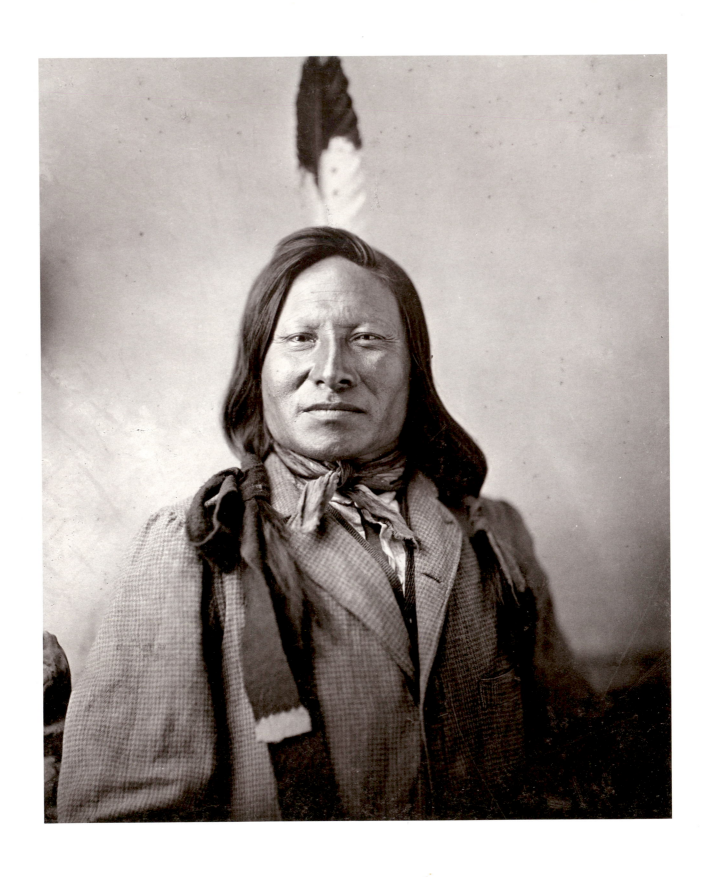

129. David F. Barry (1854–1934), *Iromagaja, or Rain-in-the-Face, about 1889.* Albumen print. The New York Public Library

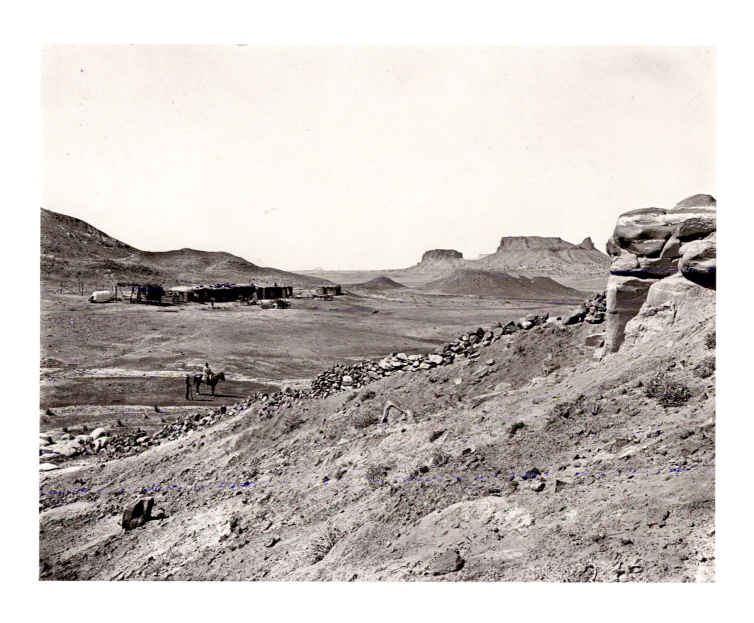

130. Ben Wittick (1845–1903), *"A Ranche on the Arizona desert," with Navajo.* Albumen print. Collection of Lori and Victor Germack

131

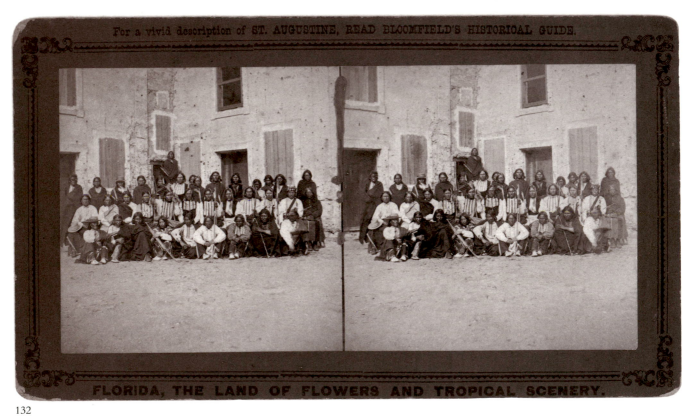

132

131. Charles R. Savage (1832–1909), *Paiute Chief.* Albumen print. Collection of Lori and Victor Germack

132. *"A Picture of ten Indian Cut Throats and Scalpers, who were confined in the Old Spanish Fort as prisoners of war by the United States Government."* Albumen stereograph. Collection of Lori and Victor Germack

133. *Young man with braids*. Albumen sterograph. Collection of Lori and Victor Germack

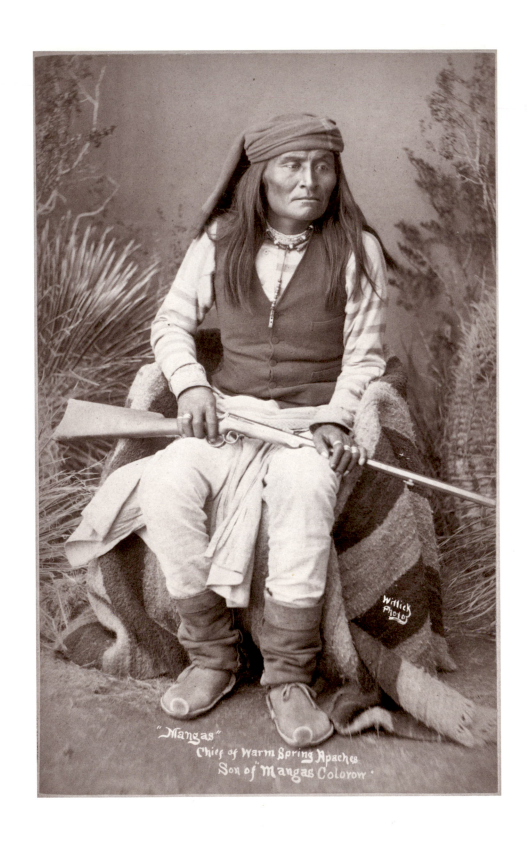

134. Ben Wittick (1845–1903), *Mangus, Chief of the Warm Springs Apaches, Son of Mangus Colorow*. Albumen print. Collection of Lori and Victor Germack

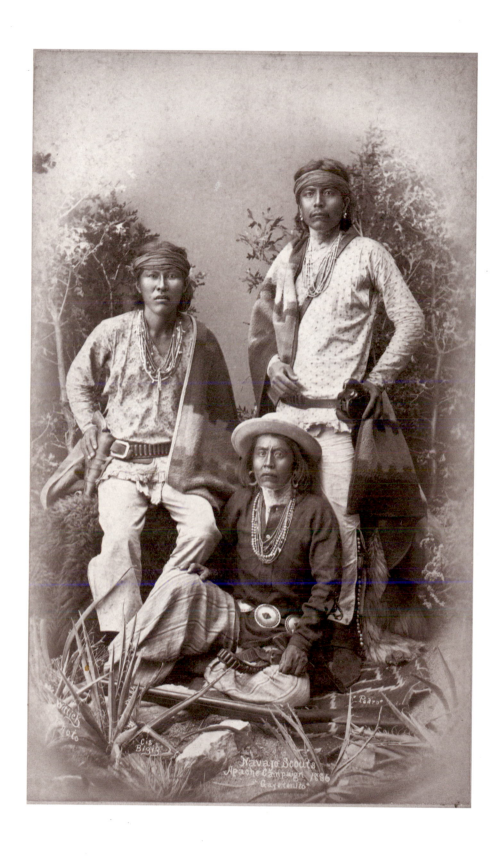

135. Ben Wittick (1845–1903), *Navajo Scouts, Apache Campaign, 1886: from left, Cis Bigig, Gayetanito and Pedro*. Albumen print. Collection of Lori and Victor Germack

136. Ben Wittick (1845–1903), *"Apache Indian Braves."* Peaches stands between two unidentified scouts. In 1883 Peaches deserted Chatto's band and served as General Crook's guide on the 1883 Apache campaign. He was the scout who led General Crook to the Chiricahua hideout in the Sierra Madre mountains. Albumen print, about 1885. Collection of Lori and Victor Germack

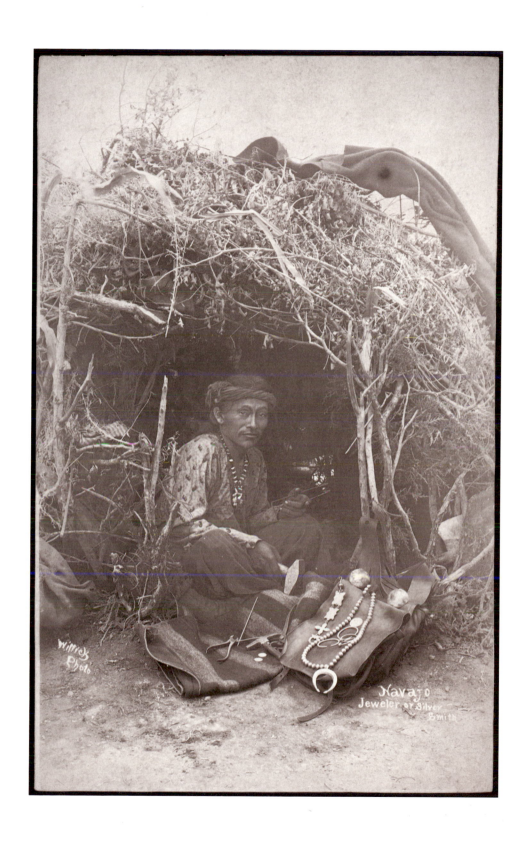

137. Ben Wittick (1845–1903), *"Navajo Jeweler or Silversmith," called Jake*. Albumen print, about 1886. Collection of Lori and Victor Germack

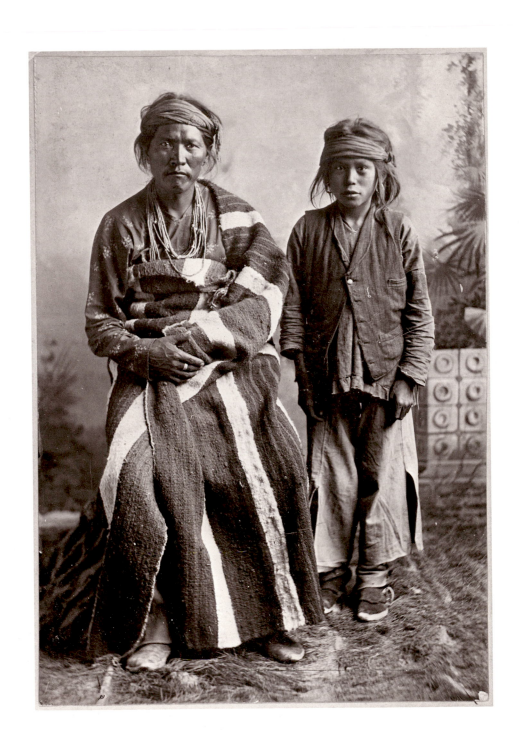

138. *Two Navajo*. Albumen print. Collection of Lori and Victor Germack

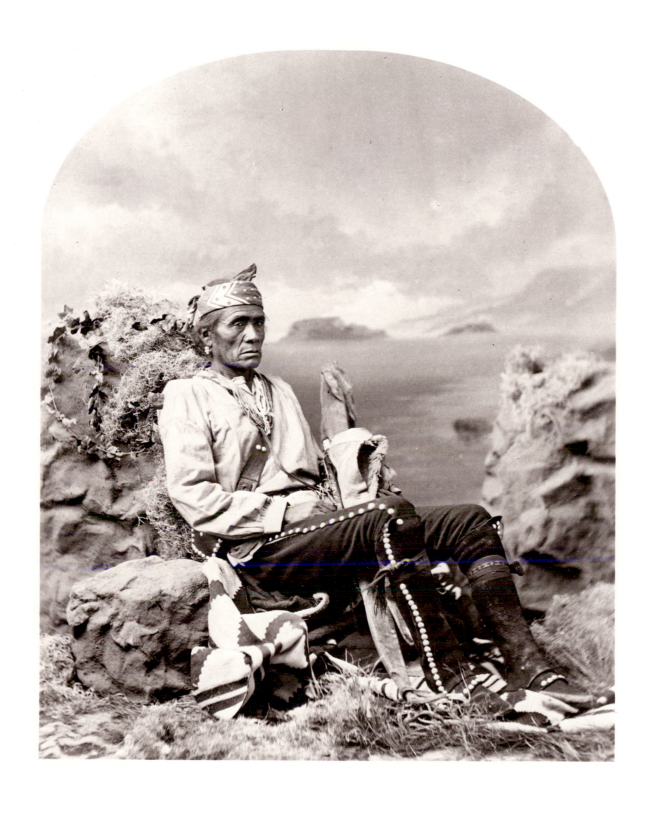

139. *Narbona Primero, Navajo*. Albumen print. The Princeton Collections of Western Americana, Gift of Sheldon Jackson

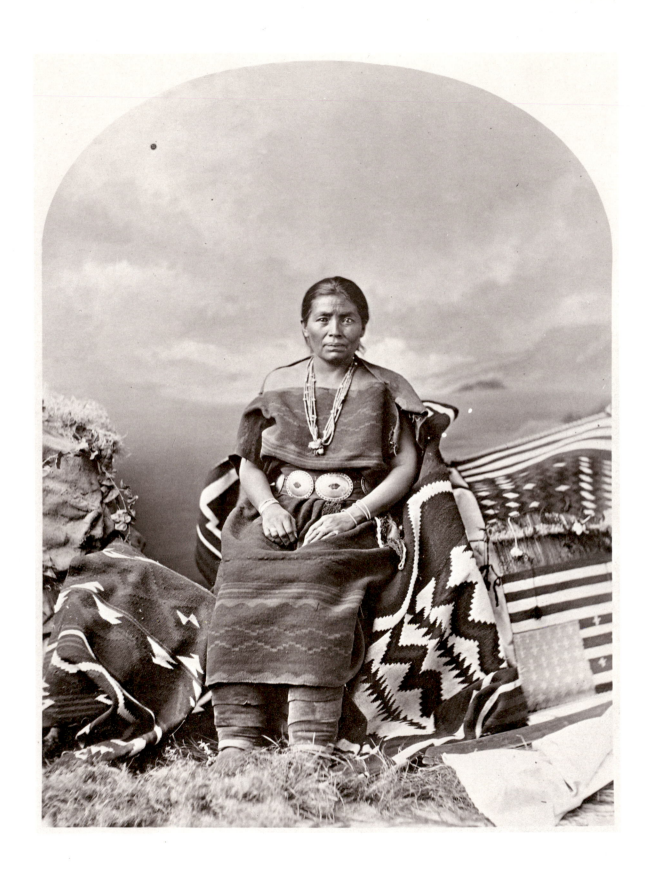

140. William Henry Jackson (1843–1942), *Juanita Bahad, Navajo*. Albumen print. The Peabody Museum of Natural History, Yale University

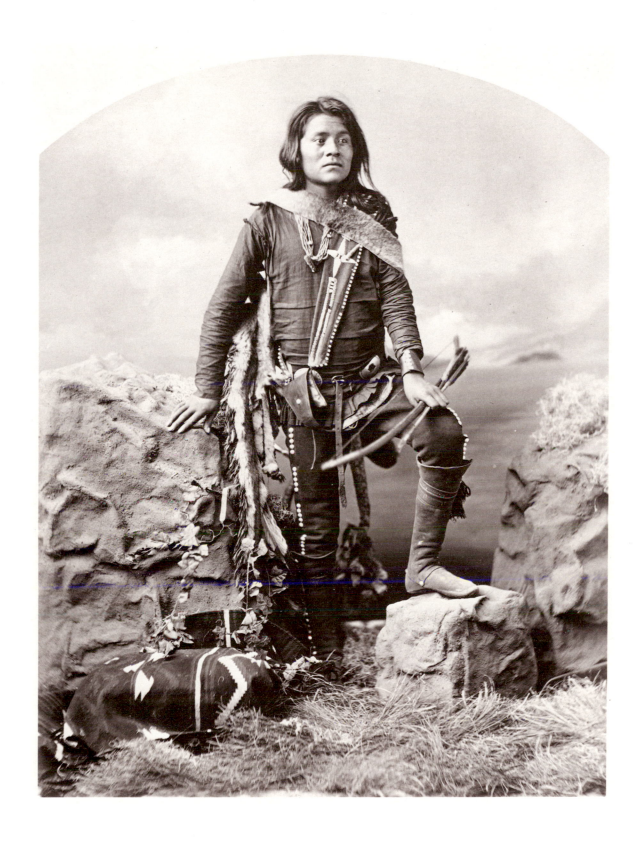

141. William Henry Jackson (1843–1942), *Ich-Han-Ng-Bas-Dan-Ny Begay, Navajo.* Albumen print. The Peabody Museum of Natural History, Yale University

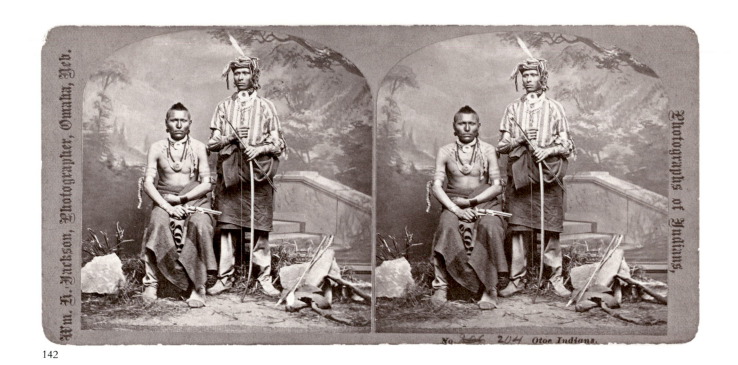

142

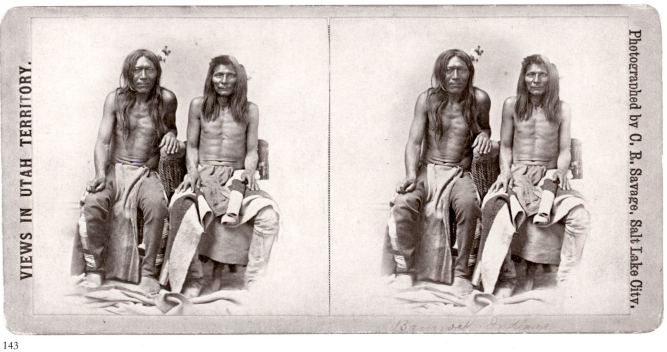

143

142. William Henry Jackson (1843–1942), *Otoe Indians.* Albumen stereograph. Collection of Lori and Victor Germack

143. Charles R. Savage (1832–1909), *Bannocks.* Albumen stereograph. Collection of Lori and Victor Germack

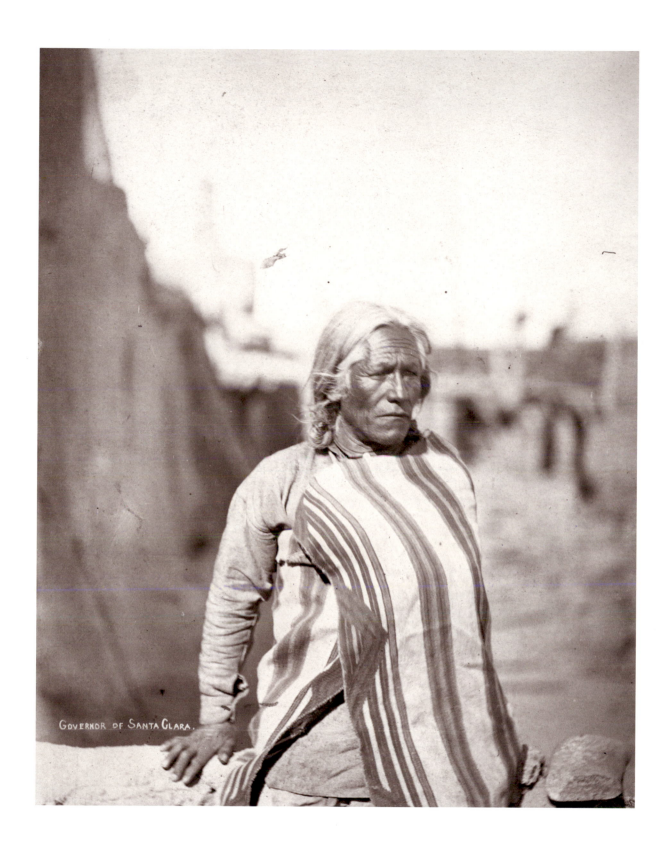

GOVERNOR OF SANTA CLARA.

144. John. K. Hillers (1843–1925), *The Governor of Santa Clara Pueblo, New Mexico.* This Tewa image was taken sometime before 1882. Albumen print. The Princeton Collections of Western Americana, Gift of Thomas Baird

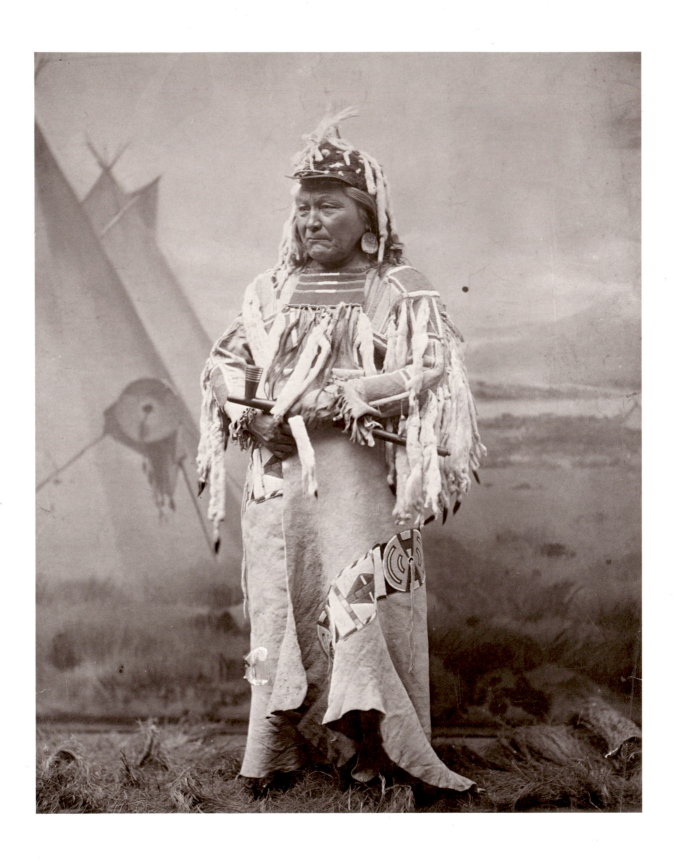

145. *Native with teepees*. Albumen print. The New York Public Library

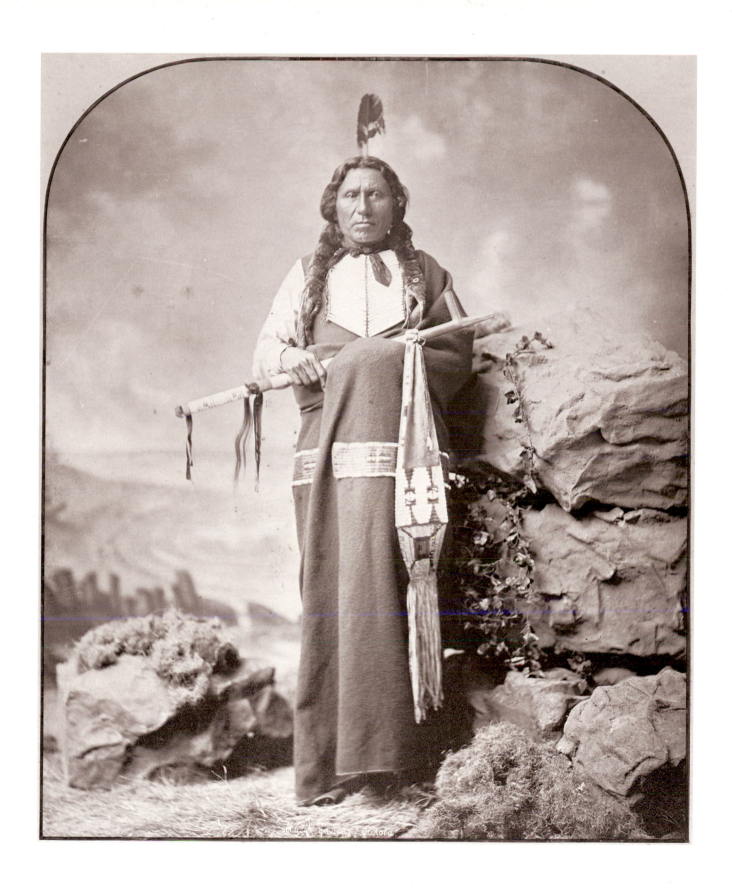

146. *Plains man with pipe*. Albumen print. Collection of Paul Katz

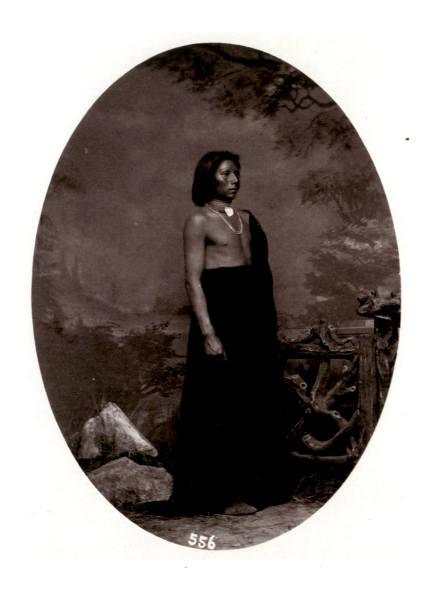

147. *Small Boy, a Pawnee.* Albumen print. The Princeton Collections of Western Americana, Gift of Sheldon Jackson

148. Walter S. Bowman (c. 1862–1938), *A teepee interior, probably Umatilla, with potlatch bundles*. Silver print. The Oregon Historical Society

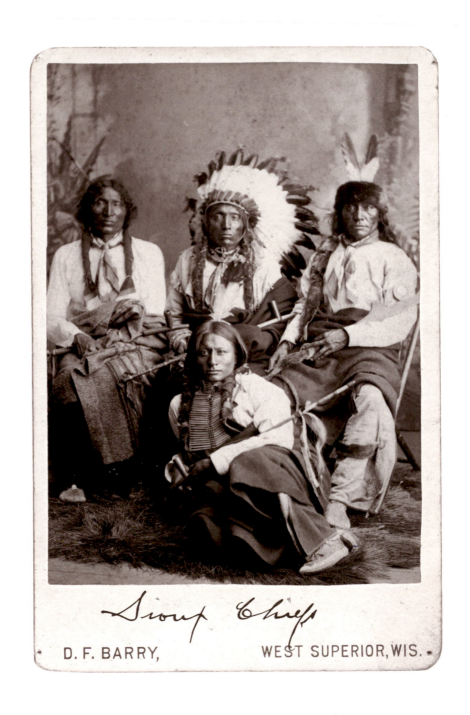

149. David F. Barry (1854–1934), *"Sioux Chiefs" - Slow White Buffalo, Crow Eagle, Iron Thunder and Fool Thunder, Dakota Sioux*. Albumen print, 1880s. Collection of Lori and Victor Germack

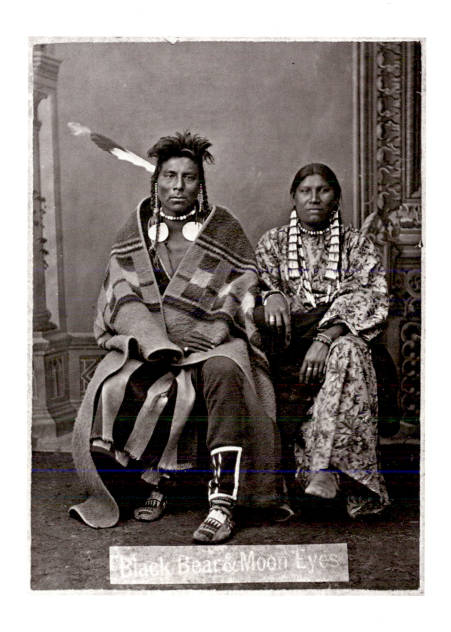

150. *Black Bear & Moon Eyes*. Albumen print. Collection of Lori and Victor Germack

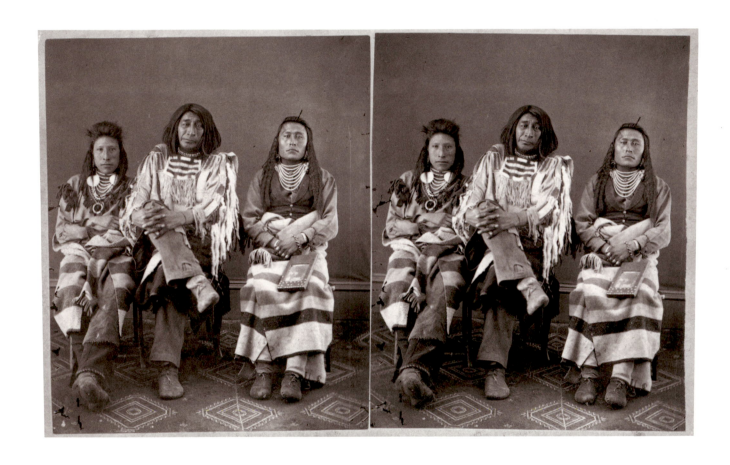

151. H. B. Calfee (active 1870s–1890s), *Men in Pendelton Blankets, early 1880s.* Part of a series titled "The Enchanted Land or Wonders of Yellowstone National Park." Albumen stereograph. Collection of Lori and Victor Germack

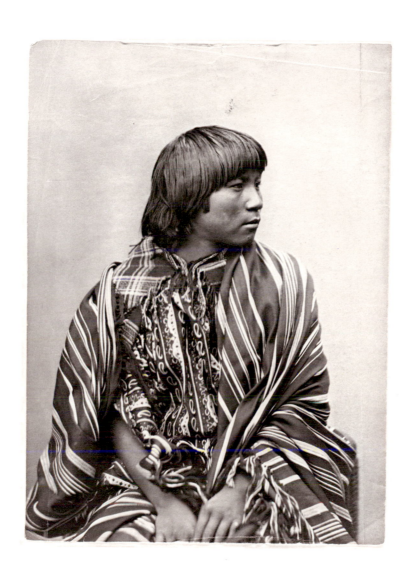

152. *Tamparethka, daughter of Gap In The Salt, Comanche.* Albumen print. The Princeton Collections of Western Americana,
Gift of Sheldon Jackson

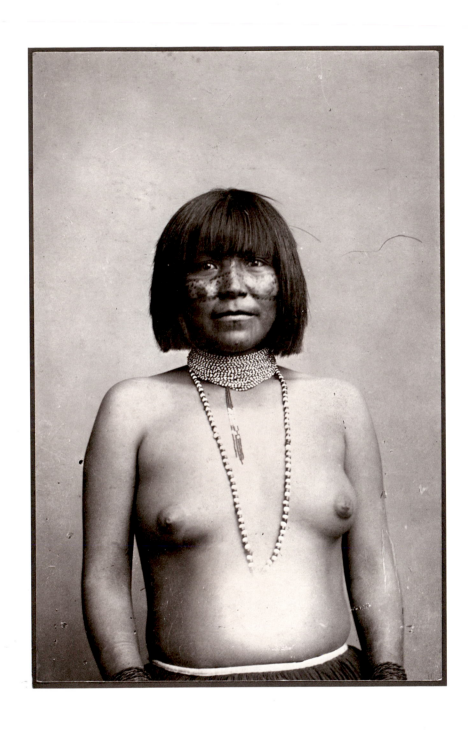

153. Baker & Johnson (active 1880s), *Apache woman with painted face*. Albumen print. The Peabody Museum of Natural History, Yale University

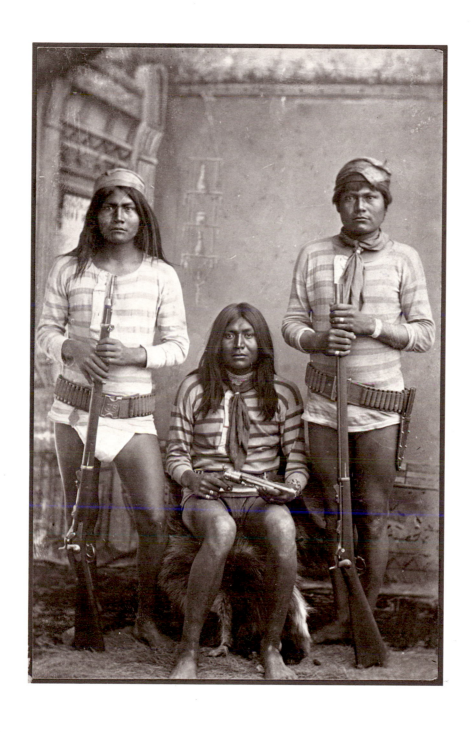

154. Baker & Johnson (active 1880s), *Yuma Apache scouts*. Albumen print. The Peabody Museum of Natural History, Yale University

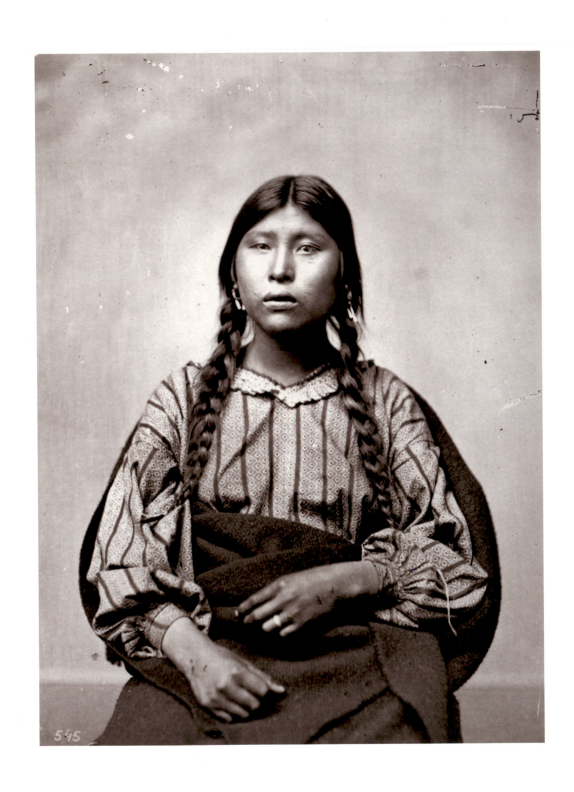

155. *Pawnee woman*. Albumen print. The Princeton Collections of Western Americana, Gift of Sheldon Jackson

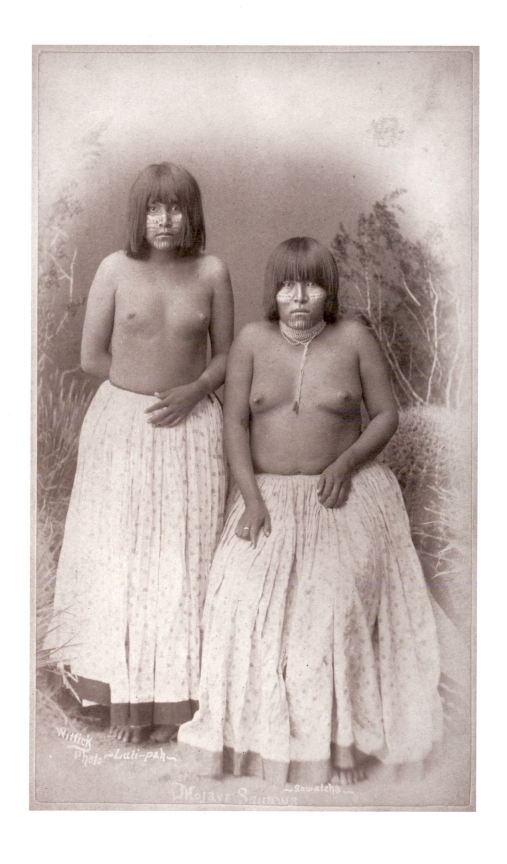

156. Ben Wittick (1845–1903), *Lulipah and Sawatcha, Mohave women.* Albumen prints, 1880s. Collection of Lori and Victor Germack

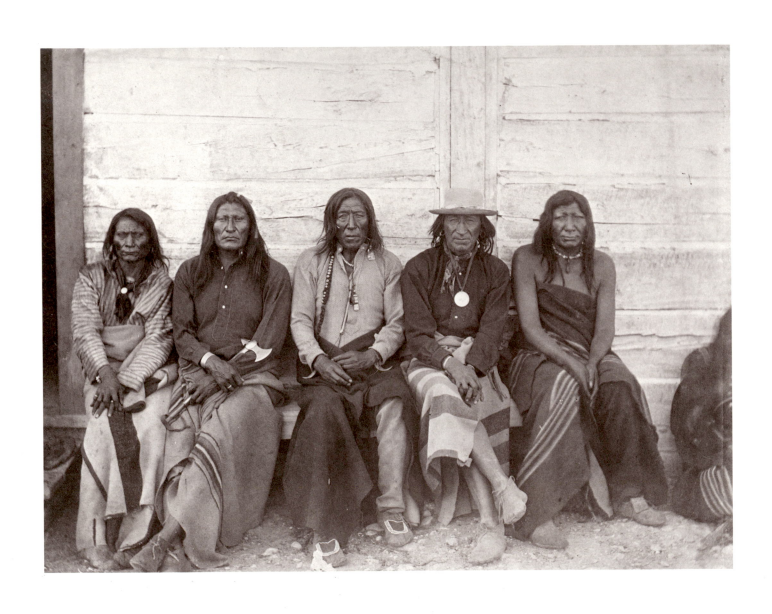

157. William Henry Jackson (1843–1942), *Crow leaders*. Albumen print. The Peabody Museum of Natural History, Yale University

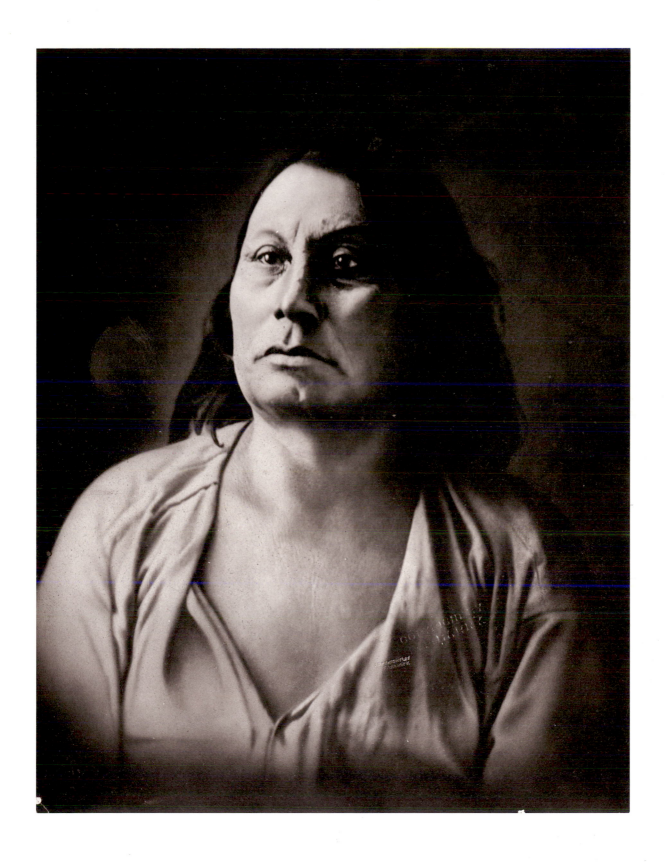

158. David F. Barry (1854–1934), *Pizi, called Gall (c.1840–1894), War Chief of the Hunkpapa Sioux, and principal warrior at the Battle of the Little Big Horn, 1876*. Bromide print, most probably taken at Fort Buford, 1881. Collection of Lori and Victor Germack

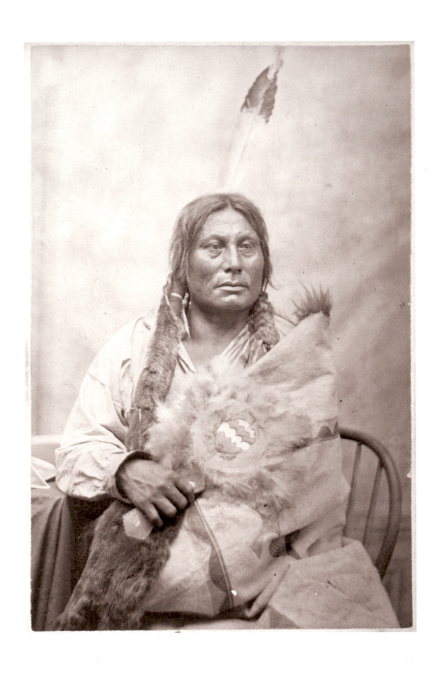

159. David F. Barry (1854–1934), *Gall*. Albumen print. Collection of Paul Katz

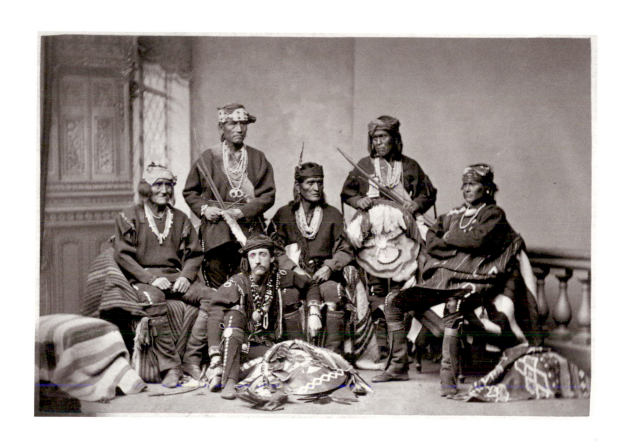

160. James Wallace Black (1825–1896), *Zuni leaders with Frank Cushing and a Hopi, Boston, 1882.* Left to right: Old Pedro Pino, or Laiiuaitsailu; Naiiutchi, a Bow Priest; Tenatsali, or Frank Cushing, also a Bow Priest (seated on floor); Palowahtiwa, Governor of Zuni Pueblo and the son of Laiiuaitsailu; Kiasi, another Bow Priest; and Nanake, a Hopi. Albumen print. Collection of Lori and Victor Germack

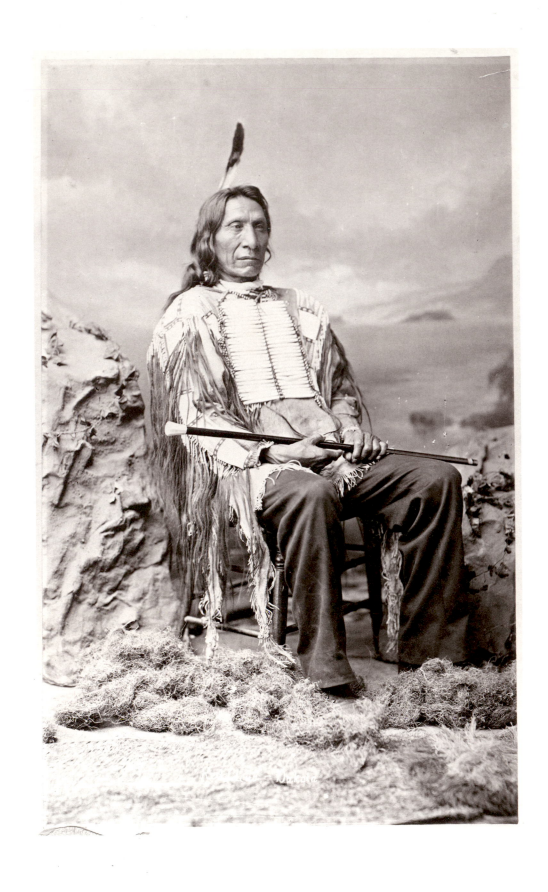

161. Charles M. Bell (1848–c.1893), *Red Cloud, Dakota Sioux, 1880.* Albumen print. The Peabody Museum of Natural History, Yale University

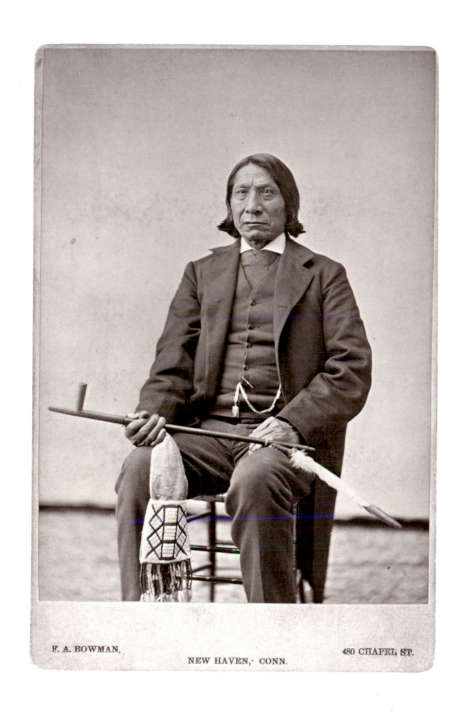

162. F. A. Bowman (active 1883), *Red Cloud, during his visit to Yale University, 1883*. Albumen cabinet portrait. The Peabody Museum of Natural History, Yale University

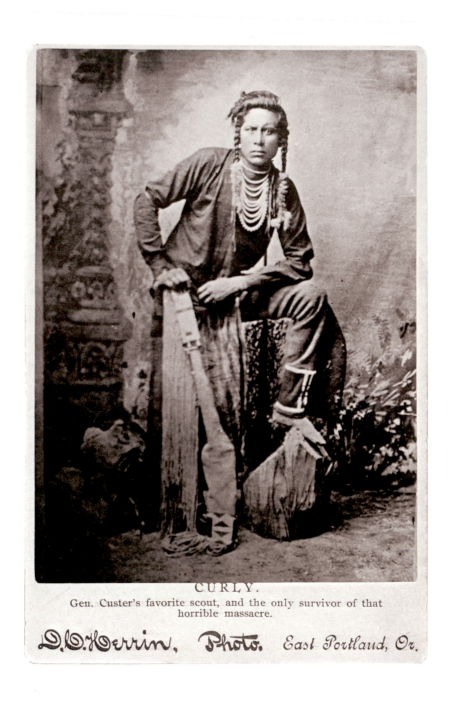

CURLY.
Gen. Custer's favorite scout, and the only survivor of that horrible massacre.

D.C. Herrin, Photo. East Portland, Or.

163. David C. Herrin (active 1895–1904), *"Curly. Gen Custer's favorite scout, and the only survivor of that horrible massacre."* Contrary to the photographer's caption, Curly was haunted not by his presence at the Battle of the Little Big Horn, but by his absence from it. Albumen print. The Oregon Historical Society

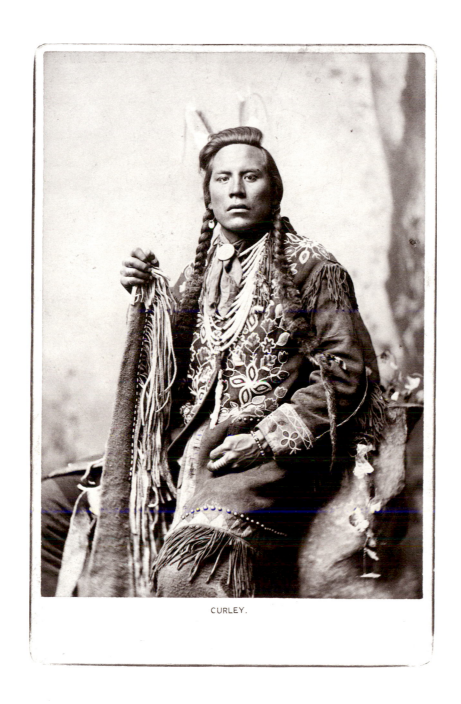

CURLEY.

164. Frank Jay Haynes (1835–1921), *Curly*. The inaccurate rumor of Curly's participation in the Battle of the Little Big Horn and his obvious photogenic presence made Curly one of the favorite Indian subjects of late nineteenth-century photographers. Albumen print. The Peabody Museum of Natural History, Yale University

165. Ben Wittick (1845–1903), *"Tzashima," Pueblo of Laguna, N.M.* Albumen print. Collection of Lori and Victor Germack

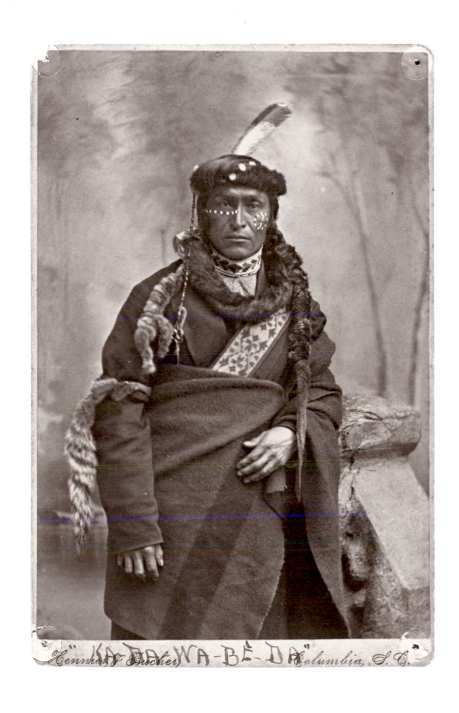

166. Henies & Bucher, Columbia, South Carolina. *"Ke-Da-Wa-Be-Da."* Albumen print. The Peabody Museum of Natural History, Yale University

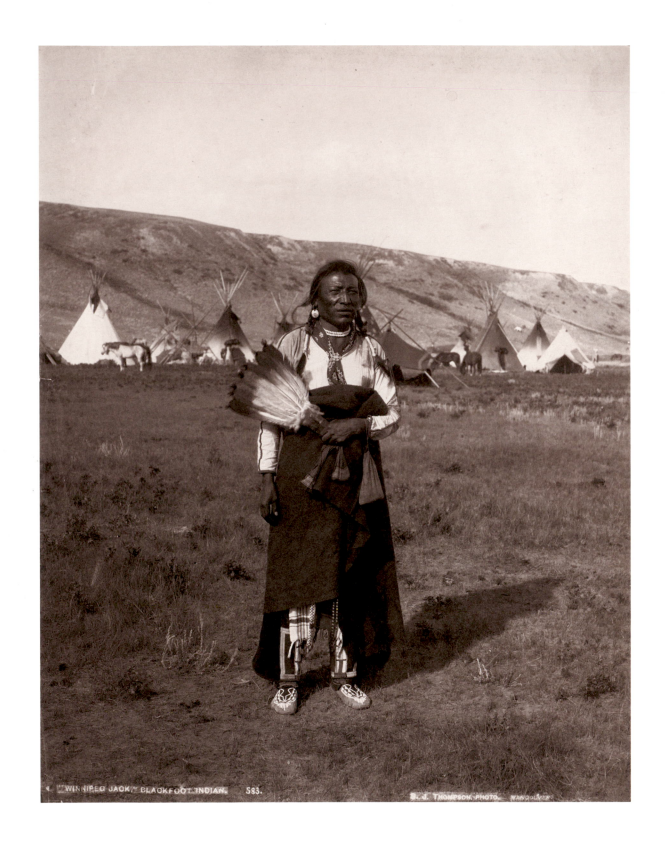

167. Stephen J. Thompson (1864–1929), *"Winnepeg Jack," Blackfoot Indian*. Silver print. The Princeton Collections of Western Americana, Gift of William G. MacKenzie

154

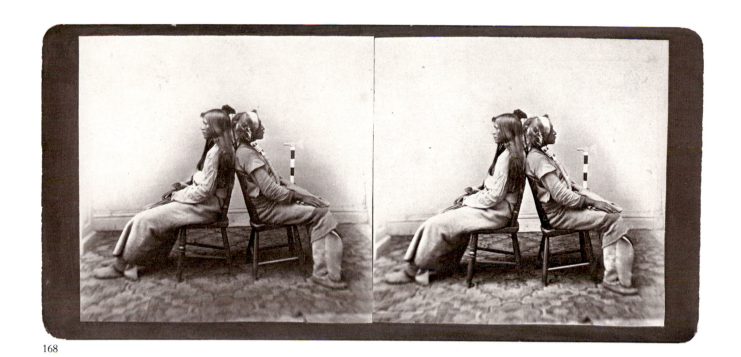

168

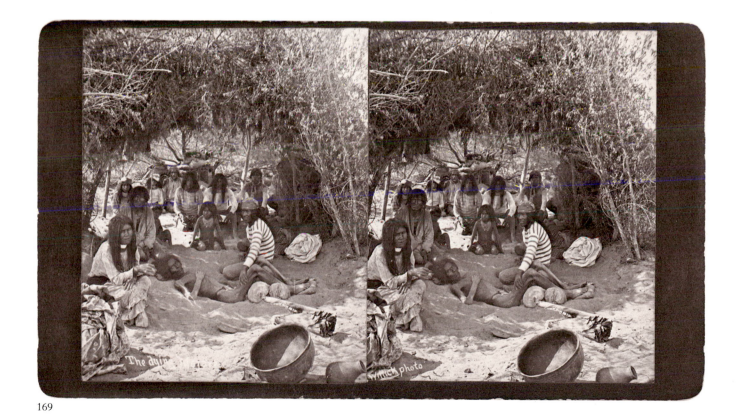

169

168. Charles William Carter (1832–1918), *Indian Courtship*. Albumen sterograph. The Peabody Museum of Natural History, Yale University

169. Ben Wittick (1845–1903), *Dying Mohave with his family*. Albumen stereograph. The Peabody Museum of Natural History, Yale University

155

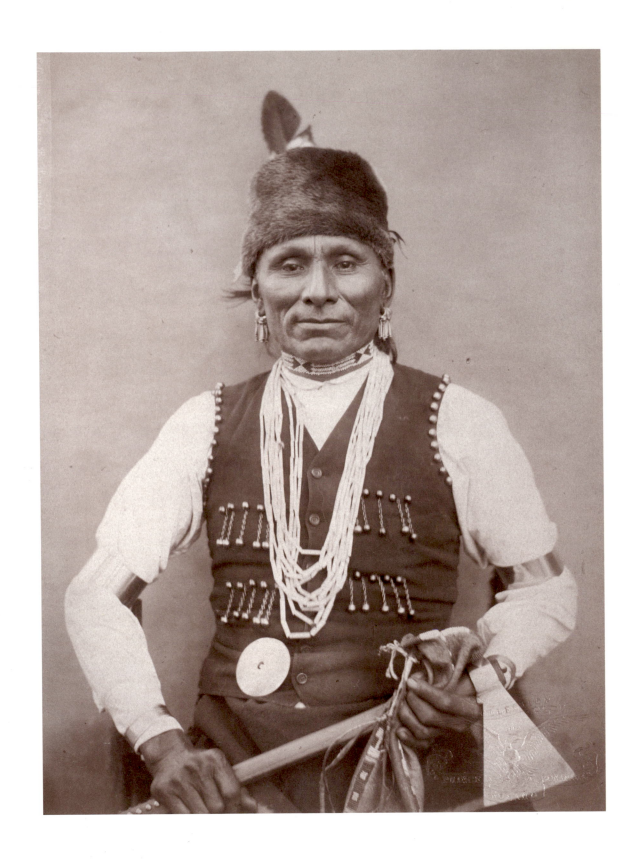

170. Prince Roland Napoleon Bonaparte (1858–1924), *Omaha Sub-Chief Standing Bear*. This photograph was taken at the Jardin d'Acclimation Exposition in Paris in 1883. It is plate three of eighteen in the series "Types d'Indiens, 1880–1890." Collection of Lori and Victor Germack

171. Benjamin Gifford (1859–1936), *Indians overlooking the Falls of the Columbia River, Celilo, Oregon, about l880.* Albumen print.
The Oregon Historical Society

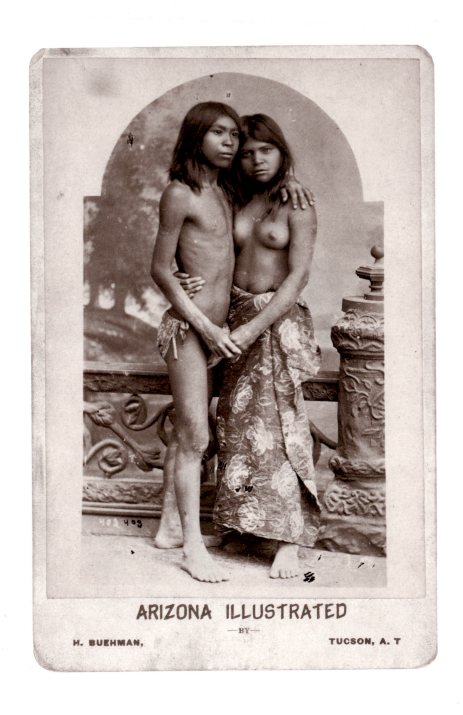

ARIZONA ILLUSTRATED
—BY—
H. BUEHMAN, TUCSON, A. T

172. Henry Buehman (1851–1912), *A young Mohave couple*. Albumen print. Collection of John H. Burkhalter III

Group of Moquis at Oraylee.

173. Charles R. Savage (1832–1909), *A group of Hopis at Oraibe.* Albumen stereograph. Collection of Lori and Victor Germack

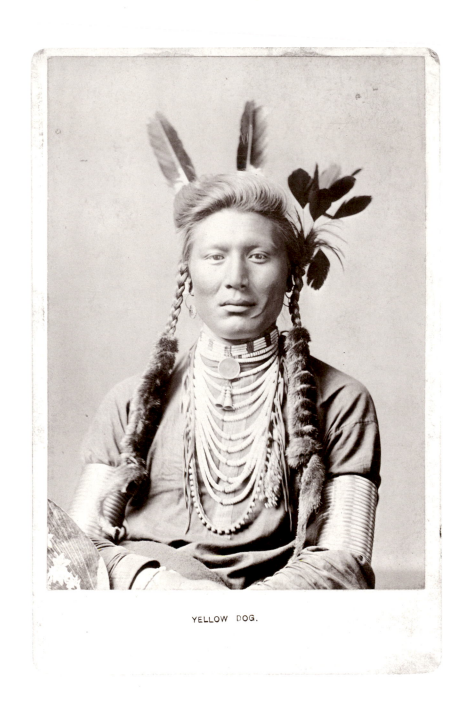

YELLOW DOG.

174. *Yellow Dog*. Albumen print. The New York Public Library

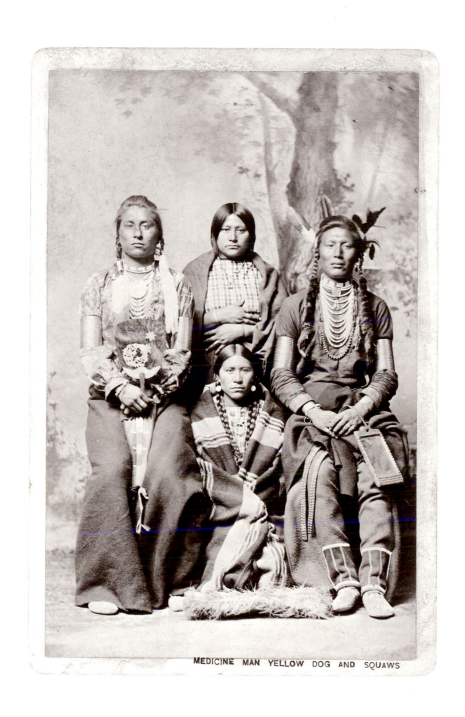

MEDICINE MAN YELLOW DOG AND SQUAWS

175. *Medicine Man, Yellow Dog and wives*. Albumen print. The New York Public Library

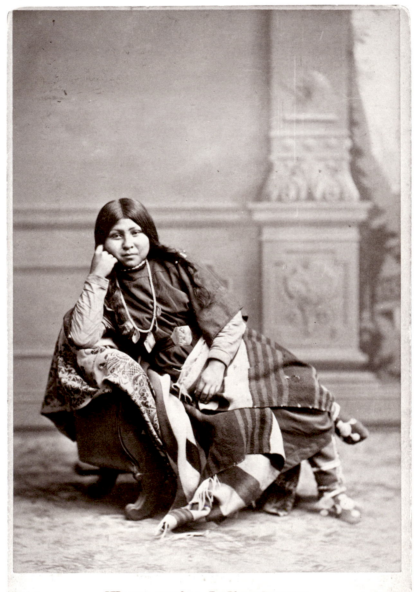

Warm Spring Indian Squaw.

Houseworth, Photographer, 12 Montgomery St., San Francisco.

176. Thomas Houseworth (1829–1915), *Warm Spring Indian Woman*. Albumen print. The New York Public Library

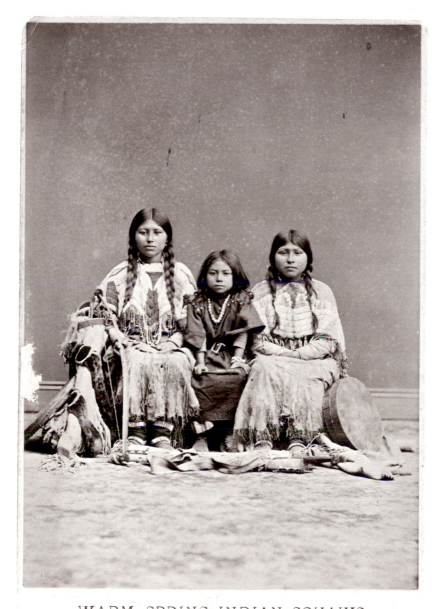

WARM SPRING INDIAN SQUAWS.

HOUSEWORTH, PHOTO. 12 MCNTGOMERY ST., SAN FRANCISCO.

177. Thomas Houseworth (1829–1915), *Warm Spring Indian Women*. Albumen print. The New York Public Library

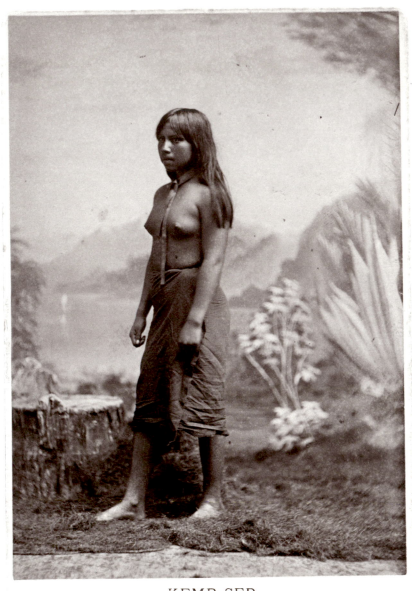

KEMP SEP,
MARICOPA INDIAN RUNNER, ARIZONA.

HOUSEWORTH, PHOTO, 12 MONTGOMERY ST., SAN FRANCISCO.

178. Thomas Houseworth (1829–1915), *Kemp Sep, Maricopa Indian Runner, Arizona*. Albumen print. The New York Public Library

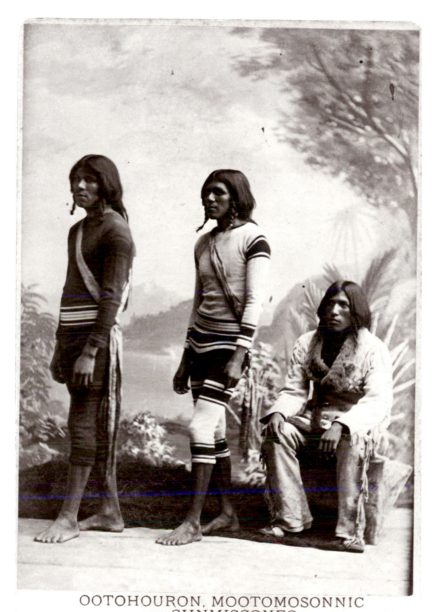

OOTOHOURON, MOOTOMOSONNIC
AND CHNMISCONEC,
YUMA INDIAN RUNNERS.
HOUSEWORTH, PHOTO, 12 MONTGOMERY ST., SAN FRANCISCO.

179. Thomas Houseworth (1829–1915), *Ootohouron, Mootomosonnic, and Chnmisconec, Yuma Indian Runners.* Albumen print.
The New York Public Library

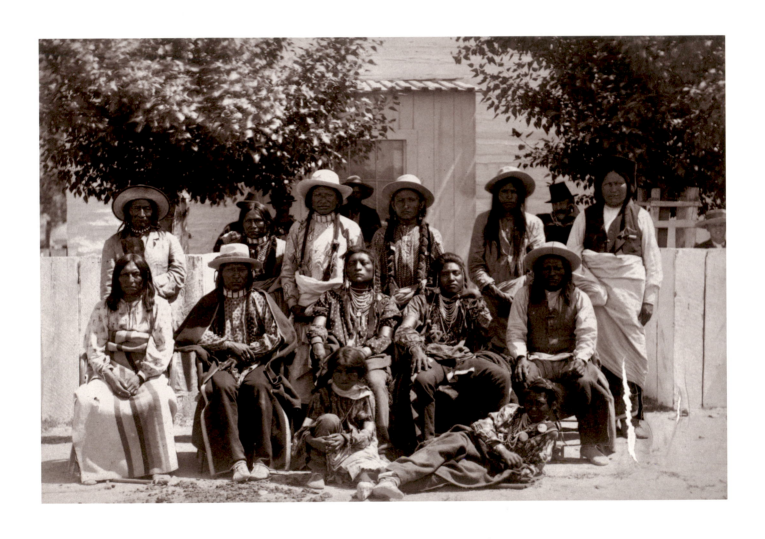

180. *Men at Fort Washakie, August 1883, waiting to meet with President Chester A. Arthur and his party.* Albumen print, 15.2 × 22 cm., from *Journey through the Yellowstone National Park and Northwestern Wyoming 1883. Photographs of Party and Scenery along the route traveled.* The Princeton Collections of Western Americana, Gift of Philip Ashton Rollins

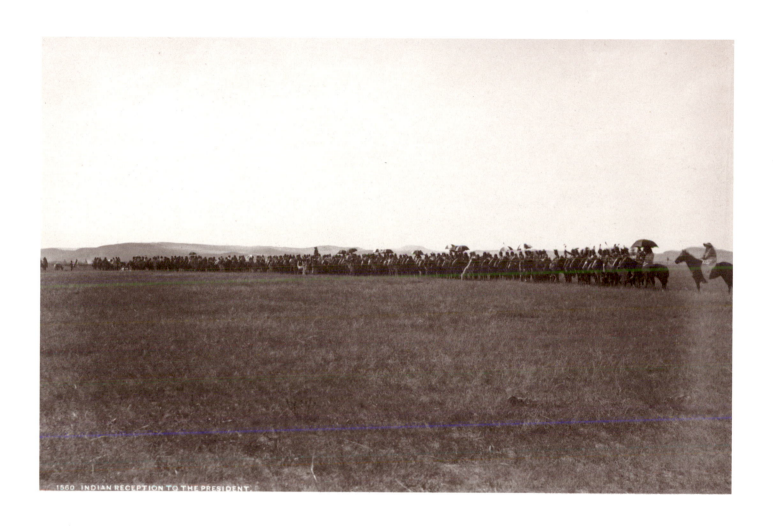

181. *"Indian Reception to the President," Fort Washakie, August 1883.* Albumen print, 14.4 × 22 cm., from *Journey through the Yellowstone National Park and Northwestern Wyoming 1883.* The Princeton Collections of Western Americana, Gift of Philip Ashton Rollins

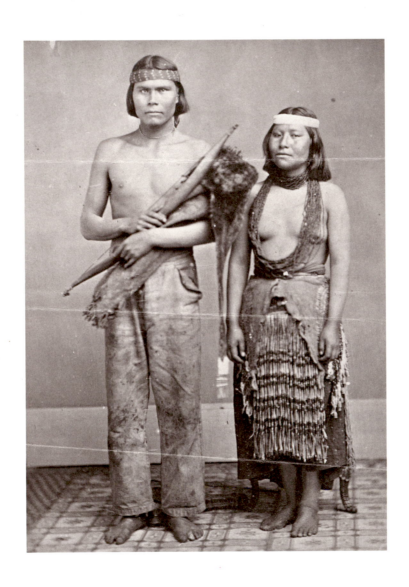

182. *An Indian couple with bow and quiver*. Albumen print. The Peabody Museum of Natural History, Yale University

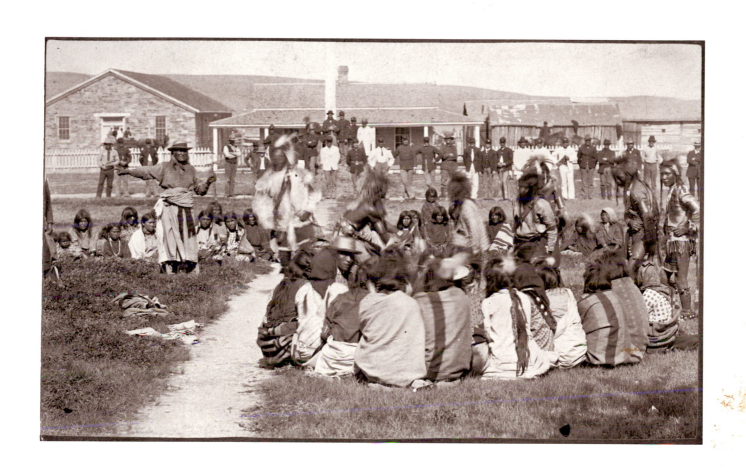

183. Baker and Johnson (active 1880s), *Eastern Shoshone Dance at Fort Washakie, 1884.* Chief Washakie, at left in a hat, faces the camera. Albumen print. The Historical Society of Pennsylvania

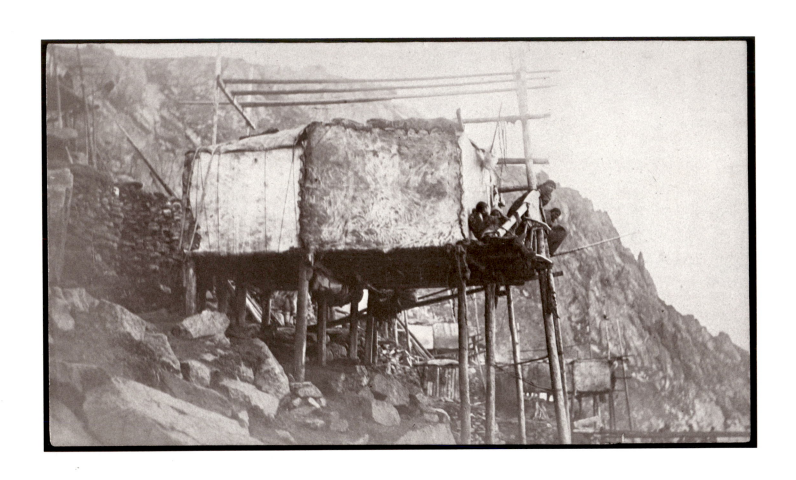

184. Charles S. Fairchild, *Natives look to the water from King's Island houses, 1887–1888.* Albumen print. The New York Public Library

170

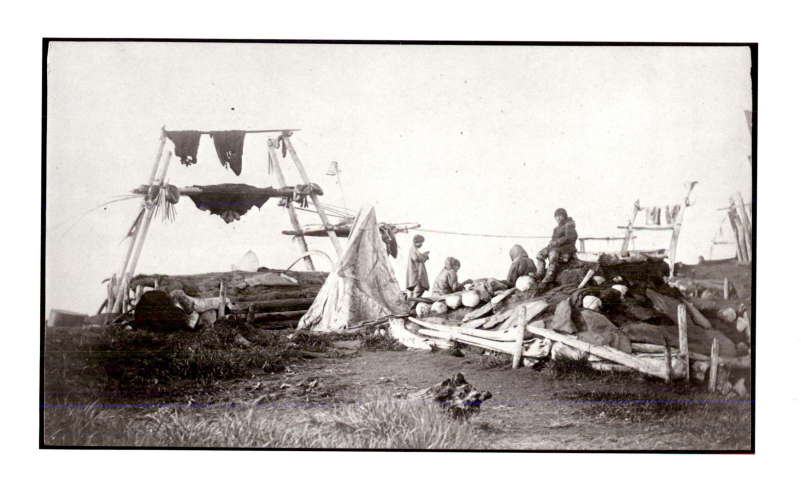

185. Charles S. Fairchild, *Natives at an encampment, Point Hope, 1887–1888.* Albumen print. The New York Public Library

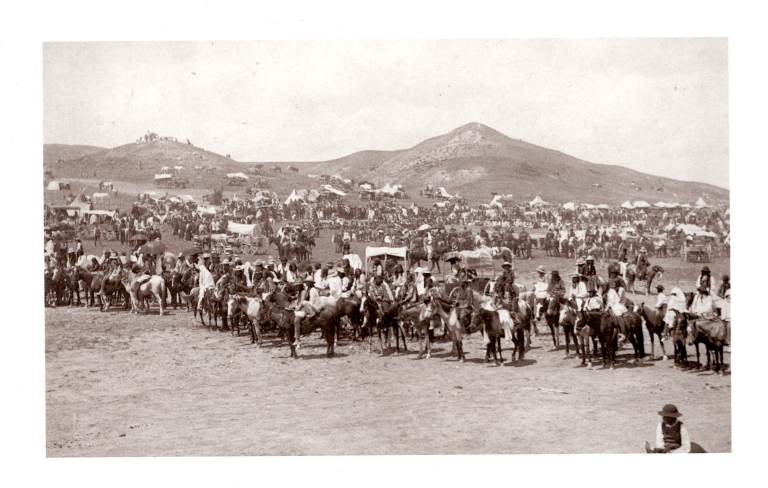

186. John A. Anderson (1869–1948), *Gathering of Sioux near Fort Niobrara*. This image was probably made in 1885 when Anderson was a civilian photographer for the U.S. Army at Ft. Niobrara. Albumen print. The Historical Society of Pennsylvania

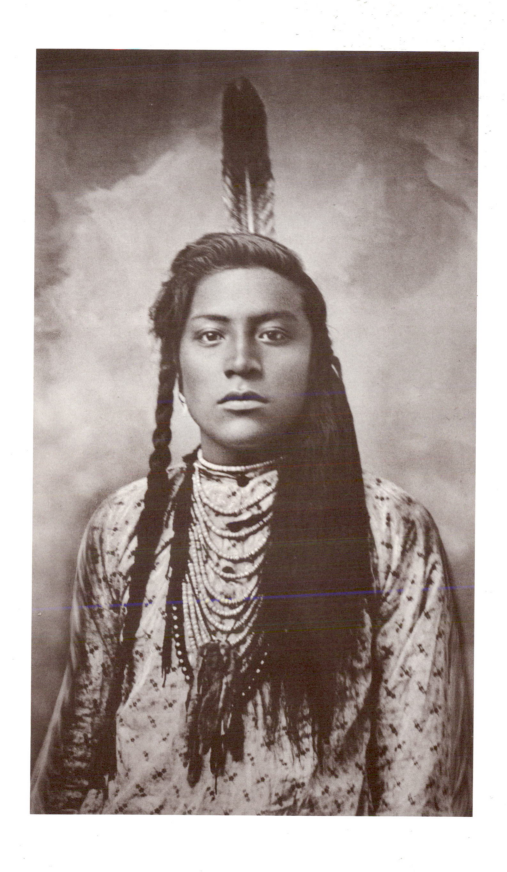

187. Laton A. Huffman (1854–1931), *A Young Plains Man*. Calotype, 1890. The Princeton Collections of Western Americana, Gift of Thomas Baird

188. William S. Prettyman (1858–after 1905), *Anna Wilmot, Pottawatomie, January 3, 1892.* Albumen print. The Princeton Collections of Western Americana

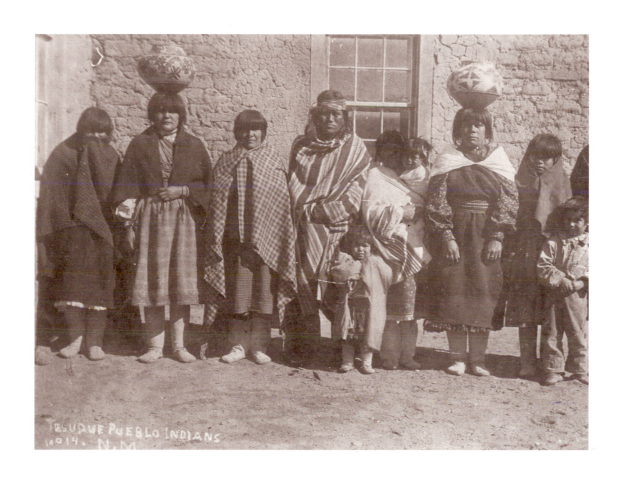

189. *Tesuque Pueblo Indians.* Albumen print. The Princeton Collections of Western Americana, Gift of Thomas Baird

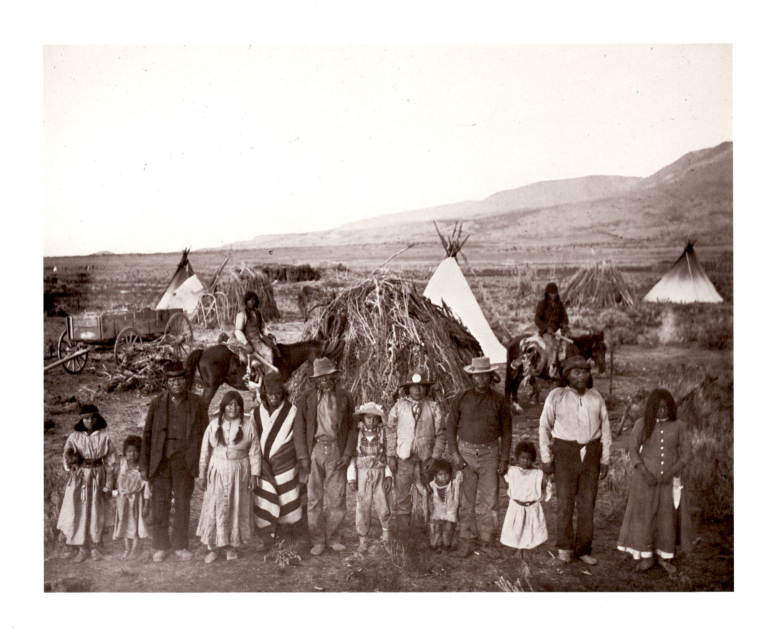

190. George Anderson (1860–1928), *Paiutes at Kanosh, Utah, 1900.* Modern silver print from the original glass-plate negative by Rell G. Francis, 20.5 × 25.3 cm. The Princeton Collections of Western Americana

191. Sumner Matteson (1869–1920), *"Young Man in Fancy Dress." Fort Belknap, Montana, 1905.* Modern silver print, 50 × 42.2 cm., by Phil Bourns from the original negative at The Science Museum of Minnesota, St. Paul. The Princeton Collections of Western Americana

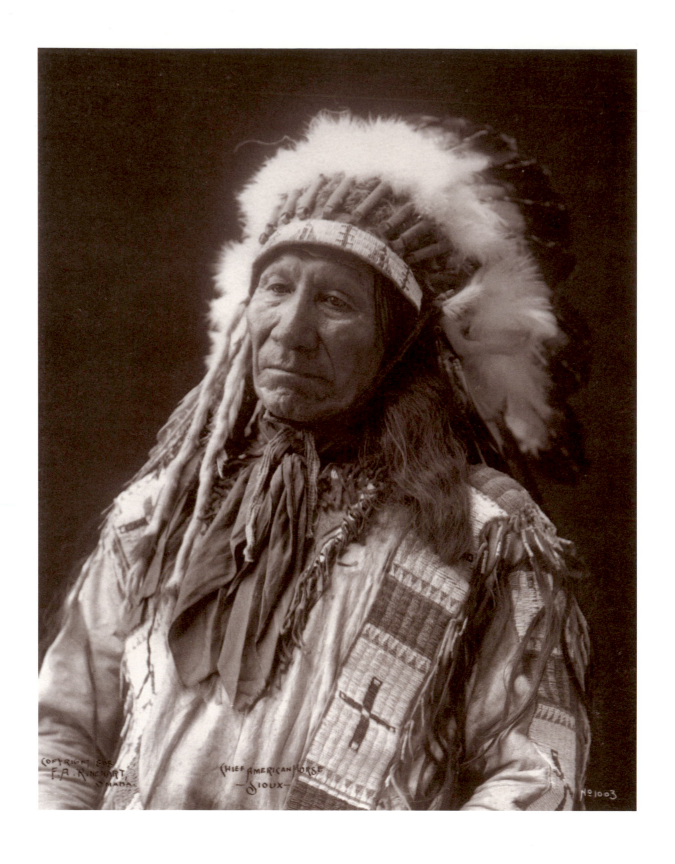

192. Frank A. Rinehart (1861–1928), *"Chief American Horse—Sioux."* Taken at the Trans-Mississippian & International Exposition, Omaha, 1898. Collection of Lori and Victor Germack

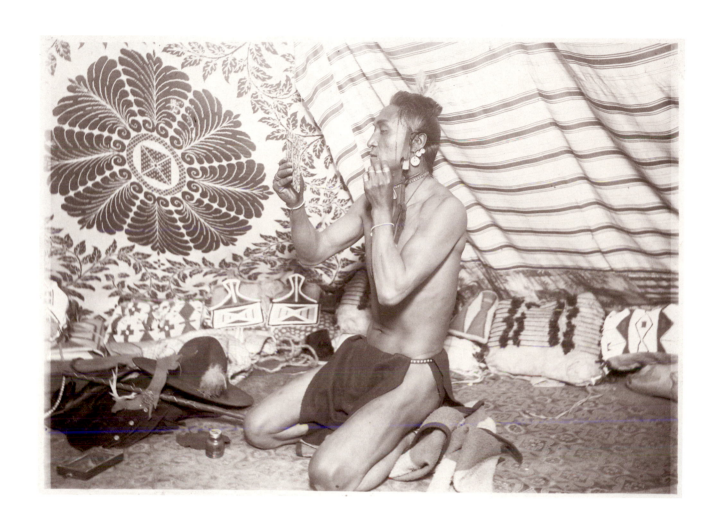

193. Fred E. Miller (1968–1936), *Smart Iron, also known as Has No Foretop, grooming with tweezers.* Albumen print. The Fred E. Miller Collection, Nancy Fields O'Connor, Director

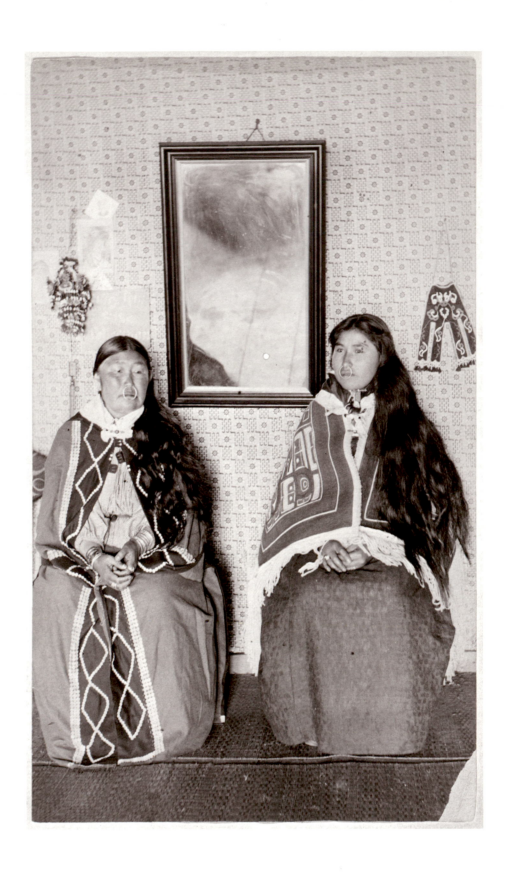

194. Reuben Albertstone, *Alaska Native Women, 1890*. Albumen print. The New York Public Library

Auk Indian Squaws (faces blackened) Juneau, Alaska.

LANDERKIN & WINTER, Photographers, Water Front,
 Juneau, Alaska

195. Landerking & Winter, Juneau, Alaska, *Auk Women (faces blackened), Juneau, Alaska.* Albumen print. The New York Public Library

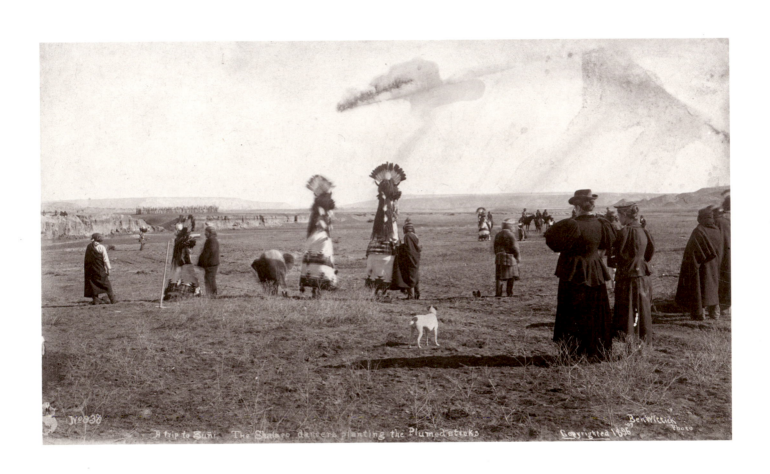

196. Ben Wittick (1845–1903), *"A trip to Zuni. The Shalako dancers planting the plumed sticks,"* 1896. Albumen print. The Princeton Collections of Western Americana, Gift of Thomas Baird

Snake and Antelope Ceremonies

No Native American phenomenon attracted so many cameras as the annual Snake and Antelope ceremonies in the Hopi villages of Northern Arizona. The roster of late nineteenth- and early twentieth-century photographers who set out to capture the ceremony on film is long and distinguished, and the amateur cameramen added to the equipment-crowded edges of the dance plazas. One result was the ban on photography requested by the Hopi religious leaders in 1915. The following photographs represent hundreds taken before that date. The Hopi rites continue today without the presence of the camera, and, in the last decade, without non-Indian viewers.

197. Sumner Matteson (1867–1920), *"Oraibe snake men leaving kiva and Antelope [priests] in plaza." The Hopi villages, 1900.*
Modern print, 40.5 × 50.5 cm., by Phil Bourns from the original negative at The Science Museum of Minnesota, St. Paul.
The Princeton Collections of Western Americana

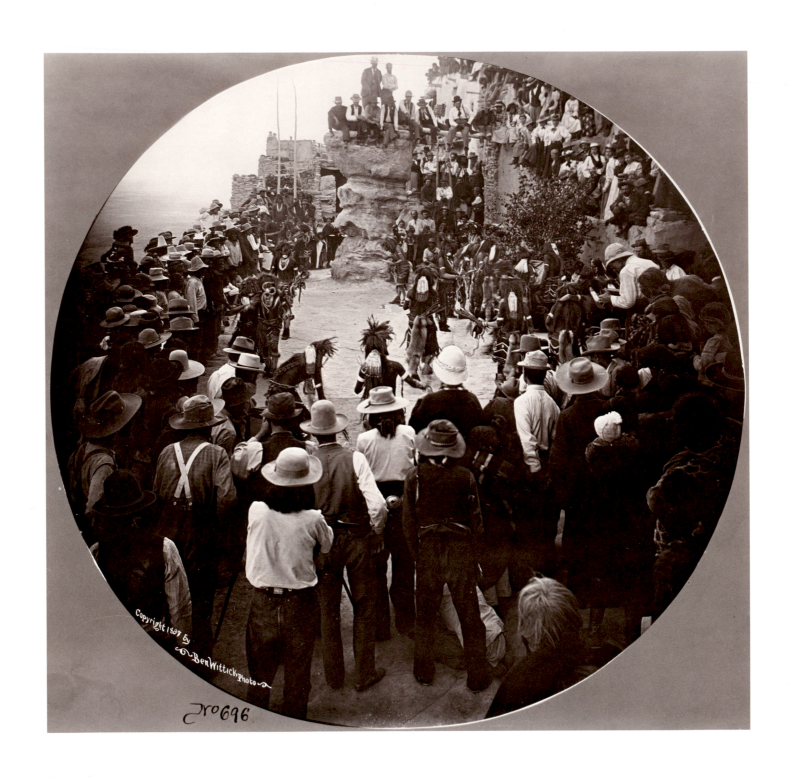

198. Ben Wittick (1845–1903), *Snake Dance of the Hopis at Walpi, Arizona, 1897.* Albumen print. The Peabody Museum of Natural History, Yale University

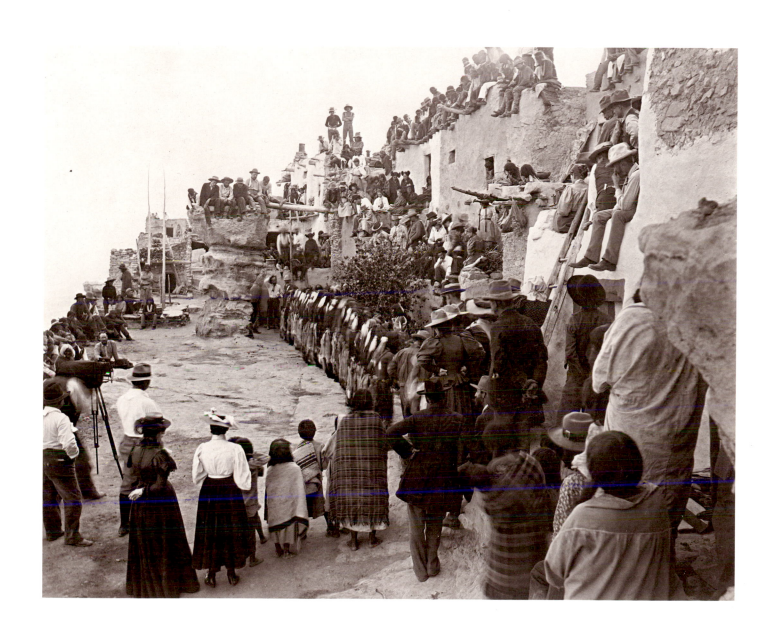

199. Ben Wittick (1845–1903), *At the Hopi Snake Dance, Walpi, 1897.* Albumen print. The Peabody Museum of Natural History, Yale University

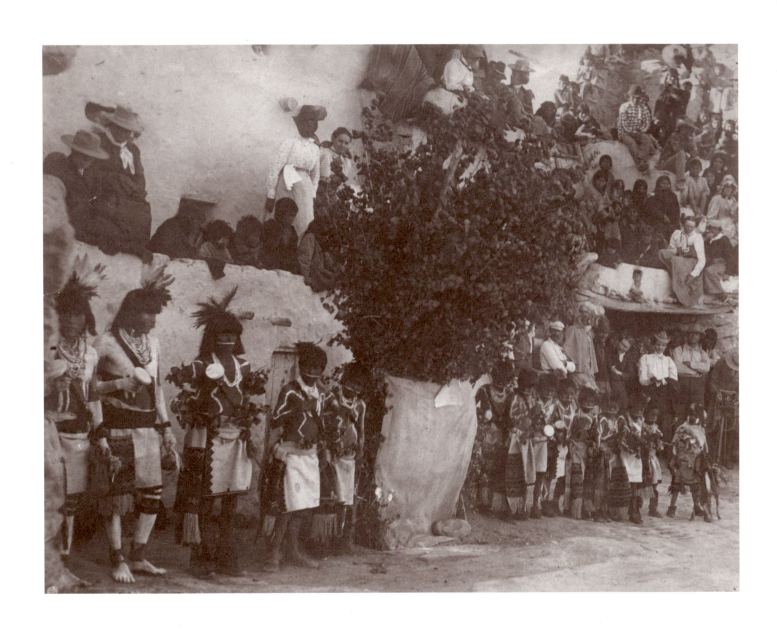

200. Frederick Monsen (1865–1929), *Antelope and Snake priests at the beginning of the public portion of a snake ceremony in a Hopi village about 1905*. Platinum print, 27.7 × 35.5 cm. The Princeton Collections of Western Americana

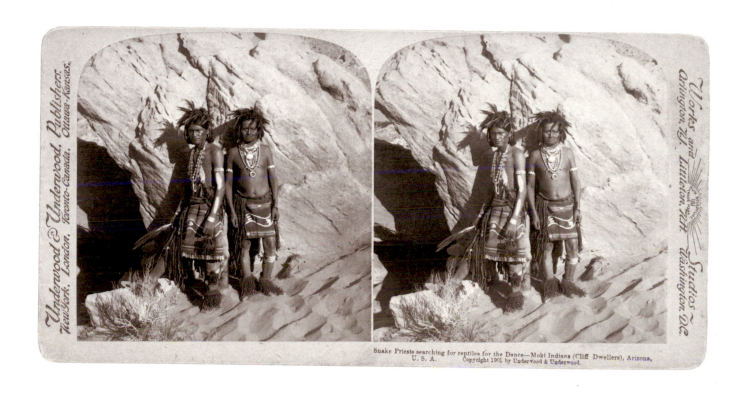

Snake Priests searching for reptiles for the Dance—Moki Indians (Cliff Dwellers), Arizona, U. S. A. Copyright 1901 by Underwood & Underwood.

201. Underwood and Underwood, *Snake priests searching for reptiles for the ceremony, 1901.* Albumen stereograph. The Princeton Collections of Western Americana

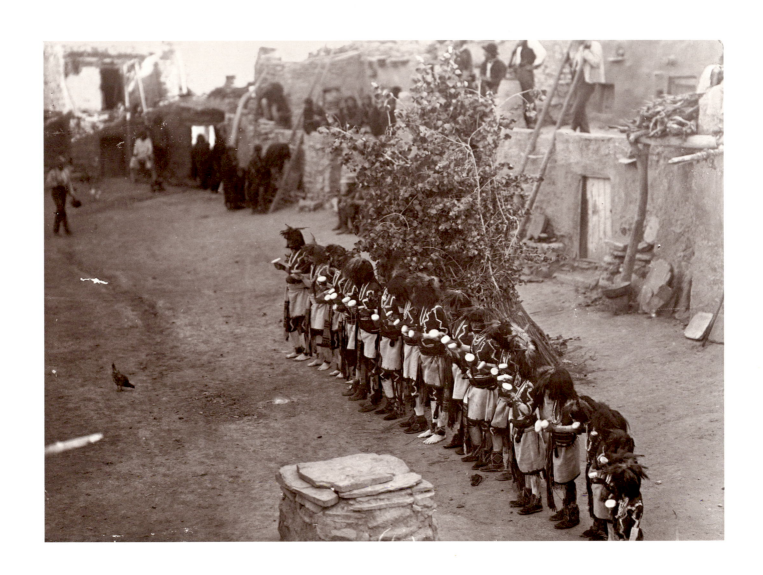

202. George Wharton James (1858–1923), *Antelope priests in line, Snake Dance, 1897.* Albumen print. The Princeton Collections of Western Americana

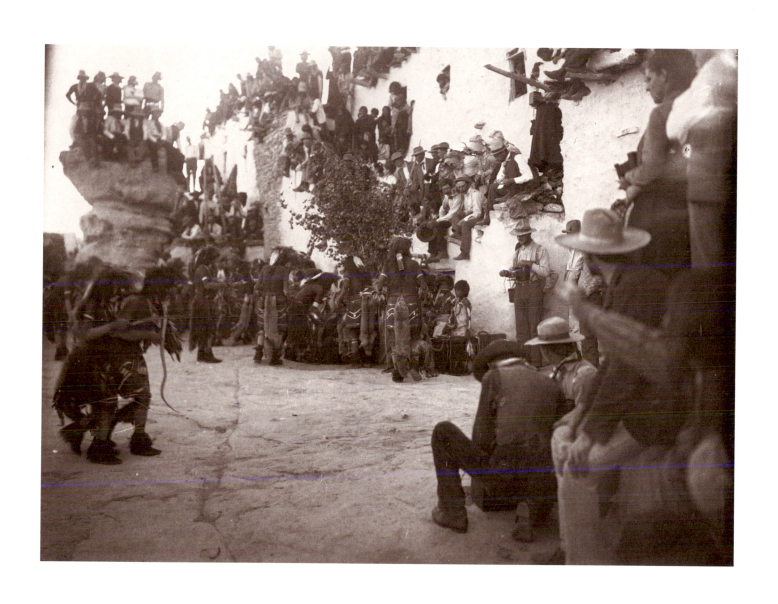

203. Adam Clark Vroman (1856–1916), *"Moki Towns (Snake Dance, Walpi),"* Hopi, 1901. Platinum print. The Princeton Collections of Western Americana, Gift of Mrs. Ario Pardee

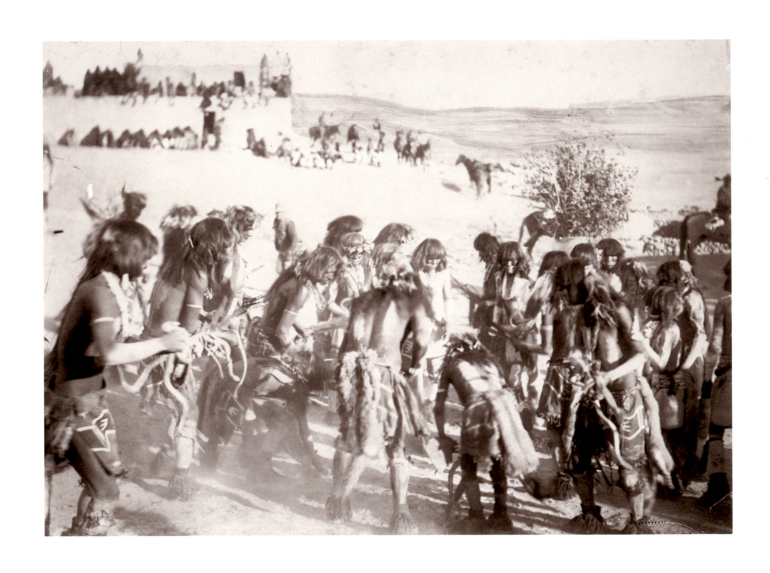

204. Frederick H. Maude (1858–1960), *Casting snakes into the sacred circle before the Kisi, Oraibe, 1896*. Albumen print. The Princeton Collections of Western Americana

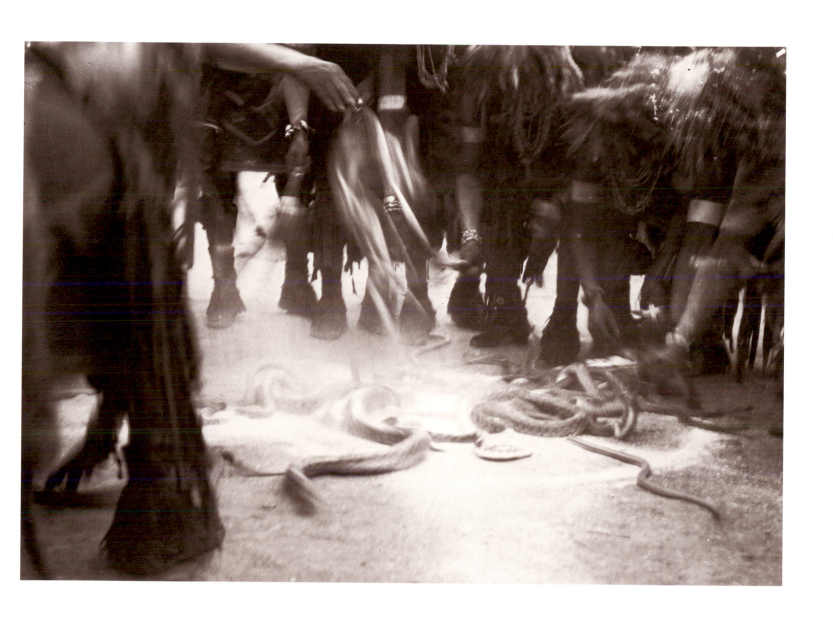

205. H. F. Robinson, *Final blessing of the snakes, Hopi Snake Ceremony, probably at Walpi, 1911.* Modern print from a negative in the Museum of New Mexico collections, negative number 21603, 20.7 × 25.5 cm. The Princeton Collections of Western Americana

The New Century

Photographs of the Snake and Antelope ceremonies at Hopi—capturing as they do one of the few rites to survive with no change through European contact—surprise us by the fact that they reach into the first decades of the twentieth century. They present a picture of Native American ceremonialism thriving in a new century in which indigenous cultural survivals were to be especially vulnerable. The images of the new century document that vulnerability—and in vivid glimpses, the astonishing tenacity of many aspects of American Indian life.

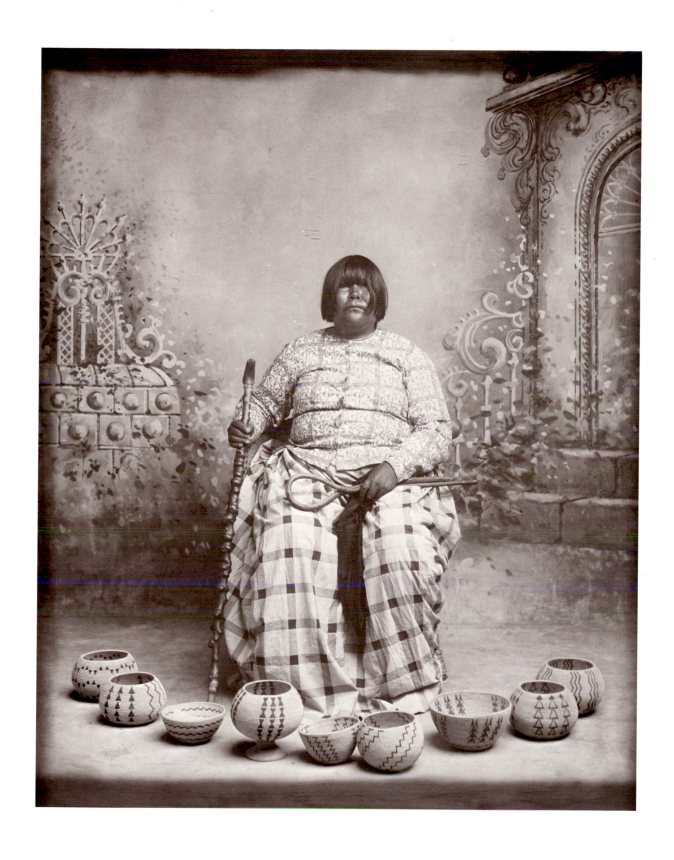

206. Amy Cohn (1860–1919), *Datsolalee, "Queen of Basket Makers," also known as Louisa Keyser (died 1925).* Albumen print, Carson City, Nevada, 1897. The Peabody Museum of Natural History, Yale University

195

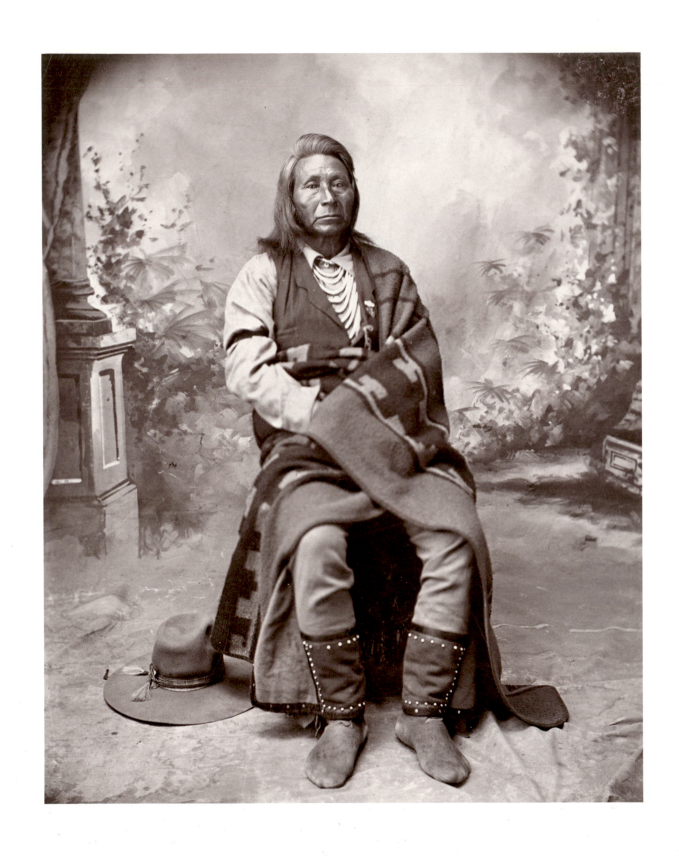

207. Frank La Roche (1853–1934), *Umatilla Man, 1899*. Albumen print. The Peabody Museum of Natural History, Yale University

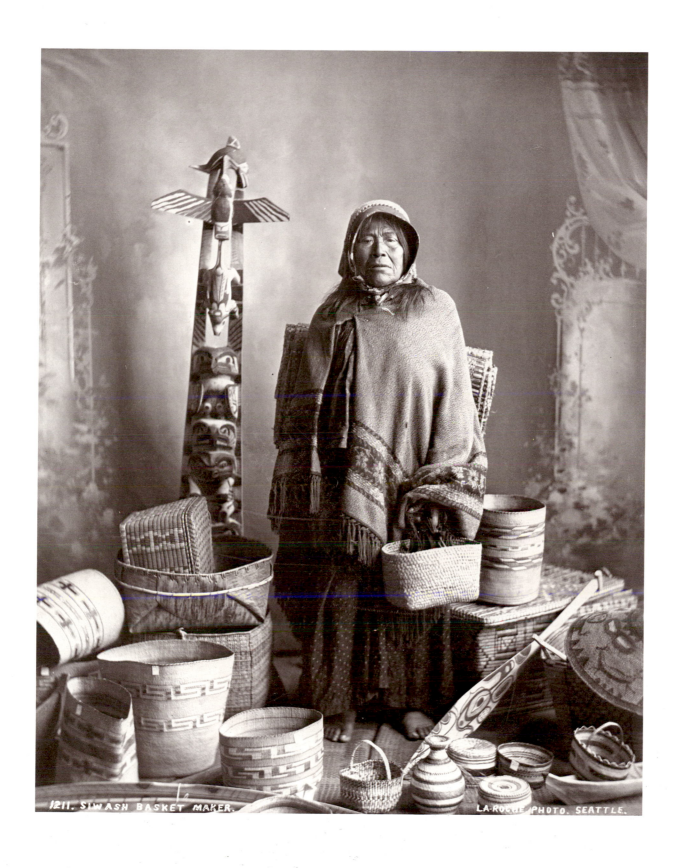

208. Frank La Roche (1853–1934), *"Siwash Basket Maker."* Albumen print. The Peabody Museum of Natural History, Yale University

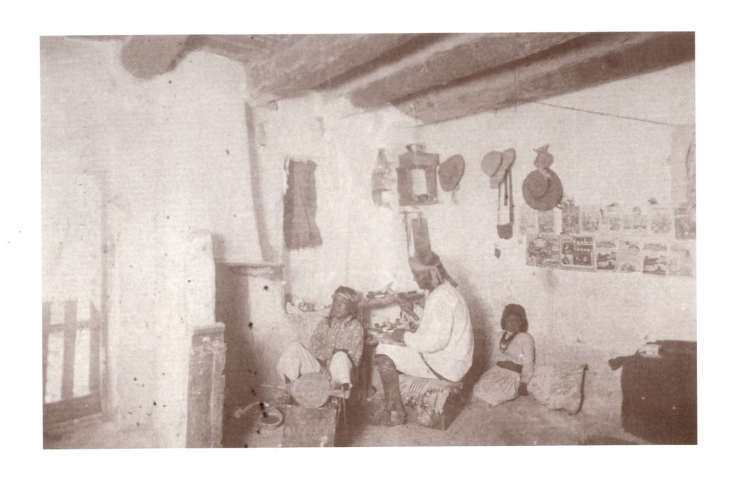

209. Charles Lummis (1859–1928), *Silversmith in his workshop, probably at Isleta Pueblo, New Mexico*. Cyanotype print. The Princeton Collections of Western Americana

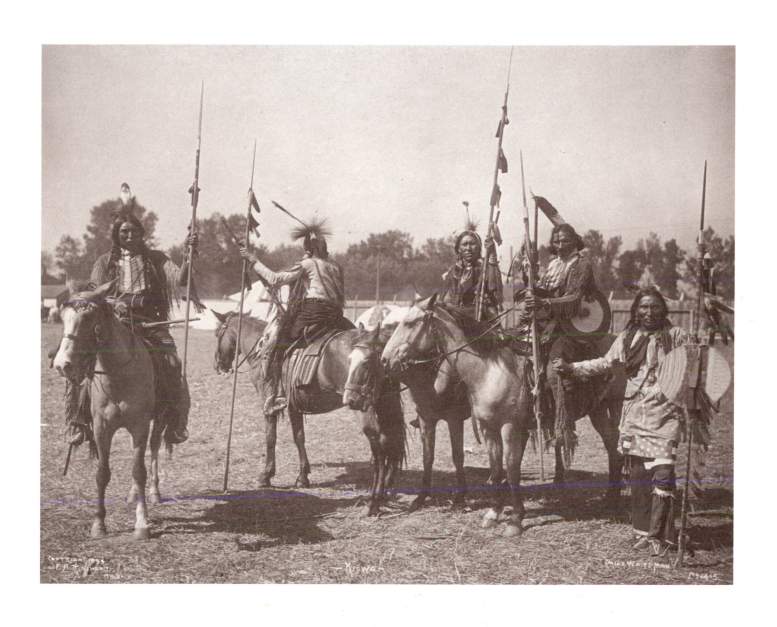

210. Frank A. Rinehart (1861–1928), *Chief White Man and attendants at the Trans-Mississippian and International Exposition, Omaha, 1899.* Platinum print, 19 × 23.5 cm. Collection of Lori and Victor Germack

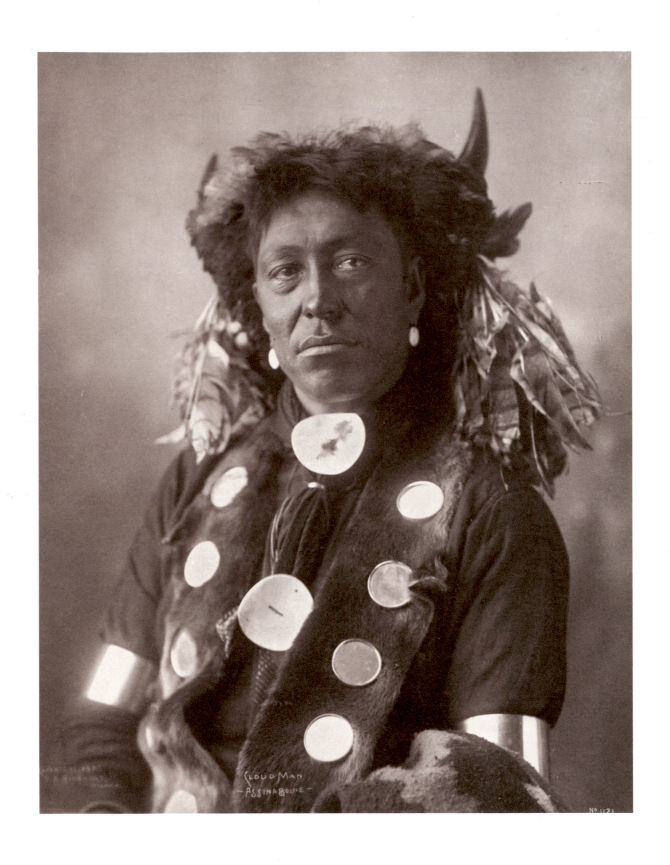

211. Frank A. Rinehart (1861–1928), *"Cloud Man, Assinaboine," l899.* Platinum print, 23.6 × 18.3 cm. Collection of Lori and Victor Germack

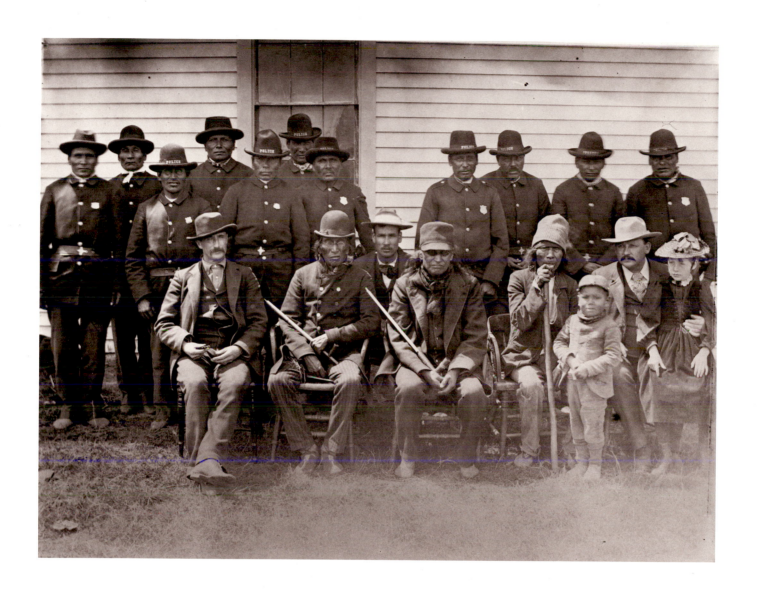

212. *Sioux Police, Devil's Lake Reservation, North Dakota, about 1893.* Modern print from a negative at The Museum of the American Indian, Heye Foundation, New York City, 20.5 × 25.4 cm. The Princeton Collections of Western Americana

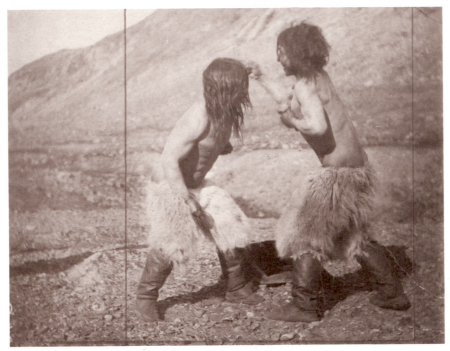

213

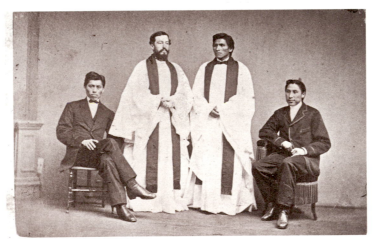

214

213. Robert E. Peary (1856–1920), *Eskimos boxing*. Silver print. Collection of Paul Katz

214. William P. Morgan, *Carlisle Divinity Students*. Albumen print, *carte de visite*. Collection of Lori and Victor Germack

215. *The Convocation of the Indian Deanery of South Dakota, 1889.* Albumen print. The Indian Rights Association, Philadelphia

216. Sumner Matteson (1867–1920), *An Isleta woman carrying water with her husband and daughter*. Isleta Pueblo, 1900. Silver print. Collection of Lori and Victor Germack

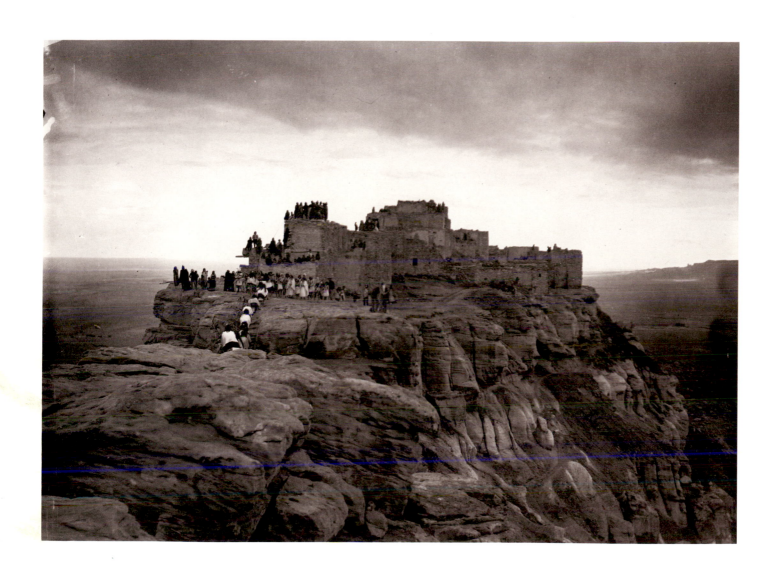

217. Sumner Matteson (1867–1920), *"Sunrise procession of flute ceremony at Walpi, Arizona."* The Hopi villages, 1900. Modern print, 40.5 × 50.5 cm., by Phil Bourns from the original negative at The Science Museum of Minnesota, St. Paul. The Princeton Collections of Western Americana

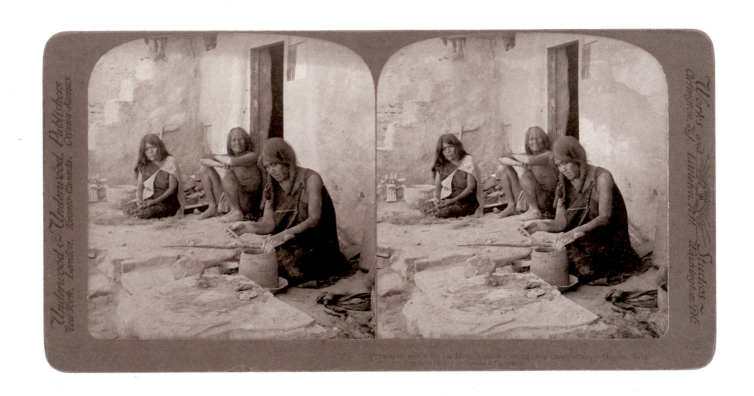

218. Underwood and Underwood, *"Primitive methods—a Hopi squaw coiling clay into pottery, Oraibe, Ariz.,"* 1903. Captions, like this one, often record the prejudices and stereotypes of the period. In fact, the subject is Nampeyo, now celebrated as the most highly accomplished potter of her era—the woman who singlehanded revived Hopi pottery as a modern craft tradition, not only through her ceramic skill, but also her scholarly use of archaeologically recovered fragments of ancient pottery. Her efforts provided a continuing source of income for numerous Hopi families, and a permanent source of pleasure for museum-goers throughout the world. Silver print sterograph. The Princeton Collections of Western Americana

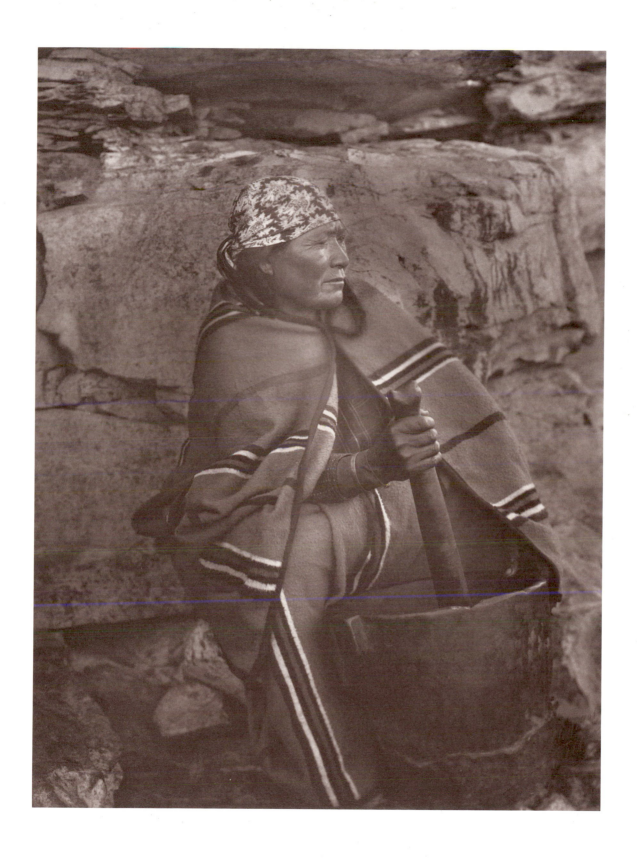

219. Lily E. White (c.1868–1930s), *"In the Shadow of the Rock,"* 1901. Modern print from a negative in the collections of the Oregon Historical Society. The Princeton Collections of Western Americana

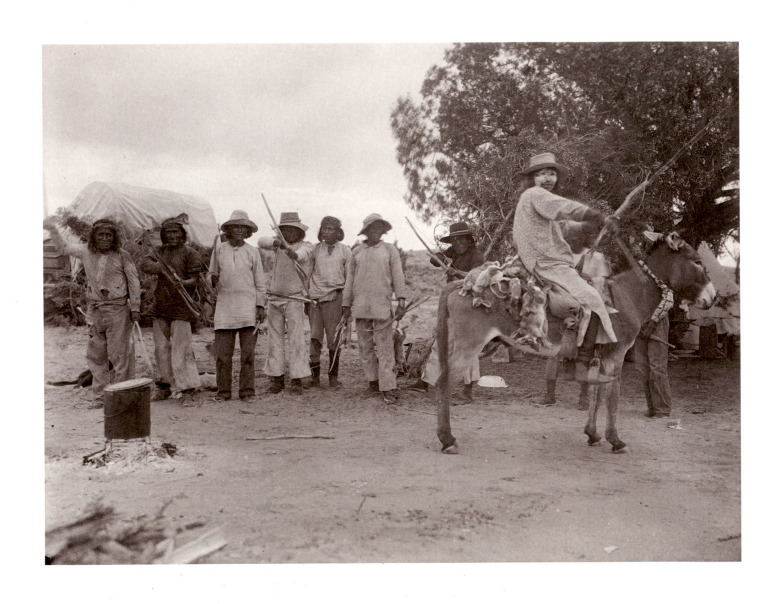

220. Adam Clark Vroman (1856–1916), *"Moki 'Souie Moktu,' Rabbit Hunt," 1901.* Platinum print, 16 × 21.2 cm. The Princeton Collections of Western Americana, Gift of Mrs. Ario Pardee

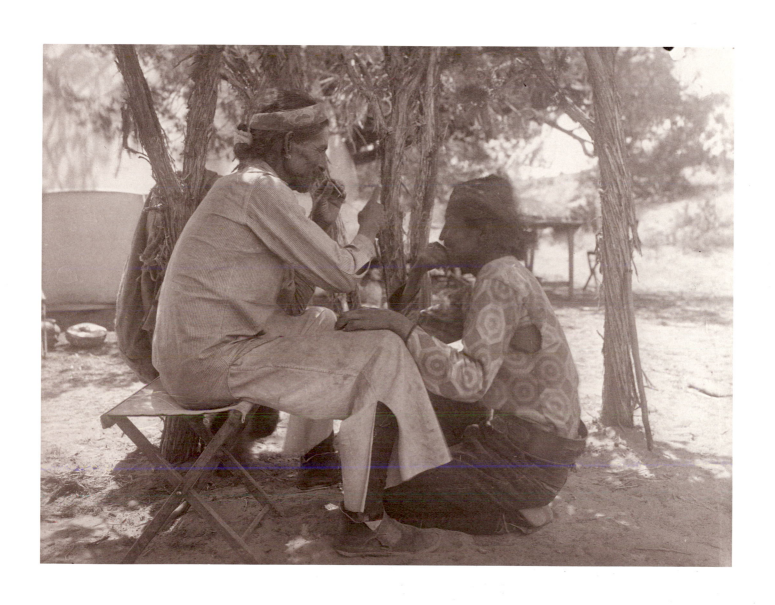

221. Adam Clark Vroman (1856–1916), *"Cottonwood Camp. (Charlie telling a Story),"* *1901.* Platinum print, 16 × 21 cm. The Princeton Collections of Western Americana, Gift of Mrs. Ario Pardee

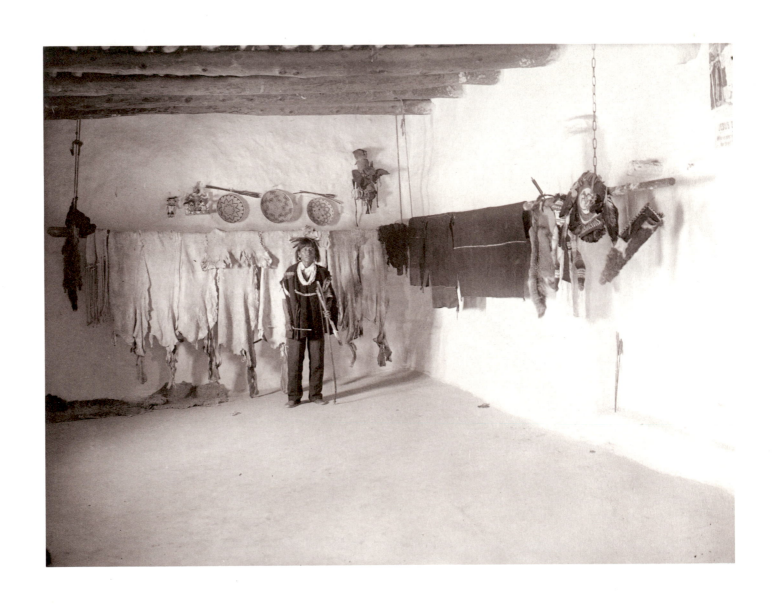

222. Adam Clark Vroman (1856–1916), *"Moki Towns (Interior, Sikatila's House),"* Hopi 1901. Platinum print, 16 × 21 cm.
The Princeton Collections of Western Americana, Gift of Mrs. Ario Pardee

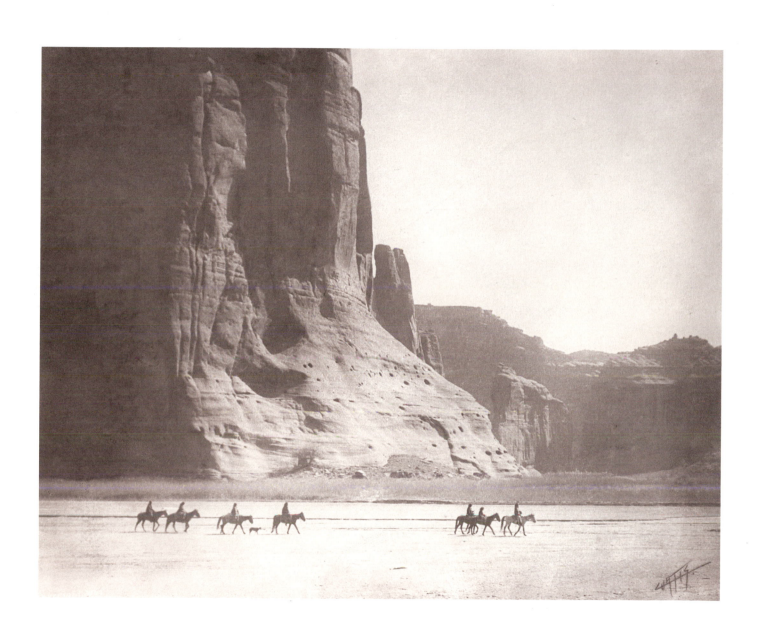

223. Edward Sheriff Curtis (1868–1952), *Navajos in Canyon de Chelley, 1904.* Platinum print, 41.3 × 51.3 cm., signed in gold.
Collection of Lori and Victor Germack

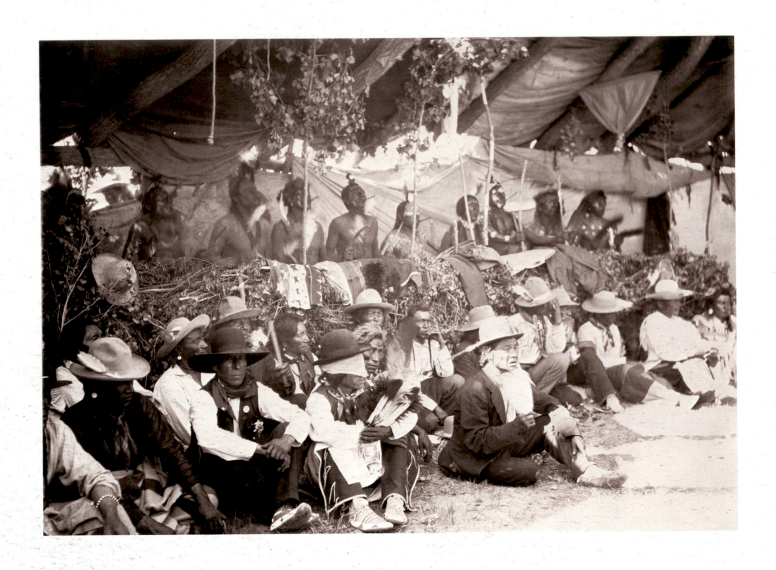

224. Sumner Matteson (1867–1920), *"Assiniboine Indians in medicine lodge—policemen watching."* Fort Belknap, Montana, 1906. The dancers carry eagle-bone whistles in their mouths. Modern print, 40.4 × 50.5 cm., by Phil Bourns from the original negative at The Science Museum of Minnesota, St. Paul. The Princeton Collections of Western Americana

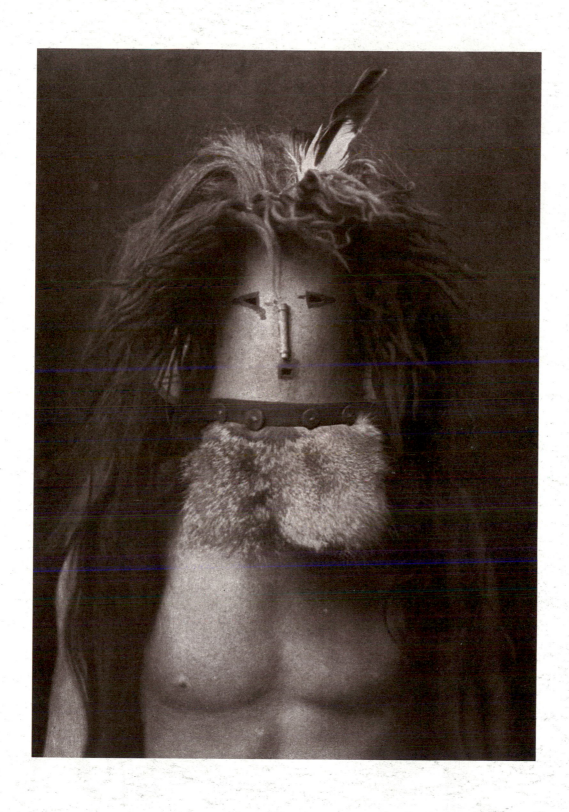

225. Edward Sheriff Curtis (1868–1952), *"Haschebaad—Navajo," 1904.* Photogravure print in a proof copy of the first volume of Curtis's *The North American Indian,* 1907. The Princeton Collections of Western Americana, Gift of Dr. J. Monroe Thorington

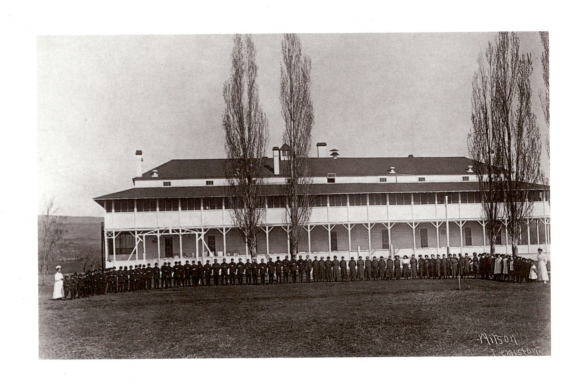

226. John Wilson (active 1904), *Patients lined up in front of the Indian Sanatorium, Fort Lapwai, Idaho, 1904.* Silver print. The Indian Rights Association, Philadelphia

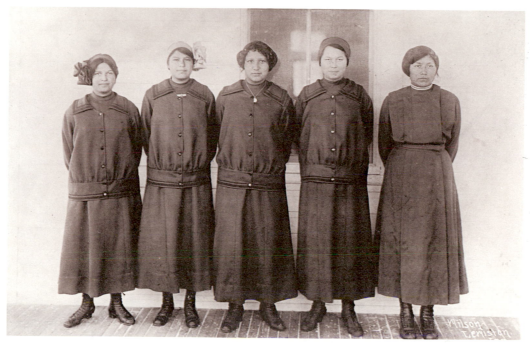

227

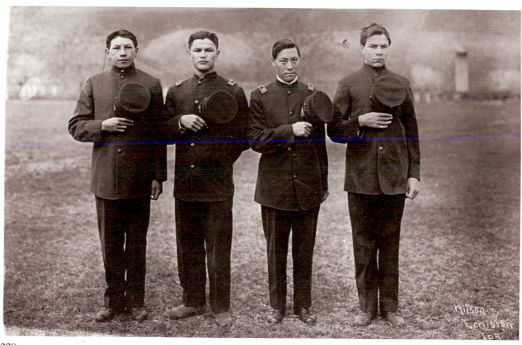

228

227. *Five Indian women at Fort Lapwai Indian Sanatorium, 1904.* Silver print. The Indian Rights Association, Philadelphia

228. *A Menominee, a Munsey and two Alaskan tuberculosis patients at Fort Lapwai Indian Sanatorium, 1904.* Silver print. The Indian Rights Association, Philadelphia

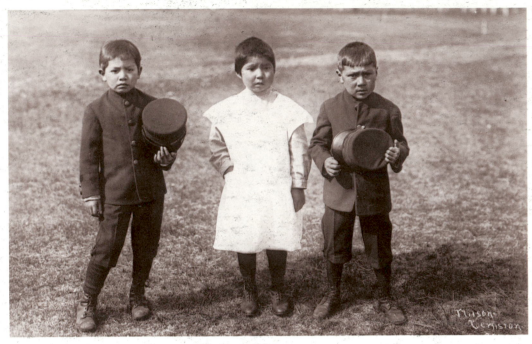

229

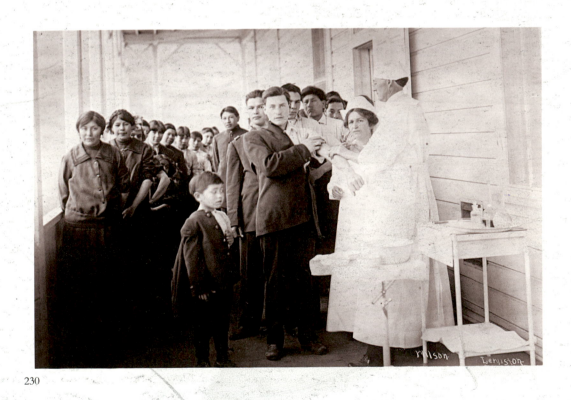

230

229. John Wilson (active 1904), *"Just before six [years of age] when incipient tuberculosis can be arrested." Fort Lapwai Indian Sanatorium, 1904*. Silver print. The Indian Rights Association, Philadelphia

230. John Wilson (active 1904), *Innoculations, Fort Lapwai Indian Sanatorium, 1904*. Silver print. The Indian Rights Association, Philadelphia

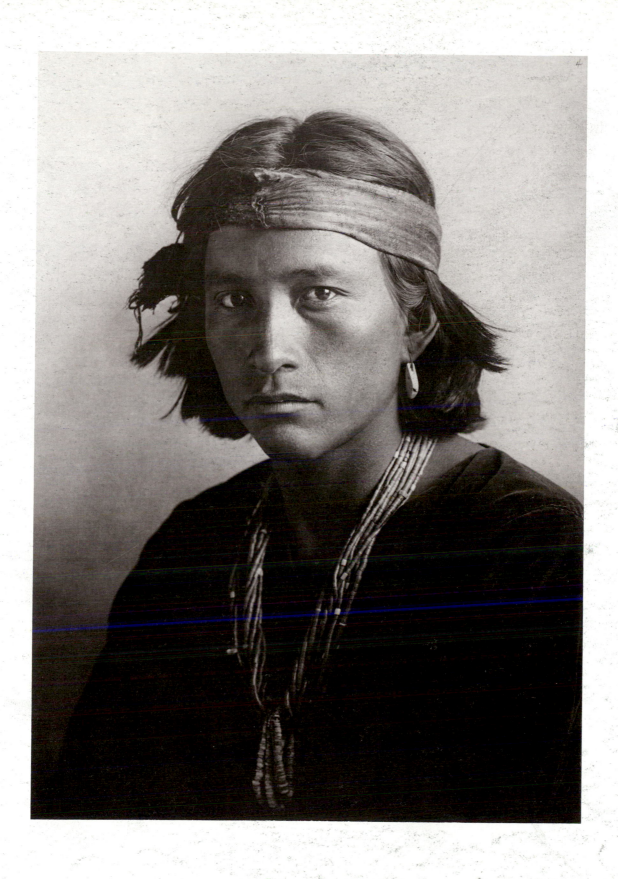

231. Carl Moon (1879–1948), *Young Navajo*. Silver print, c.1905. The New York Public Library

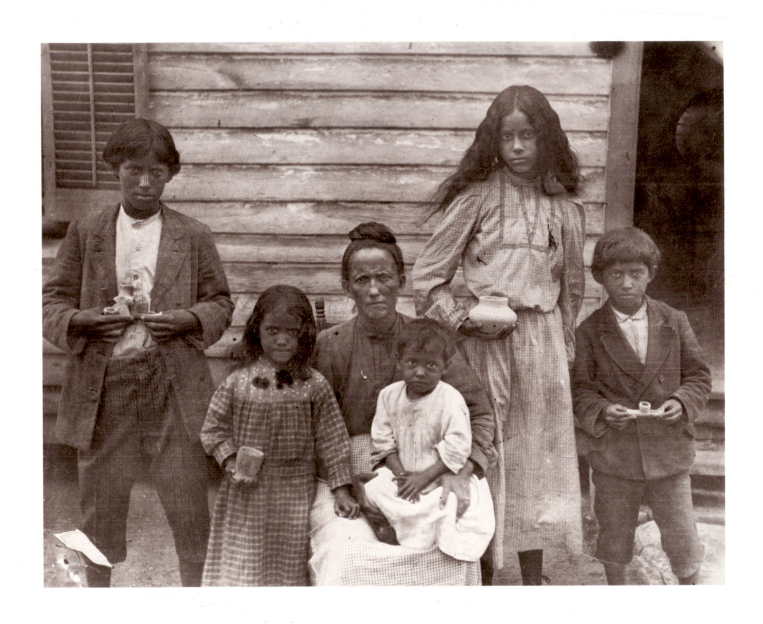

232. Mark R. Harrington (1882–1971); *Last family of potters and pipemakers, Pamunkey, Virginia, 1908.* Modern print from a negative at The Museum of the American Indian, Heye Foundation, New York City, 20.3 × 25.4 cm. The Princeton Collections of Western Americana

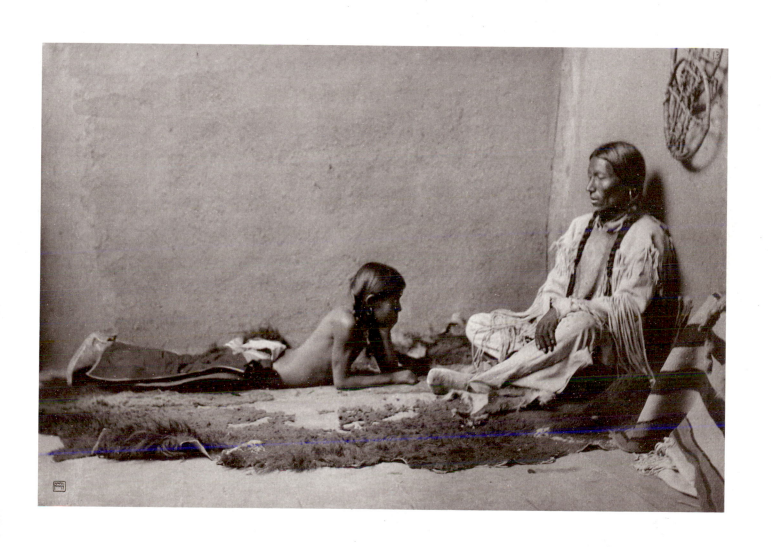

233. Carl Moon (1879–1948), *Tale of the Tribe, about 1910*. Toned silver gelatin print, 20 × 41.6 cm. The New York Public Library, Photography Collection

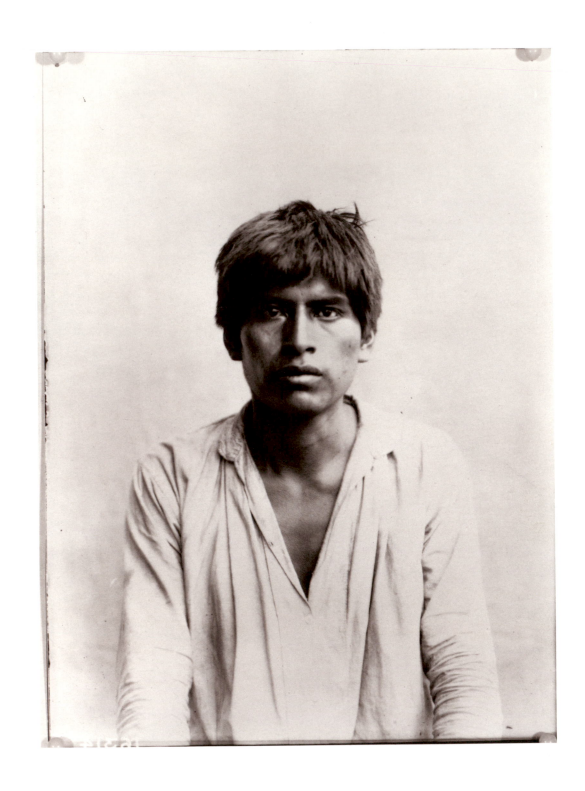

234. Frederick Starr (1858–1933), *Cedonia Sida, Chinantec from San Juan Zantla, Oaxaca, Mexico, 1894–1910*. The photograph was recognized as an ideal means of recording physical tribal characteristics by late nineteenth-century anthropologists. Modern print from a negative in The Museum of the American Indian, Heye Foundation, New York City, 25.3 × 20.5 cm. The Princeton Collections of Western Americana

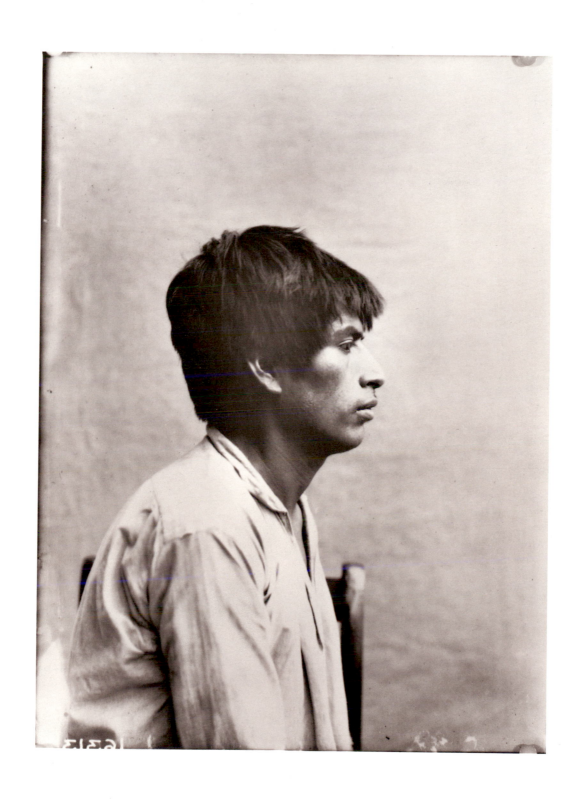

235. Frederick Starr (1858–1933), *Profile of Cedonia Sida, a Chinantec.* Modern print from a negative in The Museum of the American Indian, Heye Foundation, New York City, 25. 3 × 20.5 cm. The Princeton Collections of Western Americana

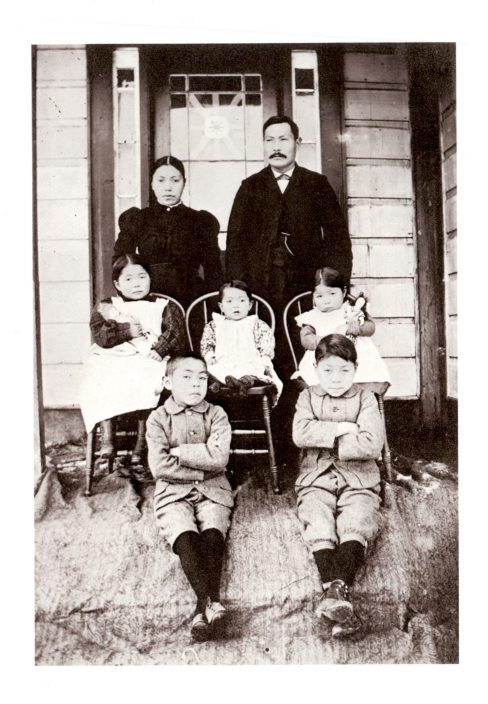

236. Benjamin Haldane (Tsimshian, active 1890s), *Native family*. Silver print. Sir Henry S. Wellcome Collection (RG 200), National Archive–Alaska Region

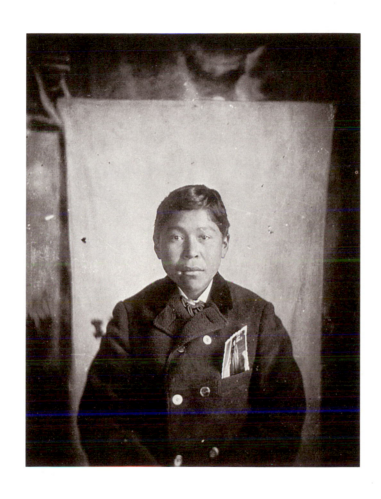

237. Benjamin Haldane (Tsimshian, active 1890s), *Peter Williams, Tlingit of Metlakatla, 1894*. Albumen print. Sir Henry S. Wellcome Collection (RG 200), National Archive–Alaska Region

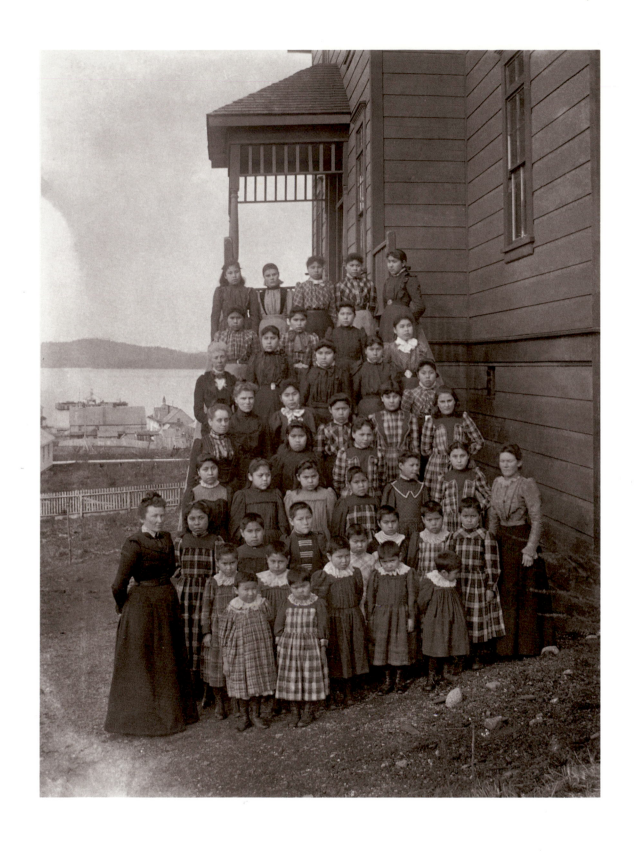

238. Henry Haldane (Tsimshian, active 1890s), *School at Port Simpson, British Columbia*. Albumen print. Sir Henry S. Wellcome Collection (RG 200), National Archive–Alaska Region

224

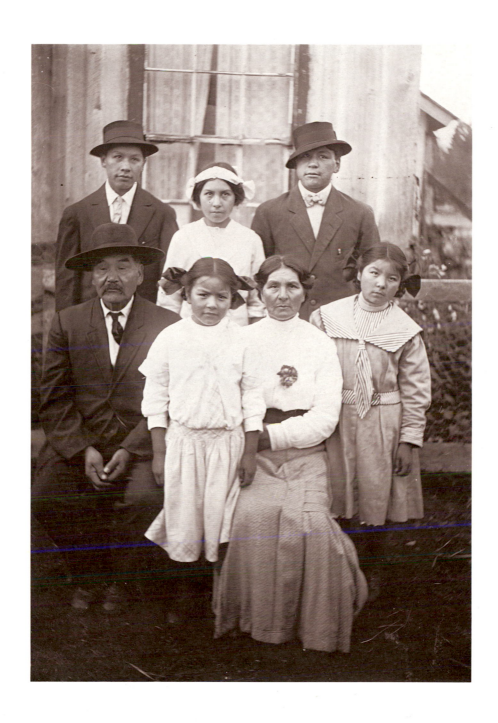

239. *John Adams, first Indian Methodist preacher among the Siletz, and his family.* Silver print. The Oregon Historical Society

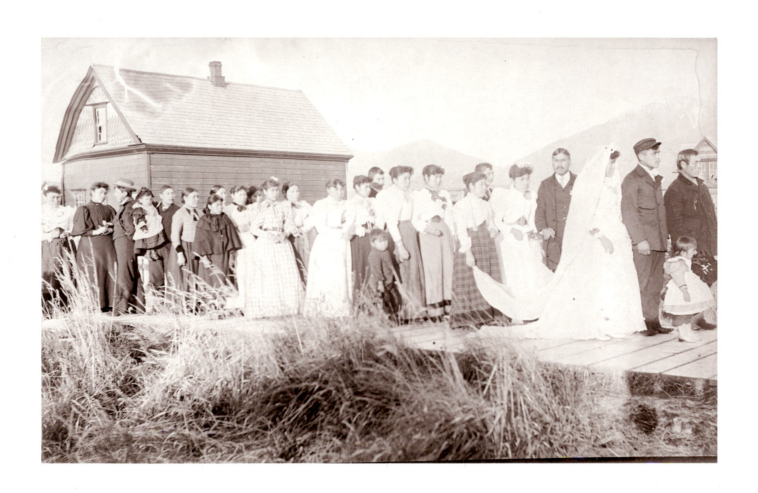

240. Thomas Eaton (Tsimshian, born 1864 – died after 1900), *"Wedding, Metlakahta."* Silver print. The Alaska State Library

241

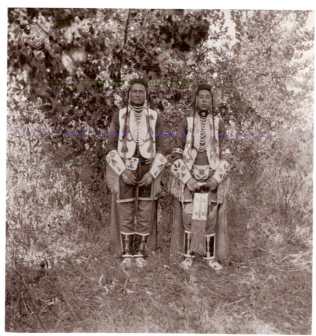

242

241. *Group in dresses with elk teeth*. Silver print. The Indian Rights Association, Philadelphia

242. *Two Plains Men*. Silver print. The Indian Rights Association, Philadelphia

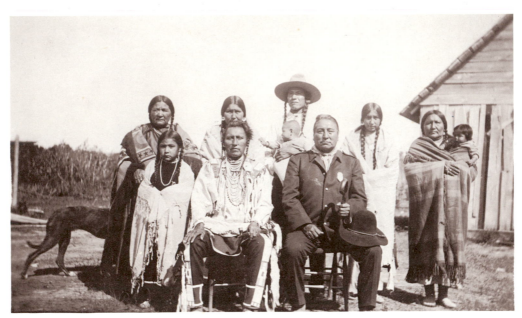

243

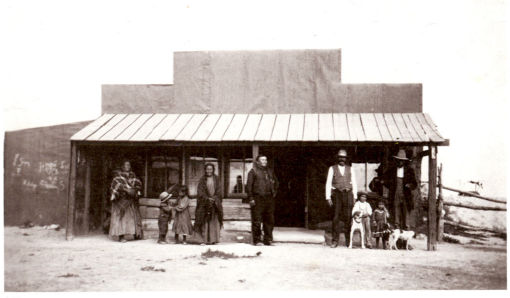

244

243. *Big Medicine, his family and friends, at Crow Agency, Montana, 1912.* Silver print. The Indian Rights Association, Philadelphia

244. *The Norris Post Office Store of Reuben Quick Bear, Rosebud Reservation, Black Pipe District, South Dakota.* Silver print. The Indian Rights Association, Philadelphia

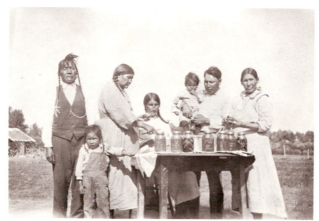

245

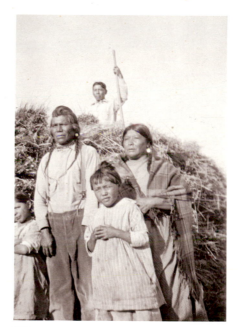

246

245. *Mrs. Bird Rattler's Canning, Blackfeet Reservation, Montana.* Silver print. The Indian Rights Association, Philadelphia

246. *Night Shoot and his family, Blackfeet Reservation, Montana.* Silver print. The Indian Rights Association, Philadelphia

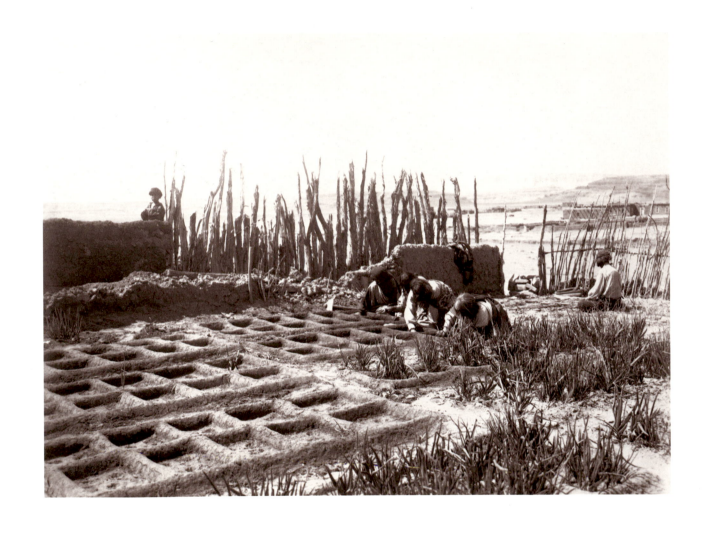

247. Jesse L. Nusbaum (1887–1975), *Members of the Paquin family in their waffle gardens at Zuni Pueblo, New Mexico, 1910–1911.* Modern print from the negative at the Museum of New Mexico, Santa Fe (negative number 8742). The Princeton Collections of Western Americana

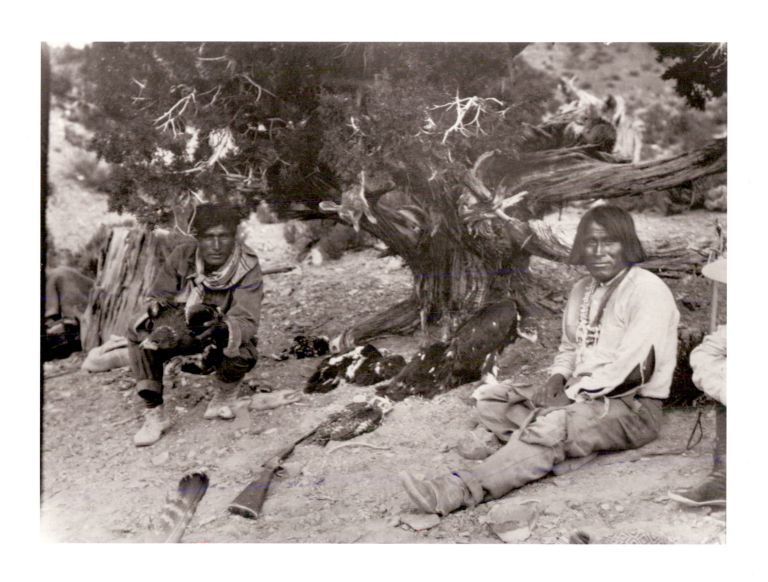

248. Emory Kopta (died 1953), *Hopi eagle hunters with catch, 1915.* Modern print from a negative at The Museum of the American Indian, Heye Foundation, New York City, 20.5 × 25.3 cm. The Princeton Collections of Western Americana

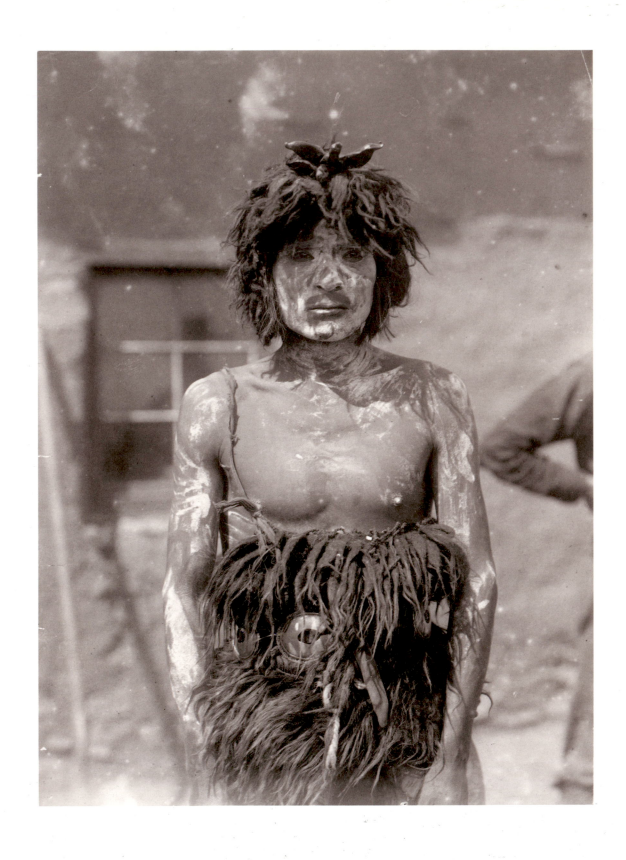

249. George Wharton James (1858–1923), *"Leader of Moki Dances at Tuba City, Ariz."* A priest from Moencopi in the Hopi villages. Albumen print. The Princeton Collections of Western Americana

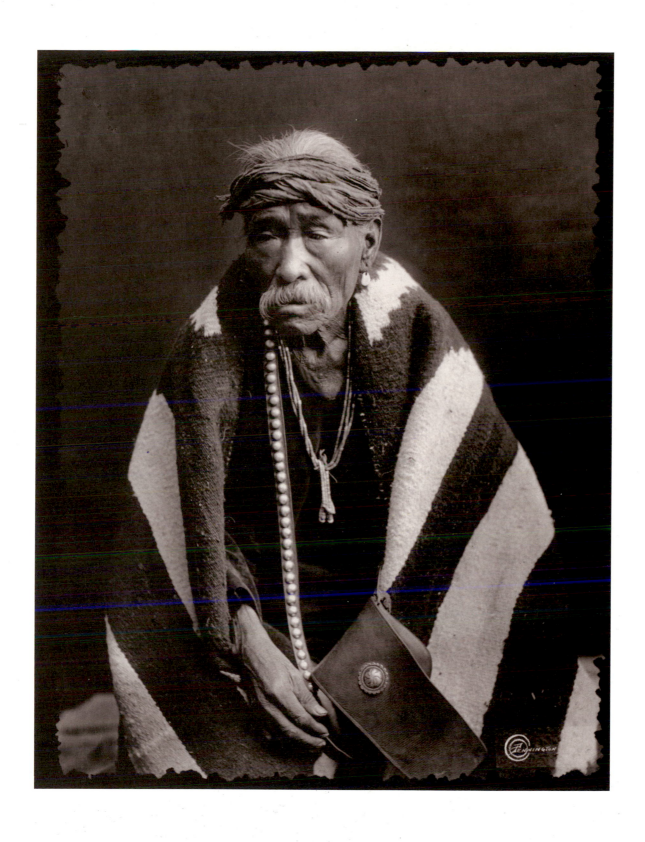

250. William Pennington (born 1875), *A Navajo, about 1915*. Platinum print, 26 × 20.1 cm. The Princeton Collections of Western Americana

233

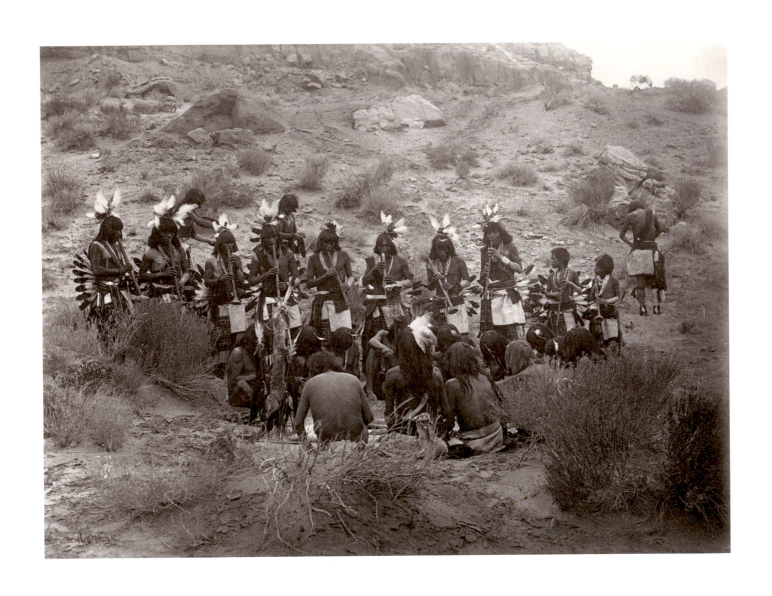

251. Adam Clark Vroman (1856–1916), *"Moki Towns (Flute Ceremony) Oraibe," Hopi, 1901*. Platinum print. The Princeton Collections of Western Americana, Gift of Mrs. Ario Pardee

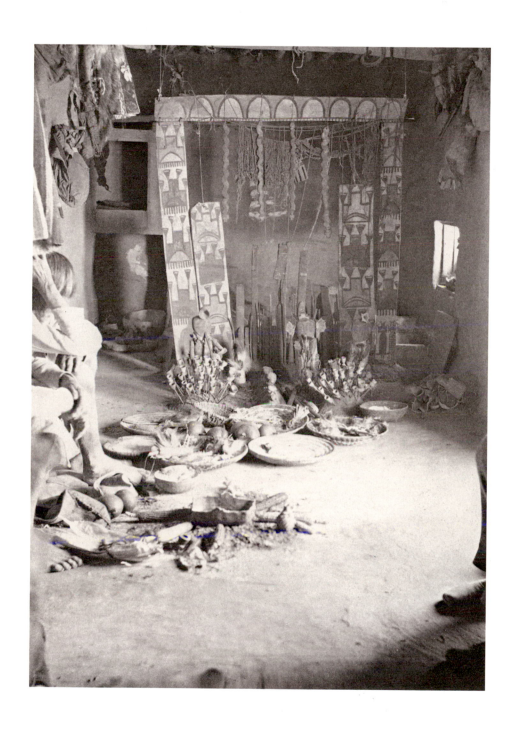

252. *Three priests before an altar in a Hopi kiva.* Albumen print. The Princeton Collections of Western Americana

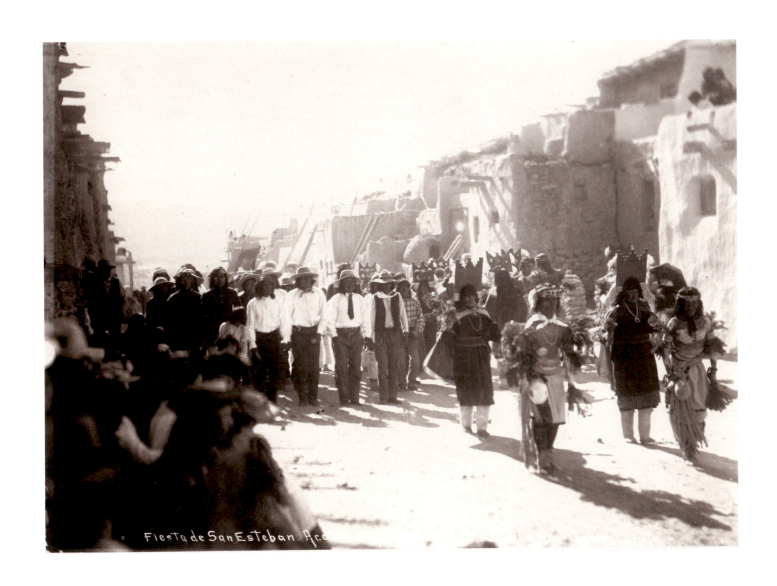

Fiesta de San Esteban. Ac...

253. Frederick H. Maude (1858–1960), *Fiesta de San Esteban, Acoma Pueblo*. The male chorus stands to the right of the dancers. Collection of George Wharton James. Silver print. The Princeton Collections of Western Americana

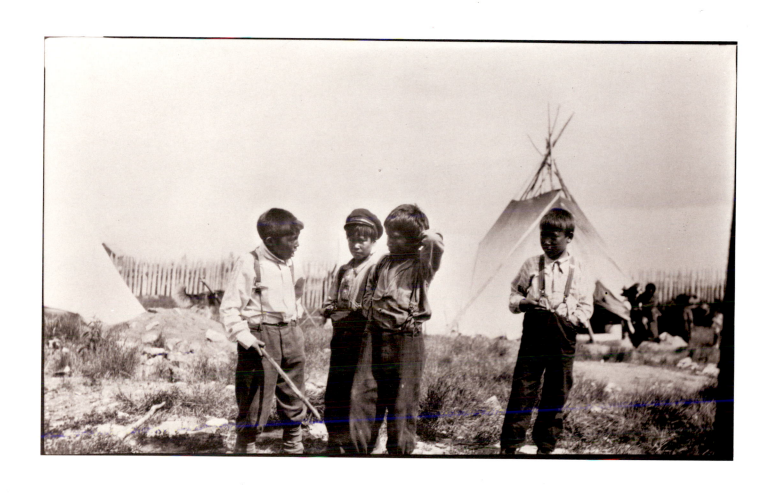

254. Donald A. Cadzow (active 1917–1926), *Slavery Indian boys, Mackenzie River, Northwest Territories, 1919.* Modern print from a negative at The Museum of the American Indian, Heye Foundation, New York City, 20.4 × 25.4 cm. The Princeton Collections of Western Americana

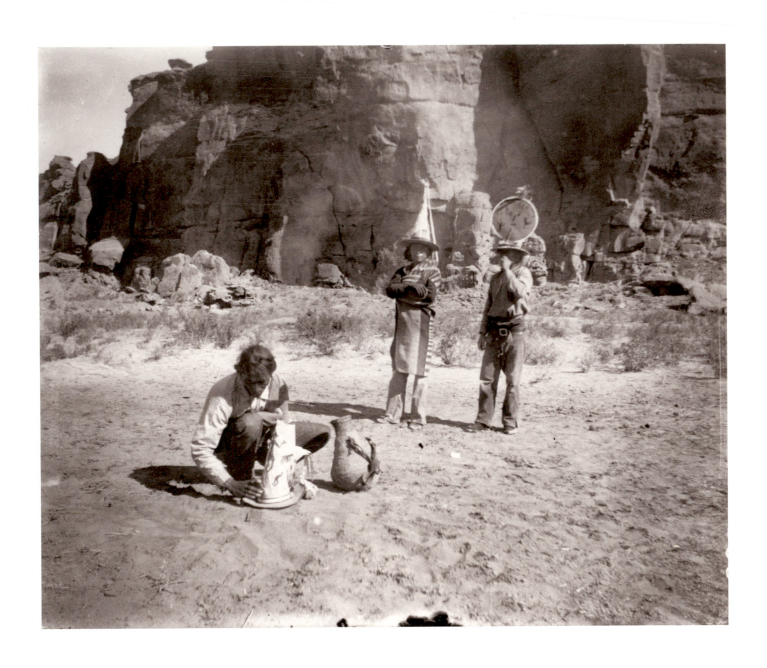

255. Donald A. Cadzow (active 1917–1926), *Navajo ceremony, Chaco Canyon, New Mexico, 1919*. Modern print from a negative at The Museum of the American Indian, Heye Foundation, New York City, 20.5 × 25.4 cm. The Princeton Collections of Western Americana

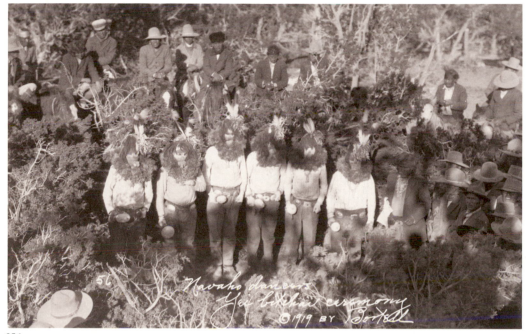

256

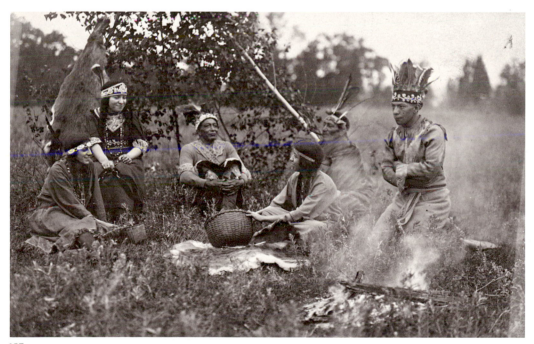

257

256. P. Clinton Bortell (active 1910s), *"Navajo dancers, Yei bitchai ceremony," 1919.* Once in the collection of George Wharton James. Photographic postcard. The Princeton Collections of Western Americana

257. *Mohegans at Shanton Fort, 1920.* Photographic postcard. The Princeton Collections of Western Americana

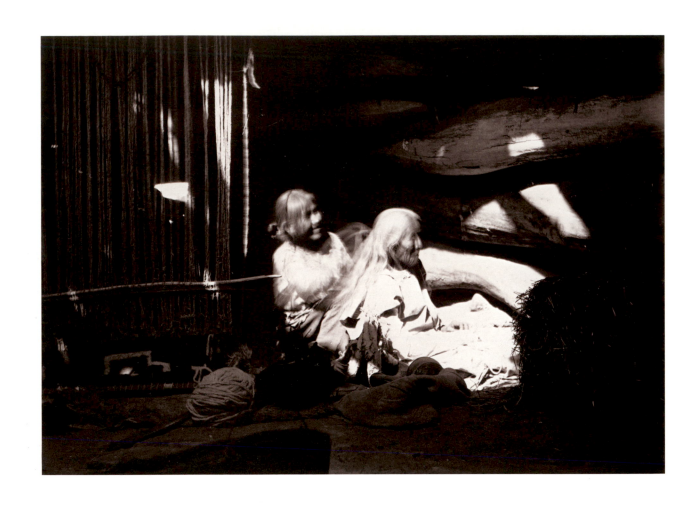

258. *Navajo women grooming their hair, about 1910–1920.* Modern print from a negative at the Museum of New Mexico, Santa Fe (negative number 21635). The Princeton Collections of Western Americana

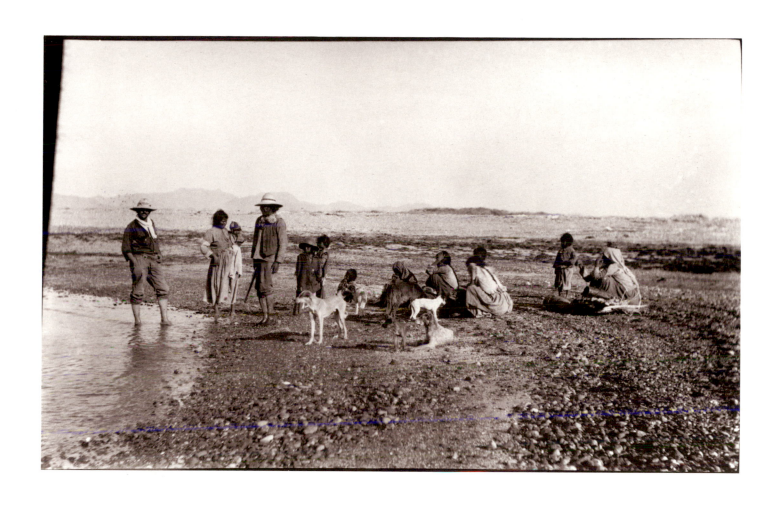

259. Edward H. Davis (1862–1951), *Seri Indians waiting for the boat, Tiburon Island, Mexico, 1922.* Modern print from a negative at The Museum of the American Indian, Heye Foundation, New York City, 20.5 × 25.3 cm. The Princeton Collections of Western Americana

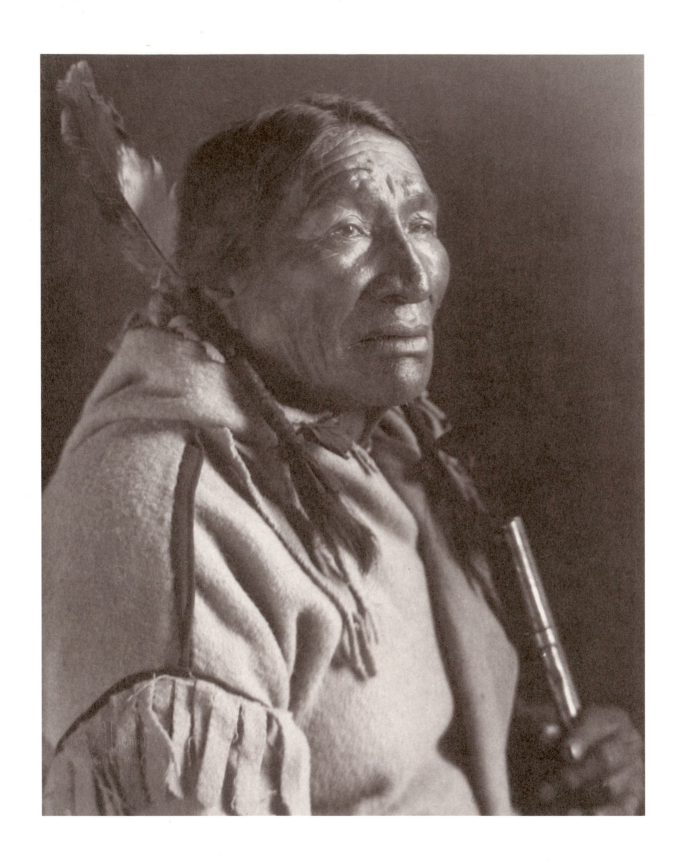

260. Tomer J. Hileman (1882–1945), *Plains Man, 1927*. Silver print, 24 × 19 cm. Collection of Lori and Victor Germack

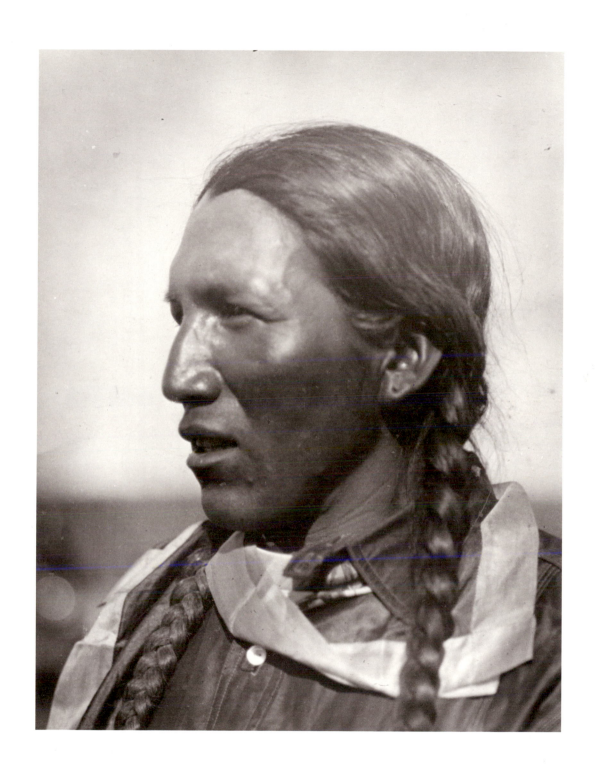

261. Frederick Allen Williams (1898–1958), *Apache Man, Dulce, New Mexico, 1927*. Silver gelatin print, 30.7 × 26 cm. The New York Public Library, Photography Collection

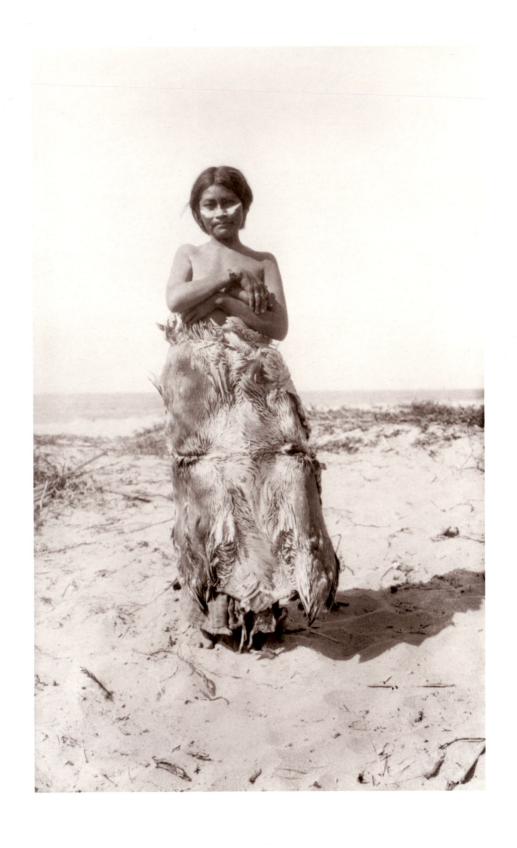

262. Edward H. Davis (1862–1951), *Seri woman in a pelican skin blanket, Tiburon Island, Mexico, 1922.* Modern print from a negative at The Museum of the American Indian, Heye Foundation, New York City, 24.5 × 15.5 cm. The Princeton Collections of Western Americana

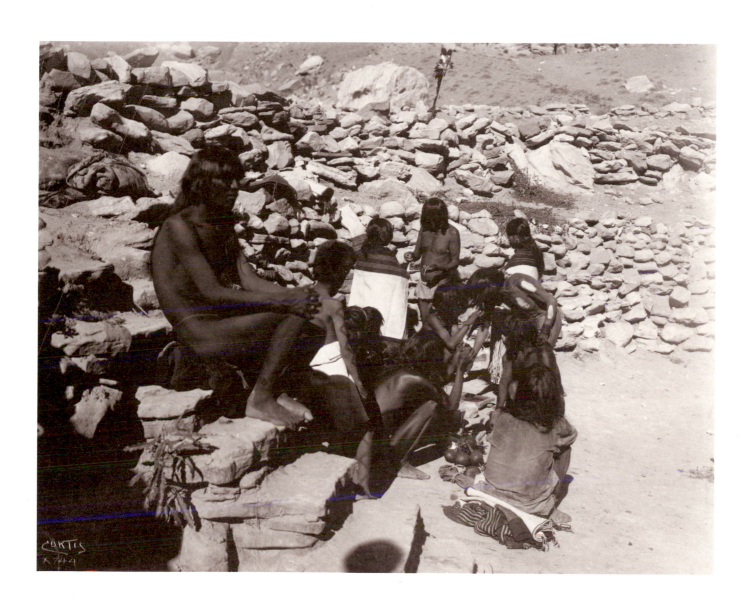

263. Edward Sheriff Curtis (1868–1952), *Preparations for a ceremony in the Hopi villages*. Albumen print. Collection of Alfred L. Bush

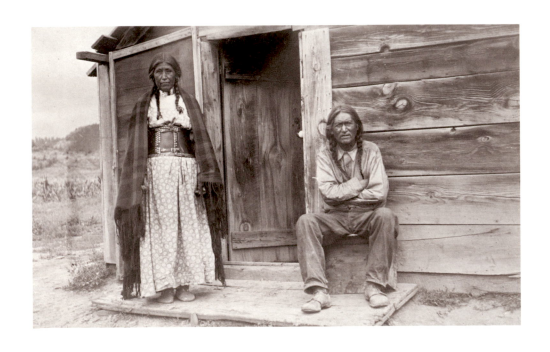

264. Katherine S. Kilbourne (1873–1968), *Harry Gene Largo and his wife, Jicarrilla Apaches, Dulce, New Mexico, 1931.* Silver print. The Princeton Collections of Western Americana, Gift of William S. Kilbourne

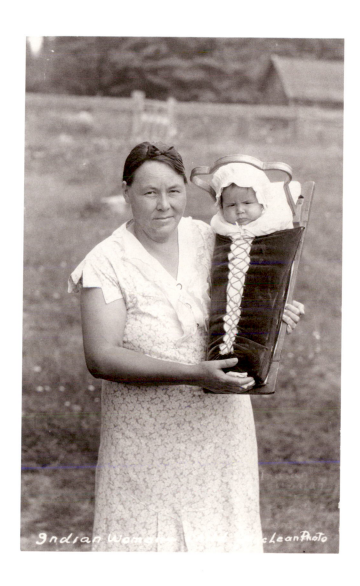

265. MacLean Photo, *Indian woman and child*. Photographic postcard. The Princeton Collections of Western Americana

247

266

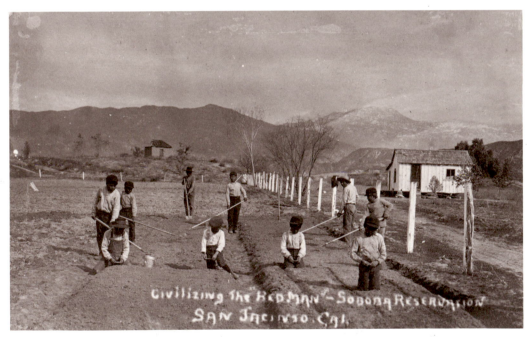

267

266. *"The Battle of Sobora," Mission Indian children at play.* Photographic postcard, once in the collection of George Wharton James. The Princeton Collections of Western Americana

267. *"Civilizing the 'Red Man'—Sobora Reservation, San Jacinto, Cal." Mission Indian children at work.* Photographic postcard, once in the collection of George Wharton James. The Princeton Collections of Western Americana

268. *"Sobora Reservation, San Jacinto Cal." Three Mission Indian children at play.* Photographic postcard, once in the collection of George Wharton James. The Princeton Collections of Western Americana

269. *Miami Herald* photograph. *Howard Tiger, first Seminole volunteer in the Marine Corps, displays his new uniform to his family at the Seminole Indian Agency, Fort Myers, Florida, 1942.* Silver print, 20.9 × 25.4 cm. Archives of the Association on American Indian Affairs, The Princeton Collections of Western Americana

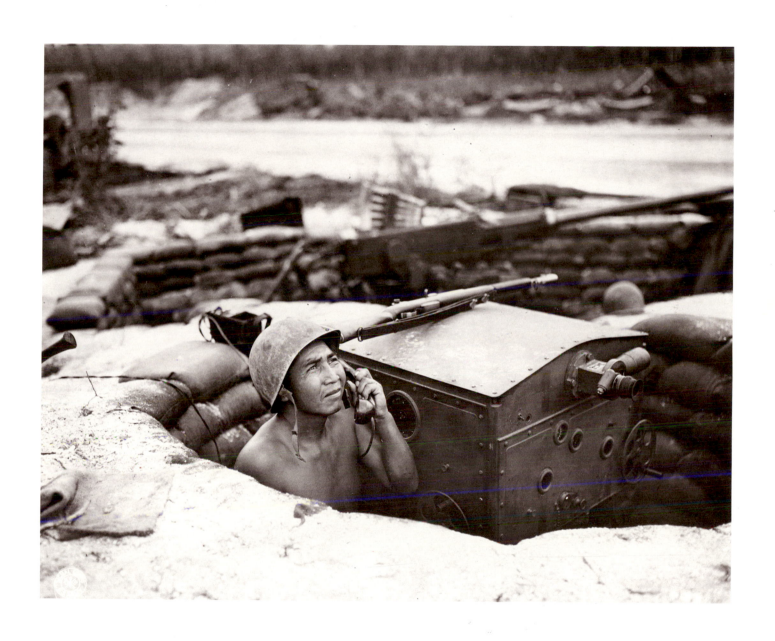

270. William Guyon, *Pvt. Henry Bobb, Paiute from Fallon, Nevada, operates telephone of director finding equipment for the 211st Coast Artillery in the Admiralty group of the South Pacific, 1944.* Silver print, 20.6 × 25.4 cm. Archives of the Association on American Indian Affairs, The Princeton Collections of Western Americana

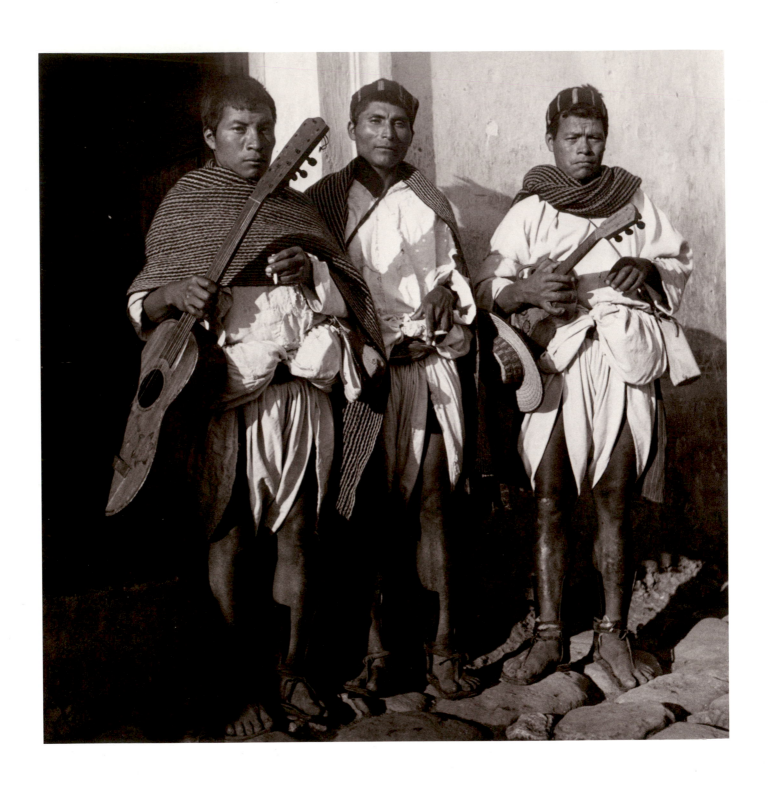

271. Gertrude Duby Blom (1901–1993), *"Maya Musicians; Chilil, Huistan; 1952."* Plate VI from the 1982 portfolio titled *Chiapas Maya.* Silver print, 22 × 23.8 cm. The Princeton Collections of Western Americana, Gift of David Hunter McAlpin

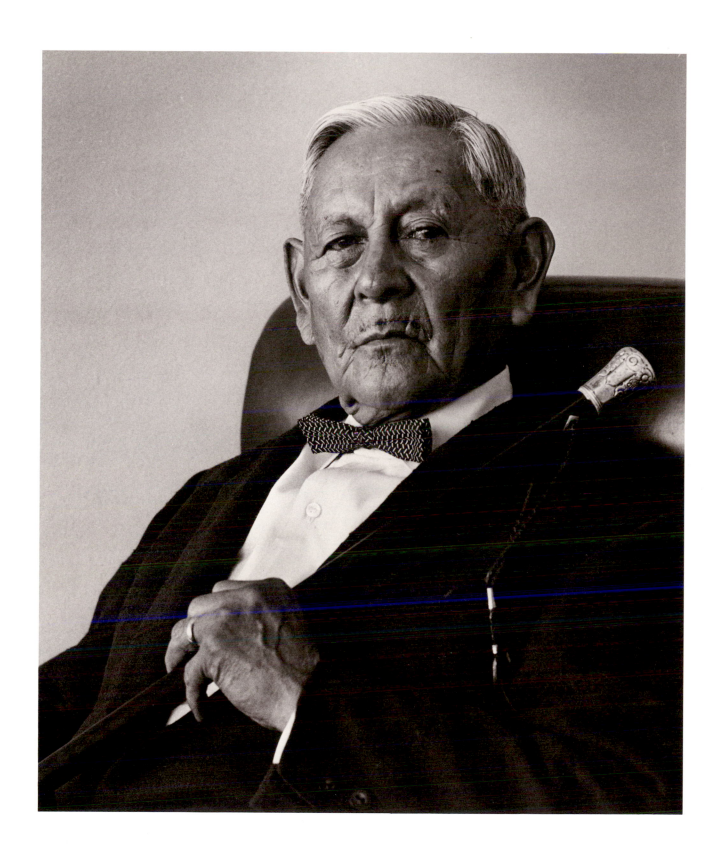

272. Lee Marmon (Laguna Pueblo, born 1925), *Walter Sarracino (1890–1964), with the governor's cane of office, Laguna Pueblo, 1953*. Silver print, 28.5 × 24.2 cm., one of twelve portraits in a portfolio titled *Laguna Ha'Ma Ha'*, 1986. The Princeton Collections of Western Americana

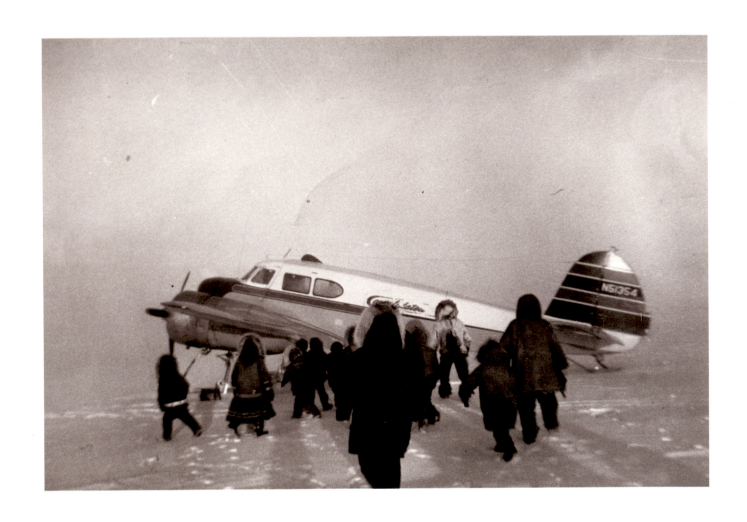

273. *An Eskimo snapshot, village of Tununak, Alaska, about 1960.* Silver print by Alex Harris from the Eskimo original. Collection of Alex Harris

274. Gladys Seufert (born 1913), *Hanna Yallups and Lily Heath roasting salmon at an Indian Festival in Celilo Park, 1967.* Silver print from a negative in the collections of the Oregon Historical Society. The Princeton Collections of Western Americana

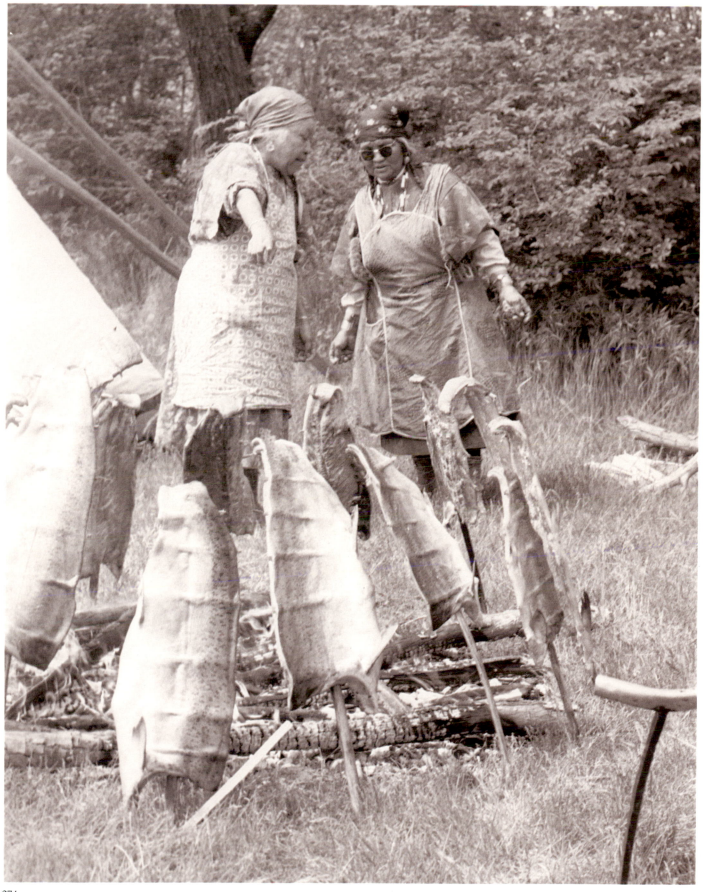

275. Adelaide de Menil (born 1935), *A confrontation at Kingcome Inlet, British Columbia, 1968.* Silver print. The Princeton Collections of Western Americana, Gift of the photographer

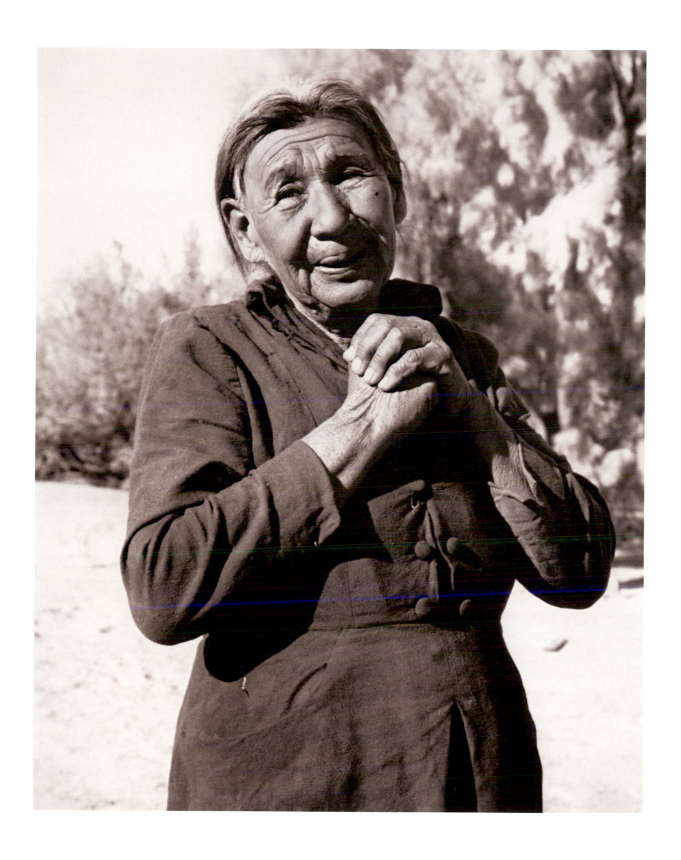

276. Anita Alvarez de Williams (born 1931), *"Adelaida telling her Dream," 1972.* Adelaida Gonzalez Saiz, a Cocopa (who died in her nineties in 1985), photographed near her house on the Hardy River in Baja California. Silver print, 25.3 × 20.3 cm. The Princeton Collections of Western Americana, Gift of the photographer

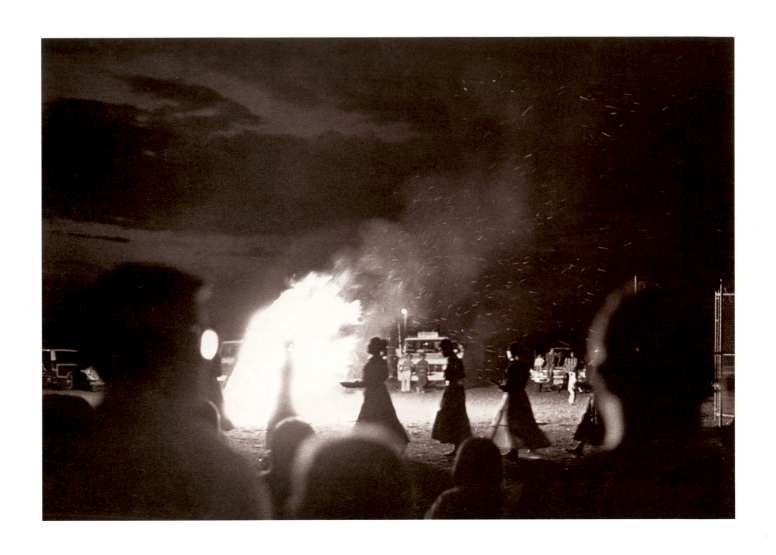

277. A. Boyd Whitesinger (Navajo, born 1946), *Night ceremony*. Silver print, 20.5 × 25.3 cm. The Princeton Collections of Western Americana, Gift of the photographer

278. David Noble (born 1939), *Mohawk Steelworker, New York City, 1970.* A print from a portfolio of photographs of American Indians produced in 1973. Silver print, 7.3 × 24.7 cm. The Princeton Collections of Western Americana

279. Douglas Kent Hall (born 1938), *A Taos elder*. Silver print. The Princeton Collections of Western Americana

280. Owen Seumptewa (Hopi, born 1946), *A young sacred clown*. The photograph was taken at the Second Mesa Day School during Indian Day, 1973. Silver print, 25 × 16.2 cm. Collection of the photographer

281. Robin Lloyd (born 1950), *Three American Indian students at Princeton 1973.* From top down: Regis Pecos (Cochiti Pueblo), Conroy Chino (Acoma Pueblo) and Lily Shangreaux (Lakota). Silver print. Collection of Alfred L. Bush

282. Alex Harris (born 1949), *Lizzie Lee, Shungnak, Alaska, 1974*. Silver print. The Princeton Collections of Western Americana

283. Stanley T. Malincay (Pomo), *Pomo Dancer*. Silver print, 39.3 × 31 cm. Collection of the photographer

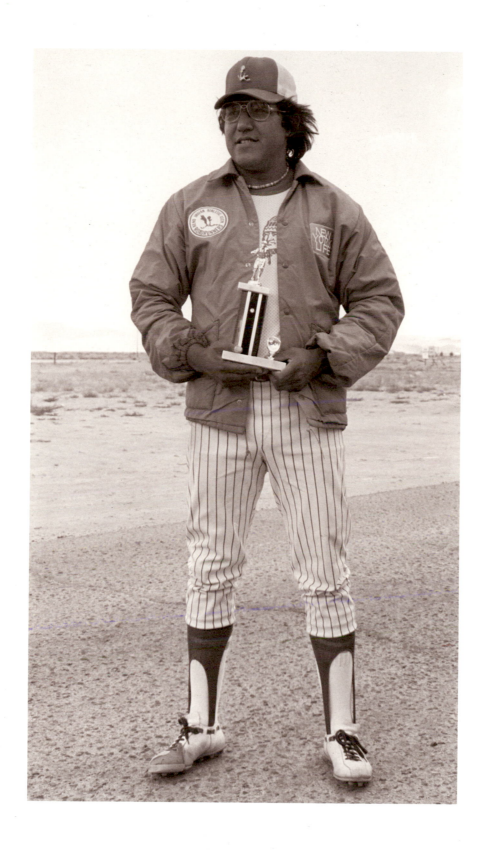

284. Dugan Aguilar (Pit River-Maidu-Northern Paiute, born 1947), *Native with trophy*. Silver print. Collection of the photographer

285. Roger Manley (born 1952), *Women playing Cidil, Navajo community of Chil-Chin-Beto, 1980*. Silver print, 47 × 34 cm. The Princeton Collections of Western Americana

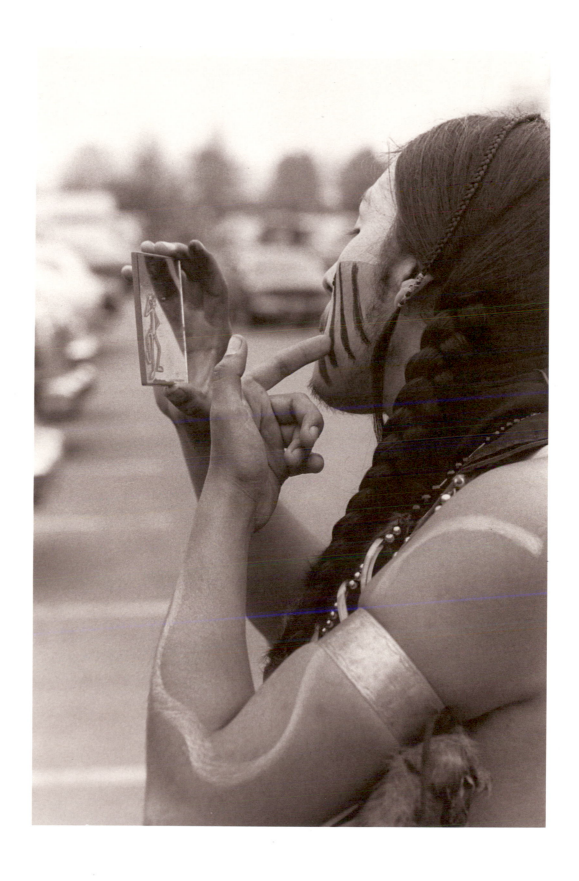

286. Jeffrey M. Thomas (Onondaga–Cayuga, born 1956), *Richard Poofpybitty, Comanche-Omaha*. Part of Thomas's "Pow Wow Dance Series." Collection of the photographer

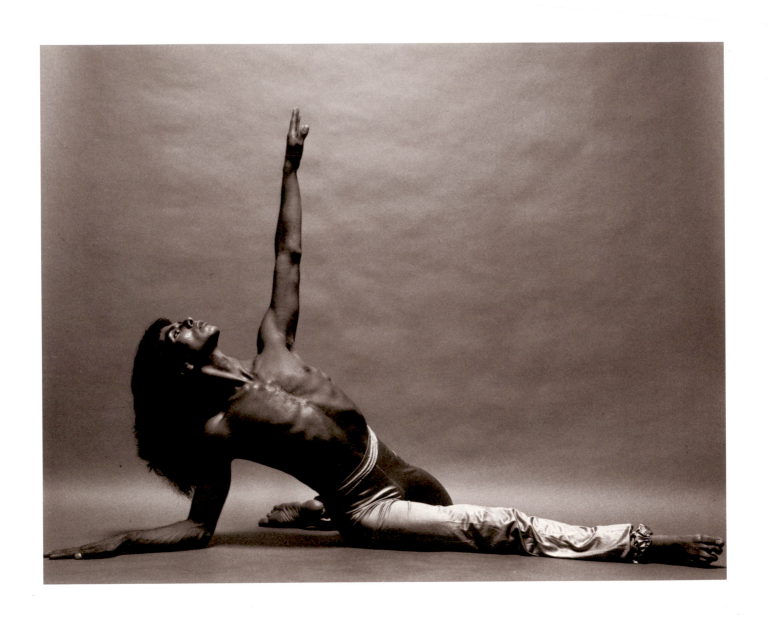

287. Frank Richards (born 1936), *Rene Highway, a Cree dancer with the Toronto Dance Theatre, 1979*. Silver print, 20.6 × 25.5 cm. The Princeton Collections of Western Americana, Gift of the photographer

288. Hope Wurmfeld (born 1939), *Jock Soto, Navajo dancer with the New York City Ballet, 1985.* Silver print, 35.5 × 27.8 cm. The Princeton Collections of Western Americana, Gift of the photographer

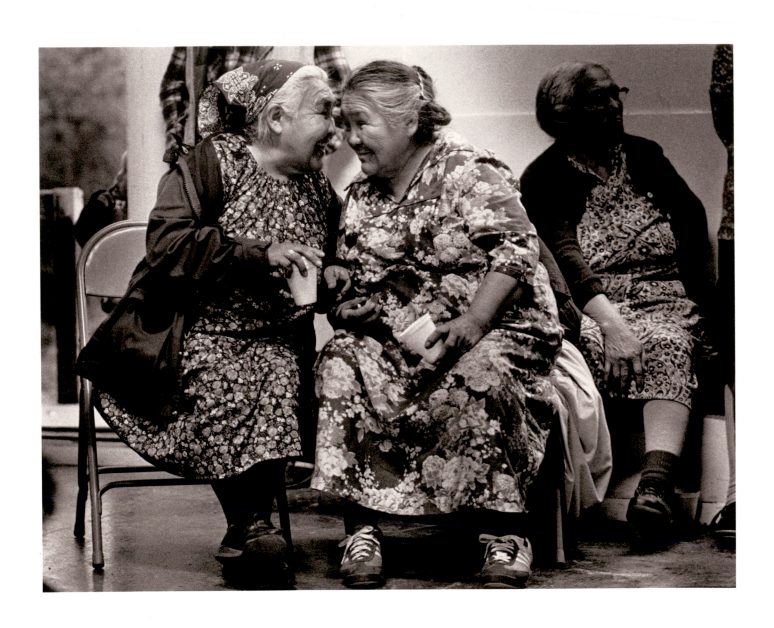

289. William Hess (born 1950), *Alaskan Women*. Silver print, 28 × 35.6 cm. Collection of the photographer

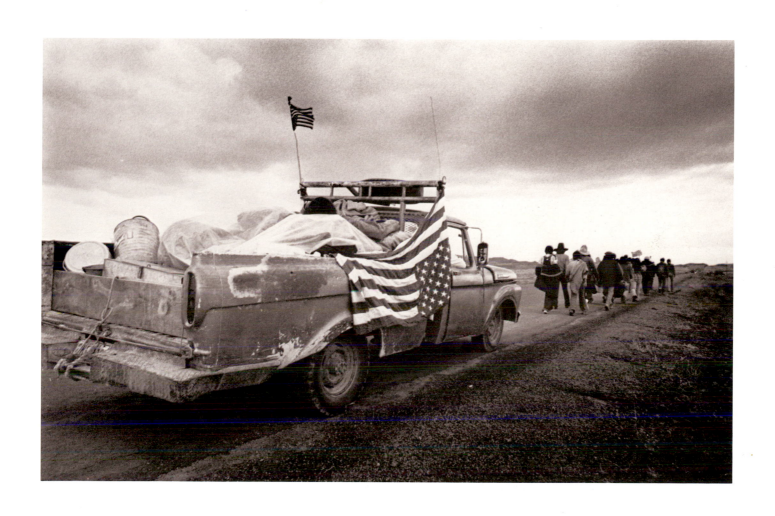

290. Paul Natonabah (Navajo, born 1944), *Demonstration against Relocation*. Silver point, 20.3 × 25.4 cm. The Princeton Collections of Western Americana, Gift of the photographer

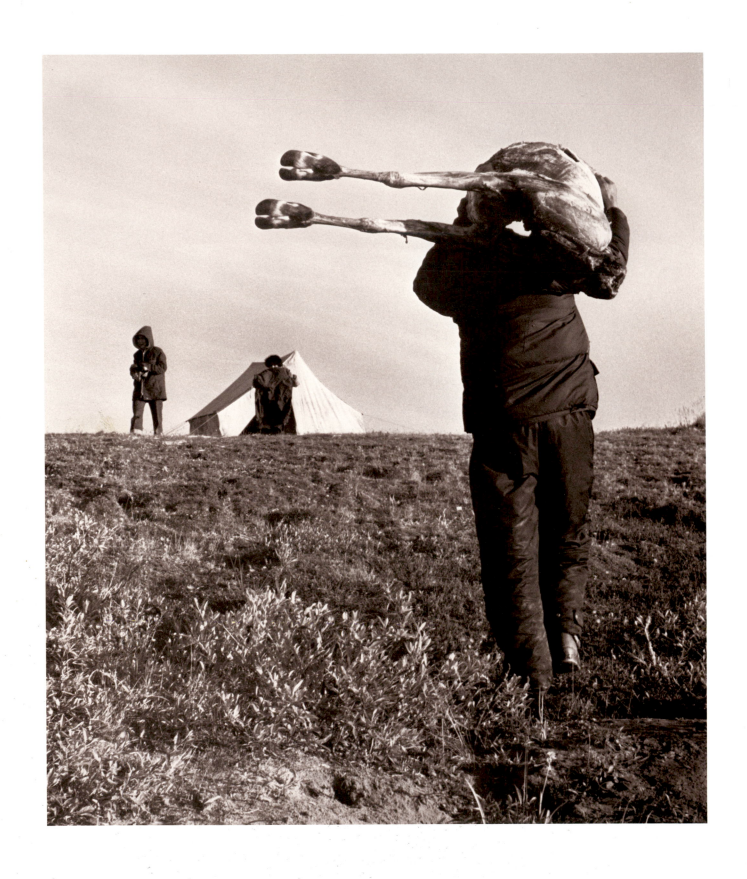

291. Ulli Steltzer (born 1923), *James Raben with a caribou, Panlatuk, North West Territories, 1980*. Silver print, 35.5 × 28 cm. The Princeton Collections of Western Americana, Gift of the photographer

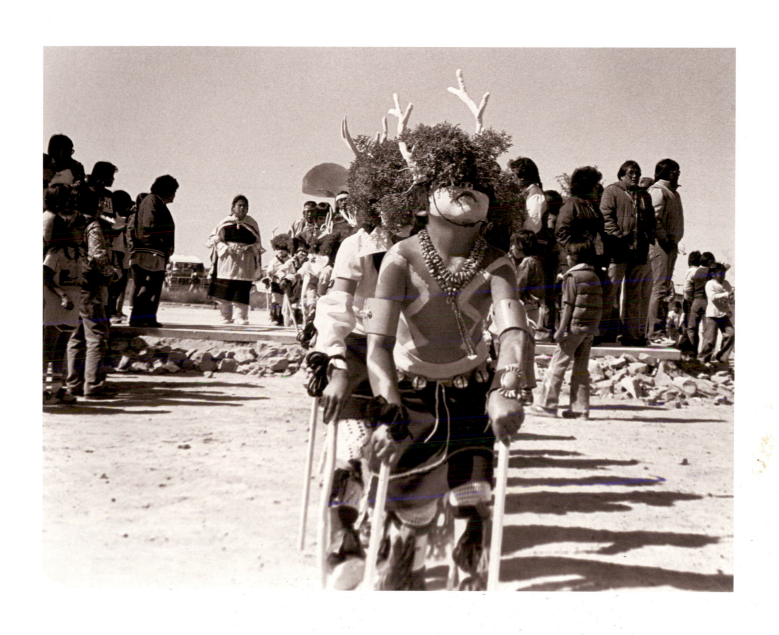

292. Merwin Kooyahoema (Hopi, born 1957), *Deer dancers, 1980*. Silver print, 8 × 23 cm. Collection of the photographer

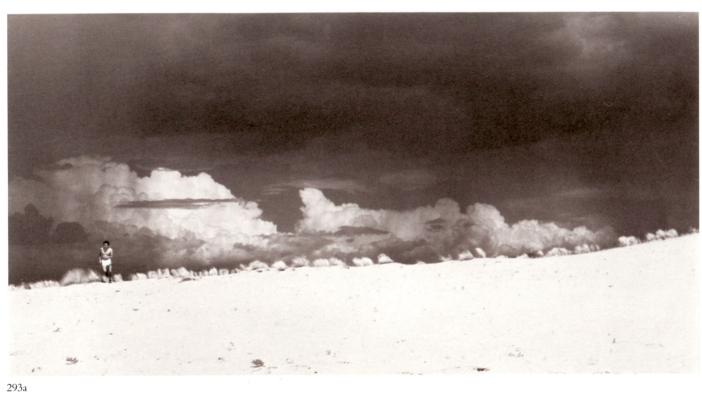

293a

293b

293. Victor Masayesva, Jr. (Hopi, born 1951), *Rain Runner*. From "Masks & Metaphors No. 2, 1983–1984." A solitary Hopi runner is seen through two openings in these paired photographs, suggesting the view from a kachina mask. Silver prints. The Princeton Collections of Western Americana, Gift of Douglas Ewing

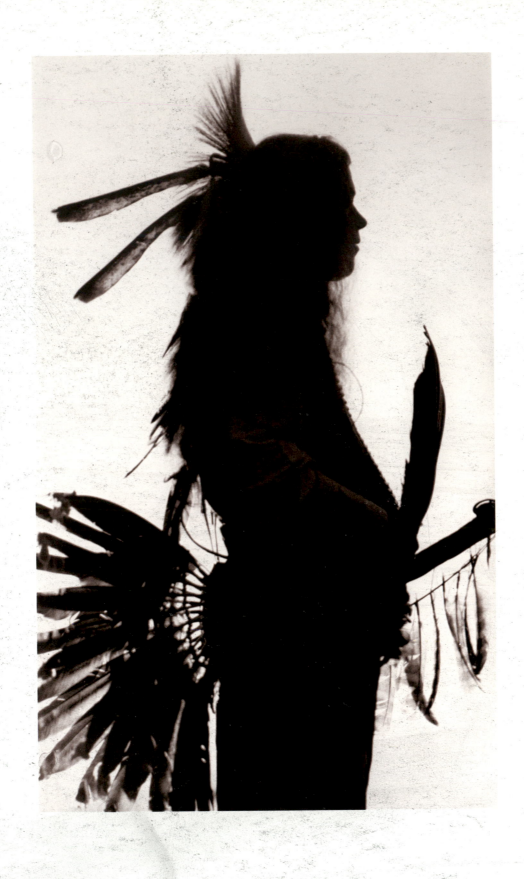

294. Christopher Sheriff (born 1952), *Silhouette with Feathers, 1983.* Photographed in Minneapolis, Minnesota. Silver print, 35 × 21 cm. Collection of the photographer

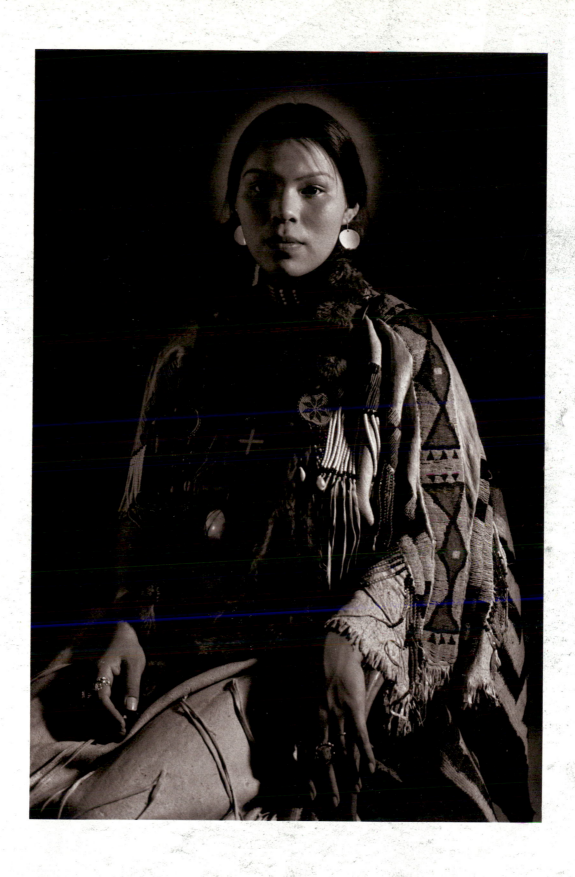

295. Hulleah J. Tsinhnahjinnie (Navajo-Creek-Seminole, born 1954), *"Idelia," 1983*. Silver print, 76 × 51 cm. The Princeton Collections of Western Americana, Gift of Donald Mackie

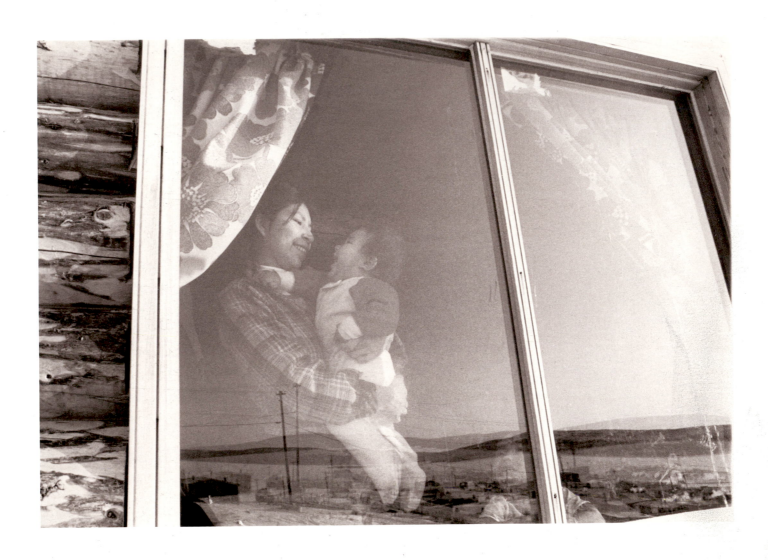

296. Dorothy Chocolate (Dene, born 1959), *Verna Catholique, with her son, Snowdrift, North West Territories, 1984*. Silver print. The Princeton Collections of Western Americana

297. Everett Scott (born 1952), *Genizaro, 1985*. Silver print, 50.5 × 40 cm. The Princeton Collections of Western Americana, Gift of the photographer

298. Larry McNeil (Tlingit-Nishka, born 1955), *Yupic Eskimo woman weaving a basket*. Silver print. The Princeton Collections of Western Americana

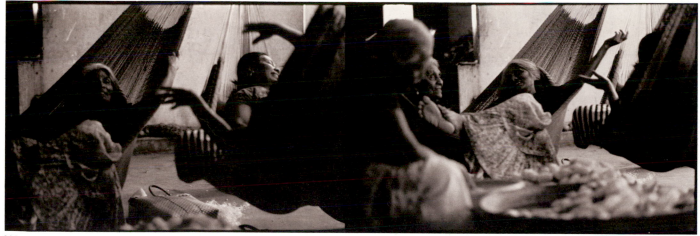

299

300

299. Cynthia Wooley (born 1955), *Tehuanas, Tehuantepec, Mexico, 1985*. Silver print. Collection of Alfred L. Bush

300. Herbert Zazzie (Navajo, born 1965), *Dancer, 1985*. Silver print. The Princeton Collections of Western Americana, Gift of the photographer

301. Jolene Rickard (Tuscarora, born 1956), *Giving Thanks II*. Silver print. Collection of the photographer

302. Bill Wright (born 1933), *Dance during celebrations for St. Anthony, Ysleta, Texas, 1987.* Silver print, 20.2 × 25.4 cm. The Princeton Collections of Western Americana, Gift of the photographer

303. Margaret Morgan (born 1926), *Two Princeton undergraduates: Yolandra Gomez (Jicarilla Apache) and Rex Lee Jim (Navajo), on the campus, June 1985.* Silver print. The Princeton Collections of Western Americana, Gift of the photographer

284

Color Plates

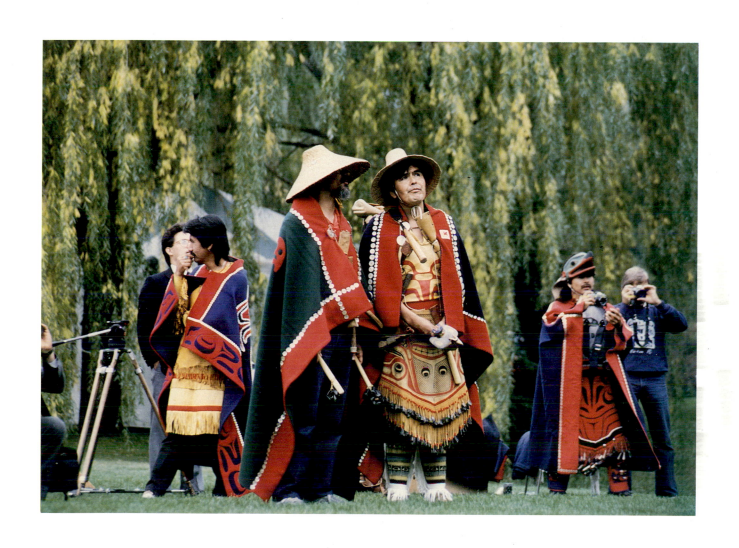

1. James Floyd (born 1947), *Haidu photographers at the raising of a totem pole, Pepsico Sculpture Garden, Purchase, New York, September 19, 1986.* Color print. Collection of the photographer

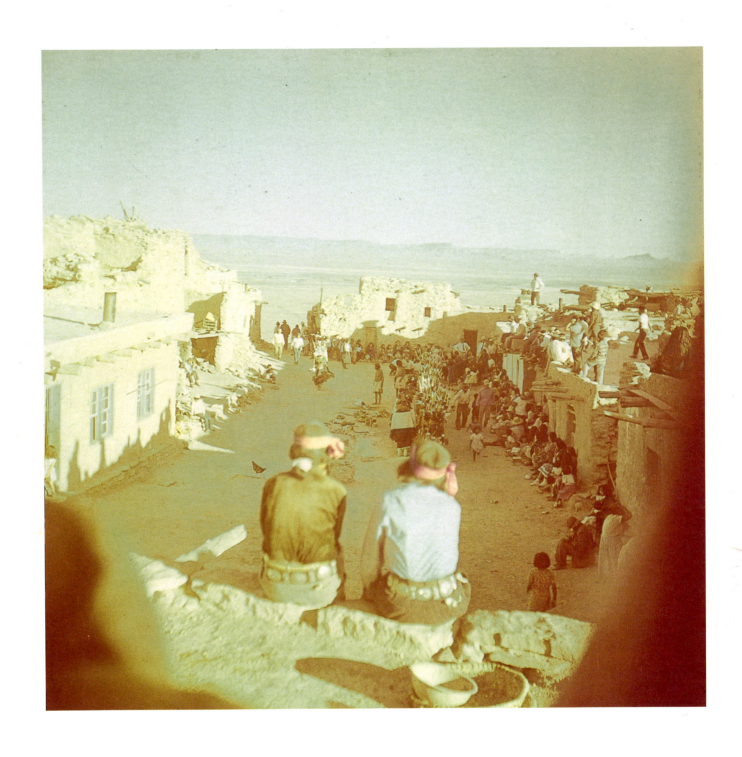

2. Jean Fredericks (Hopi, 1906–1990), *Niman ceremony, Mishongovi, Second Mesa, about 1945.* Color print. The Princeton Collections of Western Americana, Gift of the photographer

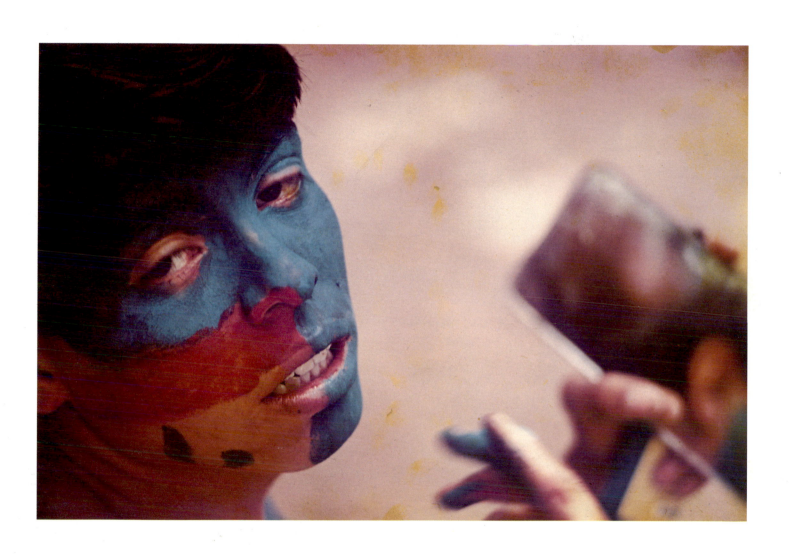

3. Marcia Keegan (born 1942), *Preparing for the Nambe dance*. Collection of the photographer

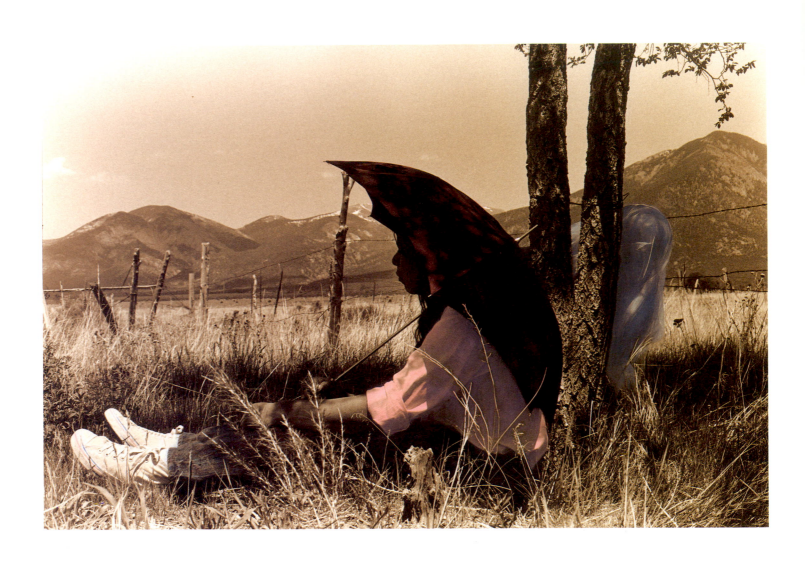

4. Carm Little-Turtle (Apache/Tarahumara, born 1952), *The parasol near Taos*. Color print. The Princeton Collections of Western Americana

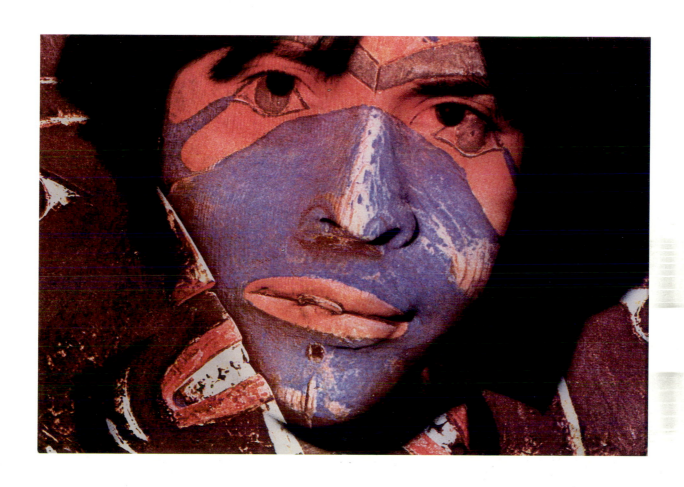

5. Jesse Cooday (Tlingit-Nishka, born 1955), *Self-portrait*. Mixed media. Collection of the artist

6. Skeet McAuley (born 1951), *Navajo window washer, Monument Valley Tribal Park, Arizona, 1984.* Color print. The Princeton Collections of Western Americana

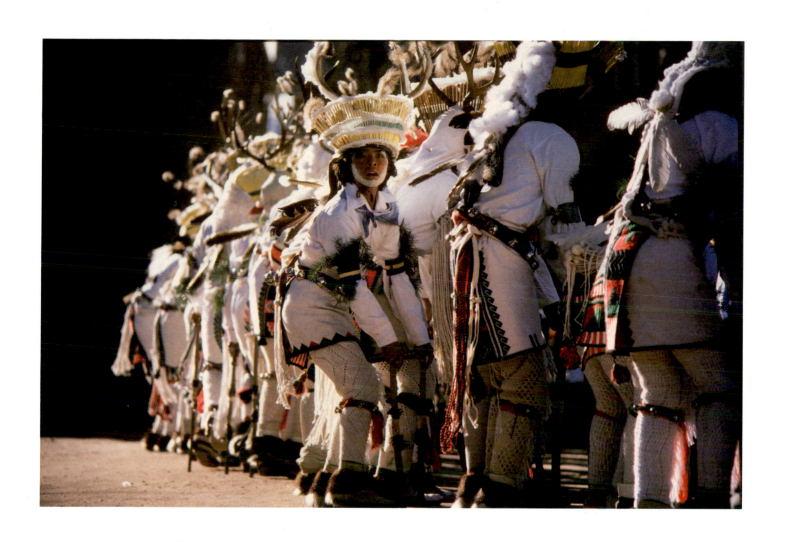

7. Stephen Trimble (born 1950), *Deer Dance at San Juan Pueblo, 1986*. Color print. Collection of Alfred L. Bush

8. Paul Tioux (Sioux, born 1959), *Bay-povi and Nana at the Tesuque Water Tower, 1986*. Color print. Collection of the photographer

Biographies of Photographers

These sketches of some of the photographers represented in this volume are drawn from publications cited in the bibliography and from interviews and correspondence preserved in the Princeton Collections of Western Americana.

AGUILAR, DUGAN (Pit River-Maidu-Northern Paiute, born 1947)

With a 1973 degree in Industrial Technology/Design from California State University, Fresno, Dugan Aguilar pursued his interest in photography at the University of Nevada, Reno. In 1977 he taught photography and graphic arts for the Inter-Tribal Council of Nevada. His earliest exhibition entries, at the 1981 CAL EXPO Indian Days Art Show, won first and third places. That same year Aguilar continued his education in photography at the University of California, Davis.

Drawn to the art of Ansel Adams at a San Francisco exhibition in 1982, Aguilar participated in Adams' Yosemite Workshop the following year, when he also attended a photography workshop at the University of California, Santa Cruz. Since 1984 Aguilar's photographs have been exhibited throughout the West at such institutions as San Francisco's American Indian Contemporary Arts Center, Stanford University, The Arizona Commission of the Arts, the Scottsdale Indian Art Show, and the Chaw'se Indian Art Show in Grinding Rock, California. From 1986 to 1989 he took part annually in the Red Cloud Indian Art Show in Pine Ridge, South Dakota.

Aguilar has worked for the University of Nevada's Desert Research Institute and for the *Sacramento Bee*. His photographs have been published in the *Bee*, as well as in *Sesame Street Magazine*, *The Native Nevadan*, and *Parenting Connections*.

Dugan Aguilar's name, which translates as "Dark Eagle" from its Gaelic and Spanish roots, reflects the photographer's Irish and American Indian ancestry. Aguilar's mother is from California's Pit River and Maidu tribes, while his father is from Nevada's Walker River Paiute Tribe.

ANDERSON, GEORGE (1860–1928)

George Anderson, born in 1860 to Mormon converts from Scotland and England, arrived in Utah during the 1870s, became an apprentice to the photographer Charles Savage, and, in 1877, set up his own studio in Salt Lake City. His photographic career took him from town to town in Central Utah. He finally settled in Springville at the turn of the century. En route to England in 1905 as a Mormon missionary he photographed Mormon historical landmarks and published *The Birth of Mormonism in Pictures* in 1909. He devoted the rest of his life to photographing Mormon historical sites and recording rural life in Mormon Utah, where he died in 1928.

ANDERSON, JOHN ALVIN (1869–1948)

In 1884 John Anderson immigrated with his family from Sweden to the United States, settling in Cherry County, Nebraska. The following year he was commissioned as a civilian photographer for the U.S. Army at Fort Niobrara, Nebraska, and began photographing across the state border on the Rosebud Reservation in South Dakota. He later established a studio in Valentine, Nebraska, and in 1889 photographed the Crook Treaty Commission with the Sioux at the Rosebud Agency.

Anderson spent much of the early 1890s in Pennsylvania but returned to the Rosebud Reservation to work as a clerk in the trading post there. He lived among the Brule Sioux and was privileged to photograph many of their ceremonies. He documented villages and schools, councils and beef-issues, and in 1896 published *Among the Sioux*. After 1900 Anderson's interests shifted to portraiture and posed tableaux of daily rituals. In 1936 he developed and became director of the Sioux Indian Museum in Rapid City, South Dakota, and two years later sold his collection of Indian artifacts to the U.S. Department of the Interior. In 1939 he moved to California, where he died in 1948.

BARRY, DAVID F. (1854–1934)

David Barry was born in Honeoye Falls, New York. In 1861 he moved with his family to Oswego, Wisconsin, where he met—and carried water for—itinerant photographer O. S. Goff. In 1878 Barry became Goff's assistant in Bismarck, Dakota Territory. The following year, while Goff traveled, Barry managed the studio, eventually taking it over as his own. He set up a branch studio in the early 1880s at Fort Buford, from which he traveled to photograph at Fort McGinnis, Fort Yales, and Fort Custer. In 1886 Barry photographed the twentieth-anniversary commemoration of the Battle of the Little Big Horn.

Having appropriated many of Goff's images as his own by 1890, Barry sold the Bismarck studio to William DeGraff, moved to Superior, Wisconsin, and there opened a new photographic establishment. In 1897 he closed this business and moved to New York City to try his hand at photography there. He returned to Wisconsin after only one year. Barry made a final journey to the Little Big Horn battlefield in 1925 to observe its fiftieth anniversary. He continued his studio work in Superior until his death in 1934.

BELL, CHARLES MILTON (1848–c.1893)

Born in 1848 in Virginia, Charles Milton Bell was the youngest of a family of photographers who established themselves in Washington, D.C., in the 1860s. There he collaborated with Francis, William, Jackson, Nephi, James, and Thomas Bell in establishing a number of partnerships, eventually becoming the sole proprietor of Bell & Brothers.

Some of Charles Bell's work was listed in William Henry Jackson's 1877 catalogue. Because the Jackson catalogue did not properly credit Bell's work and because both Bell and Jackson appropriated images belonging to the U. S. Geological Survey, Bell was subsequently plagued by problems of attribution. He proceeded nonetheless with his important work of documenting Indian delegations to Washington. Upon Bell's death in 1893 his photographic business continued under the management of his wife.

BLOM, GERTRUDE DUBY (1901–1993)

Born Gertrude Elizabeth Loertscher in Bern, Switzerland, she was raised and educated in the village of Wimmis where her father was a Protestant minister and where she learned about American Indians through the works of Karl May. At an early age she married Kurt Duby, general secretary for the trade union for Swiss railway workers, who introduced her to socialist ideas. She studied both horticulture and social work and was soon deeply involved in the politics of the socialist movement. She began writing for socialist newspapers in Switzerland and traveled throughout Europe as a correspondent reporting on the movement. After her divorce from Duby she campaigned in Germany for the Social Democratic party. In 1939 she came to the United States to organize a woman's world congress against war. On her return to Europe she was arrested in Paris as an anti-fascist and placed in a detention camp for five months. In 1940, frustrated by her unsuccessful fight against fascism, she left for Mexico as a refugee, and there spent the rest of her life. In her early years in Mexico she worked as a social worker and journalist. She was especially concerned about the working conditions of Mexican women and published a series of articles on women who had fought in Zapata's revolutionary army. In connection with this series she purchased a camera from a fellow refugee and took her first photographs.

She arrived in Chiapas in 1943 where she first photographed Mayas on an expedition into the Lacandon jungle. The rest of her life was devoted to efforts to protect both the Lacandon Maya and their environment against the onslaught of the twentieth century. She married Frans Blom, a distinguished Danish anthropologist and explorer of southern Mexico. In 1950 they purchased the building in San Cristobal de Las Casas which was to become Na Bolom, their residence and a center of scientific, cultural, and aesthetic activity in the Maya highlands. Though Trudy, as she was known to all, insisted she was not a photographer in any formal sense, her photographs of the Maya and the Lacandon jungle soon became an important tool in her advocacy of both. Her photographs were published, exhibited, and sold to museums, libraries, and private collectors in Europe, Mexico, and the United States, culminating in a retrospective exhibition at the International Center of Photography in New York City in 1984 with the accompanying volume, *Gertrude Blom, Bearing Witness*. She continued her crusade to bring Mexicans to a recognition of the value of the rain forest and its indigenous peoples to the last years of her life, photographing, reforesting, lecturing, and responding to the needs of her Lacandon Maya friends.

BONAPARTE, PRINCE ROLAND NAPOLEON (1858–1924)

Roland Bonaparte was the grandson of Lucien, second brother of Emperor Napoleon I. Because the laws of his native France prohibited him from pursuing a military career, he cultivated an interest in the sciences. Trained in geography and ethnology, he traveled to Amsterdam to photograph the 1883 Colonial Exposition. In 1887 Bonaparte crossed the Atlantic to photograph the North American Indian—a pursuit that would continue when Indian delegations later visited his studio in France—and came to be noted for his portraits of Omaha chiefs in ceremonial attire. By 1906 Bonaparte's collection included over 7,000 negatives. His North American Indian album, *Peaux Rouges*, was donated to the Smithsonian Institution.

BOWMAN, WALTER SCOT (1865–1938)

Walter Bowman's father homesteaded in Pendleton, Oregon, and is reported to have built the first house there. The son, who was a successful commercial photographer in Pendleton for most of his adult life, began as an itinerant photographer in Eastern Oregon from 1887 through 1890 when he established himself permanently in Pendleton. By 1892 he was advertising himself as a "Leading Photographer and View Artist, Copying, Enlarging, Tin Types, Stamp Photos on Silk, etc" on Main Street. Bowman was a strong supporter of the Pendleton Round-Up, which began in 1910. He photographed the initial event and those of each successive year. These photographs were widely published, made available as postcards, and were an important factor in bringing the celebration to wide public attention.

BRADY, MATHEW B. (1823–1896)

Celebrated as the photographer of the Civil War and for his ambitious *Gallery of Illustrious Americans*, Brady aspired to be a painter and learned the daguerreotype process from Samuel F.B. Morse and John W. Draper. Brady opened a portrait studio in New York City in 1844 and another in Washington in 1849, which failed. His second attempt at a studio in Washington, about 1858, was successful and continued until 1881. There he and his assistants photographed Indian delegations visiting the capitol. His New York studios photographed Indian participants with P. T. Barnum's circus. Brady's studios were the training grounds for numerous American photographers in the second half of the nineteenth century.

BUEHMAN, HENRY (1851–1912)

A native of Bremen, Germany, Henry Buehman immigrated to the United States, arriving in San Francisco in 1868. He worked at a photographic studio there and in 1869 established his own studio in Visalia, California. From 1871 to 1874 Buehman traveled in California, Arizona, Nevada, and Utah, photographing landscape and people. He settled in Tucson, Arizona, in 1874 where he purchased the studio of Julio Rodrigo. In 1883 he formed a partnership with F. A. Hartwell, who had worked as his assistant, which lasted until 1889. Although he is one of the major photographers of Arizona, amassing an important collection of images of the

Apache, Cocopa, Pima, and Papago people, Buehman was also a successful surgeon-dentist and Mayor of Tucson (1894–1898).

CADZOW, DONALD A. (active 1917–1926)

Born in Auburn, New York, of Russian and Polish stock, Cadzow was the nephew of Daniel Cadzow who spent the greater part of his life in the Canadian Northwest, establishing the trading post, Rampart House, eighty miles from the Arctic Circle. In 1911 Donald joined his uncle at this remote post where Athapascan Loucheux Indian territory and Nunatagmiut Eskimo lands met. After five years working for his uncle, young Cadzow made his way by dog sled to Skagway, and thence home to New York with a collection of ethnographic materials. On the basis of this group of objects Cadzow joined the staff of the Museum of the American Indian, Heye Foundation, of New York City and promptly returned north on a collecting trip. It is reasonable to assume that photographs were also an object of these travels, since his photographs from these journeys are now part of the collections of the Museum. He sought out objects of material culture from among the Copper and Kogmollik Eskimo and crossed the Endicott Mountains to enter Alaska. Once in Alaska, World War I drew Cadzow into joining the United States Navy, where he received an Ensign's commission. At the conclusion of the war, accompanied now by a wife, Cadzow ventured again to the Arctic to study the Athabaskan tribes.

Cadzow later journeyed to New Mexico as a member of the Hodge expedition excavating at Hawikah. He also traveled with M. R. Harrington during investigations in the Ozark Mountains. He returned north at least once more to collect for the Heye Foundation among the Plains Cree and their neighbors on the prairies west of Hudson's Bay.

CARTER, CHARLES WILLIAM (1832–1918)

British by birth, Charles William Carter served in the Crimean War from 1853 to 1856. While in the army he learned photography and later taught it while a schoolmaster in England. In the late 1850s Carter was converted to Mormonism, and moved in 1859 with his sisters to Utah. There he found work at the Savage and Ottinger Photographic Gallery in Salt Lake City shortly after his arrival. He opened his own photography studio, "Carter's View Emporium," in 1863. Carter's 1887 advertising boasted 1,000 images of "Utah Scenery, Notabilities, Indians." He became known for his portraits of the Mormon religious hierarchy and views of Salt Lake City. But in his notebook he reported with pride the occasion when "Pahute Jim" came to his studio to be photographed and the photographer arranged the Indian in an apparently unprecedented pose, with his arm around his wife. Carter used the wet-plate process into the 1890s, long after it became obsolete. In later years he sold his historic pictures to tourists on Temple Square in Salt Lake City. His negatives were sold in 1906 to the Bureau of Information of the Mormon Church which discovered Carter's extensive collection in its archives in 1963.

CHOATE, JOHN NICHOLAS (1848–1902)

In 1878 Captain Richard Henry Pratt began recruiting students, primarily from the Rosebud and Pine Ridge reservations, to attend a training school for Indians in Carlisle, Pennsylvania. When the school opened in 1879, John Choate, originally from Maryland, became its official photographer. He had established himself as a photographer in Carlisle in 1875. Choate continued work there and as the Indian school photographer until his death in 1902, documenting the students on arrival and the school's transformation of them. He also recorded visiting Indian delegations and Indian relatives, and views of the school at work. His photographs were available for purchase at the school. An important collection of Choate's work is held by the Cumberland County Historical Society at the Hamilton Museum in Carlisle.

CHOCOLATE, DOROTHY (Dene, born 1959)

One of twelve children, Dorothy Chocolate was born and raised in the Rae Lakes area of the Northwest Territories, where her father was a hunter and trapper. She attended school in Yellowknife, worked for *Native Press* (Native Communications Society of the Western N.W.T.), and became a photography editor for the *Northern Star* newspaper there. Her work has been published in the *Native Press* and exhibited through the Native Indian/Inuit Photographers' Association, including *Silver Drum, Five Native Photographers*, in 1986. She is one of the photographers represented in *A Circle of Nations*, 1993. Chocolate is a member of the Rae Dogriv band of the Dene tribe. She lives in Yellowknife with her family.

COHN, AMY (1860–1919)

A native of Pittsburgh, Pennsylvania, Clarrise Amy Cohn is said to have removed to Nevada as a young woman. Married first to August Lewis, of a prominent Nevada family, in 1888 she married Abe Cohn, the owner of the Indian Curio Shop in Carson City and its counterpart in Tahoe. Abe and Amy Cohn became patrons of the now-celebrated Washoe basket maker Datsolalee. They agreed to support her and her husband in exchange for most of the baskets she produced. They promoted her as "Queen of Basket Weavers," and used a registry of her baskets and certificates of authenticity to solidify her position. Amy Cohn was the author of a number of papers on Indian lore and symbolism in which Indian basketry is employed as documentation.

COODAY, JESSE (Tlingit-Nishka, born 1955)

Jesse Cooday was born in Ketchikan, Alaska. His Tlingit name is "Shoowee Ka." He graduated from the Petersburg (Alaska) High School in 1972 and proceeded to New York City, where from 1978 to 1980 he studied photography at the School of Visual Arts. He served as editor for Image Bank from 1986 to 1992. Cooday, who works in mixed media, is currently a New York City resident.

Since 1982 Cooday's photographs have been featured in group exhibitions at the Art Institute of Philadelphia and the Yellowstone Arts Center, among other sites. The Institute of American Indian Arts Museum in Santa Fe, New Mexico, presented his images in the 1993 exhibition "Through the

Native Lens." *The Washington Post* called his work "the most compelling" of those included in "The Submuloc Show," a 1993 travelling exhibition countering the Columbus Quincentennial celebrations. Cooday's art is in the permanent collection of the Heard Museum in Phoenix, Arizona.

CURTIS, EDWARD SHERIFF (1868–1952)

Edward S. Curtis, the photographer most celebrated for his images of the American Indian, was born in White Water, Wisconsin. As a youth he moved to Minnesota where he seems to have found a job in a St. Paul photographer's studio. By 1896 he had received an award from the Photographer's Association of America. He became a commercial Pictorialist, capturing landscapes and composing portraits through a decidedly romantic vision.

A chance meeting with George Bird Grinnell, resulted in his being invited to join the E. H. Harriman expedition to Alaska as official photographer. In 1900, with Grinnell, Curtis visited the Blackfoot reservation in Montana and there began his great enterprise of documenting "the vanishing American." Theodore Roosevelt aided Curtis in obtaining generous patronage from J. Pierpont Morgan, who financed the phototgrapher's dream: over the next six years Curtis and his assistants visited and recorded the people of the tribes of the Southwest, the Great Plains, and the Pacific Northwest. Exhibitions of this work were mounted in 1905 in Washington, D.C., in Boston, New York, and Pittsburgh. The first volumes of Curtis' *The North American Indian* appeared in 1907, the twentieth and final volume and portfolio in 1930. Though praised by many, the enterprise was not a financial success and Curtis was little known at his death in 1952. His work regained its acclaim in the 1970s with the renewal of interest that continues to grow. Curtis' work has been criticized for its romantic objectives, for the editing of "modern" elements from the views, and for his use of props and costumes not current at the time of the photograph. But Curtis' objectives are clearly set out in his work: he was trying to capture a world that had vanished or was about to, and it seems unfair to hold him to standards other than those he set for himself.

DAVIDSON, ISAAC G. (born 1845)

Originally from Warren County, Illinois, I. G. Davidson moved with his family to Oregon in 1850. He married in 1869 and reared five children following his wife's death in 1883. He was a farmer, teacher, and bookkeeper before becoming active as a landscape photographer. His brother, John, was part of the photographic partnership, Shuster & Davidson, in Portland from 1875 to 1877. The two then joined to establish Davidson Brothers from 1877 to 1879, and also created a traveling enterprise called the Palace Gallery. I. G. Davidson operated his own studio at various locations in Portland from 1879 to 1888. In the late 1880s and early 1890s, his studio in Tacoma advertised for sale an extensive stock of landscape views of the Pacific Northwest. In the 1890s he became a real estate broker in Portland.

DAVIS, EDWARD HARVEY (1862–1951)

Edward Davis was born to a family of shippers in Brooklyn, New York. He moved in 1885 to Southern California where he found work as a surveyor and draftsman. Davis became interested in real estate, turning a profit on a San Diego lot in 1887 and then purchasing a large property on the Mesa Grande, where he remained until his death in 1951.

In the early 1900s, having settled into ranching and fruitgrowing, Davis also served as Justice of the Peace and Deputy County Assessor. But learning about the Indians on the Mesa was his true preoccupation and by 1907 Davis was made a ceremonial chief of the Mesa Grande tribe. He also became an acknowledged member of the tribe in Yuma and was considered a Medicine Man among the Seris of Tiburon Island. Fortunately Davis had a camera with him during most of the years he spent among the Indians.

In 1915 the Museum of the American Indian—Heye Foundation purchased most of Davis' collection of Indian artifacts. That same year Davis built Powam Lodge, a hotel featuring American Indian design motifs, and encouraged the Mesa Grande Indians to sell their finest arts and crafts there. Davis met with George Heye, the founder of the Museum of the American Indian, and in 1916 became a field collector of ethnological artifacts for that institution. He traveled widely in the Southwest in the following years, meeting and trading with Indian people of the region. He amassed a vast collection for the museum. Many of his own important artifacts were unfortunately lost when a fire destroyed his hotel in 1930.

DE MENIL, ADELAIDE (born 1935)

Born in France, Adelaide de Menil graduated from Sarah Lawrence College. She has worked for the American Museum of Natural History, photographing an archaeological expedition in Greece, and for Magnum Photo in Paris. Other photographic expeditions have taken de Menil to Cambodia, Japan, Brazil, Peru, and New Guinea. Her 1966–1968 photographs of Alaskan totem poles were exhibited at the Amon Carter Museum in Fort Worth, Texas, and featured in *Out of the Silence*. De Menil's photographs also appear in *Agni, the Vedic Ritual of the Fire Altar*, published in 1984.

EATON, THOMAS (Tsimshian, 1864 to after 1900)

Thomas Eaton stamped his photographs: "Thomas Eaton, Native Photagapher, Metla Kahtla, Alaska." Very little is known of him or his work. In the 1900 U.S. Census his birth is recorded as April 1864, his place of birth as Canada, his and his wife's tribe as "Tsimpshean," the year he relocated in Alaska as 1887, and his wife, two sons, and two daughters are listed. In the same record it is noted that while he was employed in Canada as a "Cannery Laborer," his occupation in Alaska was that of a "Store-keeper," and that he could read and write. By the 1910 census only the youngest daughter is listed, and then as the granddaughter of William Reece and his wife Susan, both Tsimshian, suggesting that the Eaton

parents were by then deceased. We know that Thomas Eaton was a student at the Sitka Industrial School and delivered the Fourth of July Recitation at the school exercises in 1889; and that he was later the director of the choir at this school. Eaton married Emily Reece in January of 1891 in Metlakatla. Not long before then Eaton returned to his "home" at Skeena River in British Columbia for a two month stay where he visited "our old place; it made me sad to see that place, once crowded with our people, now desolate and only a very few people living there." He was asked "how you are since you went on American side?" His answer was "We are free since we are under the American flag . . . and we will be true citizens of the United States."

FLOYD, JAMES (born 1947)

James Floyd is by profession a Psychologist. He graduated from Princeton University in 1969 and went on to complete a Ph.D. at the University of Rochester. He has been a devoted amateur photographer since his undergraduate years. His photographs were featured on the program "20/20" on WABC television in the autumn of 1993.

FREDERICKS, JEAN (Hopi, 1906–1990)

Born in the village of Old Oraibi in 1906, Jean Fredericks was educated on the Hopi reservation and the Sherman Indian Boarding School in Riverside, California. He found work as an automobile mechanic and then served in the U.S. Army. He bought his first camera in 1941 and became one of the earliest Hopi photographers. After his Army service he returned to the Hopi reservation and created a darkroom at his house in Kykotsmovi where he did his own developing and printing. Fredericks became Governor of the village of Kykotsmovi and after many years of service on the Hopi tribal council became it's chairman during 1967–68.

GARDNER, ALEXANDER (1821–1882)

Alexander Gardner worked in Scotland, his birthplace, as a reporter and editor for the Glasgow *Sentinel* until immigrating to the United States where, in 1849, he and a brother founded a Utopian community in Iowa. When the community was destroyed by an influenza epidemic, Gardner moved to New York in 1856 and found work at Matthew Brady's New York City photographic gallery. He became manager of Brady's Washington, D.C., branch in 1858. Along with other cameramen, including Timothy O'Sullivan, Gardner joined Brady's corps of Civil War photographers.

After a dispute over copyright and proper photographic credit, Gardner left Brady's gallery in 1862 to open his own, joined by colleagues from the Brady enterprise. He was named official photographer of the Army of the Potomac and worked with the Secret Service. In 1866 Gardner published his (and others') war views in *Gardner's Sketch Book of the War*. He became the official photographer for the Union Pacific Railroad from 1867 to 1873. His Native American images range from Indian delegation portraits made in Washington to views of leaders of various Great Plains tribes, including Spotted Tail and the Brule Sioux warriors at Fort Laramie in 1868. Gardner died of tuberculosis in 1882.

GURNSEY, BENJAMIN H. (c.1844–1881?)

Paula Fleming notes Gurnsey's presence in Indiana, Dakota Territory, and Iowa in the 1860s and 1870 when he photographed at the Winnebago Agency, near Sioux City, Iowa. The 1870 census documents his being a neighbor of William H. Illingworth in Sioux City, and photographic mounts bear the designation "Gurnsey & Illingworth."

Gurnsey appears in local directories as a photographer in Pueblo, Colorado, in 1872–73. He formed a partnership with Eugene Brandt in 1875. He was also active in Colorado Springs from 1872 until 1880. In 1881–82 the business is listed under the name of Mrs. B. H. Gurnsey, suggesting that her husband had recently died. William Henry Jackson noted that Gurnsey's negatives were scattered among several photographers at his death.

HALDANE, BENJAMIN A. (Tsimshian)

Benjamin A. Haldane, a Tsimshian Indian, is one of the earliest Native Americans to make photographs. When Reverend William Duncan converted a group of Tsimshians to Christianity and moved them in 1887 from British Columbia to Alaska, Benajmin Haldane was part of the exodus. He settled in the new Metlakatla, on Annette Island, and established himself as a storekeeper and the community's official photographer. Haldane was also an accomplished musician, reading music without formal training and playing the pipe organ, piano, cornet, trombone, and violin. He also led the community's choir and concert band.

Haldane had several run-ins with the authorities of the community. In 1908 his store stocked copies of J. W. Arctander's book, *The Apostle of Alaska,* against the wishes of William Duncan, who disapproved of the text. The same year, Haldane was recruited by a teacher to petition for improvement of native schooling, and he made a formal complaint to the Bureau Commission. In 1910, as Secretary of the Town Council, Haldane travelled to Seattle with a delegation of Metlakatla natives to seek the establishment of a government-sponsored boarding school. Ultimately, however, when encouraged to bring Duncan down by means of slander, Haldane refused.

As a photographer Haldane was active from the early 1890s to 1908 or later, and a photograph of Josiah Guthrie, commissioned by H. S. Wellcome, was made by Haldane in 1923. A sign on his studio door read, "Benj. A. Haldane, Scenic and Portrait Photographer." Haldane's brother Henry was also a photographer in Metlakatla. B. A. Haldane's glass plate negatives remain in Metlakatla, although some of his prints are in the Sir Henry Wellcome Collection at the National Archives in Seattle and the Alaska State Library in Juneau.

HALL, DOUGLAS KENT (born 1938)

Photographer, novelist, and filmmaker Douglas Kent Hall grew up in Vernal, Utah, and graduated from Brigham

Young University in 1960. He received a Master of Fine Arts degree in Creative Writing from the University of Iowa in 1963 and subsequently taught there and at the University of Portland. Hall turned seriously to photography in 1965 and in 1967 began making portraits of poets and writers, including subjects such as W. H. Auden, Galway Kinnell, Allen Ginsberg, and Robert Bly. He also photographed major Rock and Roll stars and embarked on a decade of commercial photography for corporate clients.

Hall's photographs have been exhibited at more than eighty museums and galleries in the United States and England, including the Whitney Museum of American Art in New York City. His works are held in the collections of Santa Fe's Museum of Fine Arts and the Bibliothèque Nationale, Paris, as well as in the collections of corporations such as Atlantic Richfield, Chase Manhattan Bank, Wells Fargo Bank, and Mobil Oil.

A master of both image and word, Hall has divided his time between photography and writing. In addition to conducting many panels and workshops since 1979, Hall has authored seventeen books and had his work included in many other publications. His photographs form the basis for *Van People* (1977), *Working Cowboys* (1984), *The Border* (1988), *In Prison* (1988), *Passing Through* (1989), and *Frontier Spirit* (1990). Hall has also written motion picture screenplays, including "The Great American Cowboy," which won a 1974 Academy Award for Best Feature-Length Documentary. He has lived since 1977 in a New Mexico village on the border of the San Juan Pueblo reservation.

HARRINGTON, MARK RAYMOND (1882–1971)

Mark Harrington was born in Ann Arbor, Michigan, the son of an academic. In 1891 the Harringtons moved to Washington, D.C., and four years later to Seattle, where the young Harrington became a friend of Chief Seattle's daughter, Princess Angeline. The family relocated to New York City in 1897. As a child Harrington was fascinated with Indian relics. He began a lifelong friendship with F. W. Putnam, head of the Department of Anthropology at the American Museum of Natural History in New York and while visiting Putnam met Chief Joseph of the Nez Perce. By the time he received his B.S. degree from Columbia University in 1907 he had many years of archaeological work behind him and friendships with some of the most distinguished anthropologists in the country. After receiving his Master's degree under Franz Boas' direction in 1908 he began a series of visits to American Indian tribes. He collected and photographed for George Heye, became a curator of the Museum of the University of Pennsylvania, and after many years devoted to archaeological work, accepted the position as curator at the Southwest Museum in Los Angeles. Harrington died in 1971, having visited or lived with forty-three different American Indian tribes.

HARRIS, ALEXANDER EISEMANN (born 1949)

Harris was born in Atlanta, Georgia, and educated at Phillips Andover Academy and Yale University. After graduating from Yale in 1971, he photographed migrant workers in North Carolina. These images were published in *I Shall Save One Land Unvisited* in 1978. From 1972 to 1974 he collaborated with Robert Coles on *The Old Ones of New Mexico*, images of rural, northern New Mexico. Again working with Coles, Harris photographed Alaskan Eskimo for *The Last and the First Eskimos*, also published in 1978. In 1979–80 he received a Guggenheim Fellowship to pursue his own photography in New Mexico. As part of an NEA group survey grant Harris photographed the New Mexico landscape from 1982 to 1984. Some of these images were published in *The Essential Landscape*, 1985. Harris began his affiliation with Duke University in 1975 as lecturer in documentary photography. For eight years, beginning in 1980, he served as director of the Center for Documentary Photography at Duke, and became a Professor of the Practice of Public Policy and Documentary Studies there in 1987. He has also served as lecturer in American Studies at the University of North Carolina at Chapel Hill.

River of Traps: A Village Life, documenting the life of a Hispanic villager of northern New Mexico, with text by William duBuys and photographs by Harris, was published in 1990. *Red White Blue and God Bless You: A Portrait of Northern New Mexico,* with both text and photographs by Harris, presents the photographer's work from 1979 to 1988. Harris has also edited seven photographic books, including the 1984 book of Gertrude Blom's Indian photographs titled *Bearing Witness.*

Ten one-man exhibitions of Harris' work at such galleries as the International Center of Photography in New York City and the Southeastern Center for Contemporary Art in Winston-Salem, North Carolina, have given the photographer a large audience. His photographs are in the permanent collections of the Museum of Modern Art, New York, The Metropolitan Museum of Art, New York, The Museum of Fine Arts, Santa Fe, New Mexico, The University of Alaska Museum, Fairbanks, the National Museum of Natural History of the Smithsonian Institution, and the Rencontres Internationales de la Photographie, Arles, France, among others. Harris was the first recipient of the Elliot Porter Purchase Award from the New Mexico Council on Photography. His and deBuys' *River of Traps* was a finalist for the Pulitzer Prize in general non-fiction and the winner of the 1991 Evans award for the best biography set in the American West.

HAYNES, FRANK JAY (1853–1921)

Born in Michigan, trained as a photographer in Wisconsin, F. Jay Haynes opened a studio in Moorehead, Minnesota, in 1876. That same year he began making photographs for the Northern Pacific Railroad. Traveling the railway route through the Northwest, Haynes photographed settlements, military posts, mining camps, ranches, and battlefields. He also became fascinated by Indians and in 1877 he is thought to have photographed Chief Joseph of the Nez Perces in Bismark, Dakota Territory—an image later circulated by O. S. Goff.

By 1879 Haynes had opened a second studio in Fargo. His wife managed the Minnesota office while he traveled. Haynes

visited Yellowstone National Park for the first time in 1881 and the site of the Battle of the Little Big Horn where he met and photographed Curly, the Crow scout with Custer who was erroneously celebrated as the lone survivor of the Battle of the Little Big Horn. In the early 1880s Haynes became the official photographer for the Department of the Interior, which leased him space for a studio in Yellowstone, and for the railroad, which provided an elegant Pullman car he called "Haynes Studio Palace." In 1885, as the railroad progressed to the Pacific, Haynes was able to photograph Sioux, Crow, Blackfoot, Shoshone, Gros Ventre, and Assiniboin peoples. The images he made at the Flathead Reservation in Montana were used by the U.S. Government to show the success of their efforts at "civilizing" the Indians.

While assistants operated the railroad car in 1890, Haynes, with his brother, established a gallery in St. Paul, Minnesota. After 1895 he had a studio of his own there. In 1905 he closed "Haynes Studio Palace" car, was joined in business by his son, Jack Ellis Haynes, and gave his collection of photographs to the Montana Historical Society.

HELLER, LOUIS HERMAN (1839–1928)

A native of Darmstadt, Germany, Louis Heller immigrated to the United States about 1855 and became an assistant to Julius Bien, the celebrated lithographer and scientific-map engraver. In the early 1860s Heller joined a New York photographic organization to learn the trade. He moved to California in 1862 and settled in the Siskiyous in 1864. That same year Heller became a naturalized U.S. citizen and opened his own photographic studio. In 1869 he sold this business and established a new one at Fort Jones, from which he could travel widely to photograph in the mountain region's many new mining communities.

Heller is best known for his photographs of the U.S. Army's 1873 war with the Modoc Indians—images that were later appropriated and produced by Carleton Watkins' Gallery in San Francisco. Heller sold his Fort Jones Studio in 1900 and moved to San Francisco.

HENIES & BUCHER (active 1880s)

George Valentine Henies, who had apprenticed to a photographic firm with roots in Columbia, South Carolina, reaching back to 1859, opened his own firm there in 1879. Bucher was one of a succession of men associated as partners with this establishment, which survived into the 1920s.

HERRIN, DAVID C. (active 1895–1900)

David Herrin was an itinerant photographer in Medford and The Dalles in Oregon from 1895 through 1899 when "Abell-Herrin Co., photographers" is listed in the Portland City Directory. After 1900 the establishment was run by David's widow, Margaret, who kept it going into 1904.

HESS, BILL (born 1950)

Bill Hess, a photojournalist and documentary photographer, focuses his work on the Alaska Native and the American Indian. Born in Ogden, Utah, he attended Brigham Young University. From 1976 to 1979 he was editor, photographer, and reporter for the *Fort Apache Scout* in Arizona. A freelance photographer from 1979 to 1981, Hess' photographs of the White Mountain Apache were published in *National Geographic*. Upon moving to Alaska in the early 1980s, he became editor, photographer, and reporter for the state's Native newspaper, *The Tundra Times*.

With his wife, Margie, a member of the White Mountain Apache Tribe, Hess operates Running Dog Publications and serves as editor and photographer for *Uiniq—The Open Lead*, a magazine dedicated to documenting villages of Alaska's North Slope. Inspired by his father, a World War II pilot who enjoyed taking photographs from the air, Hess travels in his airplane, "The Running Dog," for which he named the photographic magazine that he established in 1990. Recently Hess has been preparing a photographic essay on the Inuit peoples of Russia, Alaska, Canada, and Greenland. Bill and Margie Hess live with their four children in Wasilla, Alaska.

HILEMAN, TOMER J. (1882–1945)

Born in Marienville, Pennsylvania, T. J. Hileman worked for a time in Chicago before going west to Colorado where he apparently began his photographic career. In 1911 he moved to Kalispell, Montana, where he spent the rest of his life. Hileman is known especially for his photographs of Glacier National Park where his work was popular with visitors.

HILL, DAVID OCTAVIUS (1802–1870), AND ROBERT ADAMSON (1821–1848)

Hill & Adamson, a partnership forged in 1843, was one of the earliest artistic collaborations to take advantage of the photographic process. David Octavius Hill, a Scottish landscape painter and illustrator, set out to make a commemorative painting of the assembly forming the Free Church of Scotland. When a friend suggested that Hill make use of calotypes in rendering the required likenesses of 474 dignitaries, the painter sought out Robert Adamson. Adamson had learned the calotype process from his brother, a chemist who created Scotland's first calotype portrait in 1842. Robert Adamson had opened his own portrait studio in Edinburgh in the summer of 1843, just as he began his collaboration with Hill.

Included in the nearly 1500 calotypes made by Hill & Adamson is a grouping considered to be the oldest surviving photographs of a North American Indian. The Reverend Peter Jones, an Ojibway Indian missionary born in Ontario, Canada, to a Welsh father and a Mississaugua mother, posed for a portrait during his lecture tour in Britain in 1844–1845. The resulting images, entitled "Kakewaquonaby" and "The Waving Plume," show Jones in traditional Native American dress.

From 1844 to 1846 Hill & Adamson's calotypes were exhibited at the Royal Scottish Academy, of which Hill had been a founding member. Shortly after Adamson died, at age 27, in 1848, Hill presented the National Portrait Gallery with albums containing their calotypes. Hill died in 1870, four years after finally completing his Free Church commemorative painting.

HILLERS, JOHN K. (1843–1925)

John Hillers immigrated to the United States from Germany in 1852. He served in the Brooklyn, New York, Police Department, and later in the Union Army during the Civil War. In 1870 Hillers traveled to California and the following year was hired as a general worker for John Wesley Powell's second Colorado River expedition. Having studied the methods of the accompanying expedition photographers, Hillers was named Chief Photographer in 1872 when the expedition suddenly experienced a shortage of personnel. He remained Powell's photographer through 1878 when he joined the U.S. Geological Survey and the Bureau of American Ethnology, where he remained until 1919.

Though Hillers formally retired in 1900, he continued to add photographs of Southwest Indians and landscapes to the government's collections in Washington, D.C. Utah's Mount Hillers was named for the photographer.

HOUSEWORTH, THOMAS (1828–1915)

Lawrence & Houseworth were creating stereo views in San Francisco as early as 1862. In competition with Watkins' Gallery, Lawrence and Houseworth had obtained copyrights on their negatives by 1864. In 1865 they became business partners, establishing Lawrence and Houseworth as a dealership of Western landscape photographs, and advertising "mammoth-plate" prints for sale. Within a year they had published more than a thousand views—many created by other photographers—and had given the images numeric designations.

By 1867 the partnership had dissolved and Thomas Houseworth & Company was initiating its own publishing projects. Houseworth's *Catalogue of Photographic Views of the Scenery on the Pacific Coast* was distributed in 1869 and included listings for 2,000 images, including views from China and Japan. Around 1870 Houseworth published *Views of the Big Trees of Calavera County, California* and *Views of the Yo-Semite Valley for the Stereoscope*. Other issues, most representing Western scenery, followed in the next three years, and around 1875 the company published *Houseworth's Photographs of California and Arizona Indians*.

Houseworth may have photographed scenery along the route of the Central Pacific Railroad. He also issued images from the Alaska-Yukon-Pacific Exposition, which were made by an unknown photographer from the U.S. Fish Commission.

HUFFMAN, LATON ALTON (1854–1931)

Born on a farm in Iowa, Laton Huffman began work with his father, who in 1865 purchased a photographic studio in Waukon, Iowa. That same year Huffman set up his own studio in nearby Postville, but its life was brief. In the spring of 1878 he was employed by the photographer Frank Jay Haynes at Moorhead, Minnesota, but by autumn Huffman was working on his own as a photographer at Fort Keogh, Montana. It was here that he began his friendships with various Indian groups and the series of Indian portraits that formed an important part of his life's work. He was keenly aware of his role in documenting the old ways of the Indians and the frontier that were vanishing around him. About 1880 he opened a studio in Miles City, Montana, his base of operations until 1890. He subsequently worked at a photographic establishment in Chicago, established his own studio at Billings, Montana, and then returned to open yet another photographic gallery in Miles City. Huffman closed his gallery in 1905, when he began devoting himself to the sale of photographs from his old negatives, in formats that ranged from postcards to seven-foot-long prints.

Huffman's views reached a wide audience. After his death his daughter continued to sell his work. Coffrin's Old West Gallery eventually became the owner of the photographer's original inventory and sold photographs from it until 1981 when the family formed Huffman Photos Ltd. to sell the remaining collotypes.

JACKSON, WILLIAM HENRY (1843–1942)

Although most celebrated for his Western landscape photography, William Henry Jackson produced many of the important early images of Western American Indian life. Born in Keesville, New York, Jackson received his photographic training as a retoucher and colorist in Troy, New York, and in Rutland, Vermont. As a Union soldier during the Civil War, he became a staff artist for the Vermont Infantry. In 1866 he traveled as far west as Nebraska as an ox-team driver. Joined by his brother in 1867, he opened Jackson and Brothers, a photographic portrait studio in Omaha. While Edward ran the gallery, William set out with a traveling darkroom to record the region's scenery and inhabitants, including the Winnebago, Omaha, Osage, Otoe, and Pawnee tribes before their removal to reservations. He soon teamed up with Arundel C. Hull to photograph the newly completed Union Pacific Railroad line.

Hired in 1870 as a photographer for the Hayden Survey, Jackson traveled to Colorado and Wyoming where he documented the teepee villages of the Shoshone. In 1874 he photographed members of the Uncompahgre Ute tribe and became the first man to photograph the ancient cliff dwelling of Mesa Verde. He returned there in 1875 to prepare an exhibition on the ruins for the U.S. Centennial Exhibition in Philadelphia and to photograph the region's Navajo inhabitants. The U. S. Department of the Interior published a catalogue of Jackson's North American Indian portraits in 1877, containing many images by other photographers. Jackson's landscape photographs from this period won him national acclaim and influenced Congress in the establishment of the National Park system. A member of the Hayden Survey until 1879, Jackson would ultimately have a canyon, a lake, a butte, and a city named in his honor.

After leaving the survey Jackson opened a studio in Denver and became the leading photographer for the Western railroads. He continued to travel through the Southwest, visiting New Mexico's Acoma and Laguna Pueblos in 1899. That year Jackson also became a partner and director of the Detroit Publishing Company, leasing them his negatives and services and leading them to success in the picture-postcard industry. Just before his death at age 99 his work was exhibited at the Museum of Modern Art in New York City.

JAMES, GEORGE WHARTON (1858–1923)

An author with ethnographical interests who traveled widely in the Southwest, George Wharton James is perhaps best known for his photographs of the Hopi Snake Dance. Among the books he published are *In & Around the Grand Canyon* (1900) and *Arizona The Wonderland* (1917).

With acquiescence from the United States Geological Survey directors, James was responsible for having the promontories of the Grand Canyon's south wall named for the Indian tribes of the region. Having sold thousands of his images in 1901 to C. C. Pierce, who later appropriated and copyrighted them, James' work is only now being properly credited and acknowledged. He died in 1923 at age 65.

KEEGAN, MARCIA (born 1942)

A native of Oklahoma, Marcia Keegan became a professional photographer in New York City but returned to her native West to pursue her favorite subjects: Southwestern Indian people and landscapes. Keegan graduated from the University of New Mexico and studied under New York photographer Alexey Brodovitch. From 1966 to 1969 she was an editor and photographer for the *Albuquerque Journal,* where she won a New Mexico Press Award. Keegan joined the Associated Press as a feature photographer in 1974 and 1975. She established Clear Light Publications in 1982.

Keegan's color photographs of Indian subjects have been published in a number of books: *The Taos Indians and Their Sacred Blue Lake* (1972 and 1991), *Mother Earth, Father Sky* (1974), *Pueblo and Navajo Cookery* (1977), *New Mexico* (1984), and *Enduring Culture* (1990). Keegan has taught photography at Long Island University, St. John's University, and the Chilmark Workshop in Martha's Vineyard, Massachusetts. Her photographs have been exhibited at the Smithsonian Institution, Lincoln Center, and the Institute of American Indian Arts Museum. They are included in collections at the White House, the Library of Congress, and New York's Metropolitan Museum of Art.

KEYSTONE VIEW COMPANY (1892–1963)

B. Lloyd Singley, an amateur photographer, established the Keystone View Company in Meadville, Pennsylvania, in 1892. Singley hoped to prosper from the demand for stereoscopic views which were rising in popularity at the time. After its early years issuing inferior images, the photography improved when Keystone began imitating the packaging of Underwood and Underwood. Like that leading stereograph producer, Keystone began issuing travel series and boxed sets. Through aggressive marketing and door-to-door sales, the Keystone View Company became one of the four primary publishers of stereographs.

One of Singley's principal competitors was B. W. Kilbourn, whose collection was sold in 1908 to come ultimately into Keystone hands. Keystone purchased the collection of the H. C. White Company, another business rival, around 1910. Its greatest competititon, Underwood and Underwood, turned its focus to news photography in 1912 and by 1923 had sold its negatives to Keystone too. Keystone held more than two million negatives by 1936, some dating as

early as 1860. In 1939—the year that television was unveiled at the New York World's Fair—Keystone stopped production of stereographs on a regular basis. When the company's original glass negatives were transferred to the California Museum of Photography at the University of California, Riverside, in the 1970s, they included a rich trove of images of the American Indian.

KILBOURNE, KATHERINE S. (1873–1968)

Katherine S. Kilbourne (née Skinner) was born in Haydenville, Massachusetts, and raised there and in nearby Mt. Holyoke. She attended the Ogontz School near Philadelphia and in 1903 married Robert Stuart Kilbourne, a stockbroker in New York City where they raised their family. An avid amateur photographer and a member of the congregation of St. Nicholas Church at 48th and Fifth Avenue, Mrs. Kilbourne traveled to the Jicarilla Apache reservation in northern New Mexico, probably in connection with Dutch Reformed missionary activity, in 1931. While she and her young son spent a few days on the reservation she set to work with her camera, recording the settlement of Dulce and Apache people she met. The resulting album of photographs is now in the Princeton Collections of Western Americana.

KOOYAHOEMA, MERWIN (Hopi, born 1957)

Born and raised in the Hopi villages on Second Mesa, Merwin Kooyahoema was educated at schools in Oraibi, Arizona, and Woodstock, Vermont. In 1976 he studied art for a year at the University of Arizona; then returned to the reservation to work as photographer for the tribal newspaper. In 1978 he entered the Institute of American Indian Arts in Santa Fe. After graduating in 1980 he again returned to the reservation to work for the tribe, this time in Health Education. He continues to photograph, though his primary interest remains in his accomplishment as a painter.

KOPTA, EMRY (died 1953)

An artist drawn to Indian life following a 1912 visit to Arizona, Emry Kopta moved permanently from Los Angeles to the Hopi reservation's First Mesa. He established a photographic studio in the home and store of Hopi trader Tom Pavatae, and later lived and worked in the newly developing settlement of Polacca. Trained as a sculptor, Kopta recorded the Hopi people and their lives not only in photographs but also in terra cotta. His subjects ranged from the mundane to the ceremonial in Hopi life, and included images of the Navajo who came to trade with the Hopi.

Living among the Hopi, who called him "Kopti," he came to be known for hobbling through villages on his wooden leg while singing kachina songs. In 1922 Kopta married Anna Phelps, a teacher at the Indian School, marking the occasion with a Hopi ceremony at Polacca. When Kopta, a champion of Hopi rights who hindered government assimilation efforts, resettled with his wife in Phoenix, Indian service officials were so relieved that one agent declared, "no permit should be issued to artists and literary people for longer than ninety days, subject to renewal."

Kopta is best known for designing the Art Deco ornament

on the Arizona Biltmore Hotel in Phoenix. Following his death, Kopta's wife donated his photographs to the Museum of the American Indian, New York, and the Museum of Northern Arizona.

LANDERKING & WINTER (active 1891–1945)

Although little is known of George Landerking, the photographic studio he founded in Alaska in the late 19th century went on to great success. Once a machinist's mate in the Navy, Landerking settled in Juneau, Alaska, and established his photographic business around 1891. In 1893 he met Lloyd Winter and invited him to become a business partner.

Winter was 27 when he arrived that year in Alaska. Trained as a portrait painter at the California School of Design in San Francisco, Winter had come to explore possibilities in gold mining. By July of 1893 Landerking, whose name has alternately been recorded as Landerkin, Landerkim, and Landiken, sold his stake in the studio. Winter was then joined in business by E. Percy Pond, a friend from San Francisco. An 1894 advertisement billed Winter & Pond as making and selling portraits and views, and the following year they advertised illustrations of Indian life, totems, etc. At the time of the Klondike Gold Rush in 1898, Winter sold his work to Underwood & Underwood, and to *Leslie's Weekly*. In the early 1900s their promotions emphasized "studies of Indian characters" in print and postcard form—sometimes hand-tinted. They sold native arts and crafts and published a 1905 pamphlet entitled *Types of Alaska Natives*. At the Alaska-Yukon-Pacific Exposition in Seattle in 1909, Winter & Pond served as official photographers.

The partnership owned a boat which enhanced their ability to photograph remote scenic waterways that other photographers could not reach. Their success was also due, in part, to a close association with Tlingit and Haida people. The two were given Indian names when adopted by a Chilkat Tlingit family and Winter himself knew the Tlingit language. In 1945, two years after Pond's death, Winter turned the business over to an assistant. When Winter died later that year, six of his Indian friends were honorary pallbearers.

LAROCHE, FRANK (1853–1934)

Born in Philadelphia, Frank LaRoche was at work as early as age 17 in a photographic studio there. In 1873 he moved to Maunch Chunk, Pennsylvania, where he established his own studio and pursued portrait commissions and documented the Lehigh Valley Railway. He was a technical innovator and has been credited with having made the "longest" exposure in American photographic history. Documenting architectural details on a church in St. Augustine, Florida, he is reported to have exposed a plate from 10 o'clock one morning until 4 in the afternoon the next day.

In 1878 he went to Salt Lake City to photographically record a transit of the planet Mercury for both the U.S. and the French governments.

LaRoche arrived in Seattle, Washington, one month after the Great Fire of 1889 which had burned out most of the town's photographers. He quickly gained a reputation for his accomplished portrait work and for the quality of the American Indian baskets he also sold from his commercial establishment, The LaRoche Photographic and Art Studios on Second Street. In 1894 he and F. C. Plummer produced the largest photograph of Seattle ever made: the print measured 88 × 22 inches.

LaRoche is reported to have made 108 trips to Alaska and the Yukon territory to photograph in the mining camps and on the Gold Rush trail, and produced a six-part album titled *Enroute to the Klondike*. After his death at Sedro-Wooley his son continued the family business in Bremerton. LaRoche's work survives principally in the collections of the Everett Public Library and the University of Washington.

LITTLE TURTLE, CARM (Apache-Tarahumara, born 1952)

Born in Santa Maria, California, of artist parents of Apache, Tarahumara, and Mexican ancestry, Carm Little Turtle studied both art and nursing at Navajo Community College, the University of New Mexico, and the College of the Redwoods in Eureka, California. She is a Registered Nurse who has worked in operating rooms in Flagstaff and Sedona, Arizona. Since 1981 her photographic work has been widely exhibited in galleries from California to New York City. These shows have included "Native Americans Now" in 1982 at the American Indian Museum in Santa Rosa, California; "One Woman Show" at the Southwest Museum in Los Angeles in 1983; "24 Native American Photographers" at the Gallery of the American Indian Community House in New York City in 1984; "Women of Cedar, Sage and Sweet Grass" at the Wheelwright Museum in Santa Fe in 1987; "Personal Preferences: First Generation Native Photographers" at the American Indian Contemporary Arts gallery in San Francisco in 1989; "Language of the Lens" at the Heard Museum in Phoenix in 1990; and "Ancestors Known and Unknown" at Coast to Coast in New York City that same year. She is married to the Navajo artist Ed Singer and they have exhibited jointly in shows at the Old Town Gallery in Flagstaff, Arizona. In 1993 her work was included in "Defining Our Realities: Native American Women Photographers" at the Sacred Circle Gallery in Seattle. She has also lectured, and produced and photographed documentary films. Her work is in the collections of Princeton University, the Southwest Museum in Los Angeles, the Southern Plains Indian Museum in Anadarko, Oklahoma, the Heard Museum in Phoenix, Arizona, and the Center for Creative Photography in Tucson, Arizona.

LLOYD, ROBIN (born 1950)

Robin Lloyd is a television correspondent who worked for NBC News for 14 years. His NBC assignments ranged from the White House to Latin America to South Africa to the Middle East. As a correspondent specializing in regional and international conflicts, he covered the Salvadoran and Nicaraguan Civil Wars, the Falklands War, and the Gulf War. He also reported from the State Department. His stories on Central America won an Overseas Press Club award in 1981. He is currently working as a freelance producer/correspondent developing programming ideas for foreign and domestic television stations.

Lloyd was raised in the U.S. Virgin Islands. He graduated from Princeton University in 1973. He was an International Fellow at Columbia University where he graduated from the Graduate School of Journalism in 1976. While at Princeton he headed the Student Photography Agency, and was photographer for undergraduate publications. He remains an avid amateur photographer.

LUMMIS, CHARLES FLETCHER (1859–1928)

A journalist as well as a photographer, Charles Lummis used his Indian images, as he did his journalism, for social crusade. Born in Massachusetts and educated at Harvard, Lummis moved to Ohio in 1880. Two years later he became the editor of Chillicothe's *Scioto Gazette,* leaving it in 1884 to walk across the country. In five months he reached Los Angeles, by way of New Mexico, where he became the city editor of the *Los Angeles Times.* Lummis covered the 1886 wars against the Chiricahua Apache in Arizona and shortly thereafter returned to New Mexico to recuperate from a stroke. Moving into the Pueblo of Isleta, he was soon recording Pueblo life with his camera. In the 1890s Lummis saw many of his stories and photographs of Arizona, California, and New Mexico published in books: *A New Mexico David* (1891), *Some Strange Corners of Our Country* (1891), *A Tramp Across the Continent* (1892), *The Land of Poco Tiempo* (1893), and *Spanish Pioneers* (1893). Lummis accompanied Adolph Bandelier on a two-year expedition to the Peruvian Andes. He returned to California to become editor of *Land of Sunshine,* remaining with the magazine for eight years. By reproducing his own work and that of other photographers in vivid half-tones, Lummis used the publication to urge conservation of Indian cultures. In response to an 1899 Los Angeles convention of Indian educators, Lummis published "My Brother's Keeper," a series that included photographs from his residence in New Mexico and showed the Pueblo Indians as proud, civilized, decent individuals to counter many educators' doctrines that Indians needed to be reformed.

Lummis formed the Sequoya League in 1901 to aid the 300 Cupeno Indians facing eviction from Warner's Ranch in San Diego. He established the Southwest Museum, to which he bequeathed his own collections and photographs in 1910. With his camera, Lummis visited New Mexico in 1927 and again in 1928, dying later that year.

MANLEY, ROGER B. (born 1952)

Educated at Davison College, St. Anne's College at Oxford, the University of Denver, and the University of North Carolina at Chapel Hill, Roger Manley met Laura Gilpin in 1969 when he was learning to use a 4 × 5 inch camera, and her friendship and tutelage continued until her death. In 1979 Manley accompanied a salvage archaeological expedition to Black Mesa on the Navajo reservation as site photographer. He soon found the Navajo laborers of greater interest than the Anasazi remains they were excavating. Through friendships made on that dig he began returning to the Navajo community of Chil-Chin-Bito for long periods over the next seven years. There he was able to build a trust that enabled him to capture seldom-photographed aspects of indigenous life. This work led to photographic projects among North Carolina tribes. The Roswell Museum of Art, in New Mexico, exhibited Manley's Navajo work in 1986 in a show titled "Three/ Photographers." Manley also spent a year living with and photographing two aboriginal groups in Australia. His travels and photographic subjects range from Gullah maritime communities on the Carolina coast to life in mining camps in the Canadian arctic. His current work is focused on outsider artists. Manley's photographs have appeared in numerous solo and group exhibitions and have been widely published.

MARMON, LEE (Laguna Pueblo, born 1925)

"My first camera was a 2½ × 3¼ Speed Graphic which I bought after returning to the reservation from my stint in the army. I had a hard time learning to use this first camera, learning primarily from books, trial and error, and endless hours in the darkroom." So writes Lee Marmon in a note accompanying his 1986 portfolio of Laguna tribal portraits titled *Laguna Ha'Ma Ha.* Marmon was born in Laguna Pueblo, and educated there and at the University of New Mexico. His first year at the university was interrupted by World War II and his enlistment in the U.S. Army. After military duty in California and Alaska he returned to assist his family, owners of the Pueblo trading post, with their mercantile endeavors. He has been photographing in Laguna and Acoma Pueblos since 1947. In 1966 photography became his profession when he moved to California and began photographing for the Bob Hope Classic golf tournament. He returned to the Pueblo in 1983, where his wife and he run the Blue Eyed Indian Bookshop. His work has been published in *Time, The New York Times Magazine, The Saturday Evening Post,* and *The Los Angeles Times.* He is one of the photographers included in *A Circle of Nations, Voices and Visions of American Indians* (1993). He won awards for his still photography in the PBS video "Surviving Columbus," and was commissioned by the Western American Indian Chamber of Denver to create sixteen photomurals for the new Denver airport. His photographs have been exhibited in the Living Desert Museum in Palm Desert, California, the First Street Gallery in Cathedral City, California, and, in 1993, at the Pueblo Indian Cultural Center in Albuquerque. He is the father of the writer Leslie Marmon Silko.

MASAYESVA, VICTOR, JR. (Hopi, born 1951)

Born and raised in the village of Hotevilla, on the Hopi reservation in northern Arizona, Victor Masayesva was educated on the reservation, at the Ganado Mission, the Horace Mann School in New York City, and Princeton University where he majored in English, studied photography under Emmet Gowin, and graduated in 1976. In 1976–1978 he pursued graduate work in English literature and photography at the University of Arizona on a Ford Foundation fellowship. His *Rain Bird: A Study in Hopi Logic,* a portfolio of photographs, was issued in 1977. In 1980 as director of the Ethnic Heritage Program at Hotevilla, he supervised the production of a series of video-taped documentaries in the Hopi language for use in the reservation schools. In 1982 he formed his own video-production company, IS Productions, and taught pho-

tography at the Hopi Center of Northland Pioneer College. His poetry and photography have been published in *Sun Tracks*, and with Erin Younger he produced *Hopi Photographers/Hopi Images* in 1983. Masayesva has served as Resident Artist at Arizona State University and participated in exhibitions in the New York Native American Film and Video Festival (1984), at the Arsenal, West Berlin's "Neue im Kino Video Projektionen" (1986), Wells College's Robert Flaherty Film Seminar (1986), in Artists Space, New York, "We the People" (1987), the Long Beach (California) Museum of Art's "Foreign Exchange" (1988), the Los Angeles 1988 American Film Institute Video Festival, the Anderson Ranch Arts Center for Photographic Education at Snowmass, Colorado's "The Political Landscape" (1989), The Museum of Modern Art's "Video and the Computer" (1989), the Arizona Center for the Media Arts, Tucson, "Native Visions" (1990), and New York City's Whitney Museum Biennial (1991). His video productions include "Hopiit" (1984, 15 minutes), "Itam Hakim, Hopiit" (1984, 60 minutes), "Ritual Clowns" (1988, 18 minutes), "Siskyavi—The Place of Chasms" (1989, 28 minutes), "Pot Starr" (1990, 6 minutes), and "Imagining Indians" (1992, 90 minutes). His mixed media photographs have been exhibited at the Andrew Smith Gallery in Santa Fe in 1991 and 1993.

MATTESON, SUMNER W. (1867–1920)

Born into a banking family and raised to be a businessman, Sumner Matteson was by nature an outdoorsman and an adventurer. After graduating from the University of Minnesota in 1888, Matteson returned to his birthplace, Decorah, Iowa, and trained as a bank clerk. He pursued banking in Great Falls, Montana, until 1895, when his father died, and he left to work for the Overman Wheel Company. Matteson moved to Colorado in 1896 to manage Overman's Denver operation, achieving success promoting Victor Bicycles and Kodak cameras and film supplies. When the Overman company pulled out of Denver in 1899 Matteson set off with his own bicycle and camera and began a new career as a "traveling correspondent."

In Mancos, Colorado, that summer, Matteson joined a Harvard University expedition to photograph the Mesa Verde cliff dwellings, then proceeded into Navajo country and the Pueblo Bonito ruins. After spending the fall hunting in Utah and Colorado, he sold an article to *Outing* magazine, in which he extolled the Ute Indians' efficient hunting practices. In 1900 Matteson returned to New Mexico to photograph the Penitentes' Holy Week rituals, and then traveled to Arizona to record the Hopi Snake and Flute ceremonies. While others had earned notoriety through their photographs of the Hopi rites, Matteson may have gained an unprecedented confidence of the Hopi because he was comfortable around snakes, having photographed them closely before. In 1901, Matteson photographed the Snake and Antelope fraternities, and also began to record scenes of everyday Hopi life. That year his images were published in *Leslie's Weekly*.

Matteson's interest shifted to the Great Plains in 1902. After traveling through Montana, Matteson returned to Southern California and for several years traveled and photographed on the island of Cuba. When Matteson returned from Cuba in 1904 he joined the lecture circuit. Giving up travel, in 1909 he went into retirement, but in 1920 he ventured to Mexico to ascend Mount Popocatepetl, where he made the climb twice in two days, the second time to photograph students ascending the volcano. Matteson died the following morning, at age 53, when his lungs collapsed.

MAUDE, FREDERICK HAMER (1858–1960)

Like his friend George Wharton James, Frederick Hamer Maude was an Englishman who discovered the wonder of the American West while trying to recover his health. Maude was educated at Rugby and Highgate Schools and apparently earned his degree in medicine at Cambridge and Aberdeen. By 1889 he had abandoned a medical career and arrived in Ventura, California, where he established Pacific Stereopticon, a publisher of lantern slides. In 1895, as Maude was struggling with his business and his health, George Wharton James counseled him to travel to the Grand Canyon. Maude soon served as James' substitute on an expedition to the canyon's rim. He was to take the photographs that illustrate James' *In and Around the Grand Canyon*. Captivated by the American desert, Maude returned to the canyon in 1896 accompanied by James. Together they traveled on to Oraibi to witness the Hopi Snake Dance; and Maude photographed a band of Paiute Indians en route to the ceremony. He visited the Grand Canyon regularly over the next ten summers, bringing along other California photographers.

MCCAULEY, SKEET (born 1951)

With Fine Arts degrees from Sam Houston State University and Ohio University (where he received his Master's degree in 1978), Skeet McCauley has taught photography at Spring Hill College in Mobile, Alabama, and Tyler Junior College in Tyler, Texas. He became a member of the faculty at the University of North Texas in 1981. In 1977–78 he initiated a program using the camera as a communication tool for mentally retarded adults at the Athens Mental Health Center in Ohio. The recipient of National Endowment for the Arts Individual Artist Fellowships in 1984 and 1986, McCauley has participated in numerous photographic exhibitions and his work has been widely published. His "Sign Language: Contemporary Southwest Native America," the result of five summers of photographic work with a large-format camera among the Indians of the Southwest, was organized by the Amon Carter Museum in 1989, and issued in book form the same year. His color photographs of American Indians have been praised for their insistent grounding in contemporary reality.

MCCLEES STUDIO (active 1857–1860)

James Earle McClees (1821–1887), a native of Chester, Pennsylvania, learned the daguerreotype process in 1844. Two years later he established a partnership to produce daguerreotypes and for seven years their work was exhibited at the

Institute of American Manufacturers. Though McClees' business was based in Philadelphia, his name became known in other cities where bookstores sold prints of his work. In October of 1857 he opened a branch of his Philadelphia gallery in Washington, D.C., and called it the McClees Studio. At least eight other photographers were at work in Washington then, most of them focused on photographing American and foreign dignitaries. McClees established his reputation by making studio portraits of the Indian dignitaries who visited Washington in 1857 and 1858. These years drew to Washington more than 90 Indian delegates, representing 13 tribes, and McClees photographed most of them. McClees later advertised his views of "Chiefs, Braves, and Councilors." While the images bore the McClees imprint they were probably produced by his employees. Among the photographers employed by McClees were Samuel A. Cohner, Julian Vannerson, and T. J. Dorsey Beck. Robert W. Addis bought the McClees Studio and revitalized the effort to photograph Indian delegates by the late 1860s.

McNeil, Larry (Tlingit-Nishka, born 1955)

A member of the Killerwhale clan, born to a Tlingit mother and a Nishka father, Larry McNeil is a native of Juneau, Alaska. Although he moved with his family to Anchorage at age five and later earned his degree in photography at California's Brooks Institute, McNeil has returned time and again to remote Alaskan villages to document the native heritage.

Following college, McNeil established himself as a commercial studio photographer specializing in advertising and illustration. In 1981 he began to pursue an interest in documentary work when he was commissioned by the Alaska Native Foundation to photograph master Yupik basket makers. He became the principal cover photographer for *Alaska Native News Magazine* in 1982 and the following year was selected to create the poster for the Alaska Federation of Natives Convention. Among his other subjects were Klukwan dancers in the Chilkat Valley and village elders in Noatak. His portrait series of elders from Angoon, photographed in black and white, was featured in "Rarified Light," a group exhibition of work by Alaskan artists. McNeil's photographs were also included in "Photographing Ourselves," a travelling exhibition of Native American images, and a solo show at the Western States Museum of Photography in Santa Barbara, California. McNeil was a featured speaker at the 1986 conference of the Native Indian Inuit Photographers Association. Currently a photography professor at the Institute of American Indian Arts, McNeil lives with his family in Santa Fe, New Mexico. His outstanding outdoor photography and photographic technical quality were honored in 1992 by the Native Indian/Inuit Photographers Association, which he now serves as vice-president.

Miller, Fred E. (1868–1936)

Although only a fragment of his photographic work survives, Fred Miller created one of the most complete and intimate photographic records of the Crow Indians. Born in Chicago, Illinois, in 1868, Miller moved with his family to Iowa. After graduating from the University of Iowa in Iowa City, he went to Bloomfield and there learned photography. He practiced out of studios in Iowa and Nebraska and in 1896 moved to Helena, Montana, to work as a newspaper reporter. But he soon became a stenographer for the Surveyer General in the United States Land Office, an assistant clerk for the Bureau of Indian Affairs, and—two years later—a U.S. Commissioner and land clerk at the Crow Agency.

Despite his role as Agent, Miller was trusted by many of the Indians and permitted to take pictures of them as other photographers seldom were. He served as a guide to artists Frederick Remington and Joseph H. Sharp, and often photographed alongside them as they painted. In 1905, upon his marriage to a part Shawnee woman, Miller was welcomed as a member of the Crow nation. He remained on the reservation until 1910, when he resigned as clerk and moved to nearby Hardin, Montana. He subsequently contributed to the mapping of Big Horn county, became that county's first clerk and recorder, and a cattle rancher. After his death in 1936 Miller's 500 glass-plate negatives were discarded and the few prints owned by the Smithsonian Institution and Miller's family are the only remaining records of his work.

Monsen, Frederick I. (1865–1929)

Frederick Monsen described himself as an explorer, geographer, ethnographer, lecturer, and artist, but he was, first and foremost, a photographer. Monsen's father, a Norwegian concertmaster, immigrated to Utah in 1868 with his son, aged three. By his teens Frederick Monsen was in business with his father photographing for the Denver and Rio Grande Railroad. The son considered photography a means of support for his travels. He took on assignments throughout the West for newspapers or for other photographers, including William Henry Jackson. In the late 1880s Monsen attached himself to expeditions as an unofficial photographer. He traveled with the Geological Survey in 1868 to fix the U.S.-Mexican border. He then joined Generals Crook and Miles on the Apache campaign. He joined the Brown-Stanton Survey as a substitute for official photographer Frank Nims, and proceeded on expeditions to the Salton Sea and Death Valley.

By 1893 Monsen began to present lectures using his images, but he grew restless and resumed his nomadic lifestyle within a year. He lived and worked among the Southwest Indians from 1894 to 1895, and returned again with photographer Adam Clark Vroman in 1897 after a stint as topographer with the Yosemite National Park Boundary Survey. At this time Monsen began using a Kodak camera, which facilitated his efforts at illustrating his lectures. He opened a San Francisco studio, where, with his sons' help, he created large, hand-colored prints and lantern slides and compiled a collection of Southwest Indian ethnographic studies.

In the San Francisco earthquake of 1906 Monsen's studio, along with most of his photographs, were lost to fire. With some slides and prints which had been packed for a lecture

tour, plus negatives and prints he retrieved from other collections, Monsen was able to reconstruct most of his life's work. In 1907 he settled into the lecture circuit and saw his photographs included in a number of Eastern exhibitions. His "colorgraphs," which pre-dated color photography, earned him recognition from George Eastman, who in 1909 asked to underwrite and accompany Monsen on a return trip to the Southwest, and from Henry Huntington, who purchased nine portfolios of Monsen's colorgraphs in 1923.

MOON, CARL (1879–1948)

Carl (originally Karl) Moon was born in Wilmington, Ohio, the son of a physician. After graduation from high school he served briefly in the Ohio National Guard before setting out for a career in photography. He apprenticed with photographers in Ohio, West Virginia, and Texas for six years and then in 1903 moved to Albuquerque, New Mexico. There he inaugurated his own photographic studio and in 1904 began creating what he called his "art studies" of the Indians of the Southwest. By 1906 Moon's photographs began appearing in magazines and his work was exhibited at the Smithsonian Institution and, on the special invitation of President Roosevelt, in the White House. This national attention secured Moon a commission from the Fred Harvey Company to create a collection of Indian photographs for that firm. He was also made official photographer for the Santa Fe Railroad. In 1911 he moved to the Grand Canyon, had a studio built at El Tovar on the canyon's south rim, and for seven years documented the Indian peoples of the area both in studio portraits and in their natural context. A collection of these images was purchased by the Natural History Museum of the Smithsonian in 1910.

In 1911 Moon married an artist who had studied at the Art Institute in Chicago. In 1914 he left the Fred Harvey Company, and he and his wife moved to Pasadena, California, where he produced not only photographs but also oil paintings. He had studied painting under Thomas Moran, Frank Saurewen, and Louis Akin. His paintings, like his hand-colored photographs, were meant, despite their romantic conception, to form a historic record of "the vanishing American." In 1923 Henry E. Huntington purchased a collection of three hundred large-format photographs and twelve oil paintings from Moon. The photographer then began work on a series of portfolios, four volumes of twenty-five mounted photographs, titled *Indians of the Southwest*, which he planned to issue in fifty sets. The first sets were offered in 1936 in the depths of the Depression and few were purchased. Fewer than ten sets are thought to have been completed. Moon's creative energies in his later years were diverted into illustrating Indian and Mexican tales for children, most of them written by his wife.

MORGAN, MARGARET (born 1926)

Margaret Morgan was born in Paris, raised in New York City and New Jersey, and educated at Miss Porter's School in Farmington, Connecticut. Having settled in Princeton, New Jersey, where she still lives, Morgan took up photography in the 1970s. Since that time she has studied at the International Center of Photography, the Maine Photographic Workshops, and the Ansel Adams Workshop in Yosemite.

An avid trekker and world traveler, Morgan has recorded aspects of other cultures primarily through landscapes, still lifes, and architectural photographs. Her Palladium prints and silver prints have been included in solo and group exhibitions at such galleries as The Print Club, Philadelphia, the Fine Arts Gallery, College of Santa Fe, the Soho (New York) Photo Gallery, and the New Jersey State Museum. Her work has been featured in several publications, including the 1983 book *The New Jersey House*. Morgan's photographs are in the collections of the New Jersey State Museum and the Addison Gallery of American Art at Phillips Andover Academy.

MORROW, STANLEY J. (1843–1921)

Stanley Morrow is noted for documenting the mining boom in the Black Hills, but his position as photographer in many Dakota Territory posts enabled him to produce a quantity of Plains Indian images. Born and raised in Ohio, Morrow learned photography, reportedly under Mathew Brady, in Maryland, where he was stationed as a volunteer reserve for the Union Army. In 1864 Morrow moved to Wisconsin, married, and went into business as a photographer. Two years later he and his wife traveled by covered wagon to Dakota Territory. By 1869 they had established a studio in Yankton, where they remained for fifteen years.

While his wife and their assistants ran his Yankton studio, Morrow traveled in the summers, maneuvering through the Indian wars to photograph at army posts and agencies. In 1870 Morrow and his wife traveled up the Missouri River, photographing at military outposts on the way. In July, at Fort Berthold he photographed the signers of the treaty with the Yanktonai, Dakota, Arikara, Itidatsa, and Mandan. In 1871 the photographer hired O. S. Goff to run his Yankton studio while he lived at Forts Rice and Buford. He went to the Black Hills in 1876 to record the Crook expedition to the Red Cloud Agency. Morrow set up a branch office in 1878 at Fort Keogh where he photographed captive Bannock Indians after their uprising. Although a delayed shipment of chemicals fortuitously kept him from traveling with Custer in 1876 to the Little Big Horn, Morrow accompanied Captain Sanderson on the 1879 Custer reburial expedition. That year Morrow served as the post photographer at Fort Custer, sold his Fort Keogh studio, and returned to Yankton.

In 1882 Morrow moved his ailing wife to Florida and sold the Yankton studio. He continued his photographic work in the South and East and lived on sales from his stereo-view series "Photographic Gems of the Great Northwest," until his death in Dallas, Texas, in 1921.

NATONABAH, PAUL (Navajo, born 1944)

A member of the Navajo Tribe and a graduate of the Gallup, New Mexico, High School, Paul Natonabah moved to Chicago in 1970 to study art. He returned to the Navajo reservation in 1971 and became a photographer for the *Navajo Times*. In 1974 he traveled again to Chicago to study photography at the Ray-Vogue School, and the following year continued his work at the *Navajo Times*. His success as a news

photographer is evident in the fact that his photographs have been published in *The New York Times, Los Angeles Times, Arizona Republic, Albuquerque Journal, St. Louis Star, The Denver Post, New York Newsday, U.S.A. Today,* and *TV GUIDE.* His photographs are also regularly featured in such Native publications as the *Lakota Times* and *News from Indian Country.* A resident of Gallup, Natonabah is a stringer for the Associated Press.

NEILSEN, A. P. (active in New Mexico 1886)

The little we know about A. P. Neilsen appears, according to Richard Rudisill's files, in the *Santa Fe New Mexican* in August through October of 1886 where Neilsen advertised his photographic establishment on San Francisco Street. It was a tent studio, set up next to the U.S. Revenue Office.

NOBLE, DAVID (born 1939)

A native of New England, David Noble graduated from Yale University in 1961. He first made photographs in Vietnam, where from 1961 to 1964 he served in the U.S. Army. Noble continued his photography for a weekly newspaper in New York City, where he taught at St. Bernard's School. He and his wife, artist Ruth Meria, moved to Santa Fe, New Mexico, in 1971. He joined the staff of the School of American Research, a center for advanced studies in anthropology, where he worked until 1989.

Noble, whose photographic skills are self-taught, has made images of many native peoples through his extensive travels. In Vietnam he photographed the Montagnard tribes of the highlands, and since the 1970s has recorded Mohawk steelworkers and Chippewa wild-rice harvesters. He also pursues his interests in the American Southwest, with a focus on landscapes, prehistoric ruins, and rock art. He currently leads educational travel seminars in Southwest history and culture, and continues his freelance work as photographer, writer, and editor.

Noble's books include *Ancient Ruins of the Southwest* and *New Mexico: A Historical Guide.* His photographs have been published by, among others, the National Geographic Society, the National Park Service, the Smithsonian Institution, Rizzoli, and the Sierra Club. His photographic work has been shown in solo exhibitions at The Santa Fe Center for Photography and the Pecos National Monument Museum, and in many group shows. Noble won a 1993 Award of Merit for photographs exhibited at the Museum of Fine Arts, Santa Fe. Yale University, Wesleyan University, the Rockwell Museum, the Museum of New Mexico, and Delta Airlines are among institutions that have purchased his photographs for their collections.

NUSBAUM, JESSE LOGAN (1887–1975)

Jesse Nusbaum was born in Greeley, Colorado. Though he took up photography in high school, he was, in this field, essentially self-taught. He became an instructor for Manual Training in the Las Vegas, New Mexico, Normal School and was soon one of the young men successfully mentored by Dr. Hewett. Nusbaum photographed in Las Vegas and Santa Fe in 1908–1910. He had moved to Santa Fe in 1909 where he

became the first photographer employed by the Museum of New Mexico. He became an important figure in the remodeling of the Palace of the Governors, and built the Painted Desert exhibit for the Santa Fe Rail Road at the San Diego Exposition. At the behest of Hewett & Morley he photographed the Guatemalan archaeological site of Quirigua in 1911, 1912, and 1913. By that time his career as a photographer was being eclipsed by his career as an archaeologist, a field in which he eventually earned a Ph.D. He worked at the Pecos ruins, supervising its preservation and making a photographic record of the work of stabilization. He also made a thorough photographic record of the progressing conservation of the Palace of the Governors, and also his stabilization of the ruins at Mesa Verde. He became Superintendent of Mesa Verde National Park in 1921. In 1927 he was apointed Archaeologist to the National Park Service and the Department of the Interior. He inaugurated the Laboratory of Anthropology in Santa Fe, of which he was elected director in 1920. He died in 1975. The largest collection of his photographs survives in the collections of the Museum of New Mexico. (This sketch is based on information supplied by Richard Rudisill.)

O'SULLIVAN, TIMOTHY (1840–1882)

Timothy O'Sullivan made his mark as a field photographer in the Civil War under Mathew Brady, but the larger body of his work was produced during his later years on expeditions in the American West. Presumably from an Irish immigrant family, raised on Staten Island, O'Sullivan was a teenager when he became Brady's apprentice. He made commercial portraits in Brady's New York studio and also in Alexander Gardner's studio in Washington, D.C. In 1861 O'Sullivan became a war photographer, shooting scenes at such Civil War sites as Bull Run, Gettysburg, and Appomattox.

Having proved his skills in dangerous situations, O'Sullivan joined the King Survey of the Fortieth Parallel from 1867 to 1870. He then took part in the Selfridge Expedition to map the proposed Panama Canal. In 1871 he joined the Wheeler Survey up the Colorado River to the Grand Canyon, a difficult year in which he lost many photographs to heat and rough waters. He continued his work with Wheeler from 1873 to 1875, during which time he photographed in Arizona and New Mexico. His travels to the remotest areas in the Southwest at such an early date brought him unusual opportunities to photograph American Indians.

O'Sullivan returned to Washington and in 1879 was named official photographer for the U.S. Geological Survey. He served as the Treasury Department's chief photographer for five months in 1880 until illness debilitated him. He died in 1882 of tuberculosis.

PEARY, ROBERT (1856–1920)

Robert Edwin Peary, the explorer who in 1909 was the first to reach the North Pole, was born at Cresson, Pennsylvania, of a French and English family long settled in New England. At age three, after his father's death, the family returned to Maine where Peary spent his childhood. Two years after graduating from Bowdoin College in civil engineering, Peary entered the United States Coast and Geodetic Survey. He

later joined the corps of civil engineers of the U.S. Navy and in 1884 traveled to Nicaragua to survey the route for a proposed canal. A brief summer excursion to Greenland in 1886 whetted his determination to bring about his own Polar explorations. He began a serious study of Eskimo life and in 1891 penetrated to the northernmost limit of the ice cap. This was the first of many expeditions leading to the attainment of the North Pole. Throughout these enterprises Eskimos were his capable and devoted assistants. After reaching the North Pole on April 6, 1909, with four Eskimos and his African-American assistant, Peary returned to learn that Frederick Cook, a surgeon who had accompanied Peary's 1891 expedition, claimed to have reached the North Pole a year earlier. Cook's claims were eventually discredited. Peary used a camera both to document his explorations and to capture an ethnographic record of the Eskimo. His Eskimo common-law wife, Allakasingwah, was photographed nude and included in Peary's report of the journey.

PENNINGTON, WILLIAM (born 1875–after 1935)

After apprenticing to a photographer in McKinney, Texas, William Pennington moved to Albuquerque, New Mexico, in 1904 and set up a studio with Benjamin Davis. Four years later Pennington had relocated to Durango, Colorado. There, in a photographic partnership with L. C. Updike, Pennington made long forays by wagon into the Navajo reservation, returning with genre photographs of Navajos in the context of the landscape. These photographs, combined with formal studio portraits, frequently of head and shoulders only, became characteristic of his work. About 1935 Pennington sold the Durango business and moved to Arizona.

RAU, WILLIAM HENRY (1855–1920)

The son of photographer George Rau, William Rau made his best-known photographs during his travels away from Philadelphia where he was born and died. In 1877, at age 22, Rau took his first photographic job at the stereograph company of William Bell, who later was to become his father-in-law. Purchasing the firm a year later, Rau published stereo cards and lantern slides under his own name until 1901, when he sold the company to Underwood and Underwood. Rau's photographs continued to be published by the company, and its successor Griffith and Griffith.

In the 1880s Rau collaborated briefly with William Henry Jackson in making images of the Southwest, including views of New Mexico's Pueblo of San Juan in 1881. The Lehigh Valley Railroad hired him in 1889 to take scenic photographs along the line from Perth Amboy to Buffalo. Rau is best remembered for his photographs of the Johnstown, Pennsylvania, flood and the Baltimore Fire of 1904, which were widely published in the press.

RICHARDS, FRANK (born 1936)

Born in Vancouver, British Columbia, Frank Richards for a time studied engineering at the University of British Columbia. A self-taught photographer, he opened a studio in Toronto in 1978 and specialized in dance photography. His photographs have appeared in *Dance in Canada*, *Dance Maga-*

zine, *The Globe & Mail*, *The Sun*, and other publications. Prints of his work are in the collections of Princeton University and are held privately by such collectors as Buffy St. Marie. He closed his studio in 1988 and is presently at work on a novel.

RICKARD, JOLENE (Tuscarora, born 1956)

Her mother a member of the Turtle Clan and her father of the Bear Clan, Jolene Rickard was born into the Tuscarora Nation at Niagara Falls, New York. She attended the Tuscarora Indian School and graduated from Niagara Wheatfield High School in 1974. From 1976 to 1977 she studied communication design at the London College of Printing, and in 1978 she earned a B.F.A. degree in photography from the Rochester Institute of Technology. While living in New York City she assisted with the operation of the American Indian Community House Gallery. Rickard served a residency at Lightworks in Rochester, and proceeded to Buffalo to pursue a Ph.D. in American Studies at the State University of New York.

Her photographs have been recognized by such curators as Lucy Lippard and Jaune Quick-to-See Smith, and included in "Language of the Lens," a 1990 show at the Heard Museum in Phoenix, and "The Silver Drum: Five Native Photographers," a 1987 traveling exhibition sponsored by the Native Indian/Inuit Photographers Association in Hamilton, Ontario. She is a board member of the Center for Exploratory and Perceptual Art (CEPA). She lives on the Tuscarora Reserve where she is a graphic designer and art director in advertising.

RINEHART, FRANK A. (c.1862–c.1928)

Born in Illinois to photographer A. E. Rinehart, Frank Rinehart was raised to join the ranks of the western frontier cameramen. In 1878 he moved to Denver, Colorado, and became a partner in a photographic studio with William Henry Jackson. In 1886 he married the studio receptionist and moved to Omaha, Nebraska.

Specializing in commercial portraits, Rinehart opened his own studio in Omaha the year of his arrival. In 1898 he became the official photographer of the Trans-Mississippi and International Exposition in Omaha. There, in a gallery at the Exposition, Rinehart's studio photographed over 500 members of such tribes as the Kootenai and Salish Flatheads, in Omaha for an Indian congress. Rinehart's images, which captured the Indians in ceremonial dress, romanticize a culture on the verge of becoming myth. The U.S. Bureau of American Ethnology contracted for a complete set of the photographs, while Rinehart copyrighted another set. Many of Rinehart's images were later attributed to Adolph Muhr, who worked for Rinehart at the time. Muhr contested the copyrights and in 1903 left Rinehart to work for Edward Curtis.

Rinehart died in New Haven, Connecticut. His studio remained in operation until 1966 under the management of his former partner, George Marsden.

ROBINSON, HERBERT F. (c.1865–1956)

Richard Rudisill's researches establish that Herbert Robinson was born in Lexington, Illinois, reputedly the son of

Chicago-area photographers. He lived in Phoenix from 1887 to 1898, when he was appointed Attorney General of Arizona Territory. In 1902 he left that position and moved to Albuquerque. There in 1904 he became the Indian Irrigation Engineer for the U.S. Indian Bureau, a position from which he retired in 1931, though he remained a consulting engineer with the Middle Rio Grande Conservancy District. His official positions and travels gave him unusual opportunities to photograph among Indian people, and he did so not only in Arizona and New Mexico but also among the Blackfoot of Montana. More than a thousand of his negatives survive in the collections of the Museum of New Mexico.

SAVAGE, CHARLES ROSCOE (c. 1832–1909)

Having joined the Church of Jesus Christ of Latter-Day Saints after an unhappy childhood in England, Charles Savage was to become the pre-eminent photographer of the Mormons in their stronghold in Utah. Savage arrived in New York City in 1857 and learned photography there from a fellow Mormon. In 1859 he headed west, working in galleries in Council Bluffs, Iowa, and Florence, Nebraska, along the Mormon trail. He arrived in Utah in 1860, opening photographic studios there first with Marsena Cannon, and later with George Martin Ottinger. Based in Salt Lake City, but most productive as a field photographer, Savage traveled to Idaho, Colorado, Arizona, and possibly New Mexico, photographing Native American inhabitants. On an 1886 ocean journey east by way of California, Savage spent time with Carlton Watkins in San Francisco.

Savage earned national recognition in 1869 when he photographed the joining of the transcontinental rails at Promontory Point, Utah. In 1870 he accompanied Brigham Young on a photographic tour of Zion Canyon and the Rio Virgin region, and was arrested for treason during Salt Lake City's "wooden gun rebellion," a Mormon protest against the federal government. Forming the Savage Pioneer Art Gallery in 1874, he profited from the sales of his "Views of the Great West" and from promotional photography for the railroads. Although his partnership with Ottinger had dissolved nine years before, the two traveled together to England in 1879.

Savage, who, in the Mormon custom of the time, had four wives, lost his American citizenship under newly established anti-polygamy laws in 1883. That year Savage also lost his studio to fire, but rebuilt it within months. Joined in the business by his sons, Savage went on to record the 1892 completion of Salt Lake City's Mormon temple, and to create a landscape photography display for the 1893 Columbian Exposition in Chicago. He sold the gallery to his sons in 1906 and died three years later in Salt Lake City.

SCOTT, EVERETT (born 1952)

Everett Scott graduated from Princeton University in 1977 with a senior thesis, produced while on a grant from the de Menil Charitable Trust and George Eastman House, on photographic documentation of endangered historic buildings on the Island of Lamu in Kenya. He did graduate work in Columbia University's Program in Historic Preservation and worked as photographer for the Miami Design Preservation

League and the U.S. Department of the Interior in their efforts to establish a National Historic District around the Art Deco buildings in old Miami Beach. In 1979–1980 he became Director of Development for City Without Walls, the Urban Artists Collective in Newark, New Jersey, where he mounted the exhibition "New Deal Art: New Jersey." The following year he taught photography as a member of the Art Department faculty of the County College of Morris, in Randolph, New Jersey. His *Newark: A Study in Steel and Stone* was published in 1982. From 1983 to the present he has worked as a freelance photographer, focusing most recently on the photography of gardens. His photographs illustrate *Nature Perfected: Gardens through History* (1991), and *Grounds for Change, Major Gardens of the 20th Century* (1993), both with texts by William Howard Adams.

SEUFERT, GLADYS (born 1913)

Gladys Bender was born in Iowa and trained in the School of Nursing in Omaha. She moved to Oregon in 1939 as a nursing supervisor in The Dalles General Hospital and in September of that year married Francis Seufert, of the Seufert Brothers Company—the major salmon canning enterprise of the mid-Columbia River. Francis and his father were both devoted photographers, an enthusiasm that was soon passed on to Gladys in pre-World War II photographic tours of Oregon. Her father-in-law's photographs form an important collection at the Oregon Historical Society documenting Oregon in the first half of this century. This example, and her own concern for historic preservation, combined to motivate Gladys Seufert to begin, in 1962, a purposeful program of photographing the buildings of her adopted city and the collecting and copying of earlier photographs that supplemented this record. This photographic archive of another half century of Oregon has joined the earlier Seufert photographs at the Oregon Historical Society. Gladys Seufert continues to live in The Dalles and to pursue her photographic and preservation interests.

SEUMPTEWA, OWEN (Hopi, born 1946)

An educator by profession, Owen Seumptewa has pursued photography as a means of communication by which the culture of his Hopi people is preserved and passed on to future generations. Born at the Navajo Army Depot in Bellmont, Arizona, and schooled in Flagstaff, Seumptewa visited the Hopi reservation with his parents nearly every weekend as a child.

Seumptewa held administrative and faculty positions at the Navajo Community College, Northland Pioneer College, and Northern Arizona University in the 1960s and 1970s. In 1982 he received his Bachelor of Science degree in biology at Northern Arizona University followed by a Master's degree in Education in 1984. From 1986 to 1988 Seumptewa directed the Indian Science Teacher Education Program in Washington, D.C. He returned to Northern Arizona University where he served as Hopi Coordinator for the Center for Excellence in Education. From 1990 to 1992 he managed the Department of Human Services for the Hopi Tribe. He has since become manager of the Hopi Solar Electric Enterprises, and also operates his own business, Native Shadows and

Graphics. He is a resident of both Flagstaff and Kykotsmovi, Arizona.

Seumptewa began taking photographs in high school and took his first photography class in college. He taught photography at Northland Pioneer College's Hopi campus. During 1989–1990 he participated in the Sundance Institute Film Laboratory. His photographs have been exhibited at the Smithsonian's National Museum of Natural History, the Heard Museum in Phoenix, and the Southwest Museum in Los Angeles, among other institutions. His work has been published in *The New York Times*, *USA Today*, *Natural History*, and *Scholastic Magazine*.

SHERIFF, CHRISTOPHER (born 1952)

Sheriff inherited his interest in the American Indian from his grandfather, Irving Sheriff, who created paintings of Native Americans based on the photographs of his cousin, Edward Sheriff Curtis. Born in Merrill, Wisconsin, Christopher Sheriff studied photography at Brigham Young University, at the Agfa Graphic Arts Camera Workshop in Minneapolis, at the Archeological Field School at Tel Mikal in Tel Aviv, Israel, and at the North Central Technical Institute in Wausau, Wisconsin. His freelance work has included commissions from the Winnebago Tribe of Nebraska, the Museum of the Rockies, the Lower Sioux, and the American Indian Healthcare Association. He has worked as a photojournalist, photographic lab technician, and archaeological site photographer, both in Israel and the Maya site of El Mirador in Guatemala. He was Documentary Photographer and Photography Instructor at the Red School House of St. Paul, Minnesota, a Native American alternative school. Since 1988 he has been senior editor for Image PSL, in St. Paul, working in the production of videos and laser videodisks. He continues to document today's Ojibway people, working with the Three Fires Society, the present day structure of an ancient alliance between the Ojibway, Ottawa, and Potowatomi Tribes.

SHINDLER, ANTONIO ZENO (1823–1899)

A. Zeno Shindler earned his reputation as a photographer of Indian delegations to Washington, D.C., in the 1860s and 1870s. He is also known, as were many of his contemporaries, for assuming authorship of other photographers' work. As Antonio Zeno he fled from what is now Bulgaria to Germany and then to France where he studied painting and took refuge with a Doctor Shindler, later adopting the name. By the 1850s he had immigrated to America, settling temporarily in Philadelphia. In 1867 he moved to Washington, D.C., and with Louis Fountaine, a relative of his wife, established Shindler & Company at the Addis Gallery. The latter establishment had taken over the earlier McClees studio. Among Shindler's sitters in the 1867 Indian delegations was Scarlet Night, whom he photographed shortly before the delegate was discovered missing and, subsequently, murdered by kidnappers seeking a ransom.

Shindler published a brochure in 1869 to accompany a Smithsonian Institution exhibition of pictures of the 1857–1858 Indian delegations. In *Photographic Portraits of North American Indians*, which came to be known as the Shindler catalogue, he appropriated credit for images created by McClees.

A photograph of Red Cloud, who had not previously been photographed, was made by Shindler in 1870—the same year that the photographer traveled to the West. During the 1870s Shindler continued his work in Washington, Philadelphia, and New York City. Following the depression of 1873 photographers often survived by stealing credit for other photographers' work. Since copyrights were obtained by registering only titles of photographs, not the images themselves, Shindler was able to appropriate Indian photographs he knew to be by William Henry Jackson, Joel Whitney, and others. In 1876 he was engaged as an artist for the U.S. National Museum in Washington. He died in Washington in 1899.

STARR, FREDERICK (1858–1933)

Frederick Starr was on the original faculty of the University of Chicago in 1892, as a member of the Department of Sociology and Anthropology. His ethnological expeditions included trips to Mexico, Japan, the Belgian Congo, the Philippines, Korea, and Liberia. One of the pioneers in seeing the use of photography as an ethnographic tool, he published eleven books.

Starr received many honors for his work, including such titles as Officer of the Leopold II (Belgium), Officer of Public Instruction (France), Chevalier Order of the Crown (Italy), Knight Commander of the Order of African Redemption (Liberia), and Order of the Sacred Treasury (Japan). He retired from the university in 1923 and moved to Seattle, Washington. His studies were continued on annual tours to Japan and the Orient. He died in Tokyo in 1933.

STELTZER, ULLI (born 1923)

Born in Frankfurt, Germany, Ulli Steltzer immigrated to the United States in 1953, accompanied by her two sons. She taught music at a Massachusetts boarding school and then became a technician at a New York City photographic laboratory. In 1957 when she moved to Princeton, New Jersey, she joined the staff of a weekly newspaper as its photographer and also opened her own photographic studio. There she made portraits of such noted personalities as Adlai Stevenson, Robert Oppenheimer, and Marian Anderson, and began establishing herself as a documentary photographer. In 1960 the New Jersey Department of Labor and Industry commissioned her to record the conditions of the state's migrant workers. She received similar assignments over the next seven years, documenting the rural and urban poor for the Woodrow Wilson National Fellowship Foundation, the Southern Christian Leadership Conference in Atlanta, and the Urban Training Center for Christian Missions in Chicago.

Steltzer travelled in the Southwest from 1968 to 1972 photographing the Hopi, Pueblo, and Navajo Indians. Since moving to Vancouver, British Columbia, in 1972, she has published photographic volumes on Canada's Native populations, on Mayas in Guatemala, and on the "New Immigrants" in California. Her books include *Indian Artists at Work*, *Coast*

of Many Faces, Health in the Guatemalan Highlands, A Haida Potlatch, Inuit, The North in Transition, and *The New Americans.* Most recently she provided photographs for *The Black Canoe: Bill Reid and the Spirit of Haida Gwaii.*

Steltzer's photographs have been exhibited widely in the United States, Canada, and Europe. She is the recipient of grants from the Canadian Council for the Arts. Two of her photographic projects, "The Blacks of Rural and Urban America" and "The David McAlpin Collection of Indians of the Southwest," are part of the collections of The Princeton University Library. "Inuit," a collection of ninety photographs is in the permanent collection of the Heritage Museum, Yellowknife, Northwest Territories.

THOMAS, JEFFREY M. (Onandaga-Cayuga, born 1956)

Jeffrey Thomas, a member of the Onondaga/Cayuga nation, was born in Buffalo, New York. He graduated from Burgard Vocational High School and pursued American studies at the State University of New York, Buffalo, from 1974 to 1976. Self-taught in photography, Thomas was inspired by the technical mastery of Ansel Adams, particularly his photographs of people.

A resident of Ottawa, Thomas has received awards from the Ontario Arts Council. He has participated in numerous exhibitions, including "The Art of Memory and Transformation," at the Museum of Civilisation, Ottawa (1993), "Perspectives from Iroquoia," at Gallery 44, Toronto (1992), and "Our Land/Ourselves," at the State University of New York, Albany (1991). His photographs have been published in *Art News, Camera Canada, Sweetgrass,* and *Turtle Quarterly.* They are held in collections at the Canada Council Artbank and the Indian Art Center.

In 1984 Thomas undertook a project to photograph pow-wow dancers, resulting in the exhibition, "The Traditional Dancer," at the Thunder Bay (Ontario) National Exhibition Center in 1985. Thomas returned to documentary work again in 1991 while working for the Aboriginal Justice Inquiry in Manitoba.

THOMPSON, STEPHEN JOSEPH (1864–1929)

A Canadian master of the platinum print, S. J. Thompson established his photographic career in New Westminster, the former capital of British Columbia, where he lived from 1885 to 1898. With an abundance of scenic beauty surrounding him, Thompson focused his camera on the landscape. Thirty-two of his views of British Columbia scenery were published in 1889. In 1895 he ventured to sell photographs from the Arcade in Vancouver. Two years later Thompson established a business in Vancouver where he sold photographs, camera equipment, and paintings by Canadian artists. He invited amateur photographers to make use of his darkroom facilities; within months he expanded the space to include a portrait studio. In 1898 Thompson accompanied a federal cabinet minister on a tour to the Klondike—then overrun by Gold Rush participants. Thompson was able to travel with his camera on the Canadian Pacific Railway throughout Western Canada, traveling as far as Wrangel, Alaska.

TIOUX, PAUL (Sioux, born 1959)

Paul Tioux was born into the Lakota Two Two family in the Indian hospital on the Pine Ridge Indian reservation. At age two he was adopted by a white couple, moving with them to Korea, and then, in 1962, to Princeton, New Jersey, when his adoptive parents were divorced. At age nine Tioux began spending summers with a Hopi-Tewa family at Polacca on the Hopi reservation. He apprenticed to a Hopi kachina maker and saw his kachinas distributed ceremonially in the Hopi village of Hotevilla. He was introduced to photography in Princeton by Ulli Steltzer who encouraged him to observe her darkroom work.

Tioux received his education at the Gunnery School, Tulane University, and the Institute of American Indian Arts, in Santa Fe, New Mexico. A woodworker by profession, he is a cabinet and furniture maker who lives with his Tewa wife and five children in Tesuque Pueblo, New Mexico.

TRIMBLE, STEPHEN (born 1950)

Born and raised in Denver, Stephen Trimble graduated from Colorado College in 1972 and began four year's work as a seasonal park ranger/naturalist in Washington, Colorado, and Utah. He wrote and photographed his first book in 1974, *Great Sand Dunes: The Shape of the Wind,* and has since written and photographed award-winning works on national parks and natural history. Trimble received an M.S. in Ecology and Evolutionary Biology from the University of Arizona in 1979. For five years he was associated with the Museum of Northern Arizona where he produced *The Bright Edge: A Guide to the National Parks of the Colorado Plateau* (1979), *Blessed By Light: Visions of the Colorado Plateau* (1986), and *Canyon Country* (1986). Working full-time since 1981 as a freelance writer and photographer Trimble has produced books and essays on many aspects of the American West including *The Sagebrush Ocean: A Natural History of the Great Basin* (1989). He moved to Santa Fe, New Mexico, in 1983 and began working with southwest Indian people, producing *Our Voices, Our Land* (1986), *Talking With the Clay: The Art of Pueblo Pottery* (1987), and a major work of photography and writing, *The People: Indians of the American Southwest* (1993).

Trimble's photographs have appeared in *Life, Newsweek,* and *Audubon* magazines and in National Geographic and Smithsonian books. In 1990 his alma mater awarded him a Doctor of Humane Letters "for his efforts to make Western landscapes and people understandable and accessible." The Sierra Club awarded him its 1992 Ansel Adams Award for "superlative use of still photography to further a conservation cause." He is now a resident of Salt Lake City.

TSINHNAHJINNIE, HULLEAH J. (Navajo-Creek-Seminole, born 1954)

The daughter of an Navajo painter and teacher at the Santa Fe Indian School and a Creek/Seminole mother, Hulleah Tsinhnahjinnie was educated in reservation schools. Trained first as a painter she turned to photography. She participated in her first exhibition in the Silver Image Gallery in Seattle in 1984. She served on the board of the American Indian Con-

temporary Art Gallery in San Francisco, and produced *The Metropolitan Indian Series Calendar* as a fundraiser for the Intertribal Friendship House in Oakland. In the mid-1980s Tsinhnahjinnie began producing photocollages. She was one of the participants in the exhibition "Talking Drum, Connected Vision: Native American Artists Addressing Affinities with Indigenous People of South Africa" in Oakland in 1990; and in a group show of Native American photographers at the Institute of American Indian Arts in Santa Fe in 1993.

ULKE, HENRY (1821–c.1910) AND JULIUS (1833–1910)

German immigrants Henry and Julius Ulke first established themselves as photographers in New York City. Henry, who also painted, is thought to have introduced the painted background to American photographers in 1857.

In 1860 the brothers moved from New York City to Washington, D.C. There they operated a studio on Pennsylvania Avenue from 1862 to 1869, and in May 1870 established a new gallery, Ulke & Brothers, with their third sibling, Leo. Henry and Julius Ulke are among those photographers who recorded the visits of Indian delegations to Washington. In 1872 the brothers made group and individual portraits of delegates from the Apache, Ute, and Crow tribes. Julius and Henry continued in the photography business until the early 1880s. Both died in 1910.

UNDERWOOD, BERT ELIAS (1862–1943) AND ELMER (1860–1947)

Established in 1882 in Kansas to sell stereoscopes, Underwood and Underwood developed out of the combined interests of brothers Bert Elias and Elmer Underwood. While Bert attended Ottawa University in Kansas, Elmer entered the printing trade and established his own periodical printing firm. He was self-taught and influenced in his work with stereoscopes by an Oliver Wendell Holmes essay in *The Atlantic Monthly*.

By 1884 Underwood and Underwood had expanded their practice to the Pacific Coast, and soon thereafter branch offices were opened in Baltimore, New York City, Chicago, Toronto, and abroad. The firm provided images to *The Illustrated London News* and *Harper's Weekly*. By 1901 they were producing 25,000 photographs a day, and in 1914 established departments for portraiture and commercial photography. During World War I Bert commanded the photographic division of the Signal Corps. He traveled as a news photographer to cover the Greco-Turkish War. Elmer also traveled and advanced the field that has come to be known as photojournalism. He photographed for several U.S. presidents.

In 1921 the firm discontinued the sale and manufacture of stereoscopes, and ten years later it reorganized into four separate firms, including U & U News Photos.

UPTON, BENJAMIN FRANKLIN (1818–1901)

Benjamin Franklin Upton arrived in St. Anthony, Minnesota, neighboring Minneapolis, around 1856. From 1857 when he first made views of the city of St. Paul, into the

1870s, Upton produced prints, stereographs, and cartes de visite. At one time he was in partnership with James E. Martin.

By the 1860s Upton had established studios in both St. Anthony and Minneapolis, but he used a wagon stocked with camping gear and photographic equipment to venture farther afield. At Fort Snelling in 1863 he photographed the captive Dakota Indians at their temporary encampment. Some of his images featured the rarely photographed Dakota women and children. Around this time he also documented the Winnebago people, a smaller band that lived in southern Minnesota from 1848 to 1863.

VANNERSON, JULIAN (born about 1827)

Vannerson, sometimes incorrectly cited as Julius Vammerson, came to Washington D.C. from Richmond, Virginia, about 1852. In Washington he worked at various photographic establishments, including the McClees Studio, and in collaboration with other photographers, including Samuel Cohner and Jesse Whitehurst.

VROMAN, ADAM CLARK (1856–1916)

A native of Illinois, Adam Clark Vroman worked as an agent for the Chicago, Burlington and Quincy Railroad from 1874 to 1892, and then moved West because of his wife's poor health. In 1894, following his wife's death, Vroman established a book dealership in Pasadena, California. He supplemented his successful business with interests in archaeology, history, and collecting. A visit in 1895 to the Hopi villages where he first witnessed the Snake Dance, prompted many return trips. He gave copies of his photographs to the Hopi in exchange for shelter, food, and permission to view tribal ceremonies. He joined the Museum-Gates Expedition in 1901 and documented life among the Navajo and the Yosemite Valley Indians.

Through photography, writing, and lecturing, Vroman shared his studies of Southwestern Indian life and crusaded against efforts at assimilation. After 1904 he traveled to the East, Canada, Asia, and Europe. Before his death in 1916 he donated his books and photograph albums to the Pasadena Public Library. From 1960 to 1973 the Natural History Museum in Los Angeles displayed Vroman's work in a gallery named for the artist, who saw his photographs as ethnographic resources rather than art.

WATKINS, CARLETON EUGENE (1828–1916)

Carleton Watkins left Oneonta, New York, where he was born and raised, in the California gold rush fever of 1849. He traveled with his boyhood friend, Collis P. Huntington, who was later to become a railroad baron and a financial supporter of many of Watkins' photographic ventures. On reaching San Francisco, Watkins worked in a bookstore until 1854, when Robert Vance hired him to run a San Jose photographic gallery and taught him the daguerreotype process. Watkins returned to San Francisco in 1857, set up his own studio, and engaged a helper so he could take to the road and photograph the Western scenery. In 1858 he made images of the giant

Redwood trees in Mariposa Grove, and in 1861 he took a 12-mule team into Yosemite Valley. He came to be known for the mammoth-plate views he made there, later naming his business the Watkins Yosemite Art Gallery.

A member of numerous excursions for the government and railroads, including the 1866 Geological Survey of California, Watkins recorded views of cities, mining camps, missions, orchards, ranches, and engineering projects. His work brought him medals at the 1868 Vienna International Exhibition. In 1874 he bought Louis Heller's views of the Modoc War, which he published on his own mounts. Watkins married in 1880, the same year he traveled to Southern California to photograph the route of the Southern Pacific Railroad, recording views of undeveloped Pasadena and Los Angeles. Watkins was in the process of selling his collection to Stanford University when he lost his business and life's work to the earthquake of 1906. Suffering shock from the loss, he was committed to the state hospital at Imola and died there ten years later.

WESTMANN, ORLOFF R. (1833–after 1886)

Born in Darmstadt, Germany, in 1833, Westmann immigrated to Chicago in 1853. In 1855 he owned a farm in Illinois, and in 1857 he left for Iowa, Nebraska, Colorado, and New Mexico where he engaged in merchandising, mining, and photography. In 1871 he was commissioned by William Blackmore to photograph Apache and Taos people in Taos, New Mexico. In 1874 he purchased the oldest photographic gallery in Joliet, Illinois, and there continued his photographic career through 1886. Many of his views are in the collections of the Smithsonian Institution.

WHITE, LILY E. (c.1868–c.1931)

Lily White was born in Oregon City, educated in public schools in Portland and pursued her interest in art with study in San Francisco and Chicago. By 1892 she was established as an artist-photographer whose paintings could be found on the walls of a number of Portland residences. In 1893 she was elected a member of the Oregon Camera Club and the following year was employed as assistant secretary of that organization. In 1900 she demonstrated photographic techniques for the OCC and was elected an honorary member in 1901. Her work was included in the Camera Club of New York exhibition in 1902. She was listed as an associate member of Photo-Secession in the 1903 supplement to *Camera Work*. That year she also lived for a time on a houseboat near Lyle, Washington. Her later years were spent on the Monterey peninsula of California.

An album of her platinum prints of Columbia River views and portraits of Native Americans is in the collections of the Oregon Historical Society.

WHITESINGER, ANNA BOYD (Navajo, born 1946)

Much of Whitesinger's photography is inspired by the images her parents made with their "Brownie" camera. The photographs they created encouraged Whitesinger to document her life and experiences through photography. Her for-mal introduction to the camera came in 1968 when she took a course with Anne Noggle while an undergraduate at the University of New Mexico. In 1971 she received her B.F.A. from the university. Since graduation Whitesinger has worked on or near the Navajo Nation. In 1981 she returned to the University of New Mexico to receive an M.A. in Art Education in 1983. She teaches art and photography classes and lives in Tohatchi with her husband and four children.

WHITNEY, JOEL EMMONS (1822–1886)

In 1850 Joel Emmons Whitney moved from Maine to Minnesota, where he settled in St. Paul and learned the daguerreotype process from Alexander Hesler. By 1856 Whitney had established his own gallery.

A photograph of the Minnesota Indian leader Hole-in-the-Day, from 1859 or 1860, is believed to have been made by Whitney. In 1864 at Fort Snelling, Whitney photographed a number of Indians who had participated in the Sioux Revolt two years earlier. Among his subjects were Medicine Bottle and Little Six, Mdewakanton Dakotas, as well as Old Bets, a Santee Dakota who had aided white captives during the massacre. Whitney was helped in his studio by his wife, and in 1867 he formed a partnership with Charles A. Zimmerman. Upon Whitney's retirement in 1871, Zimmerman took over the studio and circulated his former partner's numerous views of Plains Indians under his own name.

WILLIAMS, ANITA ALVAREZ DE (born 1931)

Born in Calexico, California, Anita Williams is a Mexican citizen and resident of Mexicali in Baja California. She was educated in California at both Mills and Pomona College, where she received a degree in Art History, and at Mexico City College. She was co-founder of The Egg and The Eye, now the Craft and Folk Art Museum in Los Angeles, and founder and director of the Centro Coordinador Indigenista de Baja California in Mexicali. She is responsible for the research, design, and installation of the Ethnography and History rooms at the Museo del Hombre, Naturaleza y Cultura, in Mexicali. Williams is a member of the board of directors of Native Seeds Search in Tucson. She has published widely in archaeological journals on Southwestern subjects, particularly on the ethnography of the Cocopa. Her *Travelers Among the Cucapa*, was published in 1975. She is a contributor to the Smithsonian's *Handbook of North American Indians*, and has lectured widely on the Cocopa. Her articles and photographs have been published in *La Voz de la Frontera*, *Novedades*, *The Calexico Chronicle*, and *Tiempo*. She won a Kodak International Newspaper Snapshot Award in 1971 and was given a one-person photographic exhibition at the Imperial Valley College Gallery in 1985. She was the curator of the Smithsonian/SITES exhibition "Two Eagles/Dos Aguilas: a Natural History of the Mexican American Borderlands" which opened at the San Diego Natural History Museum in October of 1993. She has been a participating member of the Grupo Fotografico Imagenes since 1976; received first place in their black and white salon in 1987, first place in the color salons of 1989 and 1991, and was elected president in 1992.

WILLIAMS, FREDERICK ALLEN (1898–1958)

A sculptor from New York City whose work frequently depicted American Indian subjects, Frederick Allen Williams used his photographs of public gatherings of Native Americans in the West as sketches for his sculpture.

WILSON, JOHN B. (active 1900s)

Little is known of John B. Wilson other than that he photographed around Lapwai, Idaho, just after the turn of the century and issued photographs with "Wilson, Lewiston, Idaho" on their mounts.

WITTICK, GEORGE BEN (1845–1903)

Pennsylvanian Ben Wittick joined the Union Army in 1861 and was stationed at Fort Snelling, Minnesota. He learned photography in 1863 from a photographer in Moline, Illinois, where he later operated a studio of his own. Around 1878 Wittick moved to Santa Fe to work for the Atchison, Topeka & Santa Fe Railroad. He formed a brief partnership with W. P. Bliss and then, in 1880, with R. W. Russell. The following year Russell and Wittick moved their firm to Albuquerque and Russell managed the operation while Wittick photographed for the Atlantic and Pacific Railroad and the 1882 Stevenson Expedition in Arizona. The partnership ended in 1884 when Wittick set up a gallery in Gallup, New Mexico. That business was in operation until 1900, when Wittick sold it to the Imperial Photograph Gallery and moved permanently to Fort Wingate, where he had previously established a second studio.

Wittick produced stereo views, lantern slides, and large format negatives and prints. During the 1880s and 1890s he made numerous trips through Arizona and New Mexico, recording views of the Grand Canyon, Zuni Pueblos, and the Hopi Snake Dances. Wittick died in New Mexico in 1903 after being bitten by a rattlesnake he had captured as a gift for his Hopi friends. For a brief time Wittick's son, who joined the business in 1900, continued to manage the Fort Wingate gallery.

WOOLEY, CYNTHIA (born 1955)

Cynthia Wooley, who graduated from Antioch University in Los Angeles, California, and holds a Master's degree in English from the University of New Mexico, currently works in a community college in Albuquerque, New Mexico, as an instructor of English as a Second Language. She has taught courses bilingually as part of the Amnesty program and pioneered classes in drama, creative writing, and literature for foreign students.

Having studied photography in workshops in Oaxaca, Mexico, in 1972, and subsequently at Immaculate Heart College, at the San Francisco Art Institute, and in the photography program at the Otis Art Institute of Parson's School of Design, she also worked as an apprentice to Norman Seeff, a portrait photographer, in Hollywood. She participated in group exhibitions at the Immaculate Heart College and the Otis Art Institute of the Parsons School of Design, both in Los Angeles. She traveled in Mexico's southernmost state, Chiapas, during 1976–1978 documenting religious fiestas. In 1979 she was given one woman shows at 1429 Gallery in San Francisco and in La Galeria in San Cristobal de Las Casas, Chiapas, Mexico. In 1982 she returned to San Cristobal to work at Na-Bolom as darkroom technician for Gertrude Blom and to pursue independent photography among the Indian people of the area. She was represented in group exhibitions at La Galeria in San Cristobal in 1983–1984 and mounted a one woman retrospective at Na-Bolom in April of 1985.

WRIGHT, WILLIAM P. (born 1933)

Born and raised in Texas, in Harlingen and Abilene, Bill Wright graduated from the University of Texas at Austin in 1956. He went on to numerous positions of responsiblity in cultural institutions in Texas, including Chair of the Advisory Council of the Harry Ransom Humanities Research Center of the University of Texas, member of the Board of Development of the Institute of Texan Cultures, and Director and Past President of the Cultural Affairs Council in Abilene. He is a founding member of the West Texas Photographic Society and served as Director of the Texas Photographic Society and as Chairman of the Historical Photography Committee of the Texas Historical Foundation. He participated in photographic workshops taught by such masters as Ansel Adams and Jerry Uelsmann. His work has been shown in more than fifty exhibitions in this country, England, and Scotland, almost half of them solo exhibitions. His photographs have been published in periodicals and catalogues and most notably in his own book *The Tiguas: Pueblo Indians of Texas*, published in 1993. His work is part of many collections in this country and Europe, including the Rijksmuseum Voor Volkenkunde, Leiden, The Netherlands, the Smithsonian Institution and the Amon Carter Museum in Fort Worth, Texas. In addition to winning many photographic awards, Wright is a teacher in photographic workshops and the presenter of lecture series in Texas, New Mexico, Mexico, and Guatemala. Wright has conceived, organized, and curated a number of exhibitions of photographs, including "*The Peruvians*: an exhibition of seventeen Peruvian Photographers"; and a exhibition of Texas photography that traveled to Scotland.

WURMFELD, HOPE (born 1939)

Hope Wurmfeld graduated from Cornell University and received a Master of Arts degree in Art History and Archaeology from Columbia University. Since 1978 she has taught photography in the Art Department at Hunter College.

Wurmfeld, who makes chromogenic prints from color negative film, has had her work featured in solo exhibitions in New York City, in Leningrad, U.S.S.R., and in Kaunas, Lithuania. Among the group shows in which she participated are the 1992–1993 exhibition "Women in Solidarity" in Sarajevo, "Soviet-American Art/Action" at the Leningrad Institute of Design, and "Mothers and Daughters" at New York City's Aperture Foundation. The Museum of Modern Art, the New York Public Library, the Princeton University Library, the Smithsonian Insitution, and the Bibliothèque Na-

tionale, Paris, hold Wurmfeld's photographs in their collections.

YAZZIE, HERBERT (Navajo, born 1965)

While a student at Brigham Young University, Yazzie worked as a photographer and reporter for *The Eagle's Eye*, a magazine published by the Native American studies center. He was the only American Indian photographer on the staff. In 1989 he began work on a degree in psychology at the University of Texas at Tyler and has recently worked for the *Tyler Courier Times*.

ZIMMERMAN, CHARLES A. (1844–1909)

When he was four years old Charles Zimmerman immigrated with his family to America from his birthplace in Strasbourg, France. By 1856 he was in St. Paul, Minnesota. An artist and writer at an early age, with a father who prac-

ticed photography, Zimmerman constructed his own camera at age 14. He is listed in the city business directory of St. Paul as early as 1866. The following year he went to work at the St. Paul studio of Joel Emmons Whitney. Zimmerman purchased the Whitney Gallery in 1871, when the elder photographer retired. He relocated the business and reissued Whitney's photographs—including those of the Dakota and Ojibwa—under his own name. His photographic work won the gold medal at the Philadelphia Exposition of 1871, and another gold medal at the Centennial Exposition in 1876.

Zimmerman went into business in 1877 with Fred H. Whitestruk—a partnership that lasted thirteen years. He also became owner and manager of a fleet of pleasure boats on Lake Minnetonka in 1881. In 1891 he rejoined the family photography firm, Zimmerman Brothers. With photography, he continued to pursue writing and watercolor painting until his death in 1909.

Bibliography

This listing focuses on publications about photographs of American Indians. It also includes works that reproduce significant numbers of photographs of Native Americans, unusual images of Indian subjects, or photographs accompanied by exceptional documentation.

Adam, Chuck, "C. C. Stotz, Photographer of Indians," *Central States Archaeological Journal*, Vol. 14, No. 4, pp. 154–157.

Alcorn, Rowena L., "More Detail About Joseph's Likeness and Some Editorial Lapses," *Montana, The Magazine of Western History*, Vol. XIX, No. 1, January 1969, p. 82. [Photographs of Chief Joseph]

The American Indian, The American Flag . . . Flint Institute of Arts, Flint, Michigan, 1976. [Historic photographs that associate Indians and the American flag]

The American Indian Illustrated . . . Folio plates from Edward S. Curtis' The North Amerian Indian, Exhibition and Sale at the Sotheby Parke Bernet Galleries, Inc., New York City, 1972.

American Indian Portraits From the Collection of Kurt Koegler, Milwaukee Art Museum May 20–September 18, 1983, Milwaukee, Wisconsin, 1983.

The American Museum of Natural History, The Frederick Monsen Indian Photographs, On Public Exhibition, January 7 to 31, 1910, New York City, 1910.

American Stereoviews, The Witkin Gallery, Inc., New York City, 1980. [Reproduces many stereo images of American Indians]

Amiotte, Arthur, and Myles Libhart, *Photographs and Poems by Sioux Children*, Rapid City, South Dakota, 1971.

Anderson, John Alvin, *Among the Sioux*, Rosebud Agency, South Dakota, 1896.

Anderson, Marilyn, and Jonathan Garlock, *Granddaughters of Corn, Portraits of Guatemalan Women*, Willimantic, Connecticut, 1988. [Photographs of Guatemalan Indians by Marilyn Anderson]

Anderson, Myrtle Miller, *Sioux Memory Gems . . . Illustrated by* [the photographs of] *J. A. Anderson*, n.p., 1929.

Anderson, Susanne, *Song of the Earth Spirit*, New York City, 1973. [Photographs by Susanne Anderson of the Navajo]

Andrews, Ralph W., *Curtis' Western Indians*, Seattle, Washington, 1962.

Andrews, Ralph W., "He Knew the Red Man: Edward S. Curtis, Photographer," *Montana, The Magazine of Western History*, Vol. 14, No. 2, Spring 1964, pp. 2–12.

Andrews, Ralph W., *Indian Leaders Who Helped Shape America*, Seattle, Washington, 1971.

Andrews, Ralph W., *Indian Primitive*, Seattle, Washington, 1960. [Photographs of coastal natives from Northern California to Alaska]

Andrews, Ralph W., *Indians, as the Westerners Saw Them*, Seattle, Washington, 1963. [Among the identified photographers are David Barry, Edward Curtis, Alexander Gardner, Heyn & Matzen, William Henry Jackson, and Frank Rinehart.]

Andrews, Ralph W., *Photographers of the Frontier West, Their Lives and Works 1875–1915*, Seattle, Washington, 1965. [Chapters are devoted to eleven photographers, including these of Indians: Edward S. Curtis, A. W. Ericson, Camillus S. Fly, Darius Kinsey, Thomas M. McKee, and Frank H. Nowell.]

Andrews, Ralph W., *Picture Gallery Pioneers 1850 to 1875*, Seattle, Washington, 1964.

Antes, Horst, *Kachina*, Karlsruhe, Germany, 1981. [The photographs include views of kachina performances.]

Armer, Laura Adams, *The Traders Children . . . With Illustrations from Photographs by the author*, New York City, 1937. [Navajo photographs by Laura Adams Armer]

"The Artistic Vision of Myrta Wright Stevens," *Montana, The Magazine of Western History*, Vol. XXV, No. 3, Summer 1975, pp. 36–47.

Austin, Mary Hunter, *Taos Pueblo, Photographed by Ansel Easton Adams and Described by Mary Austin*, San Francisco, California, 1930.

Austin, Mary Hunter, *The Land of Little Rain, Photography by Ansel Adams*, Boston, 1950.

Baez-Jorge, Felix, and Arturo Warman, *Mercados Indios*, Mexico City, 1982. [Photographs of Mexican Indians in their markets by Miguel Bracho, German Herrera, and Pablo Ortiz Monasterio]

Baker, Will, *Backward: An Essay on Indians, Time, and Photography*, Berkeley, California, 1983.

Ballinger, James K., and Andrea D. Rubinstein, *Visitors to Arizona 1846 to 1980*, Phoenix, Arizona, 1980. [An exhibition catalogue including the work of photographers of Indians]

Bancroft-Hunt, Norman, *North American Indians*, Philadelphia, 1992. [Historical photographs]

Barry, David F., *D. F. Barry's Catalogue of Noted Indian Chiefs*, Bismarck, Dakota Territory, c.1882.

Bell, William A., *New Tracks in North America*, New York City, 1869.

Belous, Russell E., and Robert A. Weinstein, *Will Soule, Indian Photographer at Fort Sill, Oklahoma 1864–1874*, Los Angeles, California, 1964 and 1969.

Bennett, Noel, *Halo of the Sun, Stories Told and Retold*, Flagstaff, Arizona, 1987. [Photographs by John Running]

Bennett, Ross S., ed., *Lost Empires, Living Tribes*, Washington, D.C., 1982. [National Geographic photographs of Indians south of the United States]

Beyer, David, and Lenore Keeshig-Tobias, "Shadowcatcher, Jeff Thomas," *Sweetgrass*, July/August 1984, pp. 24–31. [Photographs by the Onondaga photographer Jeffrey Thomas]

Bigart, Robert, and Clarence Woodcock, "The Rinehart Photographs: A Portfolio," *Montana, The Magazine of Western History*, Vol. XXIX, No. 4, October 1979, pp. 24–37. [The F. A. Rinehart collection of photographs of the delegates to the Indian Congress in 1898 at the Trans-Mississippi and International Exposition in Omaha, Nebraska]

Birrell, Andrew J., "Classic survey photos of the early West," *Canadian Geographical Journal*, Vol. 91, No. 4, October 1975, pp. 12–19.

Birrell, Andrew J., *Into the Silent Land, Survey Photography in the Canadian West, 1858–1900*, Ottawa, 1975.

Blackman, Margaret B., "The application of Photogrammetry to Photographic Ethnohistory," *Newsletter, Society for the Anthropology of Visual Communication*, Vol. 5, No. 1, 1973, pp. 9–15.

Blackman, Margaret B., "Believing is Seeing: Anthropology in Pictures," *Odyssey*, 1980, p. 19.

Blackman, Margaret B., "Blankets, Bracelets and Boas: The Potlatch in Photographs," *Anthropological Papers of The University of Alaska*, Vol. 18, 1976, pp. 43–67.

Blackman, Margaret B., " 'Copying People,' Northwest Coast Native Response to Early Photography," *B.C. Studies*, No. 52, Winter 1981–82, pp. 86–112.

Blackman, Margaret B., "Nei:wons, the 'Monster' House of Chief Wi:ha: An Exercise in Ethnohistorical, Ethnological, and Archaeological Reasoning," *Syesis*, Vol. 5, 1972, pp. 211–225.

Blackman, Margaret B., "Posing the American Indian, early photographers often clothed reality in their own stereotypes," *Natural History*, Vol. 89, No. 10, October 1980, pp. 68–74.

Blackman, Margaret B., "Studio Indians: Cartes de Visite of Native People in British Columbia, 1862–1872," *Archivaria*, No. 21, Winter 1985–86, pp. 68–86. [Photographs by Frederick Dally, Hannah Maynard, and Richard Maynard]

Blackman, Margaret B., "Tradition and Innovation: The Visual Ethnohistory of the Kassan Haida," in *The Tsimshian and Their Neighbors of the North Pacific Coast*, ed. Jay Miller and Coral Eastman, Seattle, Washington, 1984.

Blackman, Margaret B., *Window on the Past: the Photographic Ethnohistory of the Northern and Kaigani Haida*, Ottawa, Ontario, Canada, 1981.

Blackman, Margaret B., and Edwin S. Hall, Jr., "The Afterimage and the Image After: Visual Documents and the Renaissance in Northwest Coast Art," *American Indian Art*, Vol. 7, No. 2, 1982, pp. 30–39.

Blom, Gertrude Duby, *Chiapas Indigena*, Mexico City, 1961. [Photographs of Chiapas Indians by Gertrude Blom]

Blom, Gertrude Duby, *Bearing Witness*, Chapel Hill, North Carolina, 1984. [Photographs of the Maya by Gertrude Blom]

Blom, Gertrude Duby, *Das Antlitz der Mayas*, Koenigstein, Germany, 1982. [Photographs by Gertrude Blom]

Bogojavlensky, Sergei, and Robert S. Fuller, "Polar Bears, Walrus Hides and Social Solidarity," *The Alaska Journal*, Vol. 3, No. 2, Spring 1973, pp. 66–76. [The 1937 photographs of the Eskimo of King Island, Alaska, by Father Bernard Hubbard, S.J.]

Bohn, Dave, and Rodolfo Petschek, *Kinsey, Photographer*, two vols., San Francisco, 1975. [Vol. 2 contains the Indian photographs of both Darius and Tabitha Kinsey.]

Bourns, Phillips M., "Matteson as Photographer," *The Science Museum of Minnesota Encounters*, Vol. 5, No. 6, July-August 1982, pp. 12–13.

Bowen, Ezra, and others, *The Old West, The Indians*, by the editors of Time-Life Books with text by Benjamin Capps, New York City, 1973. [The many photographs gathered for this book are unreliably captioned and seldom documented. Some of them bear credits to Christian Barthelmess, Edward S. Curtis, Alexander Gardner, and L. A. Huffman.]

Brenner, Anita, and George R. Leighton, *The Wind That Swept Mexico, The History of the Mexican Revolution 1910–1942*, New York, 1943. [Photographs of the Mexican Revolution, many of them of Indian participants]

Breunig, Robert, and Michael Lomatuway'ma, *Hopi Scenes of Everyday Life*, Flagstaff, Arizona, 1983. [Reprinted from Vol. 55, No. 1 of *Plateau*. A selection of the photographs of Emry Kopta, dating from 1912 through 1922]

Brill, Charles, *Indian and Free, A Contemporary Portrait of Life on a Chippewa Reservation*, Minneapolis, Minnesota, 1971. [Photographs by Charles Brill]

Broder, Patricia Janis, *Shadows on Glass, The Indian World of Ben Wittick*, Savage, Maryland, 1990.

Bromberg, Nicholette Ann, "Clarence Leroy Andrews and Alaska," *The Alaska Journal*, Vol. 6, No. 2, Spring 1976, pp. 66–77. [Andrews' photographs of Alaska Natives date to the first three decades of this century.]

Bronson, William, "Eskimo, The People of the Far American North as They Were Seen and Recorded during the Great Turn-Of-The-Century Nome Gold Rush," *The American West*, Vol. VII, No. 4, July 1970, pp. 34–47. [Photographs from 1898 by E. A. Hegg, the Lomen Brothers, and F. H. Nowell]

Brown, Joseph Epes, "The North American Indians: A Selection of Photographs by Edward S. Curtis," *Aperture*, Vol. 16, No. 4, 1972.

Brown, Mark Herbert, and W. R. Felton, *Before Barbed Wire, L. A. Huffman, Photographer on Horseback*, New York City, 1961. [Includes a few of Huffman's Indian images]

Brown, Mark Herbert, and W. R. Felton, "L. A. Huffman, Brady of the West," *Montana, The Magazine of Western History*, Vol. 6, No. 1, January 1956, pp. 29–37.

Brown, Mark Herbert, *The Frontier Years, L. A. Huffman, Photographer of the Plains*, New York City, 1955.

Bruemmer, Fred, *Seasons of the Eskimo, A Vanishing Way of Life*, Photography and text by Fred Bruemmer, Greenwich, Connecticut, 1971.

Brust, James S., "Into the Face of History," *American Heritage*, Vol. 43, No. 7, November 1992, pp. 104–113. [Indian

photographs of John H. Fouch at Fort Keogh, Montana Territory]

Bryant, Barbara, "Native American Images: Collection Documents a Period in Nation's History," *Library of Congress Information Bulletin,* Vol. 52, No. 15, 26 July 1993, pp. 302–305.

Bryson, George, "Larry McNeil, Focus on the Heart of Alaska, Its People," *We Alaskans, The Anchorage Daily News Magazine,* 8 December 1985, pp. l, 4–11. [Reproduces 10 photographs by or of Larry McNeil, a Tlingit photographer in Alaska]

Buckland, Gail, *First Photographs, People, Places and Phenomena as Captured for the First Time by the Camera,* New York City, 1980. [Identifies on pp. 38 and 39 the first photographs of American Indians]

Bunnell, Glenn E., "No Night, No Death, No Winter . . . A Picture Story of What May Well be The Last Medicine Lodge Ceremony of the Great Blackfeet Tribe," *Montana, The Magazine of Western History,* Vol. 8, No. 2, April 1958, pp. 21–25. [The 1955 photographs of Glenn E. Bunnell]

Bunster, Ximena, "Talking Pictures, Field Method and Visual Mode," *Signs,* Vol. 3, No. 1, Autumn 1977, pp. 278–293.

Bunzl, George, *The Face of the Sun Kingdoms, The Indians of Mexico, Guatemala, Ecuador and Peru and Their Ancient Lands,* London, 1966. [Photographs by George Bunzl]

Burckhalter, David L., *The Seris,* Tucson, Arizona, 1976. [David Burckhalter's photographs of the contemporary Seri]

Burkhardt, Elaine, "Marcia Keegan, Photo-Journalist," *OK Magazine,* pp. 3–4.

Burnette, Robert, *The Tortured Americans,* Englewood Cliffs, New Jersey, 1971. [Includes a 98-page portfolio of photographs by Richard Erdoes]

Caldwell, Carey, "Elders Record Tribal Heritage," *Center for Southern Folklore Magazine,* March 1981. [The Suquamish photographic archives]

Calmensen, Wendy, "Winter & Pond, Photographers, 1893–1956," *The Alaska Journal,* Vol. 12, No. 1, Winter 1982, pp. 10–20.

Camara Barbachano, Fernando, *Semblantes Mexicanos de Bernice Kolko,* Mexico City, 1968. [Photographs of Bernice Kolko of Mexican Indians]

Cancian, Frank, *Another Place, Photographs of a Maya Community,* San Francisco, California, 1974.

Cardozo, Christopher, ed., *Native Nations, First Americans as seen by Edward S. Curtis,* Boston, 1993.

Carley, Kenneth, *The Sioux Uprising of 1862,* St. Paul, Minnesota, 1961.

Carmony, Neil, and David E. Brown, editors, *Tales from Tiburon, An Anthology of Adventures in Seriland,* Phoenix, Arizona, 1983.

Carpenter, Edmund, *Oh, What a Blow That Phantom Gave Me!,* New York City, 1972.

Carroll, Giner A., "Stick Dance," *The Alaska Journal,* Vol. 2, No. 2, Spring 1972, cover and pp. 28 to 33. [Photographs by J. Michael Carroll of an 1971 Alaska Athapascan ceremony]

Carroll, Peter, "Portrait for a Western Album," *The American West,* Vol. XVI, No. 1, January/February 1979, pp. 30–31. [A photograph of Black Elk]

Casagrande, Louis B., and Phillips Bourns, *Side Trips, The Photography of Sumner W. Matteson 1898–1908,* Minneapolis, Minnesota, 1983.

Casaola, Juan Manuel, *Pueblo en Armas,* Mexico City, 1977.

Castles Jean L., "'Boxpotapesh' of Crow Agency," *Montana, The Magazine of Western History,* Vol. 21, No. l, Summer 1971, pp. 84–93. [The photographs of Fred E. Miller (1868–1936)]

Catalogue of the Indian Industrial School, Carlisle, Pa. . . 23D Year, 1902, Carlisle, Pennsylvania, 1902. [Ninety-one photographs of scenes at the school are reproduced, many of Indian students and Indian delegations visiting the school.]

Cavell, Edward, *A Delicate Wilderness, The Photography of Elliott Barnes 1905–1914,* Banff, Alberta, Canada, n.d.

Cavell, Edward, *Journeys to the Far West, Accounts of the Adventures in Western Canada 1858–1885,* Toronto, Ontario, Canada, 1979.

Chalat, Nan, "Rainer brings beauty, compassion to Kimball," *The Park Record,* Park City, Utah, 11 April 1985, p. B1. [The photographs of Howard Rainer of Taos Pueblo]

Chambers, Scott, "Elbridge Warren Merrill," *The Alaska Journal,* Vol. 7, No. 3, Summer 1977, pp. 138–145. [Merrill (1868–1929) opened a photography shop in Sitka, Alaska, in 1905]

Chatham, Russell, "The Spirit of the Indian Haunts the Delicate Pictures of Edward S. Curtis," *Sports Illustrated,* Vol. 44, No. 8, 23 February 1976, p. 6.

Christenson, Richard P., "An artistic quartette for April," *Deseret News,* Salt Lake City, Utah, 21 April 1985, p. 2E. [Includes a discussion of photographs by Howard Rainer of Taos Pueblo]

Cobb, Josephine, "Alexander Gardner," *Image,* Vol. 7, No. 6, June 1958, pp. 124–136.

Coe, Brian, and Paul Gates, *The Snapshot Photograph: The Rise of Popular Photography 1888–1939,* London, 1977.

Coke, Van Deren, *Photography in New Mexico From the Daguerreotype to the Present,* Albuquerque, New Mexico, 1979. [Reproduces Indian photographs by William Henry Brown, Dana B. Chase, Irving Couse, Edward Curtis, Arnold Genthe, Laura Gilpin, John K. Hillers, William Henry Jackson, Ernest Knee, Charles Lummis, Karl Moon, Timothy O'Sullivan, T. Harmon Parkhurst, William Pennington, William H. Rau, H. F. Robinson, Arthur Rothstein, Adam Clark Vroman, and Ben Wittick]

Coles, Robert, *The Last and First Eskimos . . . Photographs by Alex Harris,* Boston, 1977.

Collier, John, *On the Gleaming Way,* Denver, Colorado, 1962.

Collier, John, Jr., *Visual Anthropology, Photography as a Research Method,* New York City, 1967.

Collier, John, Jr., and Malcolm Collier, *Visual Anthropology, Photography as a Research Method,* Albuquerque, 1986.

Conetah, Fred A., *A History of the Northern Ute People, Salt Lake City,* Utah, 1982. [Photographs by DeLancey Gill, John Hillers, Maroe Studio, F. C. McKee, Francis McWinley, Meyers Studio, Savage and Ottinger, and Zeno Shindler]

Cook, Ira L., "With My Indian Friends," *Camera Craft*, San Francisco, Vol. 17, No. 4, April 1910.

Coolidge, Dane, and Mary Roberts Coolidge, *The Last of the Seris*, New York City, 1939. [Photographs by Dane Coolidge]

Cox, James, *Our Own Country, Representing Our Native Land and Its Splendid Natural Scenery . . . Reproduced in a Series of Five Hundred Superb Original Photographs . . . Revised by William S. Bryan*, St. Louis, Missouri, 1913. [Includes 57 unattributed photographs of Native Americans]

Crampton, C. Gregory, *The Zunis of Cibola*, Salt Lake City, Utah, 1977. ["The Zunis of Cibola in Photographs" on pp. 69–96 includes both historic images and modern ones by the author.]

Criqui, Orvel A., "A Northern Cheyenne Called Roman Nose," *Kansas History*, Vol. 8, No. 3, Autumn 1985, pp. 176–185. [Reproduces photographs by Alexander Gardner and DeLancey Gill, and discusses the use and misidentification of photographs of Roman Nose]

Cummings, Stephen, Brenda Mitten, Richard Hill, and Sandra Semchuk, *Silver Drum, Five Native Photographers*, Hamilton, Ontario, 1986. [Photographs by Dorothy Chocolate, Richard Hill, George Johnston, Murray McKenzie, and Jolene Rickard]

Cunningham, Robert E., *Indian Territory, A Frontier Photographic Record by W. S. Prettyman*, Norman, Oklahoma, 1957.

Current, Karen, and William Current, *Photography and the Old West*, Dobbs Ferry, New York, 1978.

Curtis, Edward S., *In a Sacred Manner We Live*, Yonkers-on-Hudson, New York, 1915.

Curtis, Edward S., *In the Land of the Head-Hunters . . . Illustrated with Photographs by the Author and Drawings by F. N. Wilson*, Yonkers-on-Hudson, New York, 1915. ["This book had its inception" as a "scenario for a motion picture drama dealing with the . . . Indians inhabiting northern British Columbia."]

Curtis, Edward S., *Indian Days of Long Ago, Illustrated with Photographs by the Author and Drawings by F. N. Wilson*, Yonkers-on-Hudson, New York, 1915.

Curtis, Edward S., "Indians of the Stone Houses," *Scribner's Magazine*, Vol. XLV, 1909, pp. 161–175.

Curtis, Edward S., *The North American Indian; Being a Series of Volumes Picturing and Describing the Indians of the United States and Alaska*, Seattle, Washington, 1907–1930. [Twenty volumes and twenty portfolios]

Curtis, Edward S., *Portraits from North American Indian Life*, New York City, 1972.

Curtis, Edward S., "The Vanishing Red Man, Inhumanity of the White Man toward the North American Indian discussed, by Edward S. Curtis," *The Hampton Magazine*, Vol. XXVIII, No. 4, May 1912, pp. 244–253, 308.

Curtis, Edward S., "Vanishing Indian Types—The Tribes of the Southwest," *Scribner's Magazine*, Vol. XXXIX, 1906, pp. 657–671.

Curtis, Edward S., "Village Tribes of the Desert Land," *Scribner's Magazine*, Vol. XLV, March 1909, pp. 275–287.

Daniel, Forrest W., "Running Antelope—Misnamed One-papa," *Paper Money*, Vol. 8, No. 1, first quarter 1969, pp. 4–9.

Daniels, David, "Photography's Wet-plate Interlude in Arizona Territory: 1864–1880," *The Journal of Arizona History*, Vol. 9, No. 4, Winter 1968, pp. 171–194.

Darrah, William Culp, "Beaman, Fennemore, Hillers, Dellenbaugh, Johnson, and Hattan," *Utah Historical Quarterly*, Vol. 17, Nos. 1–4, 1948–1949, pp. 491–503.

Darrah, William Culp, *The World of Stereographs*, Gettysburg, Pennsylvania, 1977.

Davis, Christopher, *North American Indian*, London, 1969.

Dawson, Lillian, *Jane Gay Photograph Collection Catalog*, Boise, Idaho, 1980.

Dean, Sharon, "Photo Archives responds to cultural concerns," *Smithsonian Runner*, July–August 1993, pp. 4–5.

DeMaillie, Raymond, "'Scenes in the Indian Country,' A Portfolio of Alexander Gardner's Stereographic Views of the 1868 Fort Laramie Treaty Council." *Montana, The Magazine of Western History*, Vol. 31, No. 3, Summer 1981, pp. 42–59.

Dewing, C. E., "The Wheeler Survey Records: A Study in Archival Anomaly," *The American Archivist*, April 1964.

Dicker, Laverne, "Laura Adams Armer, California Photographer," *California Historical Quarterly*, Vol. 56, No. 2, Summer 1977, pp. 186–194.

Dingus, Rick, *The Photographic Artifacts of Timothy O'Sullivan*, Albuquerque, 1982.

Dixon, Joseph Kossuth, *The Vanishing Race*, Philadelphia, 1913.

Dockstader, Frederick J., *The American Indian Observed, Exhibition Catalogue*, New York City, 1971.

Doll, Don, and Jim Alinder, *Crying for a Vision, A Rosebud Sioux Trilogy 1886–1976, Photographs by John A. Anderson, Eugene Buechel, S. J. and Don Doll, S. J.*, Dobbs Ferry, New York, 1976.

Driggs, Howard R., and William Henry Jackson, *The Pioneer Photographer*, New York City, 1929.

Dubois, Daniel, and Yves Berger, *Les Indiens des Plaine*, Neuilly-Sur-Seine, France, 1978.

"Duren Ward Mesquakie Photograph Exhibit," in State Historical Society of Iowa, *News for Members*, 35, 1982, p. 3.

Dyck, Paul, *Brule, The Sioux People of The Rosebud*, Flagstaff, Arizona, 1971. [A presentation of "The John Anderson Photographs from the Jack R. Williams Collection."]

Earth Maker's Children, a Photographic and Poetic Exhibition by a Contemporary Indian Artist, Howard T. Rainer, Provo, Utah, 1985. [Howard Rainer is a photographer from Taos pueblo.]

Edkins, Diana E., *William Henry Jackson*, Dobbs Ferry, New York, 1974.

Edwards, Elizabeth, *Anthropology and Photography, 1860–1920*, New Haven, Connecticut, 1992.

Endangered Dine: The Big Mountain Peoples and Other Land-Dispute Navajos, Window Rock, Arizona, 1980. [Photographs by Dan Budnick and John Running]

Enyeart, James L., *Invisible in America, An Exhibition of Photographs by Marion Palfi*, Lawrence, Kansas, 1973.

Ethnographical Album of the North Pacific Coasts of America and

Asia, Jesup North Pacific Expedition, Part I, New York City, 1900. [Photographs by Harlan I. Smith and Roland B. Dixon]

Eugene Buechel, S.J.: Rosebud and Pine Ridge Photographs, 1922–1942, An Exhibition Prepared by the 1974 Crossmont College Summer Photography Workshop in cooperation with the Buechel Memorial Museum in St. Francis, South Dakota, St. Francis, South Dakota, 1974.

Evans, Susan, "Henry Buehman: Tucson Photographer 1874–1912," *History of Photography,* Vol. 5, No. 1, January 1981, pp. 59–81.

Evers, Larry, editor, *The South Corner of Time, Hopi Navajo Papago Yaqui Tribal Literature,* Tucson, Arizona, 1980. [Illustrated by photographs, many by Indian photographers, including Victor Masayesva and Owen Seumptewa]

Everton, MacDuff, *The Modern Maya: A Culture in Transition,* Albuquerque, New Mexico, 1991.

Ewers, John C., "An Anthropologist Looks at Early Pictures of North American Indians," *New-York Historical Society Quarterly Bulletin,* Vol. XXXII, No. 4, October 1949, pp. 223–234.

Ewers, John C., "Artifacts and Pictures as Documents in the History of Indian-White Relations," in Jane F. Smith and Robert M. Kvasnicka, editors, *Indian-White Relations: A Persistent Paradox,* Washington, D.C., pp. 101–111.

Ewers, John C., *Artists of the Old West,* New York City, 1965.

Ewers, John C., "The Emergence of the Plains Indians as the Symbol of the North American Indian," *Annual Report of the Smithsonian Institution,* 1965, pp. 531–544.

Ewers, John C., "Self-Torture in the Blood Indian Sun Dance," *Journal of the Washington Academy of Science,* Vol. 39, No. II, February 15, 1949, pp. 335–360.

Ewers, John C., "The Last of the Buffalo Indians," *The American West,* Vol. II, No. 2, Spring 1965, pp. 26–31. [Photographs by Donald Schmidt]

Ewers, John C., "Thomas M. Easterly's Pioneer Daguerreotypes of Plains Indians," *Bulletin of the Missouri Historical Society,* Vol. 24, No. 4, July 1968, pp. 329–359.

Ewers, John C., "The Use of Artifacts and Pictures in the Study of Plains Indian History, Art and Religion," in Anne-Marie E. Cantwell and others, editors, "The Research Potential of Anthropological Museum Collections," *Annals of the New York Academy of Sciences,* Vol. 376, December 1981, pp. 247–266.

Exposicion del Fotografo Nacho Lopez, Obra Retrospectiva, Mexico City, 1981.

F. Jay Haynes Photographer, Helena, Montana, 1981.

Fairchild, Hoxie Neale, *The Noble Savage; a Study in Romantic Naturalism,* New York City, 1928.

Farley, Ronnie, *Women of the Native Struggle: Portraits & Testimony of Native American Women,* edited and photographed by Ronnie Farley, New York City, 1993.

Farr, William E., *The Reservation Blackfeet 1882–1945: A Photographic History of Cultural Survival,* Seattle, Washington, 1984.

Finlay, Nancy and Julia Van Haaften, "Four Hundred Years of Native American Portraits: Prints and Photographs from the Collections of the New York Public Library," record of labels for an exhibition at the New York Public Library, October 31, 1992–January 30, 1993.

Fiske, Turbese Lummis, and Keith Lummis, *Charles F. Lummis, the Man and His West,* Norman, Oklahoma, 1975.

The Fiske Portfolios, Bismarck, North Dakota, 1983.

Fitch, Daisy, "Gertrude Blom: A Fighter Who Won't Quit," *The Trenton Times,* 6 May 1984, pp. Gl, G7.

Fitzhugh, William W., and others, *Inua, Spirit World of the Bering Sea Eskimo,* Washington, D. C., 1982. [Nineteenth-century photographs by Edward W. Nelson]

Flecky, Michael S. J., and Harold Moore, *Photo Album: St. Francis Mission, School, and Community 1886–1976,* St. Francis, South Dakota, 1976.

Fleming, Paula Richardson, and Judith Lynn Luskey, *Grand Endeavors of American Indian Photography,* Washington, D.C., 1993. [Photographs by John Alvin Anderson, Prince Roland Bonaparte, Edward S. Curtis, Joseph Kussuth Dixon, Mamie and Emma Gerhard, George Wharton James, Sumner Matteson, Adolph F. Muhr, Roland Reed, Frank F. Rinehart, and Winter and Pond]

Fleming, Paula Richardson, and Judith Lynn Luskey, *The North American Indians in Early Photographs,* New York City, 1986. [The appendices on Delegation Photographers, c. 1840 to c. 1900 and Selected Frontier Indian Photographers are useful references for the identification and dating of Indian photographs.]

Fly, Mrs. Mary Edith, *Scenes in Geronimo's Camp,* Tombstone, Arizona, 1886. [Photographs by C. S. Fly]

Fly, Mrs. Mary Edith, *Scenes in Geronimo's Camp,* Tucson, Arizona, 1986. [A reprint of the 1886 publication]

Forrest, Earle R., *The Snake Dance of the Hopi Indians,* Los Angeles, 1961.

Forrest, Earle R., *With a Camera in Old Navajoland,* Norman, Oklahoma, 1970.

Forsee, Aylesa, *William Henry Jackson, Pioneer Photographer of the West,* New York City, 1964.

Foster, Elizabeth W., and Laura Gilpin, *Denisons of the Desert: A Tale in Word and Picture of Life among the Navajo Indians,* edited by Martha A. Sandweiss, Albuquerque, 1989. [Photographs by Laura Gilpin]

Fowler, Don D., and Rachel J. Homer, *In A Sacred Manner We Live, Photographs of the North American Indian by Edward S. Curtis,* Barre, Massachusetts, 1972.

Fowler, Don D., *The Western Photographs of John K. Hillers, Myself in the Water,* Washington, D.C., 1989.

Frederick, Richard, and Jeanne Engerman, *Asabel Curtis, Photographs of the Great Northwest,* Tacoma, Washington, 1983.

Frink, Maurice, and Casey Barthelmess, *Photographer on an Army Mule,* Norman, Oklahoma, 1965. [The photographs of Christian Barthelmess]

"From the Four Corners, Images of the Reservation Utes and Navajos," *Colorado Heritage,* Issue 1, 1986, cover and pp. 16–29. [Photographs by William Pennington]

Fryxell, Fritiof M., "William H. Jackson, Photographer, Artist, Explorer," *American Annual of Photography,* 1939.

Gaede, Marnie, Marc Gaede, and Barton Wright, *The Hopi Photographs, Kate Cory: 1905–1912,* La Canada, California, 1986.

Gaede, Marc and Marnie Walker, *Bordertowns*, La Canada, California, 1990. [Photographs by Marc Gaede]

Galusha, Hugh D., Jr., "Yellowstone Years, A story of the great National Park as chronicled in pictures, words and deeds by the venerable House of Haynes," *Montana, The Magazine of Western History*, Vol. 9, No. 3, July 1959, pp. 2–21.

Gattusco, John, editor, *A Circle of Nations, Voices and Visions of American Indians, North American Native Writers & Photographers*, Hillsboro, Oregon, 1993. [Photographs by Nancy Ackerman (Mohawk), Charles Agel (Seneca), Kenny Blackbird (Assiniboine/Sioux), Jose Martin Cantrell (Cherokee), Dorothy Chocolate (Dene), Jesse Cooday (Tlingit), Elton Daniels (Navajo), Graywolf (Cherokee), Larry Gus (Hopi), Eugene Jack (Paiute), Carm Little Turtle (Apache/Tarahumara), Larry McNeil (Tlingit/Nishka), Lee Marmon (Pueblo), Bernice Morrison (Inupaiaq), David Neel (Kwaguitl), Camela Pappan (Ponca), Mary Annette Pember (Ojibway), Sheldon Preston (Navajo), Monty Roessel (Navajo), Owen Seumptewa (Hopi), Greg Staats (Mohawk), and Richard Ray Whitman (Creek)]

Gay, E. Jane, *With the Nez Perces: Alice Fletcher in the Field 1889–1892*, Lincoln, Nebraska, 1981.

Geotzman, William H., *The First Americans, Photographs from the Library of Congress*, Washington, D.C., 1991.

Gidley, Mick, "Edward S. Curtis speaks," *History of Photographs*, Vol. 2, No. 4, October 1978, pp. 347–354.

Gidley, Mick, *Edward S. Curtis and The North American Indian*, London, 1984.

Gidley, Mick, "Edward Sheriff Curtis (1868–1952)," in *Sacred Circles: Two Thousand Years of North American Indian Art*, London, 1976, pp. 231–234.

Gidley, Mick, "From the Hopi Snake Dance to the Ten Commandments: Edward S. Curtis as Filmmaker," *Studies in Visual Communication*, Vol. VIII, Summer 1982, pp. 70–79.

Gidley, Mick, "John Collier" and "Arnold Genthe," in George Walsh and others, editors, *Contemporary Photographers*, London and New York, 1982.

Gidley, Mick, *Kopet, A Documentary Narrative of Chief Joseph's Last Years*, Seattle, Washington, 1981. [Photographs by Frank F. Avery, Edward S. Curtis, F. J. Haynes, William Henry Jackson, Edward H. Lathan, Edmond S. Meany, Fred Meyer, Lee Moorhouse, Adolph F. Muhr, and George Prince]

Gidley, Mick, "North American Indian Photographs/Images: Review Essay," *American Indian Culture and Research Journal*, Vol. 9, No. 3 (1985), pp. 37–47.

Gidley, Mick, *The Vanishing Race, Selections from Edward S. Curtis' The North American Indian*, London, 1976; New York City, 1977.

Gidley, Mick, *With One Sky Above Us: Life on an Indian Reservation at the Turn of the Century*, New York City, 1979; Seattle, 1985. [Photographs by Dr. E. H. Latham, Indian Agency Physician]

Gillmor, Frances, and Louisa Wade Wetherill, *Traders to the Navajos, The Story of the Wetherills of Kayenta*, Albuquerque, 1934.

Gilpin, Laura, *The Enduring Navajo*, Austin, Texas, 1968.

Gilpin, Laura, *The Mesa Verde National Park: Reproductions from a Series of Photographs by Laura Gilpin*, Colorado Springs, Colorado, 1927.

Gilpin, Laura, *The Pueblos, A Camera Chronicle*, New York City, 1941.

Gilpin, Laura, *The Rio Grande, River of Destiny*, New York City, 1964.

Glenn, James, "The 'Curious Gallery': The Indian Photographs of the McClees Studio in Washington, 1857–1858," *History of Photography*, Vol. 5, No. 3, 1981, pp. 149–262.

Glenn, James, "DeLancy W. Gill: Photographer for the Bureau of American Ethnology," *History of Photography*, Vol. 7, No. 1, 1983, pp. 7–22.

Glover, Ridgway, "Photography Among the Indians," *Philadelphia Photographer*, Vol. 3, No. 32, August 1866, pp. 239–240; No. 35, November 1866, p. 339; No. 36, December 1866, pp. 367–369.

Gold, Peter, "Returning Photographs to the Indians," in *Studies in Visual Communications*, Vol. 9, No. 5, Summer 1983, pp. 2–14.

Goldwater, Barry, *Arizona Portraits*, n.p., 1940.

Goldwater, Barry, *The Face of Arizona*, n.p., 1964.

Goldwater, Barry, *People and Places*, New York City, 1967.

Goodman, Theodosia T., "Early Oregon Daguerreotypers and Portrait Photographers," *Oregon Historical Quarterly*, Vol. 49, No.1, March 1948, pp. 30–49.

Gray, John S., "Itinerant Frontier Photographers and Images Lost, Strayed or Stolen," *Montana, The Magazine of Western History*, Vol. XXVII, No. 2, April 1978, pp. 2–15. [Photographs by David F. Barry, John H. Fouch, O. S. Goff, Stanley J. Morrow, and William Pywell]

Graybill, Florence Curtis, and Victor Boesen, *Edward Sheriff Curtis, Visions of a Vanishing Race*, New York City, 1926; Boston, 1976.

Greenberg, Henry and Georgia, *Carl Gorman's World*, Albuquerque, New Mexico, 1984. [Illustrated with the family and personal photographs of the Navajo artist]

Greenhill, Ralph, *Early Photography in Canada*, Toronto, Ontario, Canada, 1965.

Greenhill, Ralph, and Andrew Birrell, *Canadian Photography 1839–1920,* Toronto, Ontario, Canada, 1979. [Reproduces Indian photographs by E. S. Curtis, G. M. Dawson, Edward Dossetter, Charles Gentile, H. L. Hime, E. S. May, Mrs. Geraldine Moodie, and H. W. G. Stocken]

Greer, Sandy, "Contemporary Imagemaker, Expressing Vision," *Winds of Change*, Vol. 8, No. 2, Spring 1994, pp. 50–55. [Larry McNeil, Tlingit photographer and professor]

Grimes, Joel, *Navajo, Portrait of a Nation, Photography by Joel Grimes*, Engelwood, Colorado, 1992.

Grinnell, George Bird, "Portraits of Indian Types," *Scribner's Magazine*, Vol. XXXVII, 1905, pp. 258–273.

Griswold, Gillett, *William S. Soule Photographs: A Preliminary Survey*, Ft. Sill, Oklahoma, 1959.

Grosscup, Jeffrey P., "Stereoscopic Eye on the Frontier West," *Montana, The Magazine of Western History*, Vol. XXV, No. 2, Spring 1975, pp. 36–50. [The photographic work of William H. Illingworth]

Haddon, A. C., "A. C. Haddon Joins Edward S. Curtis: an

English Anthropologist among the Blackfeet, 1909, edited by Mick Gidley," *Montana, The Magazine of Western History,* Vol. 32, No. 4, Autumn 1982, pp. 20–33.

Haines, Robert D., Jr., *Carl Moon, Photographer and Illustrator of the American Southwest,* San Francisco, 1982.

Haley, J. Evetts, "Focus on the Frontier: [Laton Alton] Huffman and the Montana Cow country," *The Shamrock,* Amarillo, Texas, November-December 1955.

Hall, Roger, Gordon Dodds, and Stanley Triggs, *The World of William Notman, The Nineteenth Century Through a Master Lens,* Toronto, 1993.

Hamilton, Henry S., and Jean Tyree Hamilton, *The Sioux of the Rosebud, A History in Pictures, Photographs by John A. Anderson,* Norman, Oklahoma, 1971.

The Hampton Album: Forty-four Photographs by Frances Benjamin Johnson from an Album of Hampton Institute, Garden City, New York, 1966.

Hare, David, *Pueblo Indians as They are Today, Twenty Photographs in Color by David Hare,* New York City, 1941.

Harmon, Carole, *Great Days in the Rockies, The Photographs of Byron Harmon 1906–1934,* Toronto, 1978.

Harris, Alex, and Margaret Sartor, *Gertrude Blom: Bearing Witness,* Chapel Hill, North Carolina, 1984.

Harris, Alex, "Gertrude Blom's Maya," *The New York Times Magazine,* 25 March 1984.

Harris, Leo D., "Photographing My Indian Neighbors," *American Photography,* Vol. 43, No. 1, January 1949, pp. 38–40, and Vol. 43, No. 4, April 1949, p. 236.

Harrison, Julia, *Metis, People Between Two Worlds,* Vancouver, B.C., 1985.

Harrison, Steven D., "His Camera Was His Gold Mine, The Alaska Photographs of Arthur C. Pillsbury," *The Alaska Journal,* Vol. 10, No. 4, Autumn 1980, pp. 48–53.

Hathaway, Nancy, *Native American Portraits, 1862–1918, Photographs from the Collection of Kurt Koegler,* San Francisco, 1990. [Photographs by Aubert, Bailey, Charles Milton Bell, Dix and Mead, Christian Barthelmess, Beverly B. Dobbs, Frank B. Fiske, Camillus S. Fly, Alexander Gardner, F. W. Glaser, E. E. Glew, John C. H. Grabill, Heyn, John K. Hillers, Laton A. Huffman, William Henry Jackson, J. A. Johnson, Gertrude Kasebier, Charles Fletcher Lummis, Lucullus V. McWhorter, Carl Moon, Leander Moorhouse, C. A. Nast, Timothy O'Sullivan, William Marion Pennington, Harriet Smith Pullen, A. Frank Randall, Roland Reed, Frank A. Rinehart, George L. Rose, George W. Scott, William S. Soule, H. H. Whitney, Ben Wittick, and Adam Clark Vroman]

Haynes, Frank Jay, *Indian Types of the North West,* New York City, 1885.

Hegemann, Elizabeth Compton, *Navajo Trading Days,* Albuquerque, 1963. [Photographs by Elizabeth Compton Hegemann, 1925–1939]

Herold, Joyce, and Michael Taylor, *Moccasins on Pavement, The Urban Indian Experience, A Denver Portrait,* Denver, Colorado, 1978.

Heski, Thomas M., *Icastinyanka Cikala Hanzi: The Little Shadow Catcher, D. F. Barry, Celebrated Photographer of Famous Indians,* Seattle, Washington, 1978.

Heth, Charlotte, general editor, *Native American Dance, Ceremonies and Social Traditions,* Washington, D.C., 1993. [Historical and modern photographs]

Hill, Edward E., *Guide to Records in the National Archives of the United States Relating to American Indians,* Washington, D.C., 1981.

Hillers, John K., *"Photographed All the Best Scenery," Jack Hillers's Diary of the Powell Expeditions, 1871–1873,* edited by Don D. Fowler, Salt Lake City, Utah, 1972. [A portfolio of Hillers' photographs from the Powell Expeditions, 1871–1875, appears on pp. 177–213.]

Hoffmann, Gerard, *Indianische Kunst im 20. Jahrhundert,* Munich, 1985.

Hoffman, Malvina, *Heads and Tales,* New York City, 1936. [The section on "Our Aboriginal Americans" includes photographs, many of them by Hoffman herself, of Southwestern Indian physical types.]

Holm, Bill, *Edward S. Curtis in the Land of the War Canoes: a Pioneer Cinematographer in the Pacific Northwest,* Seattle, Washington, 1980.

"Home of the River Crows—by Richard Throssel, ca. 1908," *Montana, The Magazine of Western History,* Vol. 35, No. 1, Winter 1985, inside front cover. [Throssel began photographing at Crow Agency, Montana, in 1902 and established a studio in Billings in 1911.]

Hoobler, Dorothy and Thomas, *Photographing the Frontier,* New York City, 1980.

Horan, James D., *Timothy O'Sullivan, America's Forgotten Photographer,* Garden City, New York, 1966.

Horan, James D., "Timothy O'Sullivan, Pioneer Photographer of the West," *Westerner's Brand Book, New York Posse,* Vol. 14, 1967.

Horse Capture, George, "The Camera Eye of Sumner Matteson," *Montana, The Magazine of Western History,* Vol. 27, No. 3, Summer 1978, pp. 48–61.

Houlihan, Patrick and Betsy E., *Lummis in the Pueblos,* Flagstaff, Arizona, 1986. [The Photographs of Charles Fletcher Lummis (1859–1928)]

Houston, James, *Ojibwa Summer . . . Photographs by B. A. King,* Barre, Massachusetts, 1972.

Howard Rainer, Indian Poet and Photographer, Provo, Utah, 1983.

Hungry Wolf, Beverly, *The Ways of My Grandmothers,* New York City, 1980. [Photographs by Edward S. Curtis, Joseph K. Dixon, George Bird Grinnell, Arnold Lipson, Adolph Hungry Wolf, Hilda Hungry Wolf, and Paul Scholdice]

Hurt, Wesley, R., and William E. Lass, *Frontier Photographer, Stanley J. Morrow's Dakota Years,* Lincoln, Nebraska, 1956.

Huyda, R., "Exploration Photographer: Humphrey Lloyd Hime and the Assiniboine and Saskatchewan Exploring Expedition of 1858," *Transactions of the History and Science Society of Manitoba,* Vol. 11, No. 30, 1955, pp. 45–59.

"I cacciatori d'ombre ovvero fotografico degli Indiani," *Progresso Fotografico,* 85th year, No. 3, March 1978, pp. 28–32. [Photographs of Edward Curtis and Will Soule]

Images of America, Early Photography 1839–1900, A Catalog, Washington, D.C., 1957.

Immigrants, Refugees & Natives, Photographs by Lewis Hine, Michael Carlebach, David Heiden and Michal Heron, Carol Gables, Florida, 1981.

Indian Industrial School, Carlisle, Pa., Carlisle, Pennsylvania, 1896.

Inglis, Grace, "Conference in Hamilton, Native photographers overcome an old taboo," *The Hamilton Spectator,* 15 March 1985.

J. de la Fuente, Mexican Document, Photographs, New School for Social Research, November 21 to December 3, New York City, 1939.

Jackniss, Ira, "Franz Boas and Photography," *Studies in Visual Communication,* Vol. 10, No. 1, 1984, pp. 2–60.

Jackson, Clarence S., *Picture Maker of the Old West, William H. Jackson,* New York City, 1947.

Jackson, William Henry, *Descriptive Catalogue of the Photographs of the United States Geological Survey of the Territories for the Years 1869 to 1873, Inclusive,* Washington, D.C., 1874.

Jackson, William Henry, *Descriptive Catalogue of Photographs of North American Indians,* Washington, D.C. 1877.

Jackson, William Henry, *The Diaries of William Henry Jackson, Frontier Photographer,* edited by Leroy R. and Ann W. Hafen, Glendale, California, 1959.

Jackson, William Henry, *Time Exposure,* New York City, 1946.

Jacox, Elizabeth, "Cook, Photographer, and Friend: Jane Gay's Photographs, 1889–1892," *Idaho Yesterdays,* Vol. 28, No. 1, Spring 1984, pp. 18–23.

James, George Wharton, *Arizona the Wonderland,* Boston, 1917. [Photographs by George Wharton James]

James, George Wharton, *New Mexico, The Land of the Delight Makers,* Boston, 1929. [Photographs by George Wharton James]

Jensen, Oliver, Joan Paterson Kerr, and Murray Belsky, *American Album,* New York City, 1968. ["The Displaced Race" appears on pp. 87–103.]

Jensen, Richard E., R. Eli Paul, and John E. Carter, *Eyewitness at Wounded Knee,* Lincoln, Nebraska, 1991.

Jerome, Ward, "Karl Moon's Indian Photographs," *Craftsman,* Vol. 20, 1911.

Jerome, Ward, "Karl Moon's Photographic Record of the Indian of Today," *Craftsman,* April 1911, pp. 24–32.

"John Alvin Anderson, Frontier Photographer," *Nebraska History,* Vol. 51, No. 4, Winter 1970, pp. 469–480.

"John C. H. Grabill's Photographs of the Last Conflict between the Sioux and the United States Military, 1890–1891," *South Dakota History,* Vol. 14, No. 3, Fall 1984, pp. 222–237.

Johnson, Michael G., "Northern Plains and Plateau Indian Photographs from the Sir Benjamin Stone Collection," *European Review of Native American Studies,* Vol. 5, No. 2 (1991), pp. 33–40.

Johnson, Tim, "New Directions in Iroquois Photography," *Turtle,* Winter 1983, pp. 4–6.

Johnston, Patricia Condon, "The Indian Photographs of Roland Reed," *The American West,* Vol. 28, No. 1, March-April 1978, pp. 18–23.

Jones, Laura, "Photographer Captures Beauty of Indian People," *The Herald,* Provo, Utah, 14 April 1985, p. 34. [Work by the Taos Pueblo photographer Howard Rainer]

Jones, Tom, "Photographer of the North, Neal Menschel," *The Alaska Journal,* Vol. 10, No. 1, Winter 1980, pp. 22–23.

Josephy, Alvin M., Jr., *The American Heritage Book of Indians,* New York City, 1961.

Josephy, Alvin M., Jr., Trudy Thomas, Jeanne Eder, and George Horse Capture, *Wounded Knee, Lest We Forget,* Cody, Wyoming, 1990. [Historic photographs]

"Judge in Tribal Case Decides Against New Mexican Paper," *The New York Times,* 7 October 1984. [Santa Domingo Pueblo suit against *The New Mexican* for photographing one of its ceremonies from the air]

Karasik, Carol, and Jeffrey Jay Foxx, *The Turquoise Trail, Native American Jewelry and Culture of the Southwest,* New York, 1993. [Contemporary photographs by Jeffrey Jay Foxx]

Kawano, Kenji, *Warriors, Navajo Code Talkers,* Flagstaff, 1990. [Photographs by Kenji Kawano]

Keegan, M. K., *Enduring Culture, A Century of Photography of the Southwest Indians, Santa Fe, 1990.* [Photographs by Wesley Bradfield, Edward S. Curtis, Wyatt Davis, Burton Frasher, Odd Halseth, John K. Hillers, Charles Lummis, Marcia Keegan, T. Harmon Parkhurst, George H. Pepper, Simeon Schwenberger, Matilda Coxe Stevenson, J. R. Willis, Ben Wittick, and Adam Clark Vroman]

Keegan, Marcia, *Mother Earth, Father Sky, Navajo and Pueblo Indians of the Southwest,* New York City, 1974. [Photographs by Marcia Keegan]

Keegan, Marcia, *Pueblo and Navajo Cookery,* New York City, 1977. [Photographs by Marcia Keegan]

Keegan, Marcia, *The Taos Indians and Their Sacred Blue Lake,* New York City, 1972. [Photographs by Marcia Keegan]

Keegan, Marcia, *Taos Pueblo and Its Sacred Blue Lake,* Santa Fe, 1991. [Photographs by Marcia Keegan]

Kelen, Leslie G., and Sandra T. Fuller, editors, *The Other Utahns, A Photographic Portfolio,* Salt Lake City, Utah, 1988. [Photographs by George Janecek]

Kemp, E. H., "Photographing In the Hopi Land," *Camera Craft,* San Francisco, Vol. 11, No. 6, December 1905, pp. 247–255.

Kent, Kate Peck, *Navajo Weaving, Three Centuries of Change,* Santa Fe, New Mexico, 1985. [Photographs by Kenneth M. Chapman, the Keystone View Company, James Mooney, C. R. Savage, and Ben Wittick]

Kent, Kate Peck, *Pueblo Indian Textiles, A Living Tradition,* Santa Fe, New Mexico, 1983. [Photographs by Barthelmess and Schofield, John K. Hillers, T. Harmon Parkhurst, Joseph Mora, William H. Simpson, H. R. Voth, Adam Clark Vroman, and Carl N. Werntz]

Kurutz, Gary F., "Pictorial Resources: The Henry E. Huntington Library's California and American West Collections," *California Historical Quarterly,* Vol. 54, No. 2, Summer 1975, pp. 175–182.

La Farge, Oliver, *As Long as Grass Shall Grow . . . Photographs by Helen M. Post,* New York City, 1940.

La Farge, Oliver, *A Pictorial History of the American Indian*, New York City, 1956.

La Farge, Oliver, and Alvin M. Josephy, Jr., *A Pictorial History of the American Indian*, New York City, 1974.

Lakol Wokiksuye, Photographien Zur Geschichte der Plains von Little Bighorn bis Wounded Knee, Vienna, 1991. [Photographs by O. S. Goff, D. F. Barry, C. G. Morledge, and G. Trager]

Laubin, Reginald and Gladys, *Indian Dances of North America, Their Importance to Indian Life, With Paintings, Drawings and Photographs by the Authors*, Norman, Oklahoma, 1977. [Photographs by John A. Anderson, Edward S. Curtis, A. W. Ericson, A. C. Hector, Ned Hockman, Gladys Laubin, James Mooney, and A. C. Vroman] Leeson, B. W., "Photographing Brother 'Lo,'" *Camera Craft*, San Francisco, Vol. 21, No. 10, October 1914.

Levine, Robert M., *Images of History, Nineteen and Early Twentieth Century Latin American Photographs as Documents*, Durham, North Carolina, 1989. [The photographs include many of Latin American Indians]

Levine, Robert M., editor, *Windows on Latin America, Understanding Society Through Photographs*, Coral Gables, Florida, 1987. [Includes Elyn Welsh's "Glimpses of a Lost Culture: the Indians of the Southern Cone" on pp. 102–113]

Lightspeed + 11 . . . Jesse Cooday . . . Jolene Rickard . . . Sacred Circle Gallery of American Indian Art, Seattle, Washington, 1984. [The work of a Tlingit photographer (Cooday) and a Tuscarora photographer (Rickard)]

Lippard, Lucy R., "Native Intelligence," *The Village Voice*, 27 December 1983, p. 102. [Review of exhibition of photographs by Jesse Cooday (Tlingit) and Jolene Rickard (Tuscarora)]

Lippard, Lucy R., editor, essays by Suzanne Benally, Jimmie Durham, Rayna Green, Joy Harjo, Gerald McMaster, Jolene Rickard, Ramona Sakiestewa, David Seals, Paul Chaat Smith, Jaune Quick-to-See Smith, Gail Tremblay, and Gerald Vizenor, *Partial Recall, with Essays on Photographs of Native North Americans*, New York City, 1992. [Photographs by Al Abrams, Alfred M. Bailey, George L. Beam, Sam Bingham, Donald A. Cadzow, Robert Chaat, Frank Churchill, Kate Cory, Edward Curtis, Edward H. Davis, Joseph Dixon, Don Doll, Walter Ferguson, George Byrd Grinnell, M.R. Harrington, Richard Hill, G. W. Ingalls, Gertrude Kasebier, Joseph Keppler, A. Richard King, J. D. Leechman, L. C. McClure, Washington Mathews, Frank Matsura, Sumner Matteson, Fred R. Meyer, Jo Mora, C. G. Morledge, David Neel, Jesse Nusbaum, William C. Orchard, T. Harmon Parkhurst, Sarah Penman, H. S. Poley, Horace Poolaw, Helen M. Post, Harriet Smith Pullen, Charles Rau, Jolene Rickard, John Running, Alanson B. Skinner, De Cost Smith, Paul Chaat Smith, Frank G. Speck, Frederick Starr, William Stiles, Hulleah Tsinhnahjinnie, Gerald Vizenor, Mary Sharples Schaffer Warren, Kathleen Westcott, Ben Wittick, and Nancy Wood]

Long, Paul V., *Big Eyes: The Southwestern Photographs of Simeon Schwemberger, 1902–1908*, Albuquerque, 1992.

Longo, Donna A., "Photographing the Hopi," *Pacific Discovery*, Vol. XXXIII, No. 3, May 1980, pp. 11–19.

"Looking into the Past, Collection of Indian Portraits Stirs Up a Mystery," *New York Sunday News*, 5 February 1967.

Lopez, Nacho, and Salomon Nahmad, *Los Pueblos de la Bruma y el Sol*, Mexico City, 1981. [Photographs of Mexican Indians by Nacho Lopez]

Lumholtz, Carl, *Los Indios del Noroeste 1890–1898*, Mexico City, 1982. [Carl Lumholtz's photographs of Tarahumara, Pima, Tepehuano, and Huichol Indians]

Lyman, Christopher, *The Vanishing Race and Other Illusions, Photographs of Indians by Edward S. Curtis*, New York City, 1982.

MacDonnell, Kevin, *Eadweard Muybridge, the Man Who Invented the Moving Picture*, Boston, 1972.

Mahood, Ruth I., *Photographer of the Southwest, Adam Clark Vroman, 1856–1916*, New York, 1961.

Mails, Thomas E., *Sundancing at Rosebud and Pine Ridge*, Sioux Falls, South Dakota, 1978. [A "Pictorial Record of the Rosebud Sioux Sundances of 1974 and 1975" appears on pp. 237–395.]

Mangan, Terry W., *California Photographers 1852–1920*, San Francisco, 1977.

Mangan, Terry W., *Colorado On Glass, Colorado's First Half Century, As Seen by the Camera*, Denver, 1977. [Indian photographers William Chamberlain, George Kirkland, William Henry Jackson, and H. H. Tammen]

Markoe, Glenn E., Raymond J. DeMallie, and Royal B. Hassrick, editors, *Vestiges of a Proud Nation, The Ogden B. Read Northern Plains Indian Collection*, Burlington, Vermont, 1986.

Marr, Carolyn, Lloyd Colfax, and Robert D. Monroe, *Portrait in Time: Photographs of the Makah by Samuel G. Morse, 1896–1903*, Seattle, Washington, 1987.

Masayesva, Victor, Jr., *Rainbird: A Study in Hopi Logic*, Tucson, Arizona, 1978. [A portfolio of photographs by Victor Masayesva, Jr. (Hopi)]

Masayesva, Victor, Jr., and Erin Younger, *Hopi Photographers, Hopi Images*, Tucson, Arizona, 1984. Vol. 8, *Sun Tracks, An American Indian Literary Series*. [Photographs by Jean Fredericks, Freddie Honhongva, Merwin Kooyahoema, Fred Kootswatewa, Georgia Masayesva, Victor Masayesva, Jr., and Owen Seumptewa]

Mather, Christine, *Native America, Arts, Traditions and Celebrations*, New York City, 1990. [Historical photographs and contemporary photographs by Jack Parsons]

Matteson, Sumner W., "The Fourth of July Celebration at Fort Belknap," *Pacific Monthly*, Vol. 16, No. 1, July 1906, pp. 93–103.

Mattison, David, *Camera Workers, The British Columbia Photographers Directory 1858–1900*, Victoria, British Columbia, 1984.

Mattison, David, "Richard Maynard, Photographer of Victoria, B. C.," *History of Photography*, April-June 1985, pp. 109–129.

Maude, Stephen G., "Frederick Hamer Maude: Photographer of the Southwest," *Masterkey*, Vol. 59, No. 1, Spring 1985, pp. 12–17.

Mautz, Carl, *Checklist of Western Photographers, a Reference Workbook*, Brownsville, California, 1986.

McAuley, Skeet, *Sign Language, Contemporary Southwest America, Photographs by Skeet McAuley,* New York City, 1989.

McBride, Dorothy McFatridge, "Hoosier Schoolmaster Among the Sioux," *Montana, The Magazine of Western History,* Vol. XX, No. 4, October 1970, pp. 78–97. [Photographs taken by Arthur E. McFatridge at Rosebud Agency, South Dakota, beginning in 1898]

McClintock, Walter, "How it Was Possible to Make the Blackfoot Indian Collection," *The Yale University Library Gazette,* Vol. 23, No. 4, April 1949, pp. 159–174.

McCracken, Harold, *Portrait of the Old West,* New York City, 1952.

McKinney, Virginia, "Photographer of the North, Steve McCutcheon," *The Alaska Journal,* Vol. 9, No. 4, Autumn 1979, pp. 46- 59.

McLuhan, T. C., *Dream Tracks, The Railroad and the American Indian 1890–1930,* New York City, 1985. [Photographic images produced to attract tourists to visit Indian peoples of the Southwest, including frames from a motion picture by William E. Kopplin of a 1912 Hopi Snake Dance in Walpi]

Meany, Edmond S., "Hunting Indians with the Camera," *The World's Work,* Vol. XV, No. 5, March 1908, pp. 104–111. [Edward S. Curtis and his photographs]

Merriam, C. Hart, *Harriman Alaska Series,* 14 volumes, Washington, D.C., 1890–1910. [Illustrated with Edward S. Curtis photographs]

Miller, Alan Clark, "Lorenzo Lorain, Pioneer Photographer of the Northwest," *The American West,* Vol. IX, No. 2, March 1972, pp. 20- 26. [Lorain's photographs from the 1850s in Oregon include portraits of Klamath and Modoc people.]

Miller, Alan Clark, *Photographer of a Frontier, the Photographs of Peter Britt,* Eureka, California, 1976.

Miller, Joseph, *Arizona Indians, The People of the Sun,* New York City, 1941. [A book of photographs by Joseph Miller]

Miller, Joseph, *Monument Valley and the Navajo Country, Arizona [and] Utah,* New York City, 1951. [A book of photographs by Joseph Miller]

Mitchell, Daniel Holmes, *God's Country,* Cincinnati, Ohio, 1910.

Mitchell, Lee Clark, *Witnesses to a Vanishing America: the Nineteenth-Century Response,* Princeton, New Jersey, 1982. [Chapter five, "Indians and Image Catchers," includes sections on "The Frontier Photographer" and "The Pasadena Eight" (C. J. Crandall, George Wharton James, Charles Lummis, Frederick I. Monsen, Carl Moon, Grace Nicholson, Horatius Rust, and Adam Clark Vroman)]

Momaday, N. Scott, *With Eagle Glance, American Indian Photographic Images 1868–1931,* New York City, 1982.

Moneta, Daniela P., editor, *Charles F. Lummis — The Centennial Exhibition, Commemorating His Tramp Across the Continent,* Los Angeles, California, 1985.

Monroe, Robert D., "Frank LaRoche: Washington's 'Other' Indian Photographer," *Northwest Photographer* 4, No. 8, September 1981, pp. 4 and 5.

Monsen, Frederick, "The destruction of our Indians: what civilization is doing to extinguish an ancient and highly intelligent race by taking away its arts, industries and religion," *Craftsman,* Vol. XI, October 1906-March 1907, pp. 683–691.

Monsen, Frederick, "Episodes in American History and Exploration," *University of California, Bulletin of the University Extension Division,* 2, August 1916, pp. 1–15.

Monsen, Frederick, "Picturing Indians with the Camera," *Photo-Era,* No. 25, October 1910, pp. 165–171.

Monsen, Frederick, "Pueblos of the Painted Desert: How the Hopi Build their Community Dwellings on the Cliffs," *Craftsman,* Vol. XII, April-September 1907, pp. 16–33.

Moon, Carl, "An Aboriginal Thanksgiving, The Harvest Festival of America's First Farmers, Before the Pilgrims Came," *Sunset, The Pacific Monthly,* Vol. 43, No. 5, November 1919, pp. 35–37.

Moon, Carl, *Photographic Studies of Indians,* Grand Canyon, Arizona, 1910.

Moon, Carl, "Taos, The Indian Pueblo," *The Burr McIntosh Monthly,* Vol. XX, No. 80, November 1909.

Moon, Karl E., "American indians of the Southwest Photographed by Karl E. Moon," *The Century Magazine,* Vol. LXXIV, No. 6, October 1907, pp. 924–28.

Moorhouse, Lee, "Indian Photography," *The American Annual of Photography and Photographic Times-Bulletin Almanac for 1904,* New York City, 1903, pp. 77–83.

Moorhouse, Lee, *Souvenir Album of Noted Indian Photographs,* n.p., 1906.

Mora, Joseph Jacinto, *The Year of the Hopi: Paintings and Photographs by Joseph Mora, 1904–06,* Washington, D.C., 1979.

Morgan, Murray, "Portraits for a Western Album: IV, Princess Angeline," *The American West,* Vol. V, No. 4, July 1968, pp. 70–71. [A Duwamish widow — "one of the most photographed Indians of her day."]

Morrill, Allen and Eleanor, "Talmaks," *Idaho Yesterdays,* Vol. 8, No. 3, Fall 1964, pp. 2–17. [Photographs from the "Jane-Gay-Alice Fletcher collection" at the Idaho Historical Society]

Morrow, Phyllis, "Photographer of the North, James Barker," *The Alaska Journal,* Vol. 8, No. 4, Autumn 1978, pp. 295–309.

Moses, Lester G., "Wild West Shows, Reformers, and the Image of the American Indian, 1887–1914," *South Dakota History,* Vol. 14, No. 3, Fall 1984, pp. 193–221.

"Moving Pictures Show Life of Indian Tribes, Marvellous Results of Rodman Wanamaker's Expedition Displayed," *The New York Sun,* 25 October 1912, p. 4.

Mozee, Yvonne, "Film . . . But How He Races!," *The Alaska Journal,* Vol. 10, No. 2, Spring 1980, pp. 76–77. [Cinema about Native Alaskans, financed by Native Alaskans and predominately acted by them]

Mozley, Anita V., editor, *Eadweard Muybridge: The Stanford Years, 1872–1882,* San Francisco, California, 1972.

Murray, Keith A., *The Modocs and Their War,* Norman, Oklahoma, 1959.

Naef, Weston J., and James Wood, *Era of Exploration, The Rise of Landscape Photography in the American West, 1860–*

1885, Boston, 1975. [Principally the photographs of Carlton Watkins, Timothy O'Sullivan, Eadweard Muybridge, Andrew Joseph Russell, and William Henry Jackson]

Naggar, Carole, and Fred Ritchin, *Mexico Through Foreign Eyes 1850- 1990,* New York City, 1993.

Native Nations, First Americans as Seen by Edward S. Curtis, Boston, 1993.

Native Women's Centre, *The Hamilton Regional Indian Centre and The Photographers' Union proudly present . . . "Visions" First Native Indian Photography Conference,* Hamilton, Ontario, 1985.

Neal, Avon, and Ann Parker, *Los Ambulantes, the Itinerant Photographers of Guatemala,* Cambridge, Massachusetts, 1982. [Photographs by Ann Parker of the photographers and their subjects, most of them American Indians]

Neel, David, *Our Chiefs and Elders: Words and Photographs of Native Leaders,* Vancouver, 1992. [Photographs by David Neel]

Neumeier, Marty, "Howard Rainer," *Communication Arts Magazine,* Vol. 27, No. 8, January/February 1986, cover and pp. 8, 42–47.

New Directions: Eight Indian Artists, Contemporary Paintings, Photography & Sculpture by Innovative Native American Artists of New York . . . Gallery 10, New York City, 1983. [Photographs by Jesse Cooday (Tlingit) and Jolene Rickard (Tuscarora)]

Newcomb, Franc Johnson, *Navajo Neighbors,* Norman, Oklahoma, 1966. [Photographs by Franc Johnson Newcomb]

Newhall, Beaumont, *The History of Photography from 1839 to the Present,* New York City, 1982.

Newhall, Beaumont, "Minnesota Daguerreotypes," *Minnesota History,* Vol. 34, No. 1, Spring 1954, pp. 28–33. [Reproduces a daguerreotype of an "Indian camp on the site of Bridge Square, Minneapolis, 1854."]

Newhall, Beaumont, and Diana E. Edkins, *William H. Jackson,* Fort Worth, Texas, 1974. [A number of the Indian photographs are misidentified as Jackson's work, including images by Adam Clark Vroman.]

Newhall, Beaumont and Nancy, *T. H. O'Sullivan: Photographer,* Rochester, New York, 1966.

N.I.I.P.A. — Native Indian/Inuit Photographers' Association, Hamilton, Ontario, Canada, 1985.

North American Indians, Indelible Photographs, New York City, 1890.

Northern, Tamara, *To Image and To See, Crow Indian Photographs by Edward S. Curtis and Richard Throssel 1905–1910,* Hanover, New Hampshire, 1993.

Northshield, Robert, "The Healing of Robert Lee," *Smithsonian,* Vol. 5, No. 9, December 1974, pp. 74–77. [A documentary filmmaker among the Navajo]

Norwood, Vera, "The Photographer and the Naturalist: Laura Gilpin and Mary Austin in the Southwest," *Journal of American Culture,* 5, Summer 1982, pp. 1–28.

Nuss, Robert L., and Roger F. Pfeuffer, *A Photographic Essay of Pima-Maricopa Indians,* Tucson, Arizona, 1970.

O'Connor, Nancy Fields, *Fred E. Miller, Photographer of the Crows,* Missoula, Montana, 1985.

Oehser, Paul H., "De Lancey Gill (1859–1940)," *Cosmos Club Bulletin,* Vol. 30, Nos. 7–8, July-August 1977, pp. 4–8.

100 Fotografias, Hector Garcia, Arbol de Imagenes, Mexico City, 1979. [Hector Garcia's photographs of Mexican Indians]

The Open Lead (Uiniq), Barrow, Alaska, 1986– . [A journal edited by Bill Hess and illustrated by his photographs, most of them of Native Alaskans]

Ortiz Monasterio, Pablo, *Corazon de Venado,* Mexico, 1992. [Photographs of Huichol Indians of Mexico by Pablo Ortiz Monasterio; prefaced by historical photographs by Carl Lumholtz (1851–1921)]

Ostroff, Eugene, *Western Views and Eastern Visions,* Washington, D.C., 1981.

Our Book, T-O'Hana, Nuestro Libro, San Xavier del Bac, Arizona, 1969. [Photographs of Papago people]

Our Portrayals, Photography of Native Indian/Inuit People by Native Indian/Inuit People, Hamilton, Ontario, 1986. [The first issue of a quarterly publication devoted to the work of native photographers]

Packard, Gar and Maggy, *Southwest 1880 with Ben Wittick, Pioneer Photographer of Indian and Frontier Life,* Santa Fe, New Mexico, 1970.

Palmquist, Peter E., *Fine California Views, the Photographs of A. W. Ericson,* Eureka, California, 1975.

Palmquist, Peter E., "Imagemakers of the Modoc War: Louis Heller and Eadweard Muybridge," *Journal of California Anthropology,* Vol. 4, No. 2, Winter 1977, pp. 206–221.

Palmquist, Peter E., *Lawrence & Houseworth/ Thomas Houseworth & Co., A Unique View of the West 1860–1886,* Columbus, Ohio, 1980.

Palmquist, Peter E., "Photographing the Modoc Indian War: Louis Heller versus Eadweard Muybridge," *History of Photography,* Vol. 2, No. 3, July 1978, pp. 187–205.

Palmquist, Peter, E., *Photography in the West,* Manhattan, Kansas, 1987.

Palmquist, Peter E., *With Nature's Children, Emma B. Freeman [1880–1928]-Camera and Brush,* Eureka, California, 1976.

Palmquist, Peter, *Watkins,* Albuquerque, New Mexico, 1983.

Parry, Ellwood, *The Image of the Indian and the Black Man in American Art 1590–1900,* New York, 1974.

Passing The Moon, The Hopi Ceremonial Year, Hotevilla, Arizona, 1986. [A calendar published by the Bacavi School illustrated with photographs of Hopi by Forman Hanna, Emry Kopta, Sumner Matteson, and Jo Mora]

Pfaller, Louis, "James McLaughlin and the Rodman Wanamaker Expedition of 1913," *North Dakota History,* Vol. 44, No. 2, 1977, pp. 4–11.

The Photograph and the American Indian, Princeton University Library, 13 October 1985–5 January 1986, Princeton, New Jersey, 1985. [A portfolio of 14 postcards of Indian photographs whose photographers include Charles Bell, Alexander Gardner, William Henry Jackson, the McClees Studio, Everett Scott, A. Z. Shindler, Joel Whitney, and Hope Wurmfeld]

"Photographer of the North, Yvonne Mozee," *The Alaska Journal,* Vol. 9, No. 1, Winter 1979, pp. 25–31. [Photographs by Yvonne Mozee (Athabascan)]

"Photographers of the North, Rob Stapleton," *The Alaska Journal*, Vol. 8, No. 3, Summer 1978, pp. 200–213.

"Photographic Portraits of North American Indians in the Gallery of the Smithsonian Institution," *Smithsonian Miscellaneous Collections*, Vol. 14, 1867.

Photographs, including property from the Estate of Lee D. Witkin . . . Auction, Tuesday, May 7 . . . [and] May 8, 1985 . . . Sotheby's, New York City, 1985. [Photographs by Edward Curtis, Joseph K. Kossuth, Laura Gilpin, John Hillers, Karl Moon, F. A. Rinehart and Paul Strand]

Photographs of the Principal Chiefs of the North American Indians, taken when they have visited Washington as Deputations from their Tribes, Salisbury, England, 1865.

Photographs made on the Rodman Wanamaker Historical Expeditions to the North American Indian, comprise, the most complete collection of Indian subjects in existence, n.p., n.d. [The photographs were copyrighted in 1916]

Photographs by Charley and Carlin Red Blanket, Rapid City, South Dakota, 1978. [Photographs by two Sioux photographers]

Photography by Horace Poolaw, Anadarko, Oklahoma, 1979. [Horace Poolaw is a Kiowa photographer]

Pierce, Richard A., "Eadweard Muybridge, Alaska's First Photographer," *The Alaska Journal*, Vol. 7, No. 4, Autumn 1977, pp. 202–210.

Pilling, Arnold R., *William Henry Jackson, an Anthropological Photographer in the Southwest*, Washington, D.C., 1975.

Pintado, Jose Manuel, and Pablo Ortiz Monasterio, *Los Pueblos del Viento, Cronica de Marenos*, Mexico City, 1981. [Photographs by Pablo Ortiz Monasterio of Mexican Indian inhabitants of coastal Oaxaca]

Pitseolak, Peter, and Dorothy Eber, *An Inuit record of Seekooseelak the land of the people of Cape Corset, Baffin Island, People from Our Side, An Eskimo Life Story in Words and Photographs*, Bloomington, Indiana, 1977.

Pitseolak, Peter, and Dorothy Eber, *People from Our Side: A Life Story with Photographs and Oral Biography*, Montreal, Quebec, 1975 and 1993. [Photographs by Peter Pitseolak, the first Baffin Island photographer]

Pohrt, Richard A., "Nineteenth Century Michigan Chippewa Costume, Photographs of David Shoppenagons," *American Indian Art Magazine*, Vol. 11, No. 3, Summer 1986, pp. 44–53. [The photographer is Armstrong and Rudd, of Saginaw City, Michigan.]

"Portfolio: Historical Photographs of Mesquakie Indian Women," *Iowa Woman*, No. 2, 1981, pp. 16–21.

Powell, Peter John, *People of the Sacred Mountain, A History of the Northern Cheyenne Chiefs and Warrior Societies 1830–1879*, San Francisco, 1981. [The illustrations include photographs from the earliest delegation images in the 19th century to a series of photographs, by the author, of Cheyenne ceremonies in the 1970s. The historical photographers include Alfred Addis, D. F. Barry, Christian Barthelmess, Charles M. Bell, Abraham Bogardus, Charles H. Carpenter, J. N. Choate, J. K. Dixon, George Dorsey, John H. Fitzgibbon, Alexander Gardner, DeLancey Gill, John A. Grabill, Elizabeth C. Grinnell, George Bird Grinnell, J. Gurney & Son, John K. Hillers, L. A. Huffman, Maddaugh, James

Mooney, Stanely J. Morrow, C. Noel, F. A. Rinehart, and William S. Soule]

Pratson, Frederick John, *Land of the Four Directions*, Old Greenwich, Connecticut, 1970. [Photographs by Pratson among the Passamoquoddy, Malinseet, and Micmac]

Pratt, R. H., *The Indian Industrial School, Carlisle, Pa.*, Carlisle, Pennsylvania, 1979.

Price, Christine, *Heirs of the Ancient Maya, A Portrait of the Lacandon Indians, . . . Photographs by Gertrude Duby Blom*, New York City, 1972.

Primera Muestra de la Fotografia Latinoamericana Contemporanea, Mexico City, 1878.

Pritzker, Barry, *Edward S. Curtis*, New York City, 1993.

Purcell, L. Edward, "The Mesquakie Indian Settlement in 1905," and "The Ward-Mesquakie Photograph Collection," *The Palimpsest*, Vol. 55, 1974, pp. 34–63.

Rainer, Howard, "An American Indian's Photographic Journey," *The Herald*, Provo, Utah, 14 April 1985, p. 33. [Photographs by Howard Rainer (Taos Pueblo)]

Rankin, Antoinette, "He Knows the Redman . . . Carl Moon's collection of American Indian photographs," *Sunset Magazine*, Vol. 54, February 1925, pp. 28–29.

"Rare photo of the Navajo Yehichai ceremony by J. H. McGibbeny in July 1953," *Arizona Highways*, Vol. 61, No. 4, April 1985, pp. 28- 29.

"A Record of the Indians," *The World's Work*, Vol. XII, No. 4, August 1906, pp. 7913–7914. [Edward Curtis' record of "The Southwest Indians"]

Reed, Roland, *Images of the Plains, Piegan Views I, Photographs of The American Indian, Roland Reed Photographer, 1864–1934*, St. Paul, Minnesota, 1981.

Reed, Roland, *Images of the Southwest, Photographs of the American Indian, Roland Reed photographer, 1864–1934*, Southwest Series, St. Paul, Minnesota, 1980.

Rell, G. Francis, *The Utah Photographs of George Edward Anderson*, Lincoln, Nebraska, 1979.

Renner, Louis L., "Julius Jette: Distinguished Scholar in Alaska," *The Alaska Journal*, Vol. 5, No. 4, Autumn 1975, pp. 239–247. [Photographs by Julius Jette]

Reynolds, Charles R., Jr., *American Indian Portraits from the Wannamaker Expedition of 1913*, Brattleboro, Vermont, 1971. [Photographs by Joseph Kossuth Dixon]

Reynolds, Charles R., Jr., "Joseph K. Dixon: Notes on a Photographic Mystery," *Infinity*, Vol. XV, No. 8, 1966.

Rice, William S., "Photographing the Indians of the Southwest," *American Photography*, Vol. 10, No. 6, June 1916, pp. 316–321.

Richards, Rob, *Phyllis of Isleta . . . Photographs by Michal Heron*, New York City, 1973.

Rinehart, Frank A., *The Face of Courage, the Indian Photographs of Frank A. Rinehart*, Fort Collings, Colorado, 1972.

Rinehart, Frank A., *Rinehart's Prints of American Indians*, Omaha, Nebraska, 1901.

Rinehart, Frank A., *Rinehart's Indians*, Omaha, Nebraska, 1899.

Ring, Mildred, "Kodaking the Indians," *Camera Craft*, San Francisco, Vol. 31, No. 2, February 1924, pp. 71–76.

Roark, Carol E., Paula Ann Stewart and Mary Kennedy Mc-

Cabe, *Catalogue of the Amon Carter Museum, Photography Collection*, Fort Worth, Texas, 1993.

Roberts, Chris, *Powwow Country*, Helena, Montana, 1992. [Photographs by Chris Roberts]

Roberts, Gary, "In Search of Little Wolf . . . A Tangled Photographic Record," *Montana, The Magazine of Western History*, Vol. 27, No. 3, Summer 1978, pp. 48–61. ["Pictured . . . are a number of individuals who have been confused with the famous Little Wolf, . . . The portfolio dramatizes the role that the pictorial record can play in historical research and suggests how and why innaccuracies are perpetuated."]

Roberts, Gary, "The Shame of Little Wolf," *Montana, The Magazine of Western History*, Vol. XXVIII, No. 3, July 1978, pp. 36–47. [Carefully documented photographs of Little Wolf and his associates]

Roberts, Willow, Stokes Carson, *Twentieth-Century Trading on the Navajo Reservation*, Albuquerque, New Mexico, 1987.

Rodriquez, Jose Angel, *Vidas Ceremoniales*, Mexico City, 1991. [Photographs of Mexican Indians by Jose Angel Rodriquez]

Roe, JoAnn, *Frank Matsura, Frontier Photographer*, Seattle, Washington, 1981.

Roe, JoAnn, "Frank S. Matsura, Photographer on the Northwest Frontier," *The American West*, Vol. XIX, No. 2, March/April 1982, pp. 20–28.

Roessel, Robert A., Jr., *Pictorial History of the Navajo From 1860 to 1910*, Rough Rock, Arizona, 1980. [The identified photographers include Christian Barthelmess, Charles M. Bell, J. H. Bratley, J. N. Choate, Natalie Curtis, DeLancey Gill, Charles Goodman, John K. Hillers, G. Wharton James, E. H. Maude, Sumner W. Matteson, E. A. Mearns, A. Miller, Cosmos Mindelleff, James Mooney, Orchard, T. H. O'Sullivan, George H. Pepper, A. Frank Randall, A. Zeno Shindler, William H. Simpson, T. W. Smillie, W. Ray Swartz, and Ben Wittick]

Rosnek, Carl, and Joseph Stacey, *Sunstone and Silver, The Collector's Book of Southwest Indian Jewelry*, Englewood Cliffs, New Jersey, 1976. [Photographs by Laura Gilpin, Michal Heron, Jerry Jacka, Ray Manley, T. Harmon Parkhurst, Forrest Stroup, Carl M. Werntz, and Ben Wittick]

Ruby, Jay, "Photographs of the Piegan by Roland Reed," *Studies in Visual Communication*, Vol. 7, No. 1, Winter 1981, cover and pp. 48-62.

Rudisill, Richard, *Mirror Image, The Influence of the Daguerreotype on American Society*, Albuquerque, New Mexico, 1971. [The Indian reaction to early photography is discussed on pp. 107–109 and 146. Plate 28 reproduces Solomon Carvalho's whole plate view of a Plains encampment; plate 105 is a daguerreotype of Hole-in-the-Day]

Rudisill, Richard, *Photographers of The New Mexico Territory 1854- 1912*, Santa Fe, New Mexico, 1973.

Running, John, *Honor Dance: Native American Photographs*, Reno, Nevada, 1985.

Running, John, and Martin Melkonian, *The Tarahumara Indians*, New York, 1983. No. 26 of *Double P.*. [Photographs by John Running]

Sandweiss, Martha A., *Laura Gilpin, An Enduring Grace*, Fort Worth, Texas, 1986.

Sandweiss, Martha A., editor, *Photography in Nineteenth-Century America*, Fort Worth, Texas, 1991. [Photographs of Indians by Henry Buehman and F. A. Hartwell, Thomas M. Easterly, A. A. Hart, John Hillers, Alexander Gardner, Frances Benjamin Johnston, Joseph Keiley, Timothy O'Sullivan, Frank A. Rinehart, George Trager, Adam Clark Vroman, and Ben Wittick]

Scarborough, C. W., "The Voyage That Failed," *The Alaska Journal*, Vol. 4, No. 1, Winter 1974, pp. 49–50. [Scarborough photographs from the 1920s]

Scherer, Joanna Cohan, "Historical Photographs of the Subarctic: A Resource for Future Research," *Arctic Anthropology*, Vol. XVIII, No. 2, 1981.

Scherer, Joanna Cohan, *Indian Images, Photographs of North American Indians 1847–1928, from the Smithsonian Institution, National Anthropological Archives*, Washington, D.C., 1970.

Scherer, Joanna Cohan, *Indians, The Great Photographs that Reveal North American Indian Life, 1847–1929, from the Unique Collection of the Smithsonian Institution*, New York City, 1973.

Scherer, Joanna Cohan, "Introduction: Pictures as Documents (Resources for the Study of North American Ethnohistory)," *Studies in the Anthrpology of Visual Communication*, Vol. 2, No. 2, Fall 1975, pp. 65–66.

Scherer, Joanna Cohan, "You Can't Believe your Eyes: Inaccuracies in Photographs of North American Indians," *Studies in the Anthropology of Visual Communication*, Vol. 2, No. 2, Fall 1975, pp. 67–79.

Schmeckebier, L. F., *Catalog and Index of the Publications of the Hayden, King, Powell & Wheeler Surveys, Washington, D. C., 1904*; New York City, 1971.

Schmitt, Martin F., and Dee Brown, *Fighting Indians of the West*, New York, 1948. [A picture history of the Indian wars, reproducing work by Baker & Johnson, D. F. Barry, Christian Barthelmess, William Bell, Mathew B. Brady, W. G. Chamberlain, Frank F. Currier, Davies, Joseph K. Dixon, C. S. Fly, Alexander Gardner, DeLancey Gill, O. S. Goff, John C. H. Grabill, Hamacher, Louis Heller, J. K. Hillers, L. A. Huffman, W. H. Illingworth, W. H. Jackson, J. McDonald, C. A. Merkey, D. S. Mitchell, Carl Moon, Lee Moorhouse, S. J. Morrow, Eadweard Muybridge, T. H. O'Sullivan, A. F. Randall, A. Zeno Shindler, W. S. Soule, G. E. Trager, and Ben Wittick]

Scholder, Fritz, *Indian Kitsch, The Use and Misuse of Indian Images, Photographs by Fritz Scholder*, Flagstaff, Arizona, 1979. [Scholder is a Luiseno artist.]

Scully, Julia, "Seeing Pictures: The ways of the American Indian have concerned photographers for a century. Today's visual explorations show us how our fate is reflected in theirs," *Modern Photography*, volume 39, number 4, April 1975, pp. 10, 120, 123.

Scully, Vincent, *Pueblo: Mountain, Village, Dance*, New York City, 1975.

Select Audiovisual Records, Photographs of Indians in the United States, Washington, D.C., n.d.

Selleck, Lee, "Native photographers look to the future," *Native Press*, 22 March 1985, p. 9.

Sexton, Tom, "Double Takes, Stereographs by H. H. Bro-

deck," *The Alaska Journal*, Vol. 10, No. 3, Summer 1980, pp. 18–21.

Sexton, Tom, "A Sampling of 19th Century Alaskan Images, A Photographic Reading," *The Alaska Journal*, Vol. 9, No. 3, Summer 1979, pp. 60–71.

Seymour, George Steele, "Indian Notes," *The American Annual of Photography 1925*, Vol. 39, New York City, 1914, pp. 172–176. [Photographs of Acoma by Seymour]

Shaw, Charles, *Indian Life in Texas, Written and Illustrated by Charles Shaw, With photographs by Reagan Bradshaw*, Austin, Texas, 1987.

Sherman, Josepha, *Indian Tribes of North America*, New York, 1990.

Slemmons, Rod, *Frank Fiske and Western Photography*, Bismark, North Dakota, 1983.

Smith, Juane Quick-to-See, *Contemporary Native American Photography An Exhibition, January 29–March 23, 1984*, Madarko, Oklahoma, 1984.

Smith, Juane Quick-to-See, *Contemporary Native American Photography, The Silver Image Gallery . . . Seattle . . . An Exhibition, January 3–February 2, 1985*, Seattle, 1985.

Smithsonian Institution, *Photographic Portraits of North American Indians*, n.p., 1867.

Snell, Joseph W., "Some Rare Western photographs by Albert Bierstadt Now in the Historical Society Collections," *The Kansas Historical Quarterly*, Vol. 24, No. 1, Spring 1958, pp. 1–5.

Snyder, Joel, *American Frontiers, The Photographs of Timothy H. O'Sullivan, 1867–1874*, Philadelphia, 1981.

"The Soboleffs, Photographers," *The Alaska Journal*, Vol. 1, No. 1, Winter 1971, pp. 29–33.

Starr, Frederick, *Indians of Southern Mexico, An Ethnographic Album*, Chicago, 1899.

Steinbeck, John, *The Forgotten Village*, New York City, 1941. [136 photographs from a documentary film by Alexander Hackkensmid on life in a Mexican Indian village]

Steltzer, Ulli, *Building an Igloo*, Vancouver, 1981.

Steltzer, Ulli, *A Haida Potlatch*, Seattle, Washington, 1984.

Steltzer, Ulli, *Indian Artists at Work*, Vancouver, B.C., 1976.

Steltzer, Ulli, *Inuit, The North in Transition*, Vancouver, B. C., 1982. [Photographs by Ulli Steltzer]

Steltzer, Ulli, *The World of the Southwestern Indians: an Exhibit of Photographs*, Paterson, New Jersey, 1970.

Steltzer, Ulli, and Catherine Kerr, *Coast of Many Faces*, Vancouver, British Columbia, 1979. [Ulli Steltzer's photographs of native people of the British Columbia coast]

Stetter, John F., editor, *Visions from the Southwest*, Vol. 52, No. 3 of *Plateau*, Flagstaff, Arizona, 1980. [Indian photographs by Sue Bennet and John Running]

Steward, Julian Haynes, "Notes on Hillers' Photographs of the Paiute and Ute Indians on the Powell Expedition of 1873," *Smithsonian Miscellaneous Collections*, Vol. 98, No. 18, 1939.

Strand, Paul, *The Mexican Portfolio*, New York City, 1967.

Street, George G., *Che! Wah! Wah!, or, The Modern Montezumas in Mexico*, Rochester, New York, 1883. [Illustrated with original prints of photographs by R. D. Cleveland, taken during an 1882 railroad journey from Chicago to Chihuahua. Photographs include views of Isleta Pueblo in New Mexico as well as Indian scenes in Mexico.]

Strong, Thomas Nelson, "Indians of the Northwest," *Pacific Monthly*, July 1906, pp. 169–177. [Photographs by Lily E. White]

Sturhahn, Joan, Carvalho, *Artist-Photographer-Adventurer-Patriot, Portrait of a Forgotten American*, Merrick, New York, 1976.

Sturtevant, William C., *Handbook of North American Indians*, multiple volumes, Washington, D. C., 1978– . [This continuing compilation is richy illustrated with photographs from all periods, representing all Indian groups, with careful documentation.]

Sucher, David, *The Asabel Curtis Sampler*, n.p., 1973.

The Suquamish Tribal Photographic Archives Project: A Case Study, Suquamish, Washington, 1984. [Includes "A Brief Survey of Early Oregon Territory—Pacific Northwest Photography, 1850–1920, with Special Reference to the Photography of Native Americans," by Robert D. Monroe]

Taft, Robert, "Additional Notes on the Gardner Photographs of Kansas," *The Kansas Historical Quarterly*, Vol. VI, No. 2, May 1937, pp. 175–177. [Evidence for dating the Gardner photographs of 1867]

Taft, Robert, *Photography and the American Scene: A Social History, 1839–1889*, New York City, 1942.

Taft, Robert, "A Photographic History of Early Kansas," *The Kansas Historical Quarterly*, Vol. 3, 1934, pp. 3–14.

Tanner, Clara Lee, *The Vanishing Indian, Ray Manley: A Portfolio*, Tuscon, Arizona, 1983.

Taylor, Colin F., and William C. Sturdevant, *The Native Americans, The Indigenous People of North America*, New York, 1991.

Taylor, Ted, "Jo Mora, Artist of The Spanish and Indian West," *The American West*, Vol. XVI, No. 2, March/April 1979, pp. 16–31.

"Telling History by Photographs: Records of Our North American Indians Being Preserved by Pictures," *Craftsman*, Vol. IX, 1906, pp. 846–849.

Thoene, Bodie, and Rona Stuck, "Navajo Nation Meets Hollywood, An Inside Look at John Ford's Classic Westerns," *The American West*, Vol. XX, No. 5, September/October 1983, pp. 38–44.

Thomas, Jeffrey, "Portfolio: Pow Wow Dancers," *Camera Canada*, No. 61, Autumn 1984, pp. 34–39. [Thomas is an Onondaga photographer.]

Thomas, Tudy, *Images of Hopi 1904–1939*, Vol. 62, No. 1 of *Plateau*, Flagstaff, Arizona, 1991. [Photographs by Edward Curtis, Forman Hanna, Karl Moon, Kate Cory, Emry Kopta, and Joseph Mora]

Thompson, Erwin N., *Modoc War, Its Military History & Topography*, Sacramento, California, 1971.

Tilden, Freeman, *Following the Frontier with F. Jay Haynes: Pioneer Photographer of the Old West*, New York, 1964. [See especially chapter IX: "My Friend Curly," and chapter X: "The Haynes Indian Portraits."]

Trimble, Stephen, and Harvey Lloyd, *Our Voices, Our Land, Words by the Indian Peoples of the Southwest, Photographs by Stephen Trimble and Harvey Lloyd*, Flagstaff, Arizona, 1986.

Trimble, Stephen, *The People: Indians of the American Southwest*, Santa Fe, New Mexico, 1993. [Photographs by Stephen Trimble]

24 Native American Photographers, April 26–May 27, *American Indian Community House Gallery*, New York City, 1984.

Underhill, Lonnie E., and Daniel F. Littlefield, Jr., editors, "Notes and Documents, Hamlin Garland at Isleta Pueblo," *Southwestern Historical Quarterly*, Vol. LXXVIII, No. 1, July 1974, pp. 45–68. [Reproduces photographs by Hillers, Lummis, Vroman, Wittick, C. M. Wood, and two photographs by Hamlin Garland]

Union Guide to Photograph Collections in the Pacific Northwest, Portland, Oregon, 1978.

U.S. Department of the Interior, Indian Arts and Crafts Board, Southern Plains Indian Museum and Crafts Center, Contemporary Native American Photography, An Exhibition, January 29–March 25, 1984. The First Major Group Exhibition of Native American Photographers to Feature the Work of Eighteen American Indian Photographers from Throughout the United States, Madarko, Oklahoma, 1984.

Ute Photo Album, The Elders, "Nahnpuchew," Fort Duchesne, Utah, 1985.

Van Ravensway, Charles, "The Pioneer Photographers of St. Louis," *Bulletin of the Missouri Historical Society*, Vol. X, No. 1, October 1953, pp. 48–71.

Van Valkenburgh, Richard, "Ben Wittick: Pioneer Photographer of the Southwest," *Arizona Highways*, Vol. 18, No. 8, August 1942, pp. 36–39.

Verplanck, James DeLancy, *A Country of Shepherds*, Boston, 1934. [Photographs of Navajo by James Verplanck]

Vincent, John R., "Midwest Indians and Frontier Photographs," *The Annals of Iowa*, Vol. 38, 1965, pp. 26–35.

Viola, Herman J., *After Columbus, The Smithsonian Chronicle of the North American Indians*, Washington, D.C., 1990.

Viola, Herman J., *Diplomats in Buckskins, A History of Indian Delegations in Washington City*, Washington, D.C., 1981.

Viola, Herman J., *North American Indians: Photographs from the National Anthropological Archives, Smithsonian Institution*, Chicago, Illinois, 1974. [A microfilm publication]

"Visions," An Exhibition of Contemporary Native Photography Organized by the Native Indian/Inuit Photographers' Association, Hamilton, Ontario, 1985. [Photographs in an "Historical Overview" are followed by photographs and statements by 16 contemporary native photographers: Simon Grascoupe, Dorothy Chocolate, Valerie General, Patrick Green, Joel Johnson, Robert T. Johnson, Martin Loft, James Manning, Douglas Maracle, Murray McKenzie, Brenda Mitten, Lance Mitten, Shelly Niro, Greg Stats, Morely Stewart, and Jeff Thomas.]

Vogt, Evon Z., and Clyde Kluckholn, *Navajo Means People, Photographs by Leonard McCombe*, Cambridge, Massachusetts, 1951. ["The first time the Navajo have been photographed . . . to show . . . the real way of life of a people who live quietly in an old tradition in the midst of the most modern society in the world."]

Voget, Fred W., *The Shoshoni-Crow Sun Dance*, Norman, Oklahoma, 1984. [Presenting photographs, most of them of sun dances in 1941 and 1975]

Vroman, Adam Clark, "The Moki Pueblos," *Photo-Era*, February 1901.

Vroman, Adam Clark, "Photography and the Great Southwest," *Photo-Era*, January 1901.

Vroman, Adam Clark, "Zuni," with "an introduction by Ruth I. Mahood" and "a documentary portfolio of photographs," *The American West*, Vol. III, No. 3, Summer 1966, pp. 42–55.

Vyzralek, Frank, "Down the Missouri in 1918: A Photographic Journey with Frank Fiske," *North Dakota History*, Vol. 38, No. 4, Fall 1971, pp. 502–517.

Vyzralek, Frank, *Frank Bennett Fiske*, Bismarck, North Dakota, 1983.

Vyzralek, Frank, "Frank Fiske's Portraits of the Sioux," *Persimmon Hill*, Vol. 14, No. 4, 1985, pp. 32–47.

Wagner, Jon, *Images of Information: Still Photography in the Social Sciences*, Beverly Hills, California, 1979.

Walker, Willard, "Photographic Documentation in Zuni Ethnohistory," *The Masterkey*, Vol. 57, No. 2, April-June 1983, pp. 45–56.

Wall, Steve, and Harvey Arden, *Wisdomkeepers, Meetings with Native American Spiritual Elders*, Hillsboro, Oregon, n.d. [Photographs by Steve Wall]

Wall, Steve, *Wisdom's Daughters, Conversations with Women Elders of Native America*, New York, 1993. [Photographs by Steve Wall]

Wanamaker Primer of the North American Indian, The First American and First Tenant of the Soil of Philadelphia, now Occupied by the Wanamaker Store, Wanamaker, Originator, Philadelphia, 1910. [Illustrated by drawings which reproduce photographs taken by J. K. Dixon on the Wanamaker Indian expeditions]

Wanamaker Primer on the North American Indian, Hiawatha, Produced in Life, Wanamaker-Originator, Philadelphia, 1909. [Illustrated with half-tone reproductions of J. K. Dixon's photographs]

Warner, John Anson, *The Life and Art of the North American Indian*, Secaucus, New Jersey, 1990.

Watson, Elmo Scott, "Local Man Took First Picture of Sitting Bull in 1881," *Bismarck Tribune*, 12 May 1949.

Watson, Elmo Scott, "Orlando Scott Goff, Pioneer Dakota Photographer," *North Dakota History*, Vol. 29, Nos. 1 and 2, January-April 1962, pp. 210–215.

Weatherford, Elizabeth, *Native Americans on Film and Video*, New York City, 1981.

Webb, William, and Robert Weinstein, *Dwellers at the Source, Southwestern Indian Photographs of A. C. Vroman, 1895–1904*, New York City, 1973.

Weil, Andrew, "The Indian Sweat," *The American West*, Vol. XIX, No. 2, March/April 1982, pp. 42–49. [Illustrated with color photographs by Marianne Greenwood]

Weinstein, Robert A., and Russell E. Belous, "Indian Portraits: Fort Sill, 1869," *The American West*, Vol. III, No. 1, Winter 1966, pp. 50–63. [The photographs of William S. Soule]

Weinstein, Robert A., "Silent Witnesses," *G. Ray Hawkins Gallery Photo Bulletin*, Vol. 1, No. 4, April 1978, pp. 1–8. [Review of the exhibition "Documents of a Heritage: Por-

traits of the North American Indian" which included images by Edward Curtis, Julius Vannerson, and Adam Clark Vroman]

Weitenkampf, Frank, *Early Pictures of North American Indians, A Question of Ethnology*, New York City, 1950.

Weitlaner, Roberto J., and Mercedes Olivera de Vasquez, *Los Grupos Indigenas del Norte de Oaxaca . . . Fotografia de Carlos Saenz y Alfonso Munoz*, Mexico City, 1969.

Welsh, Elyn, "Glimpses of a Lost Culture: Indians of the Southern Cone," pp. 102–113 in Robert M. Levine, editor, *Windows on Latin America, Understanding Society through Photographs, Coral Gables*, Florida, 1987.

Western History Department, Denver Public Library, David F. Barry, Catalog of Photographs, Denver, Colorado, n.d.

Weyer, Edward, Jr., *Primitive Peoples Today*, New York City, 1958.

Wheat, Margaret M., *Survival Arts of the Primitive Paiutes*, Reno, Nevada, 1967. ["Old" photographs by Roly Ham and modern ones by Margaret Wheat]

Wheeler, George M., *Wheeler's Photographic Survey of the American West 1871–1873, With 50 Landscape Photographs by Timothy O'Sullivan and William Bell*, New York City, 1983.

White, Fred, Jr., *American Photography from the Fred White Jr. Collection*, Bryan, Texas, 1978.

Whiteford, Andrew Hunter, and others, *I Am Here, Two Thousand Years Of Southwest Indian Arts and Culture*, Santa Fe, New Mexico, 1989. [Photographs by Witter Bynner, Tyler Dingee, Charles Goodman, Harold Kellogg, F. Maude, Jesse Nusbaum, T. Harmon Parkhurst, Sheldon Parsons, Ben Wittick, and Carolyn Wright]

Whitmer, Linda F., *The Indian Industrial School, Carlisle, Pennsylvania 1879–1918*, Carlisle, Pennsylvania, 1993.

Willcomb, Roland H., "Bird Rattle and the Medicine Prayer," *Montana, The Magazine of Western History*, Vol. XX, No. 2, April 1970, pp. 42–47. [Including photographs of "solemn rites" in 1937 by Roland Willcomb]

Williams, Anita Alvarez de, *Travelers Among the Cucapa*, Los Angeles, California, 1975. [Photographs by DeLancey Gill, E. H. Davis, and Anita Williams]

Williams, Bradley B., "Charles F. Lummis, Crusader with a Camera," *History of Photography*, Vol. 5, No. 3, July 1981.

Williams, Stephen Guion, In *The Middle, Quitingganituk, The Eskimo Today*, Boston, Massachusetts, 1983. [Photographs by Stephen Williams]

Witkin, Lee D., and Barbara London, *The Photograph Collector's Guide*, Boston, 1979.

Witmer, Linda F., *The Indian Industrial School, Carlisle, A Photographic Essay*, Carlisle, Pennsylvania, 1993.

Wood, Nancy C., *Taos Pueblo*, New York City, 1989. [Photographs by Nancy Wood]

Wood, Nancy C., *War Cry on a Prayer Feather, Prose and Poetry of Ute Indians*, Garden City, New York, 1979. [Reproducing 44 19th-century photographs of Utes]

Wood, Nancy C., *When Buffalo Free the Mountains*, Garden City, New York, 1980. [Photographs by Nancy Wood]

The World of the American Indian, Washington, D.C., 1974. [A National Geographic production illustrated with modern color photographs as well as historic black and white images]

Wright, Bill, *The Tiguas: Pueblo Indians of Texas*, El Paso, Texas, 1993. [Historic photographs of Tiguas and modern ones by Bill Wright]

Wright, Jack, "Father Hubbard and his Camera," *The American Annual of Photography, 1952*, Vol. 64, Minneapolis, Minnesota, 1951. [The Alaskan photographs of Bernard R. Hubbard]

Wyatt, Victoria, *Images from the Inside Passage, An Alaskan Portrait by Winter & Pond*, Seattle, Washington, 1989.

Younger, Erin, "Hopi Photographers/Hopi Images," *Natural History*, Vol. 93, No. 5, May 1984, pp. 40–45.

Zepeda, Eraclio, *Magia del Juego Eterno*, Juchitan, Oaxaca, Mexico, 1985. [Photographs by Flor Garduno of Indians of southern Mexico]

Zielinski, John M., *Indians*, Kalona, Iowa, 1976.

Zielinski, John M., *Mesquakie and proud of It*, Kalona, Iowa, 1976.